W9-BYL-613

Contents

Art for Everyone

Chemeketa Art Faculty

Laura Mack, Deborah Trousdale, Deanne Beausoleil,
Kay Bunnenberg Boehmer, Cynthia Herron, Alison Lutz,
Susanne Tringali, Martin Giovannini, and Hector H. Hernandez.

Art for Everyone
ISBN: 978-1-943536-15-3
Edition 1.2 Fall 2017

Chemeketa Press

Chemeketa Press is a nonprofit publishing endeavor at Chemeketa Community College. Working together with faculty, staff, and students, we develop and publish affordable and effective alternatives to commercial textbooks. All proceeds from the sale of this book will be used to develop new textbooks.

Publisher: Tim Rogers
Managing Editor: Steve Richardson
Book Editors: Stephanie Lenox, Brian Mosher
Editorial Assistant: Jon Boisvert
Design Editor: Ronald Cox IV
Design Manager: Kristen MacDonald
Cover Design: Cierra Maher, Linette Chanthavong
Interior Design and Layout: Cierra Maher
Cover Art: Artifact by Ruth Armitage. © Ruth Armitage. Used by permission of the artist.

Additional contributions to the design and publication of this textbook came from students in the Visual Communications program at Chemeketa Community College. Additional funding came from the Chemeketa Humanities Department and a Chemeketa Online Tech Hub Innovation Grant.

Acknowledgments
Text and image acknowledgments appear on pages 278 to 299 and constitute an extension of the copyright page.

Printed in the United States of America.

Chapter 1:
What Is Art?

When you ask this question — "What is art?" — you join some of the greatest thinkers of all time. Plato, Aristotle, and many others throughout history have pursued this question, offering very different answers. These differences suggest that the meaning of the word "art" is not static but shaped by cultural shifts, artistic preferences, and innovation. The evolving definition of art also suggests that an answer embraced during one moment in history may not be sufficient for the next. This text will help you figure out your own answer to this question and prepare you to develop, change, and refine that answer in the years to come.

A. Definitions and Distinctions

The foundational principles of art are the same regardless of when or where the art was made. When you look at art in relation to these basic building blocks, you will be able to engage more deeply with the work and gain understanding of the artist's goals. There are many kinds of art, but this book concentrates on **visual art**, or art that is created primarily for the viewer's eye. Other kinds of art make use of visuals, such as literature, theater, film, architecture, and dance, but we will be setting those aside for the purposes of defining our basic building blocks more carefully.

The visual arts are typically divided into fine and applied arts. Even though this category becomes blurry with contemporary art practice — something we'll discuss in Chapter 4, "Modernism" — it is useful to make these initial distinctions in the study of art. We begin our exploration by examining the **applied arts,** items that are useful and necessary for daily life. Found everywhere, in table and glassware, embroidery, furniture, and so on, these objects may be beautifully made, but they are not generally considered fine art. However, when a piece of applied art transcends its utility, when its design and composition are unified perfectly, when its presence in our lives offers a significant visual and emotional experience, then we assign it the distinction of fine art.

An example of this distinction between applied and fine art can be seen in the cabinetwork of Gustave Serrurier-Bovy (figure 1). The sensuous curves of the wood buttresses add a living, growing energy to this piece of furniture, echoed in the calligraphic details inlaid in the doors. The design's interlocking patterns unify its multiple purposes as cabinet, buffet, and vitrine (display case). Through the designer's artistry, this piece becomes not only a place to store and display household treasures, but also a treasured work of art in its own right.

The **fine arts** involve the production of objects and experiences that are not defined by their function or utility. Yet the fine arts are not merely decorative or frivolous. We believe that the fine arts are equally necessary for our daily lives because they offer the maker and the viewer satisfying visual experiences and valuable insights into the physical, social, spiritual, and imaginative worlds we share. Those experiences and insights can sometimes seem mysterious, especially for students, so a consistent technique for viewing and discussing art is essential. Let's explore the ways visual artists and viewers look at and talk about art.

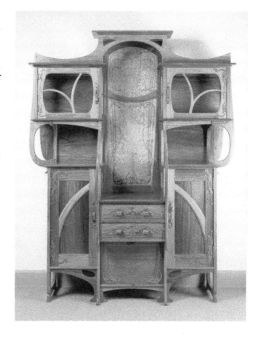

FIGURE 1.
Gustave Serrurier-Bovy, *Cabinet-vitrine*, 1899. Red narra wood, ash, copper, enamel, glass, 98 × 84 × 25 in. Metropolitan Museum of Art, New York.

B. Active Looking

The first task of the art student may seem obvious: to look. But you must do more than open your eyes and observe what's in front of you. In this book, we explain a disciplined way of looking called **active looking** that involves dynamic and intentional observation. This seemingly simple task requires ongoing practice and the development of a common vocabulary so that we can talk together and know that we are talking about the same thing.

Scientifically-speaking, seeing is the physical process of light passing through the lens of the eye to the retina. The retina's nerve cells act like sponges that soak up information and send it to the brain's visual cortex. Here the brain converts light into an image we perceive — the "truth" as we understand it to be. We are exposed to natural and manmade visual information every day, from trees and animals to picture books, magazines, graphic novels, newspapers, billboards, traffic signs, store advertisements,

Terms in bold are explained in more detail in the Glossary.

and textbooks. We watch countless images parade across screens both cinematic and pocket-sized in addition to our real-world experiences.

Due to the pervasiveness of visual information, it is important to note the difference between looking and seeing. Generally, when you look at something, you glance back and forth, becoming aware of the qualities of the object's surfaces. Your perception is influenced by many factors, not just genetics, education, and upbringing but also your own unexamined prejudices, desires, and ideas. As you take in the visual stimuli around you, you make choices about what you keep and what you edit out. This internal editing process enables us to concentrate on what is most meaningful: a computer screen providing critical information, a view of mountains, or a street sign pointing the way home. For example, when doing your homework on a computer, you're likely to be much more aware of the words being shown on the screen than you are of the brand name of the computer monitor that is printed somewhere on the plastic frame containing the screen. Your editing process, sometimes without intending to, cuts out this information as nonessential.

To see is more about comprehension. After all, when we respond to a statement with, "I see," what we really mean is that we understand. Seeing goes beyond appearances. Being visually aware means that we must pay attention to what we would normally ignore. We must carefully consider our perspective and how it changes what we see. No matter how conscious we are, vision alone is not enough to make sense of what we see. Words — spoken, written, or read — help fill in the gaps. Words translate images and allow us to frame them in terms that are memorable and communicable to others. Words can also provide context, such as historical background, religious function, or cultural significance for art. As our gaze becomes more focused and specific with new information, our direct observation sharpens our understanding. What we *see* transforms into part of what we *know*.

C. Subjective and Objective Responses to Art

It's human nature — and sometimes a matter of survival — to make quick decisions about what is good or bad, safe or dangerous, right or wrong. When we view art, the impulse to judge, for better or for worse, comes into play. Casual viewers of art often tend to think in terms of "liking" the piece or not. When you have an immediate gut reaction to a work of art, you are being **subjective**, which means that you're making judgments based on your emotions and thoughts. If you've heard the saying "there's no second chance to make a first impression," you know that subjective observations solidify swiftly and can take over, whether you're looking at a painting, a co-worker, or a mountain vista. But art is not solely about evoking strong feelings. In your study of art, it is equally important to develop an objective understanding of the piece based on formal qualities to go along with your immediate emotional reaction.

The difference between subjective and objective is not as black and white as it might seem. Nothing is when you're dealing with art. What we observe objectively elicits a subjective feeling within us, and what we experience internally is often felt so keenly that it feels like an objective fact. Like gradations on a color chart where black seamlessly transitions into white, the subjective and objective experiences of art frequently blend. As a student of art, your challenge is to choose the best stance for the task at hand. You can remember the difference between objective and subjective in this way: objective contains the word "object," which is a thing of substance that does not change form. Subjective contains the word "subject," which is an idea of the mind that, because it is influenced by factors both internal and external, is *subject* to change.

The Objective Approach

So how do you take an **objective** stance? First, you must gather your information from the object's physical characteristics and **formal elements**, such as **line**, **color**, **shape**, **texture**, **time**, and **space**. These elements will be discussed along with compositional principles in Chapter 2, "The Language of Art." By making objective observations, we're certainly not suggesting that you discount your feelings. In fact, you will find that the more informed you become

about the formal elements, the more you will be moved by a particular work of art's emotional content. This objective approach will help you find clues to understanding how art reflects and affects our lives.

The next step is to describe what you see in words, either in your own mind, in a conversation with another viewer, or in writing. Description helps you assemble your scattered ideas into a coherent whole, like putting together a jigsaw puzzle. Once you can see the "big picture," you will be able to draw conclusions from your observations. Maintaining objectivity is challenging and requires attention to both internal and external evidence. It takes effort, but the payoff is greater satisfaction in — and understanding of — the work of art.

The best way to begin to understand any image is to describe what you see. So let's start with a well-known painting by Vincent van Gogh (figure 2).

The objective approach begins with an observation of facts about the work, which can be found listed in captions, as seen in the example below.

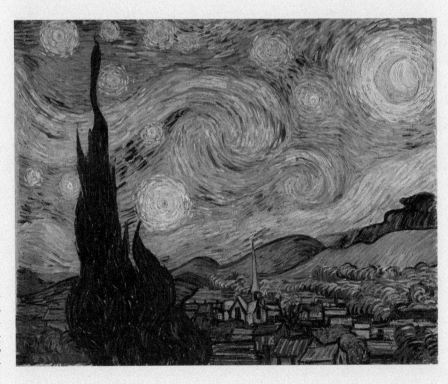

FIGURE 2.
Vincent van Gogh,
The Starry Night, 1889.
Oil on canvas, 29 × 36.25 in.
Museum of Modern Art,
New York.

An Objective Description of van Gogh's *The Starry Night*

We see a landscape showing the sky, a valley, and a village at night. The sky takes up the top two thirds of the painting. It looms with yellows and blues, swirling clouds, dazzling stars, and a huge moon that shines bright and golden. The swirling shapes in the sky are a result of brushstrokes that curve and swirl the paint. Our viewpoint is somewhere high above the valley, about level with the top of a nearby cypress tree.

The cypress tree in the foreground juts upward, visually connecting the valley and sky. It appears huge in view because of its close proximity to the painting's viewpoint. The brushstrokes of the tree also swirl, making the tree look like roiling flames. The tree on the left and the moon on the right frame the village between them.

Down in the valley, a number of simple homes surround a large, church-like building with a tall steeple. It appears to be dusk, since some lights are on in a few of the homes. The rolling hills of the valley are visible behind the houses. The steeple of the church in the valley is the only other shape besides the cypress tree that extends above the mountains.

Artist's full name, *Title of Work*, Date. Medium, Dimensions in inches. Housing Institution or Collection, Location.

Vincent van Gogh, *The Starry Night*, 1889. Oil on canvas, 29 × 36.25 in. Museum of Modern Art, New York City.

First, the artist and title are identified. If the artist is unknown, the caption begins with the title. Notice that the title is always placed in *italics*, just like the title of a book. If the title is unknown, the caption starts with a description of the work of art enclosed in brackets. After the title, the date is provided. This is an important element because it can illuminate the historical context. Next, the materials (or **medium**) are listed. This section identifies what the work is composed of, such as oil on canvas, graphite on paper, or woodcarving. Following the medium, the caption shows the exact dimensions of the work. In this textbook, measurements are given in the US Standard unit of inches only. **Two-dimensional** works of art, such as tapestry, drawing, printmaking, and photography, are always measured by height first then width. **Three-dimensional** works of art, such as sculpture and architecture, measure height, then width, and finally depth. Finally, the caption closes with the work of art's location. A surprising amount can be learned about a piece from its current whereabouts. For example, *The Starry Night* hangs in the Museum of Modern Art in midtown Manhattan, one of the most influential modern art museums in the world. When in

doubt about the essentials required to attribute a work of art, you can refer to the captions in this textbook as a guide.

In an objective description, the work of art is described without referencing individual opinion. You will notice that the model description doesn't use the first-person perspective ("I"). Using first person is not incorrect. However, it can be difficult to distinguish between your observations and opinions when using this point of view. When you describe a work of art, you should generally use present-tense verbs — "is," "shines," "looms" — as you see in this description. This enlivens your description and shows the living quality of the piece. When referring to the life of the artist or the historical period in which the work was made, on the other hand, past-tense verbs are more appropriate.

What Exactly Am I Looking At?

To maintain objectivity in your description of a work of art, ask yourself periodically and without judgment, "What exactly am I looking at?" That will help you to focus your attention on the object in front of you rather than the feelings within you.

Materials and **medium** — the singular form of the word "**media**" — are more specific ways to answer the question, "What exactly am I looking at?" For example, *The Starry Night* is an oil painting made on stretched canvas. A painting can be made from acrylic, pastel, watercolor, egg tempera, or other media. It can be painted on wood panel, plaster, sheets of metal, rocks, or glass. In each case, the materials can tell you a great deal about the way an individual piece was made and how it was intended to be used and seen. We will discuss this further in Chapter 3, "Media and Methods."

Despite the seemingly indefinable nature of art, guidelines for judgment and analysis have always existed. **Formalism** is a theoretical concept in which a work's artistic value is determined solely by its form or how it is made. The formal qualities of the work are those parts that are visible to you. They are in contrast to **subject** or **content**, which might not always be readily understood. In the example of objective description, "The sky takes up most of the painting" is a statement of form. This theoretical model evaluates work on a purely visual level, considering medium, the formal elements, style, technique, and compositional elements as opposed to any reference to subject or content.

The **formal elements** of art are the basic building blocks of any work. These elements are: value, color, line, shape, space, texture, and time. Together with the principles of art, the elements of art help us to analyze and discuss works of art. **Composition** is the way that artists organize these formal elements within their works. All art represents a synthesis of unity and variety. **Harmony, focal points, balance, scale** and **proportion, movement** and **rhythm,** and **visual flow** are ways of achieving unity, while changes in these principles can create visual interest or **variety.** The desired relationship between harmony and variety is achieved through a series of complex compositional choices. We will discuss these elements and principles in detail in Chapter 2, "The Language of Art."

To fully describe the work you are looking at, you also need to look at and describe the **subject**. In the example of objective description, the subject is identified with this sentence: "Down in the valley, there is a small town with some simple homes surrounding a church." Sometimes the title, like *The Starry Night*, tells you what the painting is about. **Subject matter** is part of objective observation because usually we can all agree on what we see in a representative work of art. This painting depicts recognizable subjects: a landscape, swirling clouds, a church, a cypress tree. When you begin to discuss how the subject makes you feel, ideas you associate with the subject, or attitudes about the artist's depiction of the subject, you are crossing over into subjective territory.

Subjective Approaches

A subjective approach is, first and foremost, a personal approach. You either like it or you don't. Expanding on this, you can then offer reasons for your likes and dislikes: "I like it because the colors are pretty. I don't like it because everything seems to be squirming around." When personal reactions are connected to defined reasons, you are on your way to combining the subjective and objective.

A work of art's subject is not the only element to consider. Often the subject is infused with content, expressing the artist's ideas about the nature of the universe and the divine, the goals and beliefs of a society, or the feelings and desires of an individual. While a work's subject can be determined objectively, the **content,** or the meaning of the work, must be interpreted subjectively, either by using information supplied from the viewer's experience or by studying the artist and the society in which

the work was made. Content can be very complex, vague, or hidden. Sometimes you may need more information than is present in the work itself. Don't get frustrated if a work of art does not immediately make sense to you. By applying the method of active looking, you can find visual clues embedded in the work that can lead to conclusions on its content.

To see how a subjective approach works, let's return to van Gogh's painting (figure 2).

This is only one of the many possible interpretations of this famous work. Unlike objective observation, subjective attitudes are both changeable and various, just as viewers are changeable and various. Taking the time to describe a work of art, taking the time to really look at it, can lead us to its content.

A Subjective Discussion of van Gogh's *The Starry Night*

Like most modern works, **The Starry Night** evokes a range of subjective reactions. The way it is painted hints at how the artist felt in that moment. We can see each brushstroke like a moment in time. The heightened and powerful colors and exaggerated scale of the stars suggest the artist's emotional response to the sky, rather than an attempt to recreate the actual night sky. The parts of the painting with the largest area, the cypress and the sky, move in two contrasting directions. The cypress is vertical and aspiring while the sky roils horizontally across the top two-thirds of the painting, relegating the tiny houses and the church to the narrow strip of valley. This opposition is made clearer by the colors: the tree's red-brown and green are at odds with the blues and yellows of the night sky, and the vertical marks emphasize the rising, flame-like quality of the tree; the village and land combine the colors and values of both. The clouds, stars, and even the landscape seem to vibrate, both from the color choices and from the strong curved marks made by the artist's paint brush. The houses tilt, their roofs rising up. Everything appears to be moving, impossible to stop, even the cypress, flaming up, briefly interrupting the dance of the sky. It seems clear that this is not what van Gogh could have seen with his physical eyes. Instead it appears to be a vision of the primal energy of nature, ignored and avoided by the inhabitants of the little village, cozy in their houses, but seen and gloried in by the artist.

Art historians might look further into the influences of an artist's education, study of other artists, and important events during the time period. However, we can figure out quite a lot through active looking and application of the language of art. To do this successfully, we need to build a solid foundation in using the language of art, making careful observations, and asking relevant questions.

D. The Purpose of Art

But what is art for? One way to answer this question is to look back in time to the beginning of human expression. During the **Paleolithic** period, commonly referred to as the Stone Age, the earliest-known artists carved their everyday bone and horn tools into shapes that resembled animals. As a species, we continue in this long tradition of making everyday tools into more complex, richer objects than are necessary for simple function.

Responding to the world around them, prehistoric artists painted and carved animal forms onto cave walls and rock shelters. Some of the most famous paintings include those of the Lascaux Caves in southwestern France (figure 3). These cave walls also reveal painted and carved geometric forms. Following in the footsteps of our cave-dwelling predecessors, we decorate our surroundings with images, both **representational**, as in the case of the Megalocerus (an extinct genus of deer) cave painting, and **conceptual**, as in the case of the geometric form and dots beneath the deer, which reflect ideas rather than the seen world.

As a whole, these images simultaneously mirror both the world in which the maker lived and the interior life of the maker's mind. Today, we continue to interpret and order our experience as individuals and as members of our collective societies through the creation and viewing of art.

FIGURE 3.
[Megalocerus, geometric form, and dots], ca.15,000 BCE. Lascaux Caves, near Montignac, France.

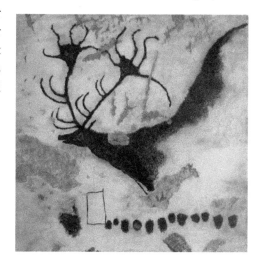

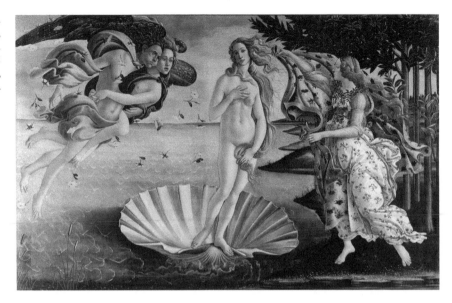

E. Beauty and Aesthetics

It is a basic human instinct to appreciate harmony, balance, and rhythm. When these elements come together, we generally consider the object to be beautiful. However, beauty is subjective and can change based on context and culture, which makes the evaluation of beauty in art a complicated and slippery concept. Specifically in art, **beauty** usually refers to an interaction between line, color, texture, sound, shape, motion, and size that is pleasing to the senses.

The concept of beauty has received a great deal of critical attention from philosophers as far back as the ancient Greeks who spoke and wrote about art. Philosophers throughout history have dedicated themselves to developing a philosophy of beauty called **aesthetics**. This particular branch of philosophy deals with the nature and appreciation of art, beauty, and taste. In practice, an aesthetic response refers to the subjective contemplation or appreciation of any object — not necessarily a work of art — while an artistic response combines subjective and objective understanding of the work.

Beauty in art can be difficult to put into words. We do not make aesthetic judgments intellectually. Instead, we respond to the work of art on an intuitive level. While there are many different ideas about what makes

something beautiful, there are also many areas of agreement. For example, Alessandro Botticelli's *The Birth of Venus* is widely recognized as a beautiful work of art (figure 4).

Classicism and the Ideal

Aesthetic judgments are always based on a local rather than a universal definition of beauty. The aesthetics of ancient Greece were different than those of ancient China, and both were different from those of the Classical Maya, as can be seen in the next three works (figures 5–7). The Tang Chinese aesthetic approach combines an interest in the naturalistic depiction of people and animals with a total disinterest in the nude body. This **relief sculpture** (figure 5) was made for the tomb of an emperor and shows his personal war horse being tended by a general.

The relative importance of costume over body structure in presenting the human figure is consistent in Chinese art. The artist who designed the relief, Yan Liben, was not a sculptor, but a painter. Painters held high status in ancient China, and painting led artistic development in other media, such as sculpture.

About a hundred years later, in the eighth century, an unknown but equally skilled sculptor carved a block of limestone to depict Lady K'ab'al Xook with her husband Shield Jaguar II (figure 6). The subject matter illustrates a bloodletting ritual in which the wife draws blood from her tongue. This period's aesthetics focus on pattern and ornament rather than on naturalistic proportions or forms, and the presence of hieroglyphic text, seen in the square blocks, play an important role in the image.

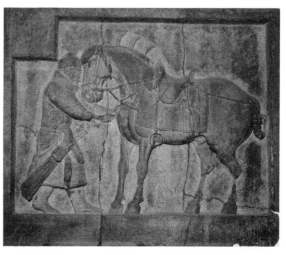

FIGURE 5.
Yan Liben, *"Saluzi" One of the Tang Horses*, Tang Period (636–649 CE). Bas relief on stone, 169 in. University of Pennsylvania Museum, Philadelphia, Pennsylvania.

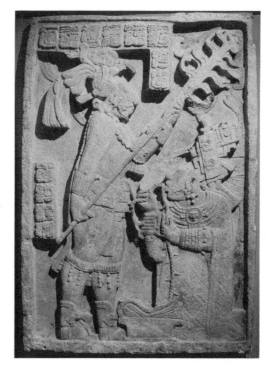

FIGURE 6.
[Lintel 24 of Structure 23 from the Mayan site of Yaxchilan (Mexico)], 725 CE. Carving in limestone, 41 × 29 in. British Museum, London.

Greek aesthetics focus narrowly on human beauty, and especially on the nude male body, which was considered as forever young and forever perfect. Platonic aesthetics, which originate with the philosophic writings of Plato (429–347 BCE), propose that ideal forms, based on geometry, underlie all physical objects, whether natural or manmade. Those ideal forms are both perfectly beautiful and universally valid. Variations found in nature, on the other hand, are neither beautiful nor desirable. This aesthetic led Greek artists to rely on mathematical proportions for the human figure and for buildings.

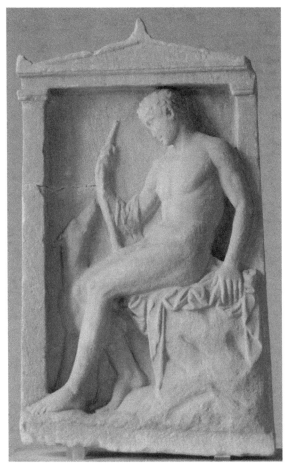

Figure 7.
[Funerary relief (Stele) of a young man, a hunter, holding a throwing weapon for hare hunting, his dog next to him], 360 BCE. Relief on marble, 46.8 × 28.5 in. Glyptothek, Munich, Germany.

By contrast, Aristotelian aesthetics, based on the writings of Aristotle (384–322 BCE), propose that nature and its extensive variety is the measure of beauty. Artists who agree with this idea tend toward naturalism and ideal naturalism. However, both Plato and Aristotle agreed that the goal of art was to create beauty and to receive pleasure in the contemplation of beauty.

Aestheticians (people who study aesthetics) point to the Greek High Classical Period (450–400 BCE) and the Italian High Renaissance (1490–1550 CE) as two periods in Western Art most concerned with aesthetics. These two periods share a deep interest in balance, harmony, and order. This preference is often expressed through carefully developed proportional relationships between parts of a composition, whether in the human figure or in architecture, as seen in this funerary relief of a young man (figure 7).

Romanticism and Expressive Art

Beauty is not always the artist's ultimate goal. Art is often intended to appeal to and connect with human emotion. Artists may express something so that their audience is stimulated in some way — by generating feelings or thoughts, inspiring religious faith, invoking curiosity, encouraging identification with a group, or triggering

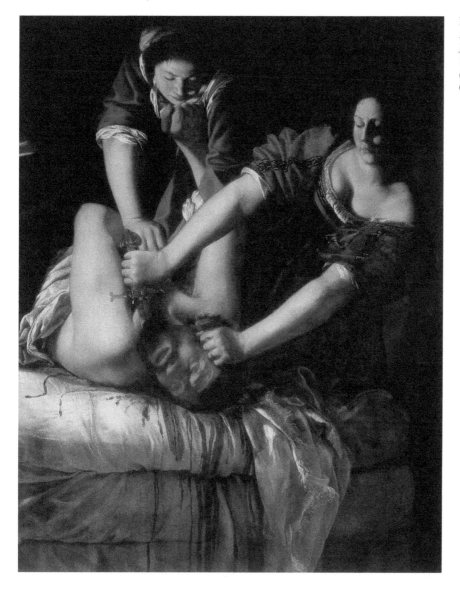

FIGURE 8.
Artemisia Gentileschi,
Judith Beheading Holofernes,
1611–1612. Oil on canvas,
62.5 × 49.4 in. Museo di
Capodimonte, Naples, Italy.

memories. One example of this is Italian artist Artemisia Gentileschi's violent and brutal work, *Judith Beheading Holofernes*, which infuses biblical subject matter with a dramatic and emotional appeal (figure 8).

This painting does not aim to please but rather evokes feelings, reactions, or questions from the viewer. Here the purpose of art may be considered an exploration of the human condition and what it means to be alive.

By the seventeenth century, it had become clear that a purely aesthetic approach to art was inadequate. Artists were creating strongly expressive works that were clearly art but followed none of the traditional aesthetic rules. This inadequacy pained philosophers, who developed an alternative understanding of these powerful works. The theory of the **sublime** was developed by Edmund Burke in 1757. In *A Philosophical Enquiry into the Origin of Our Ideas of the Sublime and Beautiful*, Burke maintained that a sublime experience is inspired by awe and terror in the face of nature, which creates a kind of delight at having lived through the experience. By extension, works of art that are strongly expressive may evoke these same feelings, as in this sublime example by American painter Albert Bierstadt (figure 9).

Burke was writing in the period that is now known as the beginning of the Romantic era (1775–1850), a time when all of the arts focused on intense emotion as the main source and primary goal of artistic expression. Expressive approaches tend toward distortion and exaggeration of human forms, imbalance, dissonance, and disorder. This tendency is much more common than you might think and can be seen in works from the late Renaissance, Baroque period, and Romantic era. Modern and contemporary artists continue to use expressive techniques to make rich and powerful works that expand our understanding of what art is and can be.

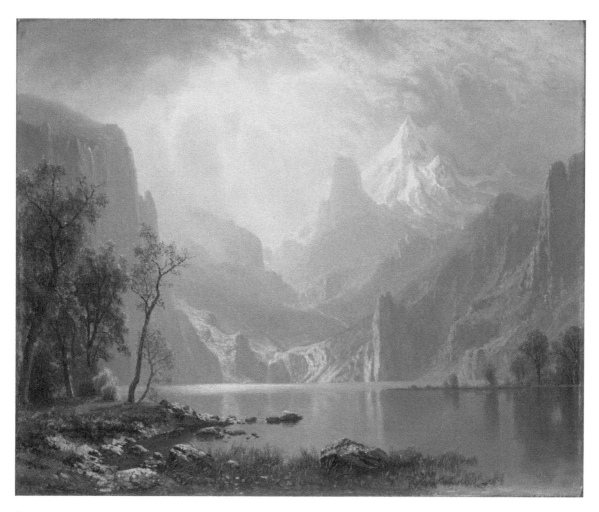

Figure 9.
Albert Bierstadt, *In the Sierras*, 1868. Oil on canvas, 13 × 16 in.
Fogg Art Museum, Cambridge, Massachusetts.

Chapter 2:
The Language of Art

2.1 Style and Technique

A. Style and Its Relationship to Subject

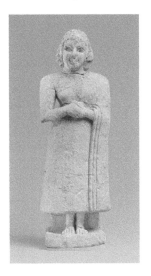

FIGURE 1.
[Standing Male Worshiper], Sumerian Early Dynastic I-II, ca. 2900 BCE. Gypsum alabaster, shell, black limestone, and bitumen, 11.625 × 5.125 × 3.875 in. Metropolitan Museum of Art, New York.

FIGURE 2.
[Standing Female Worshiper], Sumerian Early Dynastic IIIa, ca. 2600 BCE. Limestone, inlaid with shell and lapis lazuli, 9.8 × 3.375 × 2.125 in. Metropolitan Museum of Art, New York.

Let's say we ask a group of artists to paint a subject, such as a landscape, or make a physical object, such as a cup. The results will be a product not just of the individual's artistic ability, but also of the artist's style. Even when the goal is to create a work of art that is representational of its subject, different artists will approach painting the landscape or making the cup in different ways. We tend to think of personal style as unique, and it is. No single artist will produce the same landscape or cup.

While **style** is a unique characteristic, it is also influenced by one's surroundings, culture, and experiences. Artists from the same period of history show remarkable similarities in their styles, similarities that allow us to group them by so-called "period styles" such as Rococo, Cubism, or Impressionism. Each label designates a general approach shared by a particular group of artists during a defined time period. Style labels, however, act as a kind of shorthand for the art historian. They do not actually explain what the artist is doing. To understand this, we must take a look at the artist's stylistic approach.

Individual style begins with the use of one approach or, more often, a mixture of approaches. We'll take a look at several in this chapter. It's important to remember that the artist's style is expressed not only through the treatment of subject but also through choices of form and technique. When no subject is present, as we'll see with nonrepresentational work, style is developed entirely through decisions made by the artist, especially choices of technique.

Conceptual and Schematic Approaches

Artists who use **conceptual representations** are guided more by ideas and mental images of their subjects than by the precise representation of what

the eye sees. Conceptual representations are an important characteristic of **schematic approaches**, which reduce natural forms to underlying patterns. A schematic human figure would not look like a real person, yet it would still be recognizable as representing the idea of a person. Schematic figures are part of our everyday existence. For example, the male and female icons that mark restroom doors are schematic.

Most early depictions of the human figure use conceptualized representation. The concept of "worshipper" is demonstrated in these Mesopotamian figures (figure 1, figure 2). These stone figures served a religious purpose and were intended to symbolize the worshippers throughout eternity. To signal this intention, the figures have big eyes that act as the windows to the soul. The arms and fingers are also clearly defined, which emphasize the reverential pose. Other details are left out or generalized—men have beards, women don't—because they are not central to the concept. Conceptualized representation is easy for the artist to use and for the viewer to understand because it is how we all process what we see. Simple, conceptually-loaded forms do not show what the eye sees but what the mind knows about the subject.

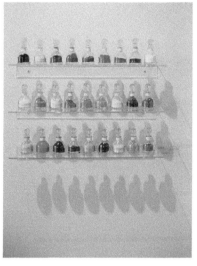

Conceptual art is work that deals directly with ideas and values. Conceptual artists often express those ideas using non-traditional media and methods such as textual elements, appropriated or borrowed images, and performances. Washington artist Catherine Haley Epstein developed the concept of a pharmacy of inspiration from artists and myths "contained" in jars of pure pigment. She was inspired by an essay written by Kazimir Malevich, an early twentieth-century Russian painter, who proposed that museums burn their art and store the ashes in jars to make room for new art. This idea intrigued Epstein and became the starting place for *My Pharmacy: Homage to Malevich* (figure 3). Her artist's statement explains more about her concept for this piece:

FIGURE 3.
Catherine Haley Epstein, *My Pharmacy: Homage to Malevich*, 2013. Acrylic shelves, glass bottles with pigment, 24 × 48 × 8.5 in. Collection of the artist.

> While I am not an advocate for burning art objects or museums, the notion of making way for the new is very exciting. As artists we stand on the shoulders of giants, and often times can be overwhelmed with the industrial focus on certain artists. I constantly look for inspiration from life and artists, so I made my little pharmacy…. And I hope that one day I can actually mix everything right, like a good chemist, to create something truly new.

Naturalistic Approaches

Naturalism is very specifically defined in art. It demands that the image create a believable illusion of the physical world, complete with appropriate scale, surface, shadow, and proportion. Naturalistic style uses recognizable images with a high level of accuracy. Naturalism also includes the idealized object: one that is modified to achieve a kind of perfection within the bounds of aesthetics and form. The image isn't too perfect, but it's not too deliberately imperfect either. In works of art, subjects look as though they have personalities, and locations look as though they're inhabited. The less this is true, the less naturalistic a work is.

To say a work of art is "naturalistic" is not the same as saying the image is "realistic," which also has a specific definition in art. Works of art that are called realistic must not only have the exact appearance of the thing mimicked, but must also show some negative aspect of the subject. Naturalism is like an air-brushed high school graduation or wedding picture. **Realism** embraces the ugly side of life and depicts it without filter, warts and all. An example of realism can be seen in French painter Léon Lhermitte's painting, *Paying the Harvesters*. Usually in art, workers are shown heroically toiling in the fields, but Lhermitte presents the authentic reality of a laborer in the late 1800s. The tired and worn workers are shown authentically, exhausted

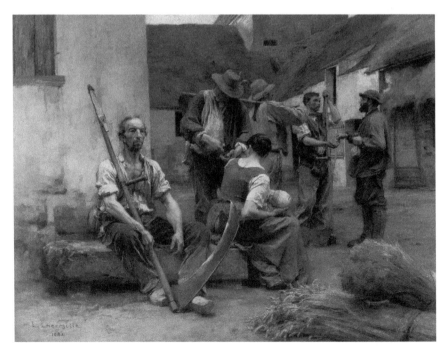

FIGURE 4.
Léon Lhermitte, *Paying the Harvesters*, 1882. Oil on canvas, 84.6 × 107.1 in. Musée d'Orsay, Paris, France.

as they await their likely meager payment. Viewers at the time did not enjoy Lhermitte's open recognition of the brutal life of laborers working for extremely low wages, who were often treated like slaves.

Idealizing and Expressive Approaches

Ideal naturalism looks naturalistic but isn't. It is too perfect. Everyone is beautiful, handsome, or rich, and the world is flawless. **Idealism** relies on the construction of images based on ideas about a perfect world rather than on what the eye sees. Forms are often distorted to create a perfect (or ideal) beauty that is impossible in real life. Ideal beauty is always culturally specific so the ideal may not be apparent to you unless you are familiar with the conventions of the culture. Sandro Boticelli's *Birth of Venus* (see Chapter 1, figure 4) is a prime example. The body of Venus is elongated and literally weightless. Her hair flows perfectly, the muscular structure under her flesh is simplified to reduce any unsightly bumps, and the dropping curve of her left shoulder is physically impossible, though beautiful.

Expressive art focuses more on emotion than ideals by revealing the artist's feelings and attempting to make the viewer feel the same way. It can sometimes be difficult to tell when a work shifts from expressive handling to expressive distortion. Violent, energetic marks indicate expressive handling. Dissonant, unnatural colors take us to the level of **expressive distortion**, as they are often used to evoke emotion in the viewer. An extreme of this is distortion of the human figure or landscape. In *Portrait of Alexander Sakharoff*, Russian painter Alexej von Jawlensky gives the male dancer an unnaturalistically elongated and pointy face and deliberately feminine figure (figure 5). The sickly green flesh, jarring reds, and slashing brushstrokes are intentionally unsettling. When in doubt, consult your feelings about the work. If you have a strong emotional reaction, look for the expressive tools that have evoked it.

FIGURE 5. Alexej von Jawlensky, *Portrait of Alexander Sakharoff*, 1909. Oil on canvas, 27.4 × 26.2 in. Städtische Galerie im Lenbachhaus und Kunstbau, Munich, Germany.

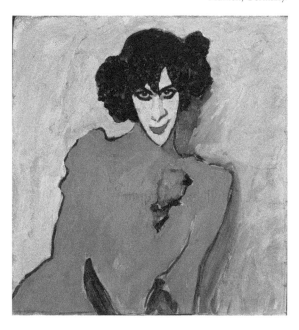

Non-Objective Approaches

Non-objective (also called **non-figural**) imagery has no relation to the "real" world. What this means is that the work of art is based solely upon itself and does not aim to represent an object or subject. In this way the non-objective style is different from the abstract style, and it's important to make a distinction between the two. Abstraction starts with the real world but takes a step back to explore a generalized aspect or characteristic of it. Artists who use the non-objective or nonrepresentational approach, on the other hand, reject the need for a recognizable subject in the first place in order to produce works that rely solely on formal elements and compositional principles. This style arose from the modern art movement in Europe, Russia, and the United States during the first half of the twentieth century.

Much work of the mid- and late twentieth century is non-objective. Oregon artist Ruth Armitage evokes the feeling of wandering through the night, suggesting (but not representing) map-like qualities and routes taken through the use of line and shape in *Night Walk* (figure 6). The colors, associated with night and artificial light, are selected out of a desire to be faithful to an idea rather than a specific night scene. No one *thing* is represented in this watercolor, making it an example of the non-objective approach.

Figure 6.
Ruth Armitage, *Night Walk,* 2014. Watercolor on paper, 30 × 22 in. Collection of the artist.

Abstract Approaches

The word **abstraction** means "taking away." Abstraction may be thought of as absence or rejection of detail. Another way to think of it is as the simplification of form or the avoidance of naturalism. This can happen anywhere in a work and may be mixed with other stylistic qualities. A little bit of abstraction is often overlooked by the viewer because the image is "close enough" to what the eye would see. Oregon artist Eric Wuest's *Bush House,* while recognizable as a domestic scene, shows very little detail (figure 7).

We see everything in this scene as if through a thin scrim of silk, but we recognize the naturalistic space and furniture. Though the forms are handled using light and shade to give them dimensionality, this artist has stopped using close description of local surfaces, especially textures and divisions between forms, which makes the figures seem a little melted or blurry. The closer you come to this work the more it loses the illusion of naturalism and starts to look like strokes of paint on a canvas.

FIGURE 7.
Eric Wuest, *Bush House* [detail], 2000. Glass drawing transferred to prepared paper and painted in oil, 18 × 24 in. Collection of the artist.

In addition to an absence of detail, abstraction can also result from the speed at which a work of art is created. A painterly approach (where visible brushstrokes are an important part of the work's effect) is characteristic of the group of artists called Impressionists, a movement founded in late nineteenth-century France. The Impressionist approach grew out of the desire to capture the *impression* of what they saw in the moment that it was happening. French painter Claude Monet's abstraction is due to his method of painting, seen here in *Woman with a Parasol*, which uses large, rapidly applied strokes of unblended paint to mimic patches of light and shade (figure 8).

Abstraction is often mixed with other stylistic approaches, particularly expressive approaches. Simplifying forms can make it easier to exaggerate or distort them through the use of strong colors. Oregon artist nic nichols' *will and nellie's ride* reduces the forms of a car to simple but accurate outlines (see figure 9). The strong contrasting colors give the work tremendous energy and verve and make the car spring off the canvas.

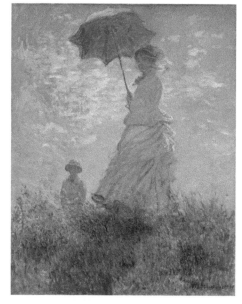

FIGURE 8.
Claude Monet, *Woman with a Parasol—Madame Monet and Her Son (Camille and Jean Monet)*, 1875. Oil on canvas, 39.375 × 31.875 in. National Gallery of Art, Washington, DC.

FIGURE 9.
nic nichols, *will and nellie's ride*, 2014. Lead pencil and oil on canvas, 20 × 30 in. Private collection.

B. Plastic, Painterly, and Linear Handling

No matter what mix of styles an artist may choose, the particular way the medium is handled affects the overall work. Handling means the way in which the artist's materials, such as paint, ink, stone, or metal, are used or treated. Another word for this is **technique**. All styles are dependent on particular kinds of handling, some for illusion, some for expressive qualities, and some for design qualities. Every work of art has a characteristic handling. Three very basic ways to discuss handling are in terms of how the mark or form is made. In two-dimensional works, this includes the extent to which the handling creates an illusion of form. The three techniques we will discuss here are painterly, plastic, and linear.

Plastic Technique

The original meaning of the word **plastic** is "moldable or malleable." Plastic handling is a term used to describe sculpture, where forms are shaped or

molded by the artist in three dimensions. Carved out of calcite, a soft stone, the two Mesopotamian votive statues seen earlier in this chapter are plastic works. When used to describe the handling of two-dimensional works, plastic refers to the artist's effort to make the forms appear three-dimensional and to erase any tool marks that might undermine that illusion. To do this the artist usually paints in relatively strong light, which illuminates all parts of the forms evenly.

Painterly Technique

Painterly handling has two possible approaches, one of which applies only to two-dimensional works. This first, which was developed during the Italian Renaissance, requires an artist to use color and value to create an illusion of form. By imitating the way that light and simultaneous contrast affect color and value, the artist can give flat surfaces the appearance of volume and depth. The artist blends the edges of objects together if they are of the same value, even though they do not meet in the real world. Where the eye would see detail, the artist paints detail. Where the eye would not see detail, the artist does not paint it, even though he or she knows that it is there. The contrast between amount of detail shown in the foreground and that shown in the background must be recognizable for the illusion of depth to work.

After the Renaissance, some artists began to make the individual brush mark an important part of the appearance of the work, leaving the medium as first laid down instead of blending it in. This painterly handling is recognizable by the extent to which the individual marks made by the artist are recognizable and become an important part of the effect of the work (see figure 8).

In three-dimensional forms, painterly qualities are created by the artist's deliberate use of value shifts, especially shadow, as part of the composition. This famous music hall of the Ali Qapu palace in Isfahan, Iran, is decorated with deep niches shaped in the outlines of jars and bottles (figure 10). It is the shadow cast by the niche that gives the form its visual power.

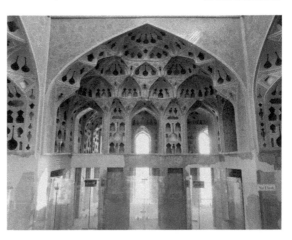

FIGURE 10.
Music Hall in the
Ali Qapu Palace, Isfahan,
Iran, seventeenth century.
Stucco decoration.

Linear Technique

Linearity is a technique that emphasizes line over form in a decorative and often flattening way. Forms may be outlined, as seen in cartoon figures, or the shapes of the forms may be turned into lines. Linearity is a powerful component in idealizing and expressive works alike because of the way it undermines naturalism through its flattening effect. English artist Aubrey Beardsley's illustration for Thomas Malory's *Le Morte d'Arthur* is remarkably linear (figure 11). The figures of Tristan and Isolde are both reduced to ornate outlines, beautiful and flat, standing before an ornamental backdrop of curtains and a narrow view of the sea.

Linearity is also a powerful tool in three-dimensional works. These ceremonial headdresses are characteristic of those used in Chiwara social rituals among the Bambara people of Mali (figure 12). The creatures are conceptual representations of antelope, emphasizing head, horns, manes, and gender, while reducing other aspects of the animals to decorative detail. The forms are handled in a particularly linear manner, masterfully combining the spiky and the curved, as well as line implied by arrangements of dots.

FIGURE 11.
Aubrey Beardsley, *How Sir Tristram Drank of the Love Drink,* 1893. Pen and ink illustration to Thomas Malory's *Le Morte d'Arthur.* Fogg Art Museum, Cambridge, Massachusetts.

FIGURE 12.
Pair of Headdresses (Ci Wara Kunw), Bamana, Baninko region, Mali, Mid-nineteenth/early twentieth century. Wood, metal, brass tacks, and grasses, Male (right): 38.75 × 16.125 × 4.25 in. Female (left): 31.25 ×12.5 × 3 in. Courtesy of the Ada Turnbull Hertle Endowment, Art Institute of Chicago.

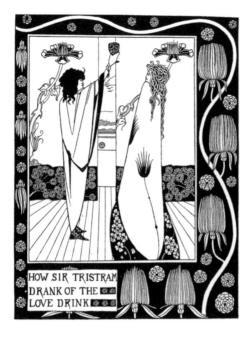

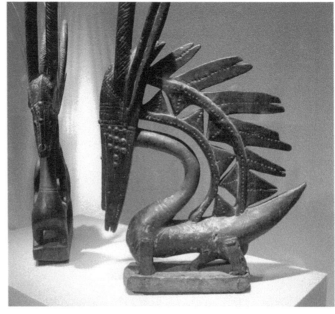

2.2 Formal Elements: Line, Shape, Mass, and Texture

Formal elements and principles make up the foundation of art. These elements are the basic building blocks of art in the same way that chemical elements are the basic building blocks of nature. Like chemical elements, the formal elements of art combine and build on each other. Lines that meet become shape and form. Form is given value, color, and texture, which in turn creates a sense of space and depth in a piece. Fortunately, there are fewer formal elements than chemical elements, so they are much easier to memorize. This section will show what these elements are and help you understand how they interact and work together.

Not all of the elements and principles are present in every work of art, and they are not all used equally. Artists interpret and apply these elements and principles to fit their particular needs and visions. As Spanish painter Pablo Picasso advised artists to "learn the rules like a pro, so you can break them like an artist." This advice reinforces the age-old distinction between knowledge and wisdom: to know the rules and tools of art is to be knowledgeable, but to be an artist is to truly understand which tool is best, which rules can be bent, and when to choose a new tool altogether.

The next three sections will examine these building blocks. In this chapter, we will start with line, shape, mass, and texture.

A. Line

Paul Klee, a Swiss-born painter known for his expressive work, once quipped, "A line is a dot that went for a walk." It's really that simple. When the tip of a pencil is placed on a piece of paper, a dot is created. Once the pencil begins to move, it becomes a line. In art practice, a **line** is a mark noticeably longer than it is wide. In nature, what we label "lines" are really the edges of things, mostly distinguishable through value or hue contrast. Artists can mimic those lines to construct an illusion of form, to make a pattern, or to evoke an emotional reaction.

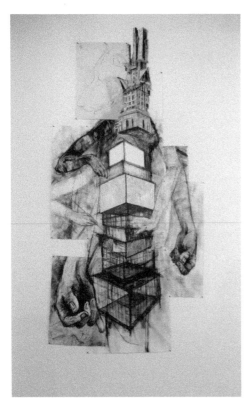

The straight lines, sharp angles, and pure curves of **geometric lines** feel orderly and logical. You can see the way vertical and horizontal lines are used by Oregon artist Andrew Myers in the center "torso" area of his drawing, *Stack #1* (figure 1). The use of the structural lines between the two arms conveys a sense of stability and precision.

Curving and changing directions freely, the lively and energetic **curvilinear lines** convey movement. In *Soldiers Fighting*, Italian artist Luca Cambiaso uses curvilinear lines to enhance the sense of energy in the battle scene (figure 2).

Jagged lines change directions sharply and evoke feelings of danger and threat. Twentieth-century Expressionist artists frequently used jagged lines to illustrate the economic and social uncertainty of their time. In *Gewecke and Erna*, German artist Ernst Ludwig Kirchner uses jagged lines to emphasize the anxious posturing of the two figures (figure 3).

Now let's look at line in practice.

FIGURE 1.
Example of rectilinear and geometric line. Andrew Myers, *Stack #1*, 2013. Mixed media on paper, 87 × 48 in. Collection of the artist.

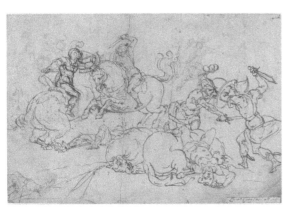

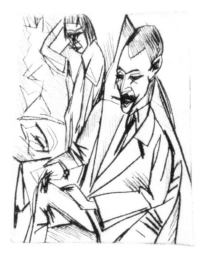

FIGURE 2.
Example of curvilinear line. Giovanni Andrea Ansaldo, *Soldiers Fighting*, ca. 1527–1585. Pen and brown ink over black chalk on laid paper, 7.25 × 11 in. Joseph F. McCrindle Collection, National Gallery of Art, Washington, DC.

FIGURE 3.
Example of jagged lines. Ernst Ludwig Kirchner, *Gewecke and Erna*, 1913. Etching and drypoint on heavy wove paper, (plate) 9.875 × 8.2 in.; (sheet) 19.75 × 14.25 in. The Robert Gore Rifkind Center for German Expressionist Studies, Los Angeles County Museum of Art, California.

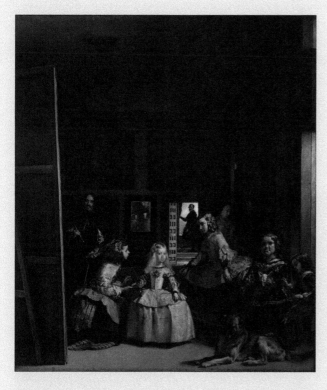

FIGURE 4.
Diego Velázquez , *Las Meninas*, 1656.
Oil on canvas, 125.2 × 108.7 in.
Prado, Madrid.

Close Examination of Line in Diego Velázquez's *Las Meninas*

Spanish painter Diego Velázquez 's *Las Meninas* offers a sumptuous imaginary world (figure 4). Its size (almost ten feet square), painterly style of naturalism, lighting effects, and the enigmatic figures placed throughout the canvas — including the artist himself — make it one of the great masterpieces in Western art history. Velázquez makes powerful use of lines, both to construct the space and to direct the eye.

Actual lines: These are lines that are physically present. The edge of the wooden stretcher bar on the left of the painting is an actual line, as are the picture frames in the background and the linear decorative elements on the some of the figures' dresses. The picture frames on the walls help to construct depth in the work by seeming to recede to a single vanishing point.

Implied lines: These lines are created by visually connecting two or more areas together. The space between the Infanta Margarita, the blonde child at the center of the composition, and the *meninas* (maids of honor) to her left and right are implied lines. The diagonals of the figures set up a relationship that implies movement. Implied lines can also be created when two areas of different colors or tones come together.

The **implied lines** in *Las Meninas* show how a painting can be composed to suggest movement and relationship without the use of actual lines (figure 4). Implied lines can also be found in three-dimensional works of art. In the Roman copy of an original Greek sculpture, *Laocoön and His Sons*, the mythological figures are attacked by sea snakes sent by the goddess Athena as punishment for warning the Trojans not to accept the Trojan horse (figure 5). The sculpture sets implied lines in motion as the figures writhe in agony against the serpents.

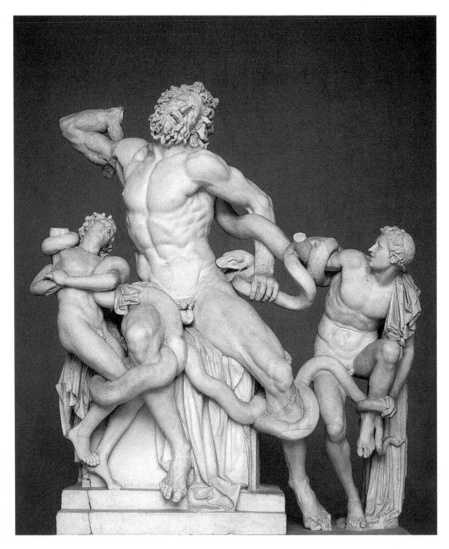

FIGURE 5.
Laocoön and His Sons (*Laocoön Group*), ca. 27 BCE–68 CE. Marble, Roman copy of Greek original, 6.8 × 5.3 × 3.7 ft. Vatican Museums, Vatican City, Italy.

Contour lines create a path around the edge of a shape, much like the outlines in a coloring book or the outer shape of a cookie cutter. Contour lines can be clearly seen in this detail of a charcoal sketch by Oregon artist Jane Lieber Mays (figure 6). The artist draws rough contour lines — in some cases more than once — as she "searches" for the most accurate edge location line. You can also see the horizontal and vertical lines the artist used to align the symmetrical curves of the pot's form.

When lines explore the interior of a shape, its inner topography, they are called **cross contour lines**. You can see these in Mays's drawing in the rim of the lid and the handle. Cross contour lines give flat shapes a sense of form — the illusion of three dimensions — and can also be used to create shading. In the second drawing, Mays also uses lines that trace the shades and reflections on the teapot (figure 7). This type of line, which explores contours, cross contours, and edges of values, is referred to as continuous line contour and can be seen throughout the drawing.

Hatched or cross-hatched lines can be applied in one or multiple directions to give shading and visual texture to the surface of an object. Multiple layers of cross-hatched lines can create rich texture and a wide range of values. You can see how surface details and light are conveyed through cross-hatched lines in this drawing by Mays (figure 8).

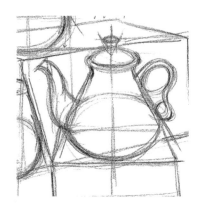

FIGURE 6.
Jane Lieber Mays, *Gesture Handout* (detail), 2007. Charcoal on paper, 8.5 × 11 in. Collection of the artist.

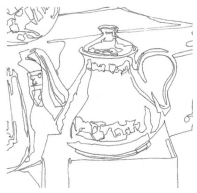

FIGURE 7.
Jane Lieber Mays, *Continuous Line Contour Handout* (detail), 2007. Pen on paper, 8.5 × 11 in. Collection of the artist.

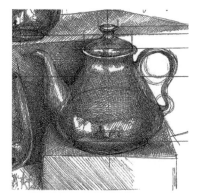

FIGURE 8.
Jane Lieber Mays, *Cross-hatched Lines Handout* (detail), 2007. Pen on paper, 8.5 × 11 in. Collection of the artist.

FIGURE 9.
Laura Mack, *Untitled*, 2014. Charcoal on paper, 18 × 24 in.
Collection of Chemeketa Community College Art Program.

FIGURE 10.
Paul Kelpe, *Machinery Abstract No. 2*, 1934. Oil on canvas, 38.25 × 26.375 in. Transfer from the U.S. Department of Labor 1964.1.27. Smithsonian America Art Museum, Washington, DC.

B. Shape and Mass

Think back to Klee's statement, "a line is a dot that went for a walk." When the line meets up with itself, it becomes a shape. A **shape** is an enclosed area and can be created by lines or edges as well as changes in value, color, and texture. Shapes are the result of a perceived difference between areas.

Real three-dimensional form cannot exist in two-dimensional art, which is composed of only height and width. Artists who work in two-dimensional approaches must choose whether to create an illusion of three-dimensional form. If so, they must also decide how believable they want that illusion to be.

Consider this: a circle is flat, but the drawing of a sphere creates the illusion of three-dimensionality. With the use of a shading technique called **chiaroscuro**, the artist can fool the eye and create a physically impossible yet visually plausible situation. This illusion is demonstrated in the still life drawing by Oregon artist Laura Mack, which *appears* to have mass and volume even though it's two-dimensional (figure 9).

Form is the three-dimensional version of shape. For our purposes, we will use the term shape, but these concepts apply to both two-dimensional and three-dimensional works of art.

Types of Shapes

In addition to defining shapes as either two-dimensional or three-dimensional, shapes can be categorized by their descriptive qualities. Our examination focuses on geometric, curvilinear, and organic shapes.

Geometric shapes tend toward clean and precise edges. German-born American artist Paul Kelpe's Depression-era painting, *Machinery Abstract #2*, was completed during his employment with the Works Project Administration (WPA). The factory scene has been flattened and abstracted with a composition based on simple geometric shapes (figure 10).

FIGURE 11. [LEFT]
Al Held, *Untitled*, 2006. Art glass window, 50 × 20 in. U.S. Court House, Orlando, Florida.

FIGURE 12. [RIGHT]
Hector Guimard, *Dress Panel*, ca. 1900. Silk and paint on silk, 27 × 18 in. Metropolitan Museum of Art, New York.

In comparison, Florida artist Al Held uses geometric shapes in a radically different way in this art glass window (figure 11). Held adds the dimension of depth to his shapes to give them the appearance of three-dimensionality. The shapes appear to have mass and volume, and his composition allows the shapes to inhabit an intuitive and physically impossible space.

Similar to calligraphic lines that spiral and swirl, **curvilinear** shapes evoke a sense of fluid movement. Curvilinear shapes were a distinctive element of the Art Nouveau ("New Art") movement, which influenced decorative arts and architecture in the late nineteenth and early twentieth centuries. In this Art Nouveau panel for a dress by French designer Hector

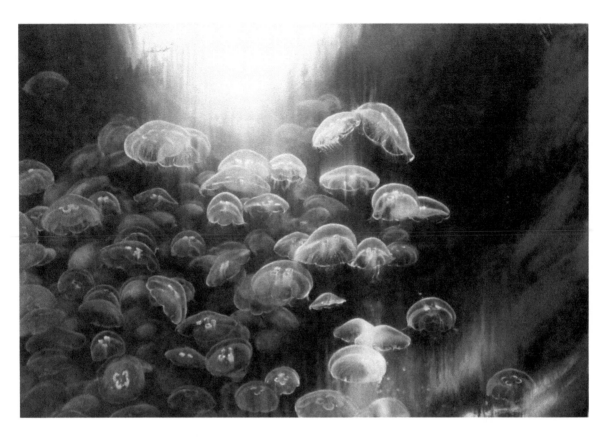

FIGURE 13.
Mary Campbell, *Moonjellies*,
2012. Oil on canvas, 56 × 82
in. Collection of the artist.

Guimard, the curving shapes create a visual flow that activates the composition and moves the viewer's eye in a figure-eight path (see figure 12).

Organic shapes typically have a softened quality to them similar to river rocks. The term is frequently applied to shapes from nature, but not all shapes from nature can be classified as organic. In *Moonjellies*, Oregon artist Mary Campbell depicts a swarm of jellyfish with their soft rounded edges that are illuminated by a light (figure 13).

Artists do not limit themselves to the use of a singular type of shape. For example, Oregon artist Eileen Cotter Howell's East of the Sun, West of the Moon incorporates a vast array of shapes (figure 14). Within this painting, she has juxtaposed angular, abstract, curvilinear, and amorphous shapes. **Amorphous** shapes are diffuse and fuzzy, with a quality similar to dense patches of fog. Areas of color and value are perceived, but the edge of the shape is neither hard nor distinct. Cotter Howell allows the warm and cool colors to shift through her painting with very little concern for the structural shapes within the composition.

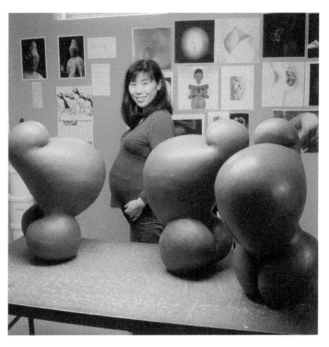

FIGURE 14.
Eileen Cotter Howell, *East of the Sun, West of the Moon*,
2011. Watercolor, 36.5 × 30 in. Private collection.

FIGURE 15.
Mika Negishi Laidlaw, Home Studio, 2008.

Mass and Volume

In everyday conversation, we often refer to an object's mass and volume
interchangeably, but the terms are, in fact, distinct. Simply put, **mass** refers
to the sense of weight of an object and **volume** relates to the object's outer
edges or dimensions. Masses are solid three-dimensional forms. Volumes
are hollow forms.

The ceramic sculptures by Minnesota artist Mika Negishi Laidlaw
are not massive in regards to overall scale, but the sense of mass is full
and heavy, depicting the later stages of pregnancy (figure 15). In these
free-standing sculptures, Laidlaw abstracts the human figure into simple
organic shapes, placing emphasis on the stomach's exaggerated girth. The
small of the back is pinched, arching from the weight of pregnancy. From
this photo taken in her studio, we can see that she is pregnant, offering the
viewer a scale reference.

Volumes are hollow, three-dimensional forms that can be measured by
height, weight, and depth. Volumes can be constructed out of traditional
materials, such as clay or glass, or enclosed by intersecting planes, as in

Formal Elements: Line, Shape, Mass, and Texture **37**

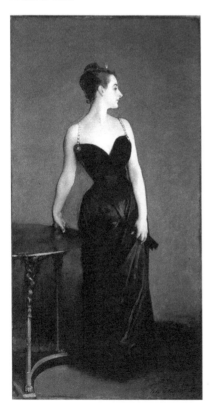

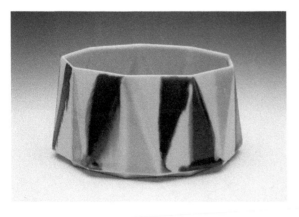

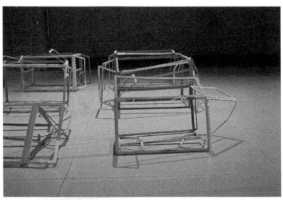

architecture. In looking at this ceramic bowl by Montana artist Alison Reintjes, you can consider the bowl's hollow shape as volume (figure 16). If we were to fill the bowl with plaster, that would refer to the mass of the object.

Volume can also be implied by lines moving in three dimensions that construct a conceptual rather than a physical barrier between outside and inside. The mixed-media sculpture by Michigan artist Brian Caponi suggests volume using a skeletal architectural structure (figure 17). Without walls, the interior and exterior realms become indistinguishable, yet the volume is implied.

Positive and Negative Shape

Positive and negative shape fit together like puzzle pieces. Both parts are equally important. **Positive shape** is the object, and **negative shape** is the area around it. Looking at *Madame X* by American expatriate artist John Singer Sargent, it is easy to see that the woman is the positive shape and the warm brown area around her is the negative (figure 18).

The negative shape is often called the "background." However, referring to negative shape in this way suggests that it is an empty, flat area. In the real world, negative shape is

multi-dimensional. Imagine a coffee cup: the cup itself is the positive shape, and the area all around and inside of the cup is the negative shape.

Positive and negative shape can also be referred to as the figure/ground relationship. This is a perceptual process that takes place in the brain of the viewer to distinguish a figure from its background and make sense out of perceived shapes. Perhaps the most familiar example of this relationship is the optical illusion known as Rubin's Vase (figure 19). Based on the research of Danish psychologist Edgar Rubin, this image offers a puzzle-like relationship between positive and negative shape and plays with ambiguity and shape reversal. When looking at the image, do you see the vase or the faces?

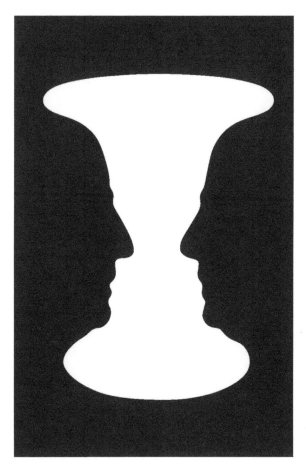

FIGURE 19.
Example of positive and negative space, Terra Hyle, 2015.
Pen and ink. Collection of the artist.

C. Texture

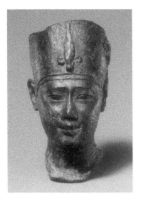

Touch is an essential way we connect with the world around us, and the **texture** of an object can be both provocative and soothing. Some people refuse to eat a certain food or wear a certain fabric because of its texture. Some children require physical contact with a soft blanket to be able to sleep. Textural qualities in art can likewise evoke strong emotional responses. Soft textures appeal to the viewer as sweet and safe while harsh jagged textures elicit strong negative emotions.

FIGURE 20.
Head of Ptolemy II or III,
246–222 BCE. Bronze, 2.6 ×
.875 × 1.875 in. Metropolitan
Museum of Art, New York.

Tactile or Physical Texture

Tactile or **physical texture** is the direct feel of a surface under the hand or against the body. In these two examples of bronze sculptures, you can see how the medium is the same but the texture is handled differently. Each texture reveals something very different about the figures. The Egyptian bronze head from the Ptolemaic period is rough and weathered due to its age (figure 20). The texture conveys the work's antiquity.

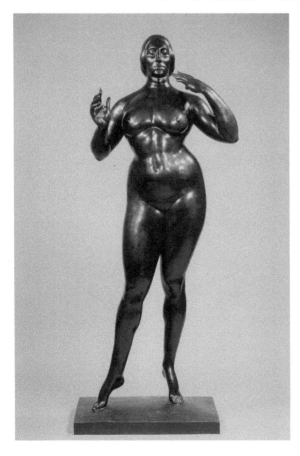

On the other hand, French artist Gaston Lachaise creates a smooth and highly polished bronze surface for his sculpture *Standing Woman* (figure 21). She stands on her toes, creating an upward movement. Her ample figure is smooth and polished, which gives a sensation of lightness, as if she is a balloon about to float away.

Impasto, the thick application of paint onto a surface, is a way to create a physical texture in painting. In *Vase with Red Gladioli*, Vincent Van Gogh paints the white and pink carnation flower petals with gobs of lumpy paint (figure 22). The paint, applied directly from the tube, looks like the ruffled texture and shadow of actual carnation petals, but the feel would be uneven

FIGURE 21.
Gaston Lachaise, *Standing Woman,* 1912–15, Cast in 1930. Bronze, 73.875 × 32 × 17.75 in. Metropolitan Museum of Art, New York.

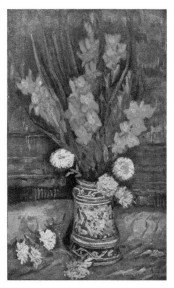

FIGURE 22.
Vincent van Gogh, *Vase with Red Gladioli*, 1886. Oil on canvas, 25.6 × 15.7 in. Private collection.

FIGURE 23.
Ginny Marsh, *Platter*, 2010. Stained and glazed stoneware, 4 × 17 × 17 in. Collection of the artist.

and rigid – if you were allowed to touch it. At first glance, this ceramic platter by Texas artist Ginny Marsh could be described as both smooth and rough (figure 23). The center green section appears smooth while the bark-like outer edges are rough. If the platter were in front of us, we could touch it and experience its actual or physical texture. What you see in this two-dimensional photo, however, is only a visual representation of actual texture.

FIGURE 24.
Georges de la Tour, *The Fortune Teller*, ca. 1630. Oil on canvas, 40.125 × 48.625 in. Metropolitan Museum of Art, New York.

Visual or Simulated Texture

Visual texture is artistic mimicry of physical textures, such as the sheen of satin or the softness of fur. This is done through careful observation of minute changes in color and value caused by light. When well-executed, visual texture appears three-dimensional. You can see the effect of this illusion in *The Fortune Teller* by French painter Georges de la Tour (figure 24).

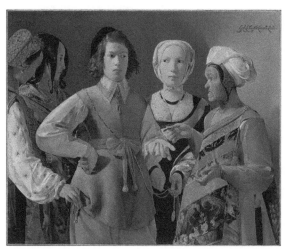

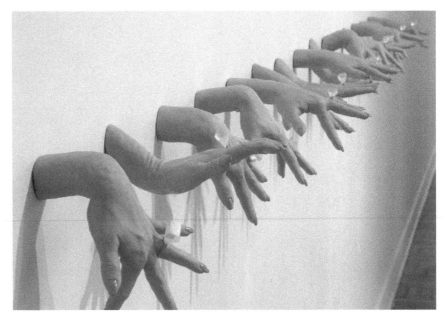

FIGURE 25.
Misty Gamble, *Tan Hands* (detail), from *Primping and the Currency of Worth* series, 2009. Ceramics and mixed media. Collection of the artist.

Trompe l'oeil refers to images that replicate shape, texture, and other formal elements so carefully that, at first sight, the viewer can hardly tell that the images aren't the actual object being represented. Trompe l'oeil means "trick the eye," and art that employs trompe l'oeil is so lifelike it can actually trick the viewer into thinking the objects are real. This installation piece by Kansas artist Misty Gamble creates a row of waving hands that look surprisingly real (figure 25).

Abstracted texture is a simplified version of visual texture. In the simplification process, usually the mass and value are reduced to create a flattened depiction of the texture. In *The Dream* by French artist Henri Rousseau, the jungle foliage retains reference to the textural qualities, but everything has been simplified (figure 26). The two broad-leafed plants in the foreground illustrate abstracted texture clearly.

Invented texture reflects neither the real or expected texture of an object. By inventing a texture, the artist can create a visual metaphor, explore unexpected visual combinations, or provide a surprising juxtaposition to hook the viewer. Maryland artist Lindsay Pichaske plays with the textural qualities in her sculpture *Aristotle's Foil* (figure 27). The straight black hair of the gorilla is exchanged for artificial red rose petals. As a viewer, you might consider the reasons this texture was chosen and how it adds to the work.

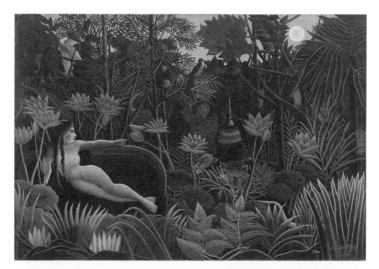

FIGURE 26.
Henri Rousseau, *The Dream*,
1910. Oil on canvas, 80.5 ×
117.5 in. Museum of Modern
Art, New York.

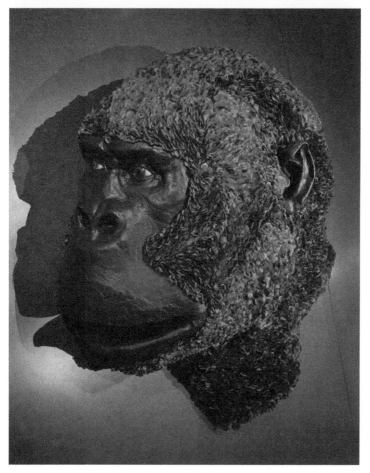

FIGURE 27.
Lindsay Pichaske, *Aristotle's
Foil*, 2010. Ceramics and arti-
ficial flowers, 16 × 36 × 36 in.
Collection of the artist.

2.3 Formal Elements: Value and Color

In this section, we continue our examination of formal elements by looking at value and color.

A. Value

Value is separated into two types, achromatic value and chromatic value. Achromatic value refers to lightness or darkness on a gray scale, a range of gray shades from black to white (figure 1). Because the human eye perceives a range of values more readily than it does color, value is an essential building block of art. Between black and white lie an infinite gradation of values from darkest gray to lightest gray, but we can divide value into three main groups: **high-key** (very light), **mid-key** (in the middle zone of the value scale), and **low-key** (very dark).

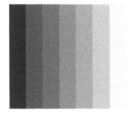

FIGURE 1.
Illustration of a gray scale.

Chromatic value refers to the infinite gradation of values in a single color. These are divided into groups based on what is added to the hue. When white is added to a hue, we get a **tint**; when black is added, we get a **shade**; and when gray is added, we get a **tone**.

Contrast

Contrast is the heart of value. Picture the inside of a cave: without light, the cave and everything in it represents the darkest value possible. Light a torch, however, and shapes in a wide range of values appear. If everything is black, we can't see anything because the contrast is so low. The same is true if everything is white. High contrast is what makes forms stand out, and low contrast makes them blend together. Contrast makes it possible for value to do its work in art.

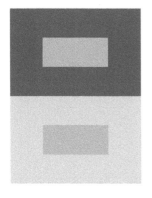

FIGURE 2.
Illustration of simultaneous contrast in value

One of the challenges of value is that it appears to change depending upon what else is nearby. In this illustration of simultaneous contrast, the two center rectangles are the same value, but they appear to be very different (figure 2). The middle gray appears lighter when placed next to a darker background. It appears darker when placed next to a lighter value.

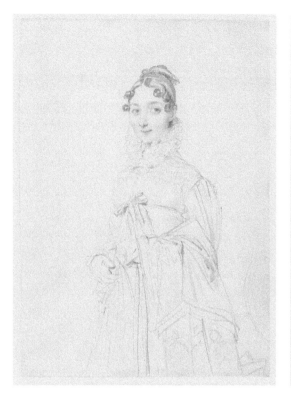

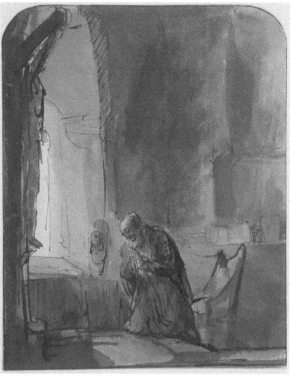

FIGURE 3.
Jean Auguste Dominique Ingres, *Portrait of a Lady*, 1815–1817.
Graphite on wove paper, 10.875 × 7.8 in. Metropolitan
Museum of Art, New York.

FIGURE 4.
School of Rembrandt (Rembrandt van Rijn), *Saint Jerome Praying
in His Study*, seventeenth century. Pen and brown ink, brush and
brown wash with touches of white and red chalk, 10.25 × 8.3 in.
Metropolitan Museum of Art, New York.

Contrast can be one way to create emphasis and direct the viewer's
attention. French artist Jean Auguste Dominique Ingres made good use
of contrast in his well-known drawings of nineteenth-century European
tourists as seen here in this portrait of a young woman (figure 3).

The lower portion of the drawing is higher in value than the lady's
face. Ingres wants the viewer to concentrate on the sitter's eyes and hair. He
accomplishes this by using more contrast in this portion of the drawing.

Overall Value

Overall value is identified by considering whether the work has a pattern
of high-key, middle-key, or low-key values. *St. Jerome Praying in His Study*
is an example of a low-key work, which uses mostly dark values and evokes

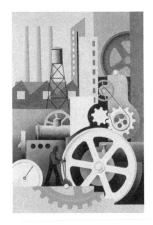

FIGURE 5.
Image converted to gray scale. Paul Kelpe, *Machinery Abstract No. 2*, 1934. Oil on canvas, 38.25 × 26.375 in. Transfer from the U.S. Department of Labor 1964.1.27. Smithsonian American Art Museum, Washington, DC.

a sober, reverential mood (see figure 4). In this work, the opposing ends of the value scale are eschewed in favor of a more compressed gray scale, producing a contrast that is harmonious rather than harsh.

In a painting we saw earlier in section 2.2, Paul Kelpe uses a mid-key value (see Section 2.2, figure 10). Because this work is painted in a range of hues, the overall value becomes more obvious when the image is converted to grayscale (figure 5).

Chiaroscuro

Italian for "light and dark," **chiaroscuro** employs a range of values to give an object form and volume, rather than a flat look. Oregon artist Robert Bibler shows the application of chiaroscuro in *Evidence from the Cave #1* (figure 6). The use of different values on the hand, box, and other objects gives them the appearance of volume.

FIGURE 6.
Robert Bibler, *Evidence from the Cave #1* (*The Myth of the Cave* Series), 1998. Conté and pastel pencil on paper, 22.25 × 26.625 in. Chemeketa Community College, Salem, Oregon.

B. Color

The human eye can see a wide range of color. For many of us, our reaction to color in a work of art is immediate. We all have strong likes and dislikes to colors, and those preferences affect our response, making color a potent element for artists to manipulate. Artists work with color through systems called **color schemes** — groups of colors chosen for their relationships and interactions with one another. Because color has social and symbolic meaning, it often triggers emotions, which is why expressive works of art tend to rely on strong or unusual color schemes.

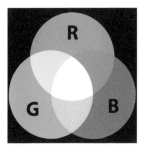

FIGURE 7.
Example of primary colors
in the additive mode.

Additive and Subtractive Color Systems

The **additive color** mode is a light-based system dealing with the perception of the primary colors — red, green, and blue. This color system is used in the screens and monitors of digital cameras, computers, cell phones, TVs, and theater lights. When primary colors are mixed together, they become lighter. When all three primaries are mixed, they create white light (figure 7).

The **subtractive color** mode deals with color in the form of pigments and inks reflected off a surface. The subtractive colors are the primaries cyan, magenta, and yellow. When mixed together, they technically become black (figure 8).

Color is a complex formal element. When these systems of additive and subtractive process connect, the overlap is not always exact. For example, you may have viewed an image on your computer monitor and then printed it on an inkjet or color laser printer. There is a good chance the colors that appeared on the monitor were not exactly the same as the ones in the printout. The reason is that when you viewed the image on the monitor, you saw an additive or light-based mode of color with the primaries of red, green, and blue. When you printed it, the printer used a subtractive mode of color ink with the primaries of yellow, cyan, and magenta. Because the primaries for the two systems are not the same, the range of colors that they create may be different.

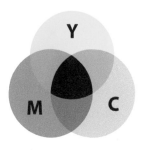

FIGURE 8.
Example of primary colors in
the subtractive mode.

How the Eye Sees Color

Two kinds of optical cells — rods and cones — are responsible for sensing light entering the pupil. The cones interpret the primary colors along with brightness, and this allows them to provide the information needed for all the colors we recognize. The cones are found in the center of the retina, where we see best. By contrast, the rods only perceive brightness and are used to see in low-light situations. That's why you can't see color very well in the dark. Because rods are on the outside edges of the retina, we also don't see as sharply with them. That's why you can see fainter stars out of the corner of your eye, but they won't seem sharply focused.

Together rods and cones allow us to see both color and brightness. But even though color seems most important, brightness is more valuable because it's always there. Value, the artistic equivalent to brightness, is thus essential to image creation. You can have visual art without a variety of colors, but visual art without a variety of values is almost impossible. Sight requires light. Without light, there is no vision, which means there can be no value, no color, and no art.

Hue, Value, and Saturation

The three basic attributes of color are hue, value, and saturation. Consider the color pink as an example of how these attributes operate together. The hue is red because pink is a lighter version (value) of red. Pink is in the higher key (lighter) value range because white has been added to the red hue. Pink's intensity has been desaturated because the addition of white affects the purity of red. Whenever value is changed, saturation changes, too.

In theory, **hue** refers to the perception of the wavelength on the visual spectrum. Red, orange, yellow, green, blue, and violet are all hues. In everyday conversation, however, color is used synonymously for both hue and color.

Value refers to the relative lightness or darkness of a color. Think about the ways colors change in value. When white, gray, or black is mixed with a color, the value of that color is adjusted. In the grayscale rendition of the Paul Kelpe painting seen earlier in this section, the wide range of value that is possible in color is evident (see figure 5).

Saturation — also known as intensity or chroma — refers to the purity or neutralization of a color. Red paint squeezed from a tube is as intense

as that hue of red can get. Once white, gray, black, or a complementary color are mixed in, the resulting color becomes a neutralized or desaturated version of red.

Basic Color Relationships and the Color Wheel

The color wheel is a tool for thinking about how colors are related. Sir Isaac Newton refracted white light through a prism into the visual spectrum and is credited with creating a color wheel with seven hues. Color wheels have evolved and changed over time. Today, traditional color wheels are usually based on twelve hues (figure 9).

Red, yellow, and blue are called **primary hues** because they cannot be mixed from other pigments but instead must be manufactured. On the color wheel, the primaries are set 120 degrees apart, creating an equilateral triangle. When two primaries are mixed, they make **secondary hues**: red + yellow = orange, yellow + blue = green, and blue + red = purple (violet). On the color wheel, the secondary hues are set between their two component hues. When a primary and a secondary hue are mixed, an **intermediate hue** is created: blue + green = blue-green, for example.

Complementary hues sit opposite each other on the color wheel. The basic hues are red/green, blue/orange, and yellow/violet, but any hue has its complement. For example, the complementary of blue-green

FIGURE 10.
Dayna J. Collins, *Freedom in the Silence*, 2014. Plaster, oil, and cold wax, 24 × 24 in. Collection of the artist.

is red-orange, and the complementary of blue-violet is yellow-orange. Mixing complementary hues together creates a whole range of related but less saturated hues, creating a broad palette of colors and values from a few basic hues.

In a **complementary color scheme**, artists use complementary colors as foundations for entire compositions. The use of complements tends to create contrast and energy in a piece. If you want to grab someone's attention, use a complementary color scheme. In the painting *Freedom in the Silence*, Oregon artist Dayna J. Collins creates vibrancy by placing the blue-purple circle against the amber yellow of the negative space (figure 10).

FIGURE 11.
Vincent van Gogh, *Wheat Field with Cypresses*, 1889. Oil on canvas, 28.75 × 36.75 in. Metropolitan Museum of Art, New York.

Colors adjacent to one another on the color wheel are called **analogous hues**. Yellow, green, and blue as well as orange, red, and violet are examples of analogous hues. Analogues always have a shared hue, which helps them make a harmonious color scheme. Van Gogh evokes the warmth of a summer day in *Wheat Fields with Cypresses* by using an **analogous color scheme** of blues, greens, and warm yellows (figure 11).

Color schemes are similar to recipes in that they are intended as directions and guidelines rather than as a rigid rules. The combinations of colors are suggested, but by no means does an artist have to stick with or be limited by formal color combinations. Oregon artist Ruth Armitage uses a **polychromatic color scheme** in *Dark Water* by combining a wide range of colors, values, and intensities with expressive results (figure 12).

FIGURE 12.
Ruth Armitage, *Dark Water* [Diptych], 2014. Acrylic on canvas, 24 × 48 in. Collection of the artist.

Color Associations

One of the most interesting things about color is how it can be used to convey emotions. Whether artists do so intentionally or not, color can impact a viewer's understanding of an image, since people often associate color with different attitudes, feelings, and symbols based on universal, cultural, or individual associations.

Universal color associations are the physiological responses to color we all have. Research shows that when viewers see the color red, their heartrate increases. The red carpet at Hollywood events is no coincidence. Red makes people want to move, so the color of the carpet has a specific purpose at an event where arriving guests have to keep moving. Blue, on the other hand, causes viewers to feel calm or relaxed.

Cultural color associations are learned through living in the culture you are part of. The thing about cultural associations is that they evolve and shift over time. For example, we often associate the color brown with dirtiness or filth, but the brown of coffee or chocolate can make us feel excited or energized in the right cultural context. Another great example of cultural color association is green and its conceptual importance to environmental issues. Green has been widely used in recycling campaigns, and "going green" symbolically means living more eco-consciously.

Of course, different cultures will have different associations with color. In Western cultures, for example, a bride's wedding dress is typically white or cream, which traditionally symbolizes purity, cleanliness, or a bride's virginity. Many wedding dresses in China, India, Pakistan, and Vietnam are red, a traditional color of good luck and prosperity.

Individual color associations are based purely on individuals' experiences, and we have little to no control over how we associate colors with our past. If you had a beloved orange-furred pet who died when you were young, anything orange might make you feel sad as you're reminded of that loss. These associations don't necessarily follow any physiological or cultural logic, they just happen. As a result, there's very little conclusive research that shows how or why this occurs.

Color associations evolve based on cultural trends, as well. Historians who study clothing or housewares of the past can determine the economic stability of a particular period based on the color choices designers made.

FIGURE 13.
Some pieces of
Depression Glass.

For example, some color theorists claim that the bright greens, yellows, reds, and blues of American "Depression Glass" could have only come out of the extreme economic instability and emotional sadness surrounding the early twentieth century Great Depression (figure 13). The people were so depressed by their economic situation that they gave the glassware of the time, which was cheap to make and therefore very popular, bright colors to cheer themselves up.

FIGURE 14.
Jean-Honore Fragonard, *The Happy Lovers*, 1760–1765. Oil on canvas, 47.76 × 35.51 in. Norton Simon Museum, Pasadena, California.

Expressive Color: Saturation and Value

Expressive qualities of colors are often linked to one or more of the association types listed above, but the saturation of a given color can have expressive qualities, as well. In Jean-Honore Fragonard's painting, *The Happy Lovers*, many bright and high saturation colors are used almost like decoration (figure 14). The couple shine out from their surroundings in their brightly-colored clothing. Fragonard's choice to use all three primary colors with the couple contributes to a balanced color scheme, but the subject's garish, saturated color makes the painting feel light and less serious, just like the subjects as they lounge in the shade. The saturation of the colors used makes the painting seem almost playful and light-hearted.

Figure 15.
Nancy Eng, *Beach Weekend*, 2015. Oil and cold wax on canvas, 12 × 12 in. Collection of the artist.

It's not just color itself that contains meaning but how the artist uses it. Compare Fragonard's painting to Oregon artist Nancy Eng's painting *Beach Weekend* (figure 15). An artist could use the same colors to express very different things. The color scheme is similar in these two paintings, but the higher value key in Eng's work, with blues, yellows, and reds tinted with white to lighten their values, gives the setting a sun-drenched quality, helping create the sensation of peacefulness and tranquility in the painting.

2.4 Formal Elements: Space and Depth

A. Space

FIGURE 1.
Peter Christian Johnson, *Red Turbine, Construction Series*, 2011. Low fire earthenware, 16.5 × 23.5 × 23.5 in. Collection of the artist.

Space is the empty area surrounding real or implied objects. Humans have defined many types of space. There is outer space, that limitless void we enter beyond our sky. Inner space resides in people's minds and imaginations. Personal space is the important but intangible area that surrounds each individual and is violated if someone else gets too close. Pictorial space is physically flat but visually present. The digital realm resides in cyberspace. Three-dimensional work occupies physical space. Art responds to all of these types of space.

In three-dimensional work, the occupied area is the **positive space** and the "unoccupied" area is the **negative space**. These terms are fairly synonymous with positive and negative shape. In *Red Turbine* by Ohio artist Peter Christian Johnson, the blades of the sculpture radiate out and activate the negative space (figure 1).

The physical location where a sculpture is displayed also plays an important role. Space can be activated or compressed depending upon the physical location of the sculpture. The proper location is vital in three-dimensional work. Artists carefully consider where and how their sculpture will be displayed. In this ceramics installation, *Self-destructing Porcelain Net* by Swedish artist Backa Carin Ivarsdotter, the large netted column of porcelain rings is suspended from the ceiling (figure 2).

The floor is covered with broken rings, and the walls limit any open space for the viewers to walk around the piece. This confinement forces the viewers to make choices. Do they stand in one spot to view the piece or do they gingerly walk through the shards on the floor? What would you do?

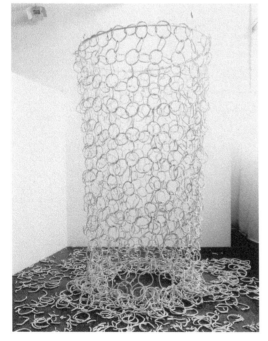

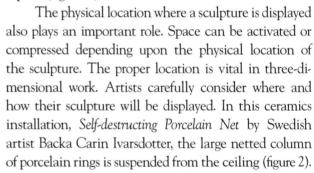

FIGURE 2.
Backa Carin Ivarsdotter, *Self-destructing Porcelain Net*, 2000. Moving installation of high fire handbuilt porcelain, 177 × 49 × 49 in. Collection of the artist.

B. Constructing Depth

A much celebrated skill in Western art is the ability to construct the illusion of depth on a flat surface. As a result, the viewer believes both in the space depicted and the forms that seem to exist there. Creating such a powerful illusion takes a solid understanding of how the eye actually sees the world and how the mind interprets that vision. It also takes training in looking at and reproducing convincing three-dimensional spaces and figures on a two-dimensional surface.

Recognizing that any space depicted by an artist is a carefully constructed illusion is a powerful tool to understanding the work and the artist's goals. These created spaces must fit the needs of the art's subject. Sometimes spaces in art can appear unreal or disorienting, and other times the spaces appear very believable. A skilled artist can undermine the construction of space or volume in subtle but powerful ways.

Illusion of Depth

Without the **illusion of depth**, the painting *Paris Street; Rainy Day* by French artist Gustave Caillebotte would look like three gigantic humans on the right side of the painting towering over several smaller and smaller floating human shapes (figure 3). The giants hold umbrellas that are roughly the same size as an entire five-story building. However, because of this illusion of depth, we can reasonably look at the content of the painting and see a believable image.

FIGURE 3.
Gustave Caillebotte, *Paris Street; Rainy Day*, 1877. Oil on canvas, 83.5 × 108.7 in. Art Institute of Chicago, Illinois.

Illusion of Volume

When we see a shadow pass over an object, such as a rock, we know that the rock doesn't physically change. Our eyes, however, use these shadows to understand the rock's volume. When artists accurately mimic the way light and shadows fall across forms, they are using **chiaroscuro** to construct a projecting or receding form. In *Still Life with Berries, Chair, and Cloth* by Oregon

FIGURE 4.
John Van Dreal, *Still Life with Berries, Chair, and Cloth*, 2010. Oil on canvas, 28 × 36 in. Private Collection.

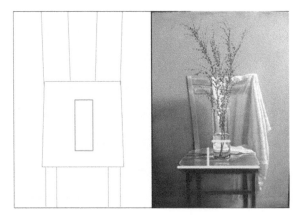

Composite drawing based on what we know of chair seats.

Lines imposed to show width and height as we actually see it.

artist John Van Dreal, we recognize shapes in the image by how the light and shadow are handled (figure 4).

We assume the light source comes from the upper right because the surfaces of the objects facing that direction are lightest and because they cast a shadow in the opposite direction. On the chair, the seat and right sides of the legs catch the light. The artist carefully mimics the shape of value areas on the objects as they shift away from the light. The folds on the cloth transition from lighter values to medium and darker values smoothly, suggesting the gentle folds and wrinkles in the soft fabric. This painting illustrates how artists use the illusion of volume to represent a three-dimensional object on a two-dimensional canvas.

An illusion of volume is not enough, by itself, to make us believe what we see. Forms created by light and shade must also look like they do in the physical world. This is more difficult than it may seem. What the eye sees and how the mind interprets those signals are two very different experiences. The apprentice artist must learn to draw what the eye sees rather than what the mind knows.

Foreshortening

Copying what the eye sees is called **foreshortening**. Foreshortening causes the eye to believe in the space that must be around the form, whether the eye can see that space or not. For example, look again at the chair seat in John Van Dreal's painting (figure 5). Even though we know they

FIGURE 5.
Example of foreshortening using John Van Dreal's *Still Life with Berries, Chair, and Cloth*, 2010. Oil on canvas, 28 × 36 in. Private Collection.

should be about equal, the seat is far shorter than its width. In fact, the depth of the seat matches the width of the vase, which is not at all true for the real objects. Measure it and see. This is what the eye actually sees, rather than what the mind knows about the shape of a chair. The combination of proper chiaroscuro and correct foreshortening allows an artist to create the illusion of a three-dimensional form.

To understand this difference between what the eye sees and what the brain does with that information, we need to look at how the brain works. The brain needs practical tools for navigating the world, so it converts those complex visual perceptions into simple and readily manipulated symbols called **schemata**. Schemata deal with forms in their simplest and most easily recognizable orientations, seen from the top, front, or side as appropriate.

This figure of Narmer in this Egyptian ceremonial palette is a perfect example of schemata that are not foreshortened (figure 6). He appears flat because his legs are in profile and his torso is shown from the front. His head is in profile and a single eye is shown. This combines the simplest views of the figure into a single view rather than foreshortening the shoulders, torso, and eye. Many cultures do not create images with shadow, relying instead on schemata to suggest a subject's entire form. Considered this way, art that might appear simple or childish to some is actually complex because it presents multiple views of a subject simultaneously, not just what the artist can see in one glance.

FIGURE 6.
[The Narmer Palette], 3001–3100 BCE. Siltstone, 25.2 × 16.5 in. Egyptian Museum, Cairo, Egypt.

Linear Perspective

Perspective is a special kind of foreshortening. The fifteenth-century Italian architect Filippo Brunelleschi developed linear perspective to accurately depict buildings. This system created the illusion of depth on a two-dimensional surface and became the most common perspective method used by artists. Linear perspective relies on one viewpoint, a spot chosen by the artist, and consistent application of measurable diminution, or decreasing size.

To understand how linear perspective works, let's look at how parallel lines appear in the world. In this photograph of train tracks, we know the tracks are parallel, but they appear to meet as they recede into the distance (see figure 7). This is called **convergence**. That point where they converge is the **vanishing point**. It is at the height of your eyes and as far away as

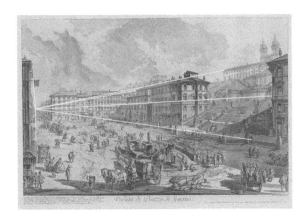

your eyes can distinguish difference. This means the convergence always occurs at **eye level**. Other objects parallel to the train tracks such as the telephone poles appear to converge at the same vanishing point.

Brunelleschi's system has been used in a variety of approaches to create the illusion of volume in images of architecture. In Italian artist Giovanni Battista Piranesi's *The Piazza di Spagna*, the red lines at the right mark the receding parallel edges of the buildings (figure 8). The blue lines mark the extension of those diagonals and how they meet at the vanishing point, which is also the eye level of the artist and viewer.

Two other methods used by artists are rising and intuitive perspectives. **Rising** or **isometric perspective** is a conceptual approach that places objects that are farther away higher in the picture without making them any smaller. In this Chinese Song Dynasty silk painting, all the figures remain consistent in scale, making it difficult to determine which are closer and which are further away (figure 9).

Instead, the artist implies depth by raising the figures up in the **picture plane**. The space appears steeply tilted toward the viewer, while the figures still seem to stand straight. Also, rather than using converging parallel lines, rising perspective keeps parallel lines parallel, even as they recede. The lines that define structures are set at a sharp angle to the format, creating a zig-zag moving up through the work.

Intuitive perspective is an observational approach. Parallel lines of buildings turn to diagonals as they recede, just as we saw in the silk painting. However, intuitive perspective

doesn't follow the exacting rules of linear perspective in its application of a single vanishing point and measurable diminution. The diagonals don't all recede to the same expected point, and this makes the space look a little strange, as if floors are tilted and walls are oddly structured. One example is by the unidentified Italian artist who painted the *Homage of a Simple Man* from the *Legend of St. Francis* (figure 10). This artist, working before Brunelleschi discovered and developed linear perspective, created receding diagonals that do not quite line up on a single eye level or point to a single vanishing point. There are multiple vanishing points and multiple eye levels.

FIGURE 9.
Huizong of Song, *Literary Gathering*, 1100–1125. Ink and light color on silk, 72.6 × 48.8 in. National Palace Museum, Shilin district, Taipei, China.

Relative Scale and Repetitive Diminution

In the physical world, all objects and spaces have absolute size relationships to one another. Some are very small, and some are very large. When two objects are next to one another, we can see that one is larger or smaller than the other. As we move away from them, however, all objects seem to get smaller, an effect that can be measured by the amount of our vision they take up. In the eighteenth century, the Irish philosopher George Berkeley realized what this meant: without external clues for comparison, the eye has no way of knowing whether it is looking at a small thing or a distant thing. As long as all of the clues are consistent with our experience and the context makes it work, we accept the object's size as plausible.

FIGURE 10.
Artist Unknown (formerly attributed to Giotto) *Legend of St. Francis: 1. Homage of a Simple Man*, 1298. Fresco, 106.3 × 90.6 in. Upper Church of San Francesco, Assisi, Italy.

So what clues are necessary to make us believe? Creating an illusion of space requires the proper relative scales of everything in the image, not only in the foreground, but also in the middle ground and the background. As we saw earlier, French artist Gustave Caillebotte accomplishes this in *Paris Street; Rainy Day* (see figure 3). Both the figures and the umbrellas appear to recede in the distance because they get smaller.

Overlapping

Visual understanding of the world depends partly on a phenomenon known as object permanence, the recognition that even though only part of an object is visible, the rest must be there — but hidden. After all, if we see an object's front, the back must also exist and take up space. Moreover, what appears to be in front must be closer to the eye, and what is behind must necessarily be farther away. Relying on the viewer's sense of object permanence, artists use **overlapping** to support the illusion of depth. They know we will recognize depicted forms as things that take up space rather than flat shapes. To create an illusion of depth in *The Dream*, German artist Franz Marc uses a series of overlaps behind a central figure (figure 11). Animals overlap hills and a structure, which in turn overlap more animals and more hills. We see the central figure as being near because nothing overlaps her.

Nonrepresentational art uses this device regularly to capture an illusion of depth. Look again at Eileen Cotter Howell's *East of the Sun, West of the Moon* (see Section 2.2, figure 14). She overlaps biomorphic structures and what looks like architecture to imply a deep space. The space is dream-like, but the illusion, at least, conforms to our expectations of actual depth.

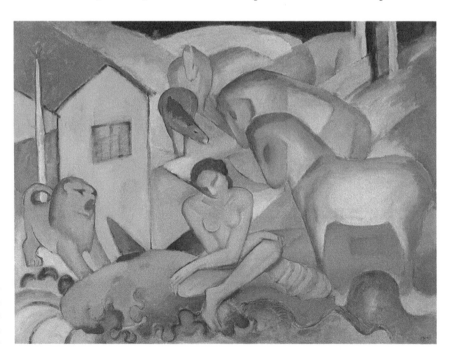

FIGURE 11.
Franz Marc, *The Dream*, 1912.
Oil on canvas, 39.6 × 53.3 in.
Thyssen-Bornemisza Museum,
Madrid, Spain.

Viewpoint and Framing

Artists locate the viewer in relation to the visual world of their work through the careful choice of viewpoint and framing. **Viewpoint** shows us if we are below, even with, or above the world we see, while **framing** shows us how close the depicted forms are to the picture plane. Most of the paintings in this chapter place our viewpoint even with the subject matter, but in *The Dream*, we can see the top of the roof and look down on the head and shoulders of the central figure, so we are above the subject matter (figure 11).

Framing can be either tight or distant. Tight framing brings the forms up close and looks at them in detail, putting us in intimate contact with the figures, while distant framing shows an expansive view with forms seen from afar. Compare the framing of the chair in Van Dreal's *Still Life with Berries, Chair, and Cloth* (see figure 5) with the chair in American artist Frederic Schuler Briggs's painting (figure 12). We experience Van Dreal's chair more intimately because it has been tightly framed to bring us in.

Detail

In real life, objects closest to us are seen most sharply and with the greatest **detail**. Objects in the distance are less focused, and detail tends to be lost. In

Figure 12.
Frederic Schuler Briggs, *Original Manuscript and Rare Book Library, Walters Art Gallery*, 1975. Watercolor on paper, 29.9 × 22.1 in. The Walters Art Museum, Baltimore, Maryland.

Figure 13.
Rosa Bonheur, *The Horse Fair*, 1852–55. Oil on canvas, 96.3 × 199.5 in. Metropolitan Museum of Art, New York.

FIGURE 14.
Evelyn De Morgan, *Love's Passing*, 1883–84. Oil on canvas, 28.25 × 43.25 in. The De Morgan Centre, London.

art, the same must happen. The illusion of distance would be undermined if objects were just as detailed in the background as they are the foreground.

In Caillebotte's *Paris Street; Rainy Day* (see figure 3), facial features are visible in the figures closer to us. The more distant figures do not have that information. The crisply defined books and furniture in the foreground of Briggs's watercolor show us page spreads and decorative molding (see figure 12). In contrast, the features of the books and furniture in the background are left as blurred forms with no specific characteristics. Artists who imitate the textures of real things use those textures to add to the illusion of volume and distance. In French artist Rosa Bonheur's painting, *The Horse Fair*, the specific textures of horse musculature, draping clothing, and trampled dirt are visible in the foreground but disappear in the more distant subject matter (see figure 13).

Atmospheric Perspective

Generally speaking, objects appear in their fullest color saturation and darkest value when they are closest to the eye. Strongly contrasting values tend to push each other forward and back. Light values come forward and dark values recede. Warm colors — reds, oranges, and yellows — tend to come forward, while cool colors — greens, blues, and violets — tend to recede. By lightening the value of a form and neutralizing its hue, the artist can make it appear to be much further away. English painter Evelyn De Morgan robes the main figures in warm tones and uses both neutral and darker tones in the background of her painting, *Love's Passing*, to aid her construction of depth (figure 14).

Atmospheric perspective is a special use of value and hue to construct depth. When we look at a faraway horizon, we are looking through a thick layer of air, which is loaded with suspended water and dust particles. This combination of particles reflects and refracts light, causing less of the light reflected from distant objects to reach our eyes. Part of the color of those objects is replaced by the actual color of the air — a pale blue — and part of the color disappears into the air. As a result, distant, tree-covered mountains may appear to be pale blue rather than the dark green that we know them to be. The effect of air and distance on color can also be observed when we look straight up at a clear sky. Since we see through a thinner layer of air, the sky seems a richer, darker blue compared to the pale blue on the horizon. The contrast of the higher, more saturated blue, and the lower, less saturated blue, as well as the loss of warm colors at the horizon, creates the effect we call atmospheric perspective.

Atmospheric Perspective in Portrait Painting

Atmospheric perspective is used in these two portraits of young women by French artist Berthe Morisot (figure 15) and Italian artist Leonardo da Vinci (figure 16). In each case, the woman in the foreground has more contrast than the background in value range from light to dark. Her overall color is also more saturated than the color in the background.

La Petite Niçoise not only compresses the background information—trees, a horizon, and a possible suggestion of a mountain range—to a few vague suggestions with minimal brushstrokes, but the girl, in contrast, is much more detailed due to a broader value range and attention to shadow, mass, and depth. Atmospheric perspective is used in this painting when the background is tinted with much more white than foreground, giving the background a consistently small range in the higher key.

Mona Lisa does a similar job of emphasizing the figure over the background, this time by giving an overall yellow hue to several features in the background such as the bridge and roads to either side of the woman. The horizon and natural landscape of trees and sky have much less range to their value than the woman, as well.

C. Rejection of Traditional Space

Sometimes an artist will purposefully reject traditional space construction. For example, American artist Romare Bearden's *Spring Way* simultaneously suggests the façades (false fronts) of urban buildings and their interiors (figure 17). The inconsistent scale of figures, textures, and architectural features such as doors, windows, siding, and staircases undermines the appearance of traditional space. The result is that some sections appear close and others far away. The man on the steps to the right could be quite close due to his scale in relation to the building, but his placement on the stairs suggests he is further back than the store fronts. The woman in the front is both an exaggerated face recessed inside a window and a large, flat poster on the wall. The viewer's eye moves forward and backward, hunting for a believable area, but finds inconsistent spatial constructions everywhere. The effect is both unsettling and oddly similar to how many people experience urban landscapes, as brief encounters with memorable images, a mental collage not unlike Bearden's physical one.

FIGURE 17.
Romare Bearden, *Spring Way*, 1964. Collage on paperboard, sheet, and image, 6.6 × 9.4 in. Smithsonian American Art Museum, Washington, DC. Art © Romare Bearden Foundation/Licensed by VAGA, New York, NY.

2.5 Compositional Principles

A work of art is strongest when it expresses an overall unity in **form** and **composition**, a visual sense that all its parts fit together and that the whole is greater than its parts. This same sense of unity also encompasses the idea and meaning of the work. We can think of this in terms of a musical orchestra and its conductor. The conductor directs many different instruments, sounds, and rhythms into a single comprehendible symphony. In the same way, the artist uses line, color, pattern, scale, and all the other artistic elements and principles to yield a more subjective view of the entire work. Taking all this into consideration, the viewer can develop an appreciation of the aesthetics and meaning that resonate in the work.

A. Unity and Variety

There is a delicate balancing act between the two concepts of unity and variety. **Unity** creates a sense of cohesion — similar to the way that a song's melody creates familiar patterns for the listener to enjoy. **Variety** produces change — the melody pauses for a drum break or a solo — so that the work doesn't become too monotonous or predictable. Variety and contrast are the counterpoints to unity, adding interest and enlivening the art. Depending upon the subject matter and content, the artist can blend unity and variety to varying degrees and with different approaches.

An artist is likely to use a variety of methods to create unity within a single work of art. Of these methods, the most common are repetition, continuation (also called visual flow), proximity, and grids. The downside to repetition, or when other methods are used too much, is that the piece can become predictable or monotonous. This is why contrast and variety are so important. Changing the repeated unit creates more visual interest. If too much variety has been added, however, chaos can result, thus overwhelming and overstimulating the viewer.

Repetition

Repetition is repeating the same or similar visual units, such as shape, color, value, style, texture, or line. Repeating a visual unit creates a sense of familiarity for the viewer. Ceramics artist Jamie Bardsley uses the principle of repetition to create unity in *Palm Prints* (figure 1).

The repeated pattern of concentric circles creates unity, and the variation in size and height of the circles produces a contrast that prevents the piece from becoming monotonous. Upon closer examination of this work, we can see that the entire piece is constructed out of small porcelain ribbons, which again reinforces the principle of unity created by means of repetition (figure 2).

British ceramics artist Thomas Stollar uses the principle of repetition in a more varied manner in *Metonymic 2* (see figure 3). The unifying factor is the cube, which is repeated dozens of times in his work. However, this installation piece doesn't become monotonous because of the variations of sizes, patterns, and colors of the cubes.

Continuation

Continuation creates a visual movement — or flow — through a work of art. This directs the viewer's eyes in and around the piece. In its simplest use, continuation moves the viewer's gaze from point A to point B within a work. In more complex compositions, continuation directs the viewer through and around the composition without conscious recognition that the eye is being guided.

This technique is frequently used in retail situations. Think about the layout of most grocery stores.

FIGURE 1.
Jamie Bardsley, *Palm Prints*, 2011. Hand-built unglazed porcelain, 1 × 16 × 10 ft. Photo courtesy of Bowling Green State University.

FIGURE 2.
Jamie Bardsley, *Palm Prints* (detail), 2011. Hand-built unglazed porcelain, 1 × 16 × 10 ft. Photo courtesy of Bowling Green State University.

FIGURE 3.
Thomas Stollar, *Metonymic 2*, 2012. Press-molded clay installation, dimensions variable. West Virginia University College of Creative Arts, Morgantown, West Virginia..

FIGURE 4.
Gary Westford, *The Wreck of the Hope (after C.D. Friedrich)*, 2010. Oil on canvas, 60 × 96 in. Original courtesy of the artist. Red lines added to show triangular composition.

The customer moves through the store by going up and down each long aisle. Now consider the store layout of a clothing boutique. The aisles are gone, and instead the merchandise is displayed on small racks or tables. The shopper moves briefly from point to point without following a clear path. The way each store is organized moves the shopper efficiently through and around the store in order to bring the shopper in contact with the maximum amount of product.

The principle of continuation can also be seen in Oregon artist Gary Westford's *The Wreck of the Hope (after C. D. Friedrich)*, which uses a triangular composition to create unity and visual flow (figure 4). The red lines that we've added show the direction of the **visual movement**. This triangular composition moves the viewer through the piece and keeps their eyes engaged within the composition. Notice the clouds and ice shards. Westford also uses the repetition of triangular shapes to add unity. Westford counters this unity with a variety of shapes and objects that keep the work interesting as the viewer's eyes move through and around the painting.

Another Oregon artist, Eileen Cotter Howell, combines both repetition and continuation to create unity in her painting *Spheres of Influence* (figure 5). The most obvious way she creates unity is through the repetition of circles. The more dominant unifying factor, however, is the visual flow created by the serpentine shape. The curvilinear, snake-like shape pulls the viewer's

gaze through the piece in a clockwise rotation. Balancing unity with variety, Cotter Howell uses contrasting scales, colors, and textures within the painting. The circles vary in size: some are thin, almost transparent, while others appear three-dimensional and opaque. This gives us many individual shapes to consider within the unity of images.

Proximity and Grouping

Artists frequently use **proximity** to unify unrelated objects. Proximity helps the viewer see the objects as a group before viewing them as individual objects. Where and how close the objects are placed determines the degree of internal tension created by that proximity. If the objects are placed closely together, the internal tension is high, creating unity. But if the objects are moved too far apart, the tension is broken, and the objects are seen separately.

Grouping and proximity are frequently used in the arrangement of three-dimensional objects. But we can also see this principle at work in Oregon artist Sarah Fagan's painting *Peninsula*, which flirts with grouping and proximity (figure 6). Spaced apart, the five objects at first give the impression of great variety. However, Fagan provides a gentle pull that draws these shapes together into groupings. She creates a gently-curved reversed C that activates a visual flow running from the small white shell at the top to the ruffle-edged shell at the bottom. This flow is coupled with a very subtle use of repetition. The small shell, the scalloped spoon, and the

FIGURE 5.
Eileen Cotter Howell, *Spheres of Influence*, 2009. Acrylic on panel, 12 × 12 in. Private collection.

FIGURE 6.
Sarah Fagan, *Peninsula*, 2014. Acrylic on panel, 20 × 16 in. Private collection.

Figure 7.
Sarah Fagan, *Organize*, 2011.
Acrylic on panel, 12 × 12 in.
Private collection.

ruffled shell share complex curves and flutings. The spoon shares its linear aspect with the pencil and paintbrush, and the pencil and paintbrush share their simplicity with the smaller shell. To balance the easily seen variety, Fagan meticulously combines various methods to create unity in the work.

Grid

A **grid** is an arrangement based on a vertical and horizontal composition. Like proximity, it is a good way to unify different objects. Websites and most magazines are based on a grid layout. Next time you visit a website, pay attention to the layout. You'll see that the website's articles, images, and lists are organized along the vertical and horizontal lines of a grid system. In Fagan's painting *Organize*, nine different objects are arranged with an even spacing over the panel (figure 7).

Again, we see in this work a strong sense of variety. No two objects are alike. At first glance, we might be tempted to classify this as an example of proximity because the objects are all different and do not touch one another. However, upon closer examination, the composition is actually unified by the use of a grid. The strong vertical and horizontal layout is what holds this composition together. The objects are a little too far apart to be viewed as a group.

B. Focal Points and Emphasis

Focal points are areas of **emphasis** that artists use to attract the viewer's attention. Focal points can be created in three basic ways — contrast, isolation, and placement. Thinking about focal points can be challenging because viewers are diverse and bring a wide range of preferences to the work of art. Some may be attracted to one area and others to another, so viewers may disagree about which areas are the focal points. Focal points are better when used sparingly. There's an old saying that "too many cooks in the kitchen spoil the broth." The same is true for focal points. If there are too many in a work, their impact is diminished.

Emphasis by Contrast

The key to creating a focal point by **contrast** is difference. When one thing is unlike the others, the different object will stand out. The difference can be in color, size, texture, value, style, and more. In the photograph, *The Ladder*, by Oregon photographer Barry Shapiro, the ladder itself is the focal point (figure 8). He has used contrast both in value, the white of the ladder against the darker value of the bush, and in shape, setting the geometric ladder against the background of tangled bushes.

Emphasis by Isolation

To create a focal point through **isolation**, the intended focal point is moved away from the group of other objects. The focal point is still close enough to the original group to feel like it belongs, but it is no longer clustered with the group. We can see this in *The Agnew Clinic* by American painter Thomas Eakins where the center of the composition becomes the area of emphasis due to the contrast in value (figure 9).

This central area is very light in comparison to the dark brown values in the background. If the painting is broken down even further, there are two focal points. The initial focal point is Dr. D. Hayes Agnew, the older doctor to the left. He is the focal point because he has been moved away from the group of surgeons. The second focal point is the group of surgeons, which is lighter in value than the onlookers. This is also an example of visual hierarchy. **Visual hierarchy** creates an order in how the viewer is to look at the focal points. The object that is most isolated — the older doctor — is viewed first, followed by the second focal point and then the other objects in the painting.

FIGURE 8.
Barry Shapiro, *The Ladder*, 2008. Black and white photography. Collection of the artist.

FIGURE 9.
Thomas Eakins, *The Agnew Clinic*, 1889. Oil on canvas, 84.375 × 118.125 in. John Morgan Building at the University of Pennsylvania, Philadelphia, Pennsylvania.

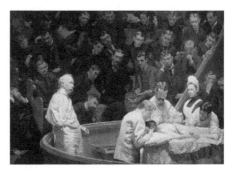

Emphasis by Placement

A common mistake in thinking about emphasis by **placement** is how we use the word "placement." The focal point is not created because "it was placed there." Instead, it is created because the viewer's eyes are directed to look at a specific area. Placement is thus similar to the concept of visual flow. Placement moves the eyes, but instead of unifying the work

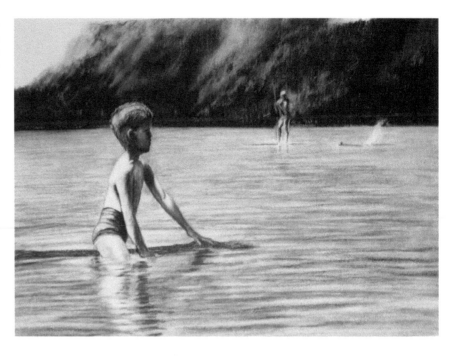

FIGURE 10.
Eric Wuest, *Adrift 1*, 2007.
Charcoal on paper, 11 × 14 in.
Collection of the artist.

the way that visual flow does, it directs the viewer to a focal point through emphasis.

Let's look at the way emphasis by placement is used in an actual work. In the charcoal drawing *Adrift 1* by Oregon artist Eric Wuest, the young boy on the log is the focal point (figure 10). The shoreline and the curves from the smoke in the background direct the viewer to focus on the boy.

Absence of a Focal Point

Not all works of art have a focal point. Sometimes the artist intends for the viewer to take in the work in its entirety with no one subject being more important than another. We see this in the varied shapes and vivid colors used in Oregon artist Carol Hausser's

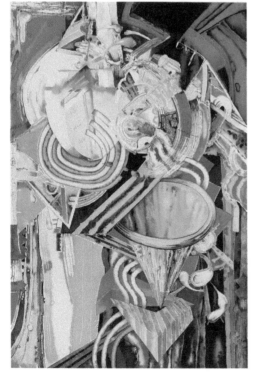

FIGURE 11.
Carol Hausser, *Transillumination*, 1997.
Transparent watercolor, 60 × 40 in.
Chemeketa Community College, Learning
Resource Center, Salem, Oregon.

watercolor *Transillumination* (figure 11). The absence of a focal point provides active viewing of the entire composition with no singular spot drawing all the attention.

C. Balance

All works of art possess some form of visual **balance**, which is the equal distribution of visual weight on either side of a composition. When we look at a work of art, we intuitively divide the piece along the vertical axis and compare the right and left sides of the composition. This sense of visual equilibrium is important. As bilateral creatures, our desire for balance is innate. Our eyes are naturally drawn to balanced compositions, and work that is imbalanced makes us uncomfortable, causing us to look away. In the charcoal drawing by Elaine Green, two figures are balanced, one upon the other's shoulders, making her title of *Balance #1* fitting (figure 12). Although the rendering of the figures is blurry, the sense of stability is present because the weight is almost perfectly balanced along the vertical axis.

We will take a close look at bilateral symmetry and asymmetry, which are two types of balance that apply to both two-dimensional and three-dimensional works of art.

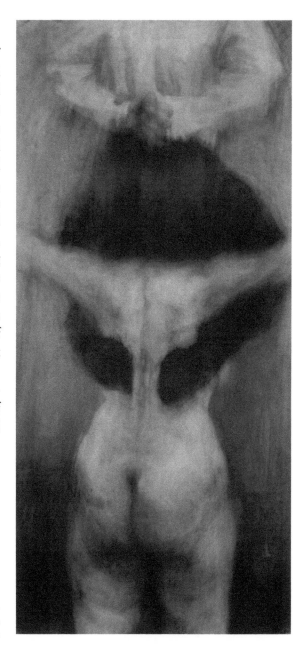

FIGURE 12.
Elaine Green, *Balance #1*, 2012. Charcoal on gessoed paper, 42 × 20 in. Collection of the artist.

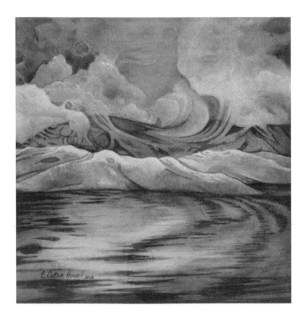

FIGURE 13.
Eileen Cotter Howell, *L'Ile Perdue*, 2012. Acrylic on canvas,
12 × 12 in. Collection of the artist.

FIGURE 14.
Jean de Chelles, [Rayonnant Gothic rose window of north
transept], thirteenth century. Stained glass.
Notre-Dame Cathedral, Paris.

Bilateral Symmetry

Bilateral symmetry is the simplest form of balance.
Each half of the composition is a mirror image of
the other. Symmetrical balance (or **symmetry**) is
the most visually stable type of balance. It is char-
acterized by an exact — or nearly exact — design
on either side of the horizontal or vertical axis of
the picture plane. Symmetrical compositions are
usually dominated by a central anchoring element.
There are many examples of this type of symmetry
in the natural world — including the reflection of
mountains on a lake surface, the crowns of trees,
and the human face.

The more a composition accentuates bilat-
eral symmetry, the more our eyes are directed to
the middle of the composition. This emphasis
creates another type of visual hierarchy. In this
case, the middle is more important than the
edges. This works for groups of figures or for
groups of shapes. Symmetry on the horizontal
axis is another basic design principle in which
the upper half is a mirror image of the lower, or
vice versa. The problem with perfect symmetry,
however, is that it rapidly becomes dull. The
human eye is always looking for novelty.

Approximate balance occurs when the
work is divided down the vertical axis and the
left and right sides are similar but not exactly the
same. This allows for more visual freedom in the
composition than pure symmetry. For example,
when we divide Eileen Cotter Howell's *L'Ile
Perdue* in half, the sides are similar but not exact
(figure 13). This approximate balance satisfies
the viewer's desire for balance but also allows for
more variety in the composition.

Radial balance suggests movement from
the center of a composition towards the outer
edge, or vice versa. Many times radial balance

FIGURE 15.
Edgar Degas, *The Ballet Rehearsal*, 1891. Oil on canvas, 18.875 × 34.625 in. Yale University Art Gallery, New Haven, Connecticut.

is another form of symmetry, offering stability and a point of focus at the center of the composition. The rose window in the north transept at Notre-Dame Cathedral illustrates both classic radial balance and bilateral symmetry (figure 14).

Asymmetrical Balance

Asymmetry uses compositional elements that are offset from each other rather than balanced. Asymmetrical visual balance is the most dynamic because it creates a more complex design. It can thus enliven an otherwise mundane arrangement.

A specific mode of asymmetrical balance is **counterweight balance**, where the visual elements of one area of a work are balanced against the visual elements of another area of the work. Of all the balance systems, counterweight balance is the most sophisticated and therefore the most difficult to recognize. It helps to imagine a teeter-totter. If you are big and your partner is small, it isn't any fun. You have two choices to solve your problem: add more weight to one end until the two sides balance, or move the fulcrum of the teeter-totter toward the heavier side so that the lighter weight has more leverage. Counterweight balance uses this method to balance the formal and compositional elements of a work.

The dynamic use of counterweight balance can be seen in *The Ballet Rehearsal* by the French artist Edgar Degas (figure 15). With the column placed almost directly in the center of the composition, it is easy to see how the left and right sides are not equally balanced. The predominance of visual weight is on the right side with the three ballerinas. Their visual complexity and weight is countered by both the simple rectangular shape of

the floor expanse on the left and the implied distance created by the row of ballerinas on the upper left. The row of ballerinas on the upper left create the counterweight that pulls the composition back into balance so that it doesn't feel lopsided.

D. Scale and Proportion

Scale and proportion show how the size of one form relates to another. Technically, **proportion** refers to the relative sizes of elements within a composition, and **scale** refers to the relationship of the objects to the overall size of the work. However, in practice, the application and use of these techniques frequently overlap. Scale and proportion are components in nature, fashion, architecture, landscape design, and other areas in our daily life. Although the concepts have a wide range of application, we focus here on how scale and proportion relate to the human figure. The human figure is often used as a measuring stick, and we can better understand scale and proportion of unfamiliar objects when we see a person standing beside them.

FIGURE 16.
Marie-Gabrielle Capet, *The Atelier of Madame Vincent*, 1808. Oil on canvas, 27.2 × 32.9 in. Neue Pinakothek, Munich, Germany.

In the painting *The Atelier of Madame Vincent*, for example, French painter Marie-Gabrielle Capet depicts an artist working on a commissioned group portrait (figure 16). The subject matter is presented as an actual event, and scale and proportion are used in a believable manner. The figures are all rendered naturalistically and the proportional relationships of one person to another are accurate.

The Ancient Greeks valued beautiful and classic proportions in both their art and architecture. Polykleitos (Polyclitus) of Argon, a fifth-century sculptor, devised a system for creating the ideal proportions for the human figure (figure 17). The units of measurement were based upon comparison of body parts. To calculate height, the head is used as the size reference. Using this system, the ideal height for man is eight heads tall, and the ideal width of the chest is two heads. In his sculpture, *Doryphoros*, the proportional relationships adhere closely to this formula. In contemporary figure drawing classes, these basic techniques are still being taught with focus on proportional relationships as opposed to the depiction of ideal form.

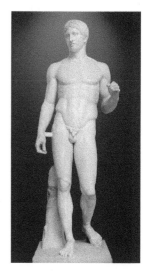

FIGURE 17.
Polykleitos of Argon, *Doryphoros* (fifth century BCE), Roman copy of the Greek original, ca. 440 BCE. Marble, 83 in. Museo Archeologico Nazionale, Naples, Italy.

Artists will also alter proportion in order to increase visual impact. In her series *The Big Head Boys*, ceramics artist Anne Drew Potter exaggerates the heads of her figures. In *Jane*, the head is huge, and the expression of sadness is obvious (figure 18). The proportion of the head draws our attention to that sadness.

Christina West is another figurative ceramics artist. In her installation *Shadow and Fog*, the figures are proportionally accurate (see figure 19). From the information in the photo, we assume the figures are life-sized. In the next image, however, a person has been added to give a reference point to the actual scale of the work (see figure 20). Suddenly it is evident that all of the figures are about two-thirds the actual size of a human. With this addition of a woman as our point of reference, we are now able to see how West has played with scale.

The actual scale or size is an important consideration in artistic creation. Should the object be something that can be held in one's hand or should it tower above us? The visual impact and the content are radically dictated by

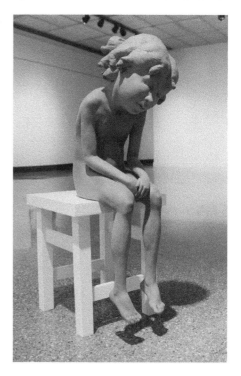

FIGURE 18.
Anne Drew Potter, *Jane*, from *The Big Head Boys* series, 2007. Hand-built terra cotta and wood, 13 × 19 × 38 in. SoFA Gallery, Collection of the artist.

FIGURES 19 [TOP] AND 20 [BOTTOM].
Christina West, *Shadows and Fog* (detail), 2008. Hand-built sculpture and mixed media installation, average height 48 in. Hallwalls Contemporary Art Center, Buffalo, New York.

scale. While technology has increased our access to masterpieces housed in museums around the world, it frequently does not give us a sense of scale of the works of art, which is an important component of the viewing experience.

The Golden Mean and the Golden Rectangle

The Golden Mean, sometimes referenced as the Golden Section or Golden Ratio, deals with the proportional relationship that is based on the ratio of 1:1.6180. It is referred to with the Greek letter ϕ (Phi). This ratio is the basis for the golden rectangle (figure 21).

Without delving too deeply into Euclidean geometry, the essence of the Golden Mean is the proportional relationships between the small parts and the larger parts within the entire piece. As you can see in the diagram of the **golden rectangle**, when a square is placed in the large rectangle, a small rectangle is created. The newly created rectangle contains the 1:1.6180 ratio. The sequence is continued, gradually creating smaller shapes, and in theory can go on indefinitely. The golden rectangle is closely connected to the **Fibonacci sequence** (figure 22). In nature, the spiraling Fibonacci sequence is evident in fiddle head ferns, fractals, and a nautilus shell. An example of the Fibonacci sequence in craft art is on page 115 (Chapter 3.4, figure 6).

FIGURE 21 [LEFT].
Diagram of the Golden Rectangle.

FIGURE 22 [RIGHT].
Diagram of the Fibonacci sequence.

FIGURE 23.
Diagram of the Gold Rectangle applied to the Parthenon. Ictinus and Calli-
crates with Phidias (architects, Parthenon Acropolis, ca. 447 BCE. Bearing
masonry, cut stone, 45 ft. Athens, Greece.

FIGURE 24.
Diagram of Fibonacci sequence applied
to *Mona Lisa*. Leonardo da Vinci, *Mona
Lisa*, 1503–1505. Oil on poplar wood,
30.2 × 20.9 in. The Louvre, Paris.

So why is any of this important? As pattern-loving animals, we are
naturally drawn to pleasing proportions. Both the Fibonacci sequence and
the golden rectangle create appealing compositions with strategies for opti-
mal placement of the forms. The Parthenon is a testament to the Greeks'
aesthetic goal for perfect proportions. The diagrammatic lines illustrate how
the proportional relationships of the golden rectangle were implemented in
the design of the structure (figure 23).

Many Renaissance artists explored and experimented with these pro-
portional systems as well. In the *Mona Lisa*, Leonardo da Vinci applied the
golden rectangle to the proportion in her face (figure 24). It is interesting to
consider that the same basic proportional device is used on such different
works of art. The golden rectangle and the Fibonacci sequence are not rules
that have to be strictly followed. They are options and techniques that go
into the artist's toolbox.

E. Rhythm

Just as in music, visual art can contain rhythmic qualities. The principle of rhythm is tied directly to repetition. A **rhythm** is created when two or more similar elements or forms are used within a composition. The systematic arrangement of repeated shapes or forms creates pattern, and the patterns can create rhythm in a composition in the same way that a repeated lyric or counter beat creates rhythm in a song. This rhythm carries the viewer or the artist's idea through the work.

FIGURE 25.
Paul Cézanne, *Large Pine and Red Earth*, 1895. Oil on canvas, 28.3 × 35.8 in. Hermitage Museum, St. Petersburg, Russia.

Rhythm can take on many forms. In *Large Pine with Red Earth*, Paul Cézanne places short brushstrokes close together to create the tree, the earth, the field, and the distant landscape (figure 25). This rhythm has a wavy, smooth, legato quality to it. The painting seems to replicate the wind swirling through the tree and waving through the grass, almost as if the

FIGURE 26.
Alison Reintjes, *Shimmer*, 2011.
Slip cast, 42 × 35 × 1.25 in.
Collection of the artist.

FIGURE 27.
Nancy Eng, *Red Hawk Winery*, 2014. Oil on canvas, 16 × 16 in. Collection of the artist.

viewer can feel it. Montana-based ceramics artist Alison Reintjes uses a similar wavy rhythm in her wall sculpture *Shimmer* (figure 26). Reintjes also incorporates an alternating rhythm by systematically alternating the various values of brown in an ABCABC pattern.

Rhythms are not always smooth and flowing. In Nancy Eng's painting, *Red Hawk Winery*, the multiple horizons and focal points, the repeated dark vertical lines, and the small, rapid brush strokes all create rhythm (figure 27). The style is somewhat abstracted, but the vines and trees are still apparent, depicting the winery in the painting's title. Although only one row of grapes is shown in the painting, vineyards usually have hundreds, if not thousands of similar rows. The use of the rhythm conveys the same feeling as seeing rows and rows of grapes.

Chapter 3:
Media and Methods

3.1 Drawing

Drawings, one of the most democratic and immediate of all art forms, are marks made using dry media, which include graphite pencils, charcoal, or chalk, and wet media, such as pen or ink. Even children have experience with this method, using crayons and paper as a way to explore their world through images. From uncontrolled scribbles to large orb-like faces to shapes that resemble people with legs and arms, children's drawings gradually take on a recognizable form.

A. Types of Drawing

In the hands of masters, this method and its simple tools have resulted in some of the most profound images in art. One such work, by the famous Italian artist Leonardo da Vinci, is *The Virgin and Child with Saint Anne and Saint John the Baptist* (figure 1), which wraps all four figures together in what is essentially an extended family portrait, at once momentary and eternal.

Da Vinci uses charcoal and white chalk to draw the figures in a naturalistic style, one that emphasizes distinct identities and surrounds the figures with a grand, unfinished landscape. He animates the scene with the Christ child pulling himself forward, trying to release himself from Mary's grasp to get closer to a young John the Baptist on the right, who turns toward the child with a look of curious interest. Da Vinci freezes these fleeting actions in a timeless present with his use of pyramidal composition. The arrangement of the figures, based on the most stable of all geometric forms, unifies them within the drawing. While the arrangement stabilizes the figures in the drawing, the medium itself emphasizes the ephemeral nature of this scene, allowing the figures to blur and blend with each other and with the indefinite background.

FIGURE 1.
Leonardo da Vinci, *The Virgin and Child with Saint Anne and Saint John the Baptist*, ca. 1499–1508. Charcoal, black and white chalk on tinted paper mounted on canvas, 55.7 × 41.2 in. National Gallery, London.

Sometimes referred to as the Burlington House **Cartoon** (another term for a drawing), this large-scale work is composed of eight pieces of paper glued together. Traditionally, cartoons served as preparatory studies for paintings. Using the cartoon as a map, the artist would transfer the cartoon to a board and make small pinpricks to outline the subjects. Da Vinci's cartoon remains intact, and there are no known paintings that correspond to this study. Perhaps the planned painting was abandoned or lost. The drawing's preservation suggests, however, that it was seen as a work of art based on its own merits and method of composition.

FIGURE 2.
Eric Wuest, *Guardians*, 2010.
Charcoal on paper, 18 × 24 in.
Private collection.

The traditional role of drawing to make sketches for larger works of art continues today. A preliminary sketch by Oregon artist Eric Wuest captures a composition of angular shapes in *Guardians*, a charcoal drawing (figure 2). In the larger painting on canvas, the arrangement maintains the angular structures but adds strong contrasts of value and hue, which create the illusion of space and depth in this two-dimensional piece (figure 3).

The use of preliminary sketches gives artists the opportunity to work out solutions involving compositional principles, such as scale, balance, proportion, and emphasis. Though the process may seem labor intensive, preliminary sketches can save artists time and materials as they fine-tune their initial visions. Similarly in the applied arts, drawings are used to plan and visualize a functional object before committing actual, costly materials to its making. This 1857 drawing of a candelabrum by J. & R. Lamb Studios, America's oldest continuously-run decorative arts company, shows the design intended to be fabricated in a metal shop (see figure 4).

When we say that there's an immediacy to the act of drawing, what we mean is the artist can construct a sense of the subject with just a few marks on paper. You can see this in the following self-portraits. Ranging from energetic to subtle, line qualities bring the subjects of these portraits

FIGURE 3.
Eric Wuest, *Guardians*, 2012. Oil on canvas, 36 × 48 in. Private collection.

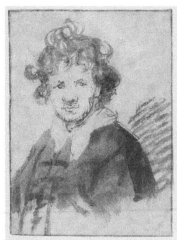

FIGURE 4.
J. & R. Lamb Studios, [Design drawing for metalwork: Seven-light candelabrum], 1857. Graphite, ink, and colored pencil, 11.5 × 15.5 in. Library of Congress Prints and Photographs Division, Washington, D.C.

FIGURE 5.
Rembrandt van Rijn, *Self-portrait*, ca. 1628–29. Pen and brown ink, brush in gray on paper, 5 × 3.7 in. Rijksmuseum, Amsterdam.

FIGURE 6.
Norman Rockwell, *Self-portrait*, 1920. Charcoal on paper, 13 × 10 in. Norman Rockwell Museum, Stockbridge, Massachusetts.

to life. Dutch artist Rembrandt van Rijn explores both expression and character in his use of loose, curvy lines that describe his hair and the more precise pen marks that capture his facial features (figure 5). The energy of the wildly waving hair along his jawline and eyebrows creates much of the portrait's emotional content.

In contrast, American artist Norman Rockwell's *Self-portrait* from 1920 shows a very different young artist (figure 6). He appears curious and calm. The meticulous shading and carefully controlled marks of this drawing capture not only the facial characteristics of the artist but also his mood, one of rational inquiry rather than emotional struggle. The composition places the artist's face and his large blank forehead in particular at the center of the viewer's attention. The intensity of focus, both in the subject's gaze outward and in the viewer's concentrated gaze at the artist's face, reveals Rockwell's familiar and direct style.

B. Drawing Media

To understand the importance of dry media, you must go all the way back to the Paleolithic era. In the earliest forms of artistic expression, in the prehistoric cave drawings using charcoal and mineral tools, you will find the origin of dry media. Coming later, white chalk, metal point, graphite, and low-fired clay sticks called Conté crayon expanded the range of values and colors available to the **draftsman**, a person skilled in drawing plans or designs. As a species, we've had a long time to explore the visual effects possible with dry media, from bold charcoaled shapes of animals on cave walls to vibrant contemporary works made with oil pastels. The tools for drawing continue to evolve as a result of artistic and technological innovation.

Each medium produces a wide range of visual effects, from thin lines to large swaths of color and tone. By pressing harder against the drawing's surface, you can increase the value, the relative darkness of the dry medium. By releasing pressure gradually, you can add gradations of tone and shade that create the illusion of shadows, depth, and shape. Through erasure, blotting, or rubbing, you can replicate the way light strikes different objects or imitate a particular texture. In the following sections, we'll explore the unique qualities of graphite, charcoal, chalk, erasers, pastels, and ink.

Graphite

Graphite media include pencils and graphite sticks, which can be powder or compressed. Each medium produces a range of values depending on the hardness or softness of the material. Hard graphite yields tones that range from light to dark gray. Softer graphite provides a range of tones from light gray to nearly black. In this drawing by French sculptor Gaston Lachaise, you can see his delicate use of graphite and ink in *Standing Nude with Drapery* (figure 7).

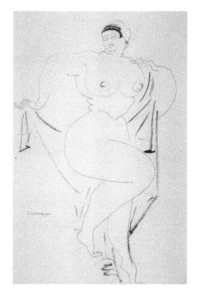

FIGURE 7.
Gaston Lachaise, *Standing Nude with Drapery*, 1891. Graphite and ink on paper, 23.5 × 18.5 in. Honolulu Museum of Art, Honolulu, Hawaii.

FIGURE 8.
Samantha Wall, *Five Words: Exhume*, 2013. Graphite and charcoal on paper, 60 × 41 in. Laura Russo Gallery, Portland, Oregon.

FIGURE 9.
[Left] Vine charcoal sticks; [Right],
Compressed charcoal squares.

With the faintest of strokes, Lachaise translates the energy and a sense of movement of the figure to the paper. This drawing demonstrates how, in the hands of a practiced draftsman, a work of art can be made using the simplest gestures and tools.

Oregon artist Samantha Wall's contemporary drawings are also testament to the range of value possible with graphite. Part of a series of portraits, *Five Words: Exhume* shows the power of pencil to depict an individual presence as well as an erasure or loss of connection to that being (see figure 8). Wall writes, "Through drawing, I probe the indistinct edges that separate one's sense of self from their body My experiences as a multiracial woman . . . influence how I navigate through the world and construct the framework for my creative practice."

Charcoal

Both Norman Rockwell and Samantha Wall's portraits above make use of **charcoal**. This medium has a long tradition in art and is made by charring wooden sticks or small branches such as vine or willow (figure 9).

Vine charcoal comes in three densities — soft, medium, and hard — each one handling a little differently than the others. Soft charcoals lend a velvety feel to a drawing. The artist doesn't have to apply as much pressure to the stick in order to get a solid mark. Hard vine charcoal offers more control but generally doesn't provide the darkest tones. Charcoal is also available in a mechanically compressed form. Compressed charcoals make deeper blacks than vine charcoal does, but these marks are more difficult to manipulate once applied to paper.

Charcoal drawings can vary in value from light grays to rich, velvety blacks. This charcoal drawing by Washington artist Elaine Green is a good example (figure 10). Notice how light changes across these faces while also defining the visual texture of the skin. This is attained by shifting values and paying careful attention to the transitions from one value to the next.

FIGURE 10.
Elaine Green, *Three Saints*, 2015. Charcoal and pencil
on canvas, 5.5 × 7.5 in. each. Private collection.

Chalk

A naturally occurring mineral made of the compressed shells of microscopic sea creatures, the **chalk** used in art is not much different from the chalk used in classrooms and on sidewalks. Because chalk is almost pure calcium carbonate and is brilliantly white, it allows an artist to add highlights to a charcoal drawing, as da Vinci does in *The Virgin and Child with Saint Anne and Saint John the Baptist* (see figure 1), or to make light marks on a dark surface. Conté crayon is an artificial chalk invented in France in the eighteenth century. It uses the roses, creams, and browns available in clay as a drawing medium for portrait work. Conté is made by kneading the clay into a stick and heating it in an oven until it is just the right hardness for drawing.

FIGURE 11.
Laura Mack, *With, Without*, 2014.
Charcoal on panel, 36 × 36 in.
Collection of the artist.

Erasers

Erasers are an important tool in the drawing process, and not just for when you make mistakes. For every mark made on paper, there is an eraser that can remove it without destroying what's beneath. **Erasers** can also be used to construct drawings by subtracting information. Oregon artist Laura Mack uses this subtractive process effectively in the drawing *With, Without* (figure 11). After adding charcoal to the drawing, the artist uses an eraser to remove the right amount of charcoal, leaving the desired tone or value behind.

FIGURE 12.
Edgar Degas, *Waiting*, 1882.
Pastel on paper, 19 × 24 in.
J. Paul Getty Museum, Los
Angeles, California.

Pastels

Pastels are artificial chalks made from powdered chalk, talc, and powdered pigment that are compressed into stick form for better handling. Pastels are characterized by soft, subtle changes in tone or color. You can see the way pastel pigments mix and layer, allowing for rich tones in French artist

FIGURE 13.
Robert Tomlinson, *Continents #9*, 2011. Oil stick, pastel, pencil, and chalk on paper, 30 × 22 in. Collection of the artist.

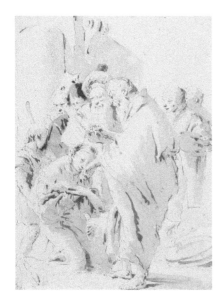

FIGURE 14.
Giovanni Battista Tiepolo, *St. Prosdocimus Baptizing St. Giustina*, ca. 1735–40. Pen and bistre ink and wash, 13.19 × 9.84 in. National Gallery of Victoria, Melbourne, Australia.

Edgar Degas's *Waiting* (see figure 12). Most pastel artists call themselves painters because of the medium's ability to create blended colors, which is a possibility more often associated with liquid media.

More recent developments in dry media are oil pastels, pigments mixed with an organic oil binder that deliver a heavier mark and lend themselves to more graphic and vibrant results. The work of Oregon artist Robert Tomlinson shows the use of bold strokes of oil pastels (figure 13).

Ink

Ink is a wet drawing medium. Full strength ink can be applied with a brush, a stick, a calligraphic pen, or with a feather. Ink can also be mixed with water to create tonal variations. In this drawing by Italian artist Giovanni Baptista Tiepolo, the artist uses both ink and paper to describe the illusion of form: dark, full-strength ink for the darkest shadows, washes for the secondary shadows, and paper left alone for the lightest areas on forms and architectural elements (figure 14).

C. Drawing and the Viewer

Contemporary artists are not as rigid with their definition of drawings as pastel or pencil or charcoal. Some artists refer to their work as mixed media drawing because it does not fall into one drawing category. Oregon artist Debra Beers uses both charcoal and pastel in *The Viewing* (figure 15). The added color expands the emotive content suggested by the confrontation or indifference between the two sentient beings.

Contemporary artists also draw with non-traditional media. California artist Rebecca Szeto creates drawings using three-dimensional steel wool. The wool is stretched and bunched up to create darker and lighter masses of contrasting value. Ironically, her chosen subject for *Steel Wool Drawings: Safety in Numbers* is sheep (figure 16).

FIGURE 15.
Debra Beers, *The Viewing*, 2015. Pastels, charcoal on paper, 39 × 50 in. Collection of the artist.

As a word, "**drawing**" can be an action, an object, or an artistic style. The versatility of the word mirrors the versatility of the method. Museums frequently display drawings under climate controlled, low-light conditions due to the medium's fragile nature and susceptibility to fading. Viewed like this in small, dim rooms, drawings present the viewer with an intimate experience that is both timeless and ephemeral. Whether child's play or masterpiece, preliminary sketch or definitive work of art, drawing shows us how the simplest tools can explore complex ideas and contribute to the diversity of artistic expression.

FIGURE 16.
Rebecca Szeto, *Steel Wool Drawings: Safety in Numbers*, 2006. Steel wool, pins, 132 × 96 × 3 in. Collection of the artist.

Drawing **91**

3.2 Painting

FIGURE 1.
Leonardo da Vinci, *Mona Lisa*, 1503-1505. Oil on poplar wood, 30.2 × 20.9 in. The Louvre, Paris.

How is painting different from drawing? Obviously, the tools are different. One artist applies paint with a brush to a canvas, another sketches with charcoal on paper. But there are other more subtle distinctions, resulting from depth of color and surface texture, that give painting its unique qualities. Like drawing, painting is a familiar medium with both artistic and practical applications. Kids express themselves with finger paints, and adults pick a new color for the kitchen walls. But unlike drawing, you can't use an eraser when you paint. It is possible to cover layers of paint using acrylic or oil, but generally, it is a less forgiving medium, one that requires knowledge of materials, careful planning, and continued practice.

To begin with a basic definition, painting is the application of paint or pastel to a surface (called a support), which can include paper, wood, canvas, plaster, clay, lacquer, and concrete. In art, the term "painting" describes both the act of painting and the finished product. Both versatile and universal, painting as a medium has survived across cultures and ages and, along with drawing and sculpture, is one of the oldest forms of creative expression.

FIGURE 2.
Edvard Munch, *The Scream*, 1893. Tempura and pastels on cardboard, 35.7 × 29 in. The National Gallery, Oslo, Norway.

The power in great painting is that it transcends mere representation of the world to reflect emotional, psychological, and even spiritual levels of experience. Great paintings can reveal some of the essence of what it means to be human. Three of the most recognizable paintings in Western art history are Italian artist Leonardo da Vinci's *Mona Lisa* (figure 1), Norwegian artist Edvard Munch's *The Scream* (figure 2), and Dutch artist Vincent van Gogh's *The Starry Night* (figure 3). These three works of art are examples of how painting can go beyond simple representation of life.

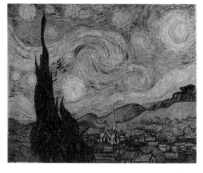

FIGURE 3.
Vincent van Gogh, *The Starry Night*, 1889. Oil on canvas, 29 × 36.25 in. Museum of Modern Art, New York.

A. Paint Ingredients

The basic ingredients of paint are pigments, which supply color; a binder, which carries the color and adheres it to the support surface; and a solvent, which thins the medium to the desired consistency. Solvents may also be used to clean brushes and tools.

Pigments are granular solids created from mineral, plant, or synthetic sources. Natural pigments can be made from clay, powdered minerals, organic substances, or chemical compounds. Clay pigments can be raw or burnt (exposed to heat to eliminate oxygen and water). It's interesting to note that the name of the pigment often includes this distinction, as in raw and burnt sienna or raw and burnt umber. Another common clay pigment is terre vert, which uses an olive-colored earth. Powdered minerals are used to produce many colors: lapis lazuli (blue), copper (green), cadmium (red), uranium (yellow), and lead (red and white). We recommend that you avoid ingesting these pigments — a rumored bad habit of Vincent van Gogh — because all of these minerals are poisonous.

Naturally occurring organic substances, such as brazilwood and cochineal insects, produce reds, and fine rotted wood and resin from Egyptian mummies produce van Dyke brown and Caput Mortuum, respectively. These organics were used in the past but are less common today because they produce fugitive pigments, which means that they fade with time and exposure to light.

Given these problems and the fact that some colors are not readily available in nature, modern pigments are often chemically compounded. The resulting colors are often brighter, purer, and more permanent than their traditional predecessors. An array of raw pigments can be seen in Catherine Haley Epstein's My Pharmacy (figure 4).

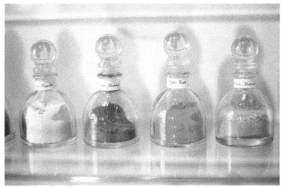

FIGURE 4.
Catherine Haley Epstein,
My Pharmacy: Homage to
Malevich (detail), 2013.
Acrylic shelves, glass bottles
with pigment, 24 × 48 × 8.5 in.
Collection of the artist.

The **binder**, commonly referred to as the vehicle or medium, is the actual film-forming component of paint. The binder holds the pigment in solution until it's ready to be dispersed onto the surface. Among the many known binders are molten wax, egg yolk and egg white, animal gelatins, vegetable resins, oils, milk solids (casein), and water-soluble plastics such as polymer medium. Each medium has its own

individual handling characteristics, reactions to pigment chemistry, surface appearance, and drying time.

Solvents control the flow and application of the paint. They are mixed into the paint, usually with a brush, to dilute it to the proper viscosity, or thickness. Once the solvent has evaporated, the paint remains fixed to the surface. Solvents range from water to oil-based products such as linseed oil and mineral spirits.

B. Media

Painting media are extremely versatile because they can be applied to many different surfaces. Some media have the ability to soak into their support materials, which can weaken and damage them over time. To prevent this, a support is first covered with a ground, a mixture of binder and chalk that creates a non-porous layer between the support and the painted surface when dry. Today, a variety of substances (called gessoes) accomplish this goal.

Paintings are typically described in terms of the materials used to create the painting. They are usually listed in the description of the painting as the medium, specifying the binder and solvent used to suspend the pigment, and the support. For example, many classical paintings are described as "oil on canvas," meaning the artist used an oil medium on a canvas support. In the following sections, we will explore some of the most common painting media: encaustic, egg tempera, fresco, oil, acrylic, and watercolor.

FIGURE 5.
Mummy Portrait of a Girl (detail), 120–150 BCE, Roman Egypt. Wax encaustic painting on sycamore wood. Liebieghaus, Frankfurt, Germany.

Encaustic

Encaustic medium mixes dry pigment with a heated beeswax binder. The heat acts as the only solvent. This mixture is then brushed or spread across a heated support surface. Reheating allows for longer manipulation of the paint. Encaustic painting dates back at least to the first century CE and was used extensively in funerary mummy portraits from Egypt's Fayum region, as you can see in the detail of *Mummy Portrait of a Girl* (figure 5).

The characteristics of encaustic painting include strong, resonant colors and extremely durable paintings. Because of the beeswax binder, encaustic forms a tough skin on the surface of the painting.

Though ancient in its origin, the encaustic technique is still used today. Iowa artist Thaddeus Erdahl uses this technique in his figurative sculptures. In *Callithumpian*, Erdahl combines encaustic, wax, white slip, and glaze on a ceramic sculpture (figure 6).

Egg Tempera

Egg tempera paint combines pigment with an egg yolk binder, which is thinned and released with water as a solvent. Like encaustic, tempera has been used for thousands of years. It dries quickly to a durable, matte finish. Tempera paintings are traditionally applied in successive thin layers, called glazes, painstakingly built up using networks of cross-hatched lines. Because of this technique, tempera paintings result in a high level of detail.

In early Christian art, egg tempera was used extensively to paint images of religious icons. The pre-Renaissance Italian artist Duccio, one of the most influential artists of the time, used egg tempera paint in *The Crevole Madonna* (figure 7). The sharpness of line and shape in this well-preserved work is apparent in the detail he renders in the face and skin tones of the Madonna (figure 8).

FIGURE 6.
Thaddeus Erdahl, *Callithumpian* (detail), 2010. Low fire clay, slip, glaze, wax, encaustic, wood, and leather, 53 × 51 × 16 in. Collection of the artist.

FIGURE 7.
Duccio, *The Crevole Madonna*, 1283–84. Tempera on board, 35 × 26.5 in. Museo dell'Opera del Duomo, Siena, Italy.

FIGURE 8.
Duccio, *The Crevole Madonna* (detail), 1283–84. Tempera on board, 35 × 26.5 in. Museo dell'Opera del Duomo, Siena, Italy.

FIGURE 9.
Reginald Gray, *Girl and Lemon Tree*, 2010. Tempera and marble dust on canvas, 27.5 × 23.6 in. Collection of the artist.

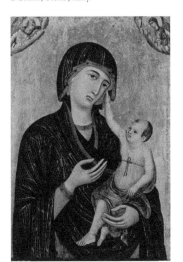

Contemporary artists still use egg tempera. Irish artist Reginald Gray created this slightly mysterious double portrait of a lemon tree and a girl in 2010, skillfully combining softly layered patches of color with hard linear areas (see figure 9).

Fresco

Fresco (fresh) painting is used exclusively on a support surface of plaster walls and ceilings. The medium of fresco has been used for thousands of years, but is closely associated with Christian images during the Renaissance period in fifteenth- and sixteenth-century Europe. There are two forms of fresco: buon fresco and fresco secco.

Buon (good) **fresco**, also called fresco vero (true), painting consists of pigments mixed with a binder of thinned plaster on fresh, still wet plaster or lime mortar. The wet plaster absorbs the pigment, and after a number of hours, the plaster dries and reacts with the air. It is this chemical reaction that fixes the pigment particles in the plaster support. Because of the chemical makeup of the plaster, a separate binder is not required. Buon fresco is very stable because the pigment becomes part of the wall itself. Domenico di Michelino's *Dante and the Divine Comedy* is a superb example of buon fresco (figure 10). The colors and details are preserved in the dried plaster wall of the Duomo del Firenze, the cathedral of Florence, Italy.

Fresco secco (dry) refers to an image painted on the surface of a dry plaster wall. This medium requires a binder since the pigment is not chemically integrated into the wet plaster. Egg tempera is the most common binder used for this purpose. It was common to use fresco secco over buon fresco murals in order to repair damage, make changes to the original, or add special colors that do not react well with plaster. Da Vinci's painting of *The Last Supper* was done using fresco secco with walnut oil as the binder (figure 11). Unfortunately, a fresco secco is ephemeral, especially on

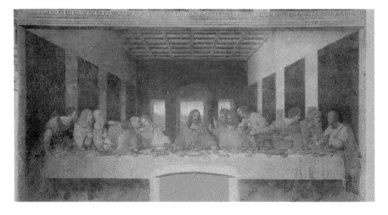

walls that can become damp, which eventually causes the added paint to peel or slide off, as has happened with *The Last Supper.*

Oil

Oil paint uses linseed oil as the binder for the pigment. Linseed oil can also be used as the solvent, along with mineral spirits or turpentine. Oil painting was thought to have developed in Europe during the fifteenth century, but recent research on Afghani cave murals found that oil-based paints were used there as early as the seventh century.

Oil painting has many benefits: a wide range of pigment choices, slow drying time, and broad application in a variety of techniques. Oil paint can be thinned down and applied in almost transparent **glazes** as well as built up in thick layers, a painterly technique called **impasto**. Boston artist Brigid Watson uses the impasto technique in her expressive, non-objective oil paintings (figure 12). The thick strokes cast shadows on the painting, adding darker value to the paint in shadow. As each additional brushstroke is applied, the wet paint from beneath is gathered, too, making each stroke unique. One drawback to the impasto technique is that the body of the paint can split over time, leaving networks of cracks along the thickest parts of the painting.

Because oil paint dries slower than other media, it can be blended on the support surface with meticulous detail. This extended working time also allows for adjustments and changes to

FIGURE 12.
Brigid Watson, *Zen Arcade*, 2013. Oil on canvas, 9 × 9 in. Private collection.

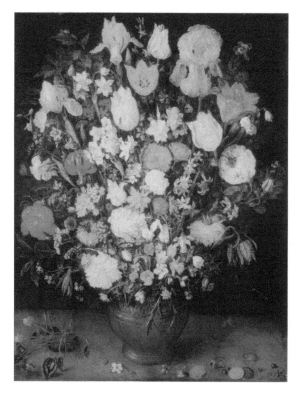

FIGURE 13.
Jan Brueghel the Elder, *Flowers in a Vase*, 1599. Oil on wood, 20.1 × 15.7 in. Kunsthistorisches Museum, Wien, Germany.

Figure 14.
Cynthia Herron, *Water Is Low*, 2014. Oil and cold wax on panel, 16 × 16 in. Collection of the artist.

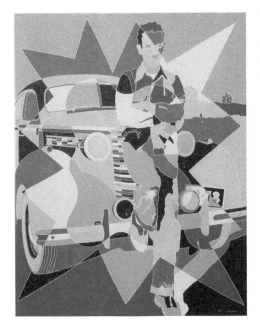

Figure 15.
nic nichols, *Chet's Ride*, 2014. Lead pencil and oil on canvas, 30 × 24 in. Collection of the artist.

be made without having to scrape off sections of dried paint. Glazes can be created by mixing small amounts of pigment with larger proportions of linseed oil and damar varnish as solvents. These are applied in successive layers, resulting in a sensation of glowing light from behind the canvas or panel support.

In Flemish painter Jan Brueghel the Elder's still life, *Flowers in a Vase*, many of the qualities mentioned above appear (see figure 13). The richness of the paint itself is evident in both the resonant colors and the inky dark values of the work. The working of the paint allows for many different effects to be created, from the softness of the blended flower petals and reflection on the vase to the many visual textures in the incredible detail of the flowers and insects.

Oregon artist Cynthia Herron's *Water Is Low* shows how the artist uses oil paint in a more fluid, expressive manner (figure 14). The distinct oil colors and brushstroke application are visible immediately, whereas the implied landscape is revealed slowly. Realistic and abstract styles are blurred in the oil paintings by Oregon artist nic nichols. *Chet's Ride* starts from a representation of an old photograph that has been divided by lines into curvilinear and zigzag shapes (figure 15). These shapes disrupt our expectations of seeing the original image, so the paint application controls the medium within these shapes in his linear style. In addition, nichols' brushstrokes are almost invisible.

Acrylic

Acrylic paint was developed in the 1950s and became an alternative to solvent-based oils and enamels. Pigment is suspended in a polymer emulsion binder, and water acts as the vehicle. Acrylic polymer has characteristics like rubber, plastic, or glue: it dries quickly, is easy to

clean up, and is non-toxic. Moreover, acrylic paints adhere to varying surfaces such as canvas, wood panel, fabric, walls, glass, and even shoes. Acrylic paints offer the body, color resonance, and durability of oils without the expense and mess. Painters can achieve some of the same glazing, scumbling, blending, and impasto effects as oils. Acrylics will not crack or yellow over time. However, unlike oils, once acrylics are dry, the surface is impervious to moisture, dust, or other solvents. Only rubbing alcohol can dissolve the paint.

Oregon artist Sarah Fagan uses the acrylic medium. Through thin layers of underpainting, glazes, and luscious surface development, she brings her carefully observed objects to life. Although Fagan's style is very plastic in *Three Spoons*, with its extremely realistic detail (figure 16), she describes her work in acrylics as moving between "painterly strokes and trompe l'oeil, to elevate the status of everyday objects."

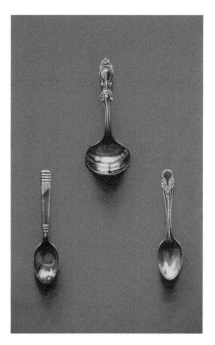

FIGURE 16.
Sarah Fagan, *Three Spoons (Abundance II)*, 2014. Acrylic on panel, 20 × 16 in. Collection of the artist.

Watercolor

Because of its portability and suitability for small-format paintings, watercolor can create images that capture a moment and hold within them a sense of immediacy. This adaptable medium comes in two types: transparent and gouache, which is opaque. Gum arabic, which comes from the sap of the acacia tree, is used as the binder and easily dissolves in water. Transparent watercolors operate in a reverse relationship to other painting media: painters reserve lights and build up darks. The painter relies on the whiteness of the paper to reflect light back through the applied colors, whereas opaque watercolors reflect light off the paint itself.

Paper, the traditional support of watercolor, is best at heavier weights and textures such as 140, 220, or even 400 (weight calculated as pounds per five-hundred sheets) so that it won't buckle and tear while painting. The paper used for watercolor is generally of two types: hot pressed, which has a smoother texture, and cold pressed, which has a rougher texture.

Watercolor is the most temperamental of the painting media. It reacts to the lightest touch of the artist and can easily be over-worked. Corrections are nearly impossible to make, so many artists plan their compositions over

FIGURE 17 [LEFT].
Paul Cézanne, *Boy in a Red Vest*, 1890. Watercolor on paper, 18.1 × 11.8 in. Private Collection.

FIGURE 18 [RIGHT].
Carol Hausser, *At the World's Edge*, 2001. Transparent watercolor, 60 × 40 in. Collection of the artist.

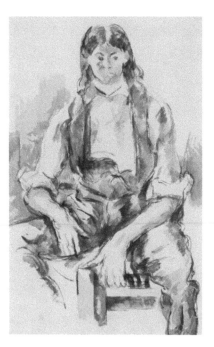

many hours. You can see the result of careful planning in *Boy in a Red Vest* by French painter Paul Cézanne as the artist builds form through nuanced colors and tones (figure 17). The way the watercolor is laid onto the paper reflects a sensitivity and deliberation common in Cézanne's paintings.

Others, however, drip onto and stain the paper, aiming for accidental effects in addition to carefully controlled articulation of forms. Oregon artist Carol Hausser uses both approaches in *At the World's Edge* (figure 18).

To accomplish this effect, one area after another of the composition is discretely developed, each becoming its own field of exploration. Transparent layers of watercolor are then washed, stippled, textured, and slowly built up until the completed segments converse with each other in elaborate illumination. Hausser explains her approach in terms of physics: "I remain attentive in my painting process to the liquid movement and forces, to the waves and particles that form line, that then coalesce into something approaching matter, and then spin on."

The unique quality of transparent watercolor requires the artist to employ varying techniques to produce specific effects. These include the use of wash, wet-in-wet, and dry brush techniques. Wash refers to an area of color applied with a brush and diluted with water to let it flow across

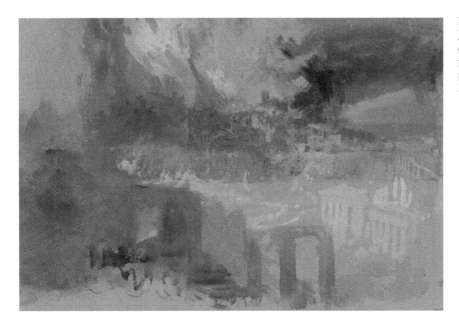

FIGURE 19.
J.M.W. Turner, *The Burning of Rome*, 1834. Gouache, pencil, and watercolor on paper, 47.8 × 14.4 in. Tate, London, England.

the paper. Wet-in-wet painting allows colors to flow and drift into each other, creating soft transitions between them. Dry brush painting uses little water and lets the brush run across the top ridges of the paper, resulting in a broken line of color and interesting visual textures.

Opaque watercolor (gouache) differs from transparent watercolor in that the particles are larger, the ratio of pigment to water is much higher, and an additional, inert white pigment such as chalk is also present. Because of this, gouache paint gives stronger color than transparent watercolor, although it tends to dry to a slightly lighter value. Gouache paint doesn't hold up well in impasto, tending to crack and fall away from the surface. It holds up well in thinner applications and often is used to cover large areas with color. Like transparent watercolor, dried gouache paint will become soluble again in water. For more permanence, they must be framed under glass. The use of gouache can be seen in *The Burning of Rome*, a vibrant painting by English artist J.M.W. Turner (figure 19). Expressive areas of color overlap easily with each other and the gray paper. The red and white areas were painted last. Turner created many such studies in preparation for his larger oil paintings of historical subjects.

Gouache is a medium in traditional painting from other cultures, too. *Zal Consults the Magi*, part of an illuminated manuscript from

sixteenth-century Iran, uses bright colors of gouache along with ink, silver, and gold to construct a vibrant composition full of intricate patterns and contrasts. Ink is used to create lyrical calligraphic passages at the top and bottom of the work (figure 20).

C. Painting and the Viewer

The next time you visit an art museum, lean as close into the painting as the museum guard and the roped off area allows. Don't touch the art. That's never a good idea. But before you dive into what the image means or if you like what you see, linger on the surface. You'll notice that some paintings have a smooth surface while others have paint layered to create texture by means of visible brushstrokes. Paintings sometimes flirt with the third-dimension of space through creating the illusion of depth or by layering paint so that it nearly drips off the canvas. Along with the depth of its tradition and its wide-ranging appeal, painting is an art form that is both technically demanding and capable of evoking strong emotions in the viewer.

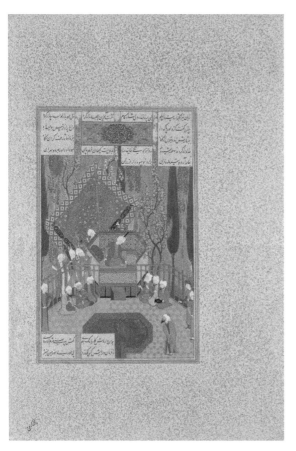

FIGURE 20.
Attributed to Sultan Muhammad, *Zal Consults the Magi.* Opaque watercolor, ink, silver, and gold on paper, Painting: 11 × 7.3 in. Entire Page: 18.6 × 12.5 in. Metropolitan Museum of Art, New York.

3.3 Sculpture

Living beings and objects exist in three dimensions. We occupy space through our height, width, and depth; together these add up to **mass**. When artists make works in three dimensions, the result is called sculpture, from the Latin verb "to carve." Historically, sculptors have focused on the human body, where their ability to create an illusion of life was prized. During the Renaissance, Michelangelo refined this idea with his approach to sculpture as a means of freeing the human form trapped within the stone. You can see his artistic idea take shape in *Young Slave* as the young man's form emerges from marble (figure 1) in a style referred to by scholars as "*non-finito*" (or incomplete). We can only speculate whether he left this piece intentionally unfinished, yet the form is suggestive of the unending human struggle to be freed from bonds both material and spiritual.

Sculpture has traditionally served a social and religious purpose through the creation of poignant memorials to the dead and spiritually revealing images of deities. Today, you can see sculptures not just in museums but in public plazas and parks. Though we typically associate marble statues with this art form, contemporary exploration of this art includes all kinds of materials, from Styrofoam to repurposed hardware, fabric, and even food. Sculpture can take any shape and be formed from almost any substance, but generally these art forms are classified in three main ways: 1) by the extent to which they are intended to be visible from all sides, 2) by the materials from which they are made, and 3) by the process used to make them. This section will focus on freestanding, relief, and contemporary variations of sculpture that include assemblage and kinetic work.

FIGURE 1.
Michelangelo, *Young Slave*, ca. 1525–30. Marble, 101 in. Accademia di Belle Arti di Firenze, Florence, Italy.

A. Sculpture Formats and Materials

Freestanding Sculpture
Just like any other work of art, sculpture is discussed in terms of composition, subject, and content. For example, this sculpture of Guanyin is composed as a **freestanding** piece so that the viewer can see the work from all sides (see figure 2). It is a wood sculpture made through the subtractive process of carving.

Its subject is the Bodhisattva Avalokiteśvara, known in China as Guanyin. He is a Buddhist saint who attained Enlightenment but stayed on earth to teach others. The artist creates content through the handling of the subject. The elaborately finished clothing and ornament worn by the Bodhisattva shows his high spiritual status, as does the superhuman scale of the form, which is almost eight feet high. The casual pose, known as the "pose of royal ease," and the calm, benevolent expression remind the devotee of the Bodhisattva's approachability and selfless devotion to the welfare of humankind. The extended right arm and raised knee create a stable triangular composition, which adds to the figure's serene presence.

FIGURE 2.
Guanyin of the Southern Sea, Liao or Jin Dynasty (907-1234). Wood and polychrome, 95 × 65 inches. The Nelson-Atkins Museum of Art, Kansas City, Missouri.

Sculpture in Relief

Sculpture may also be created in **relief**, where the primary form's surface is raised above the surrounding material. **Bas-relief** refers to a shallow extension of the image from its surroundings. This rich, animated bas-relief, carved from multiple blocks of rose red sandstone, is found at the Banteay Srei temple near Angkor Wat, Cambodia (figure 3). In this scene, animals flee as the demon Ravana, recognizable by his giant scale as well as by his multiple arms and heads, shakes Mount Kailasa, home of Shiva, to whom the temple is dedicated. The god seated on a throne above calmly presses his toe down from his throne to stop the shaking.

High relief refers to when figures project strongly from the surface. Often they are undercut to partially free them from the matrix of stone or wood. One of the most famous examples of high relief is the series of individual combat scenes carved in marble for the exterior of the Parthenon in Athens (figure 4). Many of them are now in the British Museum in London, where this photograph was taken.

As you can see, parts of this scene are in such high relief that body parts extend from the block of marble, while other details, such as the animal skin worn by the centaur, recede in shallow relief. The struggle between mythical Greeks and their equally mythical enemies bordered the temple's exterior, reminding viewers of the parallels between the imagined story of warfare and the very recent and real war with the Persian Empire. Rather than depicting the Greeks as always winning, the carvings often show the enemy as a more powerful and worthy foe. If you examine this carving closely, you will see that two of the centaur's legs

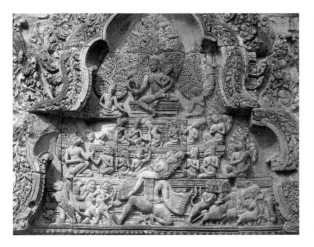

FIGURE 3.
[Detail of Banteay Srei, east pediment of south library depicting Ravana shaking Mount Kailasa], tenth century. Sandstone relief, approx. 5 ft. near Angkor Wat, Cambodia.

FIGURE 4.
Battle of a Lapith and a Centaur, Metope 30 from the south Doric frieze of the temple of Athena Parthenos (Parthenon) in Athens, Greece, ca. 447–432 BCE. Marble relief, 3.9 × 4 ft. British Museum, London.

and one arm are missing, broken off at some point in the work's complex history. That history included the temple's conversion into a Christian church and later a mosque, a major explosion, the removal of the carvings from the temple, shipping, shipwreck and retrieval, and finally placement in the British Museum.

B. Materials and Process

As demonstrated by the works of art highlighted in this section, **subtractive** processes carve away material from an existing mass, such as a chunk of stone, wood, or clay. **Substitutive** techniques replace one material with another through the process of casting. **Additive** sculptures are built piece by piece to create form. These approaches are not necessarily exclusive of each other, and we will look at some examples of three-dimensional art that cross over between categories. First, let's look more closely at the different methods.

Subtractive Method

Carving is the oldest known method for creating three-dimensional work. Using chisels and other sharp tools, artists carve away material until the ultimate form of the work is achieved. Traditionally stone, bone, ivory, and wood were the most common materials because they were readily available and extremely durable. Contemporary materials add various synthetic foams and solids to the list of possibilities. Ivory has been removed from the list because its desirability as a carving medium has contributed to the collapse of the elephant population in Africa.

The subtractive method can be seen in two of the prior images in this section. The Guanyin was carved from several pieces of wood, using wood chisels and a mallet, and then carefully drilled, pegged, and glued together (see figure 2). The carving was painted with colors and gold leaf. Because this piece is very old, it is likely that it was repainted several times. *Battle of the Lapith and Centaur* was carved out of a single piece of marble, a much harder and heavier material, using a variety of chisel shapes — claw chisels, which look like truncated forks, flat chisels for finishing, and drills for boring holes and cutting drapery lines (see figure 4). The background and perhaps the figures as well were originally brightly painted, though most of the paint has worn off.

FIGURE 5.
[Zeus or Poseidon], found in the sea off Cape Artemision, ca. 460–450 BCE. Bronze, approx. 82 in. National Archaeological Museum, Athens, Greece.

Substitutive Method

The substitutive method of **casting** has been in use for over five thousand years. It began as a manufacturing process by which a molten metal is poured into a mold that contains a hollow cavity of the desired shape. The molten metal is then allowed to solidify. In antiquity, the favored metal for large-scale sculpture was bronze, an alloy of copper and tin. Bronze has great tensile strength and is capable of extreme extension without support, as you can see in the outstretched arms of this sculpture of Zeus or Poseidon (figure 5). Found intact in the 1920s submerged in the Aegean Sea off Cape Artemision, this work of art demonstrates the durability of bronze. In

FIGURE 6.
Bethany Krull, *Prize* from the series *Dominance and Affection*, 2012. Slip cast porcelain, clear glaze, and artificial flower petals, 4 × 5 × 3 in. Collection of the artist.

contrast, marble is much more brittle, as shown by the broken appendages in the Greek combat scene (see figure 3). It must be internally supported to prevent breakage.

Along with its durability, bronze was valued for its color and kept polished to maintain its bright golden appearance. Modern bronzes are more likely to be given an added patina of color, which protects the metal from oxidation. Old bronze, unprotected by a patina, will turn green. Contemporary artists also cast in aluminum and precious metals, which are less prone to color change as they age.

Modern artists also use various cold setting materials that cure after mixing two or more components together. Examples are epoxy, concrete, plaster, and clay. Casting is often used for making complex shapes that would be difficult or uneconomical to make by other methods. It's a labor-intensive process that may allow for the creation of multiples from an original object (similar to the medium of printmaking), each of which is exactly like its predecessor. A mold is usually destroyed after the desired number of castings have been made.

Bethany Krull's *Prize* is one of a series of identical forms cast from a mold and distinguished by different fabric flower petals arranged to suggest the floating fins of ornamental goldfish (figure 6). The work thus becomes a combination of substitutive and additive methods. The use of flower petals suggests the flower-like delicacy of the living fish.

Additive Method

Modeling is a method that can be both additive and subtractive. The artist uses modeling to build up form with clay, plaster, or other soft material that can be pushed, pulled, or pinched into place. The material then hardens into the finished work. Larger sculptures created with this method make use of an armature, an underlying structure of wire that sets the physical shape of the work. Although modeling is primarily an additive process, artists do remove material in the process as seen in this image of Minnesota artist Kelly Connole finishing a ceramic sculpture (figure 7).

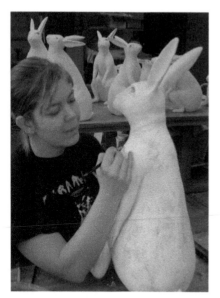

FIGURE 7.
Kelly Connole, *In the Studio*, 2008. Digital image. Collection of the artist.

Modeling a form is often a preliminary step in the casting method. Casting in metal is extremely expensive, and in nineteenth century art shows, plasters, rather than finished casts, were exhibited. Auguste Rodin modeled the plaster called *La Défense*, sometimes called *The Call to Arms*, for a competition to commemorate the defense of Paris against the German Army during the Franco-Prussian War of 1870–71 (figure 8).

It was built up with plaster over an armature, or skeleton, and patinated to look less like plaster and a little more like metal, but the plaster was never sold. Instead a mold was created from it, and a bronze cast produced. In the case of *La Défense*, the mold was four times the size of the original plaster. Because the mold and the cast were often made by professional artisans rather than by the artist, scholars regard a plaster as the original.

A fine example of a subtractive and additive sculpture can be seen in this mask from the Pacific Northwest Coast Kwakwaka'wakw culture (figure 9). Masks like this were carved of cedar wood, painted, and assembled by respected makers. The hair of the mask is made of cedar bark and fastened to the wood. The broad areas of paint give a heightened sense of character to the mask, which represents the mythical, man-eating Raven. This mask would have been used in dances by a member of the Hamatsa society in winter rituals.

Assemblage

Assemblage, a twentieth-century additive approach, uses found, manufactured, or altered objects to build form. Artists weld, glue, bolt, and wire individual pieces together. Some modern and contemporary sculptures

FIGURE 8.
Auguste Rodin, *La Défense*, or *The Call to Arms*, 1879. Patinated plaster, 44 × 23 × 16 in. Musée Rodin, Paris.

FIGURE 9.
Hamatsa Raven mask, Kwakwaka'wakw, collected at Mimkwamlis (Village Island), ca. 1917. Cedar, painted. Native American Collection, Peabody Museum, Harvard University, Cambridge, Massachusetts.

incorporate movement, light, and sound. Steve Brudniak's *The Vagus Leviathan* seems constructed to resemble a remnant of a nineteenth century mechanism ripped from its original time period (figure 10). Its evocative qualities are enhanced by an image that appears and disappears in the central glass, suggesting the instability of life and memory.

Kinetic Sculpture

Kinetic sculptures use ambient air currents or motors that allow them to move. These sculptures change in form as the viewer stands in place. *Request for an Oracle*, by Boston artist Anne Lilly, needs the touch of the viewer to start its motion (see figure 11). Once set in motion, the work gracefully moves in a repeating dance. The thin rods are connected to gears and cycle upward from their circular bases as if to meet each other above the sculpture, but then they fall back to an open position, over and over. The overlapping "lines" create shifting patterns until the motion

FIGURE 10.
Steve Brudniak, *The Vagus Leviathan*, 2008. Assemblage with photo, fiber optic lens, and kinetic mechanism, 50 × 21 × 6 in. Collection of the artist.

slows and comes to rest again. To see this piece in motion and get the full experience of the work, visit *www.annelilly.com.*

C. Sculpture and the Viewer

While sculpture occupies three dimensions, it encourages the viewer to look at space in multiple complex ways. There is the physical space in which the work of art exists. But there is also social space, psychic space, conceptual space, personal space, political space, outer and inner space — the list goes on and on. The viewer is invited into these spaces, to reflect on them and experience them through engagement with the physical object. Looking carefully at sculpture gives the viewer a greater appreciation of the labor involved in the making of art. We can imagine the artist in her studio, mallet and chisel in hand, sweating over each meticulous cut. We can picture the sculptor as he hefts the unshaped marble into place and begins to chip away toward his vision. Recognizing the technical demands placed on the artist by the materials and methods can add to our understanding of sculpture's subject and content.

FIGURE 11.
Anne Lilly, Still image of *Request for an Oracle*, 2008. Machined stainless steel, maximum dimensions reach 36 × 66 × 66 in. Collection of Elizabeth Lambert.

3.4 Crafts

Crafts are **applied arts**, as we discussed in Chapter 1. These everyday objects serve specific purposes just like a hammer or a chair does. Crafts reflect the adage that "form follows function." In other words, their shape is inspired by the job they are meant to do. The **craft** tradition is materials-based, meaning that craft workers are specialists in a single material, whether wood, clay, stone, or fabric, and its associated processes and skills.

Traditionally, craft skills, which require both handwork and specialized tools, were often passed from parent to child, or taught as part of an apprenticeship. This emphasis on tradition defines the characteristics of crafts today, both in their reliance on traditional forms and patterns developed over generations and in the high degree of workmanship and finish. Even so, individual or community creativity can go beyond traditional forms, workmanship, and finish, making objects that are not only useful and beautiful but also strikingly original.

Many contemporary artists work within or from the craft tradition, sometimes moving away from the directly useful ("form follows function") into a freer exploration of materials and methods. They may produce works more closely aligned with the fine arts while still maintaining the fine workmanship that is at the heart of traditional crafts. This section will explore only a few of the best-known craft traditions.

A. Ceramics

One of the archaeological markers for civilization is the use of clay. The Industrial Revolution brought about fundamental changes in manufacturing processes during the eighteenth and nineteenth centuries that could have obliterated handmade crafts, such as pottery and ceramics, but it didn't. Due in part to the pleasures and challenges of working with clay, the skill set survived. Today, artisans continue to create fascinating objects that are both useful and wonderful, shaping them by hand from clay. The word "ceramics" refers to fired clay, or clay that has been heated in a kiln to a high temperature, which hardens it.

Clay and Adobe

Clay can be found in large mineable deposits, especially in river valleys. When properly mixed with water and given time to develop helpful bacteria, clay becomes a workable mass. Materials known as **tempering** (chopped straw, shell, ground potsherds, chaff, or another fine, insoluble material) are added to the mass to produce a mixture called **tempered clay**.

There are many ways to prepare clay into a finished product, the simplest of which is adobe. Worked into a brick and dried, tempered clay will hold its shape rather than cracking apart. The result of this process is **adobe**, the basic building block of the ancient world and a traditional sculptural medium in Asia. Adobe is sturdy, but if it gets wet it will melt back to its original components: clay and tempering. The making of adobe is a simple form of pottery because it does not require the otherwise crucial step of firing.

Ceramics and Modern Clays

One method of working with clay involves the use of a **potter's wheel**, a round flat surface mounted to and spinning on a vertical axle (figure 1). The wheel can be spun by hand or kicked. Because the wheel will keep spinning even against considerable resistance, the potter can center a large lump of soft clay and pull it up into a hollow vessel without slowing the wheel.

Next the clay is **fired** — that is, heated to a temperature high enough to drive off chemically-bonded oxygen — to produce **ceramics,** a new material that will not melt when exposed to water. Different clays require different temperatures and length of exposure to heat. Modern clays are carefully compounded mixes of pure clay and mineral additives that affect the firing temperature, color, and handling qualities of the clay. Three types of naturally occurring clays that require firing are terracotta, stoneware, and porcelain.

Terracotta, or earthenware, is red in both raw and fired states. This red coloring is caused by its high iron oxide content. Terracotta fires at such a low temperature that it may not be waterproof. This hand-built terracotta form by Minnesota artist Mika Negishi Laidlaw is

FIGURE 1.
[Artist Tony Merino at the potter's wheel], 2014. Digital image. College of DuPage.

made by the **coil method**, which uses long "snakes" of clay, coiled up on one another, to raise the walls of the vessel (figure 2). They are joined together by a process called **luting**, using clay slip to adhere the coils, and then paddled into shape. The artist then applied a white crackle glaze that reveals the earthenware clay between each crack.

Stoneware is fired at a high enough temperature that it is waterproof, and it is used for both kitchen and storage vessels. Stoneware is usually gray and somewhat rough in body. This is evident in the fourteenth- or fifteenth- century storage jar that has embedded minerals to create its striking appearance (figure 3).

In China and Japan, country-style stoneware is particularly appreciated, and the traditional potteries in Japan still operate using ancient methods and materials developed over centuries. Traditional Japanese potteries fire their wares in wood-fired kilns, which produce a lot of smoke and ash. These burnt particles mix with the glaze and the clay body to make unique and rich patterns.

Porcelain is white, fine bodied, and fired to an extremely high temperature to produce an almost glassy material. Beautiful on its own, even without glaze, porcelain is difficult to work with because it is naturally less putty-like than terracotta or stoneware. New York artist Bethany Krull's *Seed* combines similar shapes thrown on a potter's wheel and hand built into a unified form (figure 4).

FIGURE 2.
Mika Negishi Laidlaw, *Endurance A*, 2009. Earthenware and glaze, 21 × 13 × 9 in. Collection of the artist.

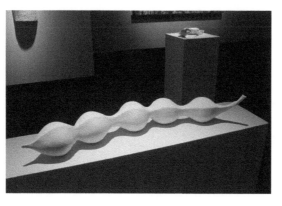

FIGURE 3 [LEFT].
[Storage Jar], Muromachi period, Japan, fourteenth–fifteenth century. Stoneware with natural ash glaze (Shigaraki ware), 18.37 × 15.5 in. Metropolitan Museum of Art, New York.

FIGURE 4 {RIGHT}.
Bethany Krull, *Seed Pod*, 2009. Unglazed, thrown, and hand-built porcelain, 6 × 36 × 6 in. Collection of the artist.

Decoration and Finished Product

Clay can be decorated by marking a design into the wet clay during construction or by adding color with slip or glaze. **Slip** is low-temperature clay that either fires to a color or is colored with mineral colorants. When mixed with water, the slip coats the clay body and fires with it to produce a different color and texture. Clay bodies are sometimes fired twice. The first firing allows the clay body to reach a porous state, called **bisque**, which hardens the clay just enough to accept decorative slips and coats of powdered minerals, called **glazes**. Once these have been applied, the clay body is fired a second time to reach its full firing temperature, hardening the body and melting the slips and glazes.

The ovens used for firing are called **kilns** and may be heated with electricity, gas, or wood. Both the fuel and the firing process have a strong effect on the final appearance of the finished work. If a work is fired with a continuous flow of oxygen to the fire, it will look very different than the same piece fired with a reduced flow of oxygen that results in a smoky atmosphere. The variability of materials and glazes produces useful, beautiful, and one-of-a-kind objects.

B. Wood

The process of creating a finished piece out of the raw material of a tree is known as **woodworking**. Many household objects and structures are made of wood, which is valued for its unique combination of lightness, flexibility, and strength. Wood's living beauty comes from its warm colors — ranging from the palest straw to yellow, orange, red, purple, and black — and from its grain, which varies depending on the type of tree and its growth pattern.

When the tree is sawn at right angles to its height, it shows growth rings. When the wood is ripped, or sawn parallel to its length, these rings show up as grain, lines of slightly differing color, thickness, and consistency. These patterns are so recognizable that a trained eye can identify the species of tree simply by looking at the wood's grain. Made from the heart of a sawn section of wood, this bowl by South Carolina artist Raymond Overman offers views of both the rings and the grain in its design (figure 5).

Wood is divided into two main groups: hardwood and softwood. Conifers, such as redwoods, Douglas fir, spruces, pines, true firs, junipers, and cedars, have relatively soft wood and straight grain. Because of this,

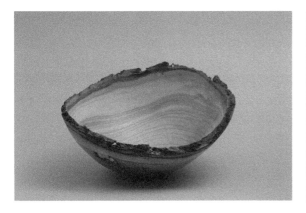

FIGURE 5.
Raymond Overman, *Turned Wood Bowl with Natural Edges*, 2006. Peach wood. Collection of the artist.

FIGURE 6.
[Shaker-style Staircase], Shaker Village of Pleasant Hill, Harrodsburg, Kentucky.

they are easily milled into boards and timbers for construction. Redwoods and cedars have naturally occurring preservative qualities, making the wood rot resistant. Hardwoods have a more complex grain. The wood is more difficult to work but more resistant to damage. When polished, it produces a piece that is beautiful and durable. Oak, maple, walnut, and cherry are traditional choices for hardwood furniture.

One of the most famous American woodcraft traditions is that of the Shakers, a religious group founded in the eighteenth century and devoted to a communal life. The Shakers developed a remarkable furniture and building tradition, emphasizing simplicity and function. Any object crafted in the Shaker style relies on the inherent beauty of the wood, the geometric simplicity of the forms, and the consistently high quality of workmanship and finish.

This Shaker-style staircase is a pure Fibonacci spiral, a shape based on an equation used to produce a set of numbers where each value in the sequence is equal to the sum of the previous two numbers. You can see the elegance of this mathematical principle translated into physical form as the staircase rises around the hollow center of the stairwell (figure 6). From any angle, the viewer can see a pleasingly curved series of forms receding away from the eyes. The staircase is made of a large number of identical rectilinear parts, sawn and fitted together.

By contrast, this Antonio Gaudí y Cornet armchair bases its design on the complex organic curves characteristic of the crafts movement known as Art Nouveau (figure 7). This style of art was popular during the

FIGURE 7.
Antoni Gaudí y Cornet, *Armchair*, 1902–4. Walnut, 38 × 25.5 × 20.5 in. Metropolitan Museum of Art, New York.

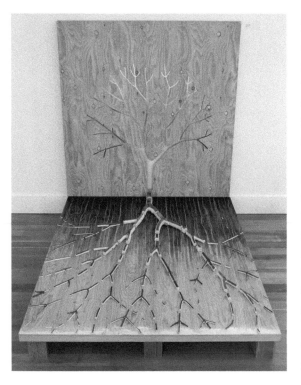

late nineteenth and early twentieth century and emphasized the use of natural forms and structures in design. The designer took great care to make the chair appear to be carved out of a single block of wood. It was actually made by jointing together five separate, interlocking pieces of wood, carefully selected for their matching grain and color.

Oregon artist Kristin Kuhns's wood sculpture, *After the Fall*, creates an evocative stencil-like portrait of a tree. At its base, the artist has assembled cut-out remnants into the shape of a fallen tree (figure 8). The design of the stencil and the pieces shows careful treatment of the wood with precise cuts and placement. Created in response to decomposition research conducted in the H.J. Andrews Experimental Forest in the western Cascade Range of Oregon, this sculpture demonstrates close attention to materials, as many crafts do, and offers an artistic interpretation of the life cycle of trees and the environmental impacts of deforestation.

FIGURE 8.
Kristin Kuhns, *After the Fall*, 2009. Fir, acrylic, and wiring, 48 × 48 × 60 in. Collection of the artist.

C. Fiber Arts

Weaving is an ancient process that unites flexible fibers into a single fabric by arranging a structural basis of parallel fibers, known as the **warp**, and passing more strips of fiber alternately under and over the warp to construct a **weft**.

Basketry is three-dimensional weaving of natural fibers to make useful and beautiful vessels, some so tightly woven that they can hold water. This nineteenth-century basket was woven by Isabella Edensaw with soaked spruce roots (Figure 9). It was then embellished with paint by her husband Charles in the indigenous style of the Haida tribe, located off the western coast of Canada on the island of Haida Gwaii.

Fabric is usually woven on a loom, which allows the weaver to pull the warp threads taut and even out the weave (figure 10). Before the Industrial Revolution, fabrics and clothing were made entirely by hand.

FIGURE 9.
Isabella and Charles Edenshaw, *Lidded Basket*, 1885–90. Spruce root and pigment, 3.75 × 4.75 in. Metropolitan Museum of Art, New York.

FIGURE 10.
Martha Cooper, *Weaver Maria Atiles at her Loom on the Second Floor*, 1994.
35mm color slide. American Folklife Center. Washington, DC.

FIGURE 11.
Kate Simmons, *Karen*, 2012. Thread on tablecloth,
36.5 × 36.5 in. Collection of the artist.

Materials varied by place, though wool spun from animal hair was widely used. Cotton, linen, ramie, and hemp are vegetable fabrics, while wool and silk are animal products. In a time when most people owned only one set of garments, color and pattern became indications of social status. The earliest fabrics may have been simple weaves, but weavers soon developed more complex looms, which allowed for even more elaborate patterns. Once woven, fabric could be dyed in the cloth, pattern dyed using resists, or embroidered.

Practical stitchery involves using a needle and thread to sew separate pieces of fabric together in order to make a garment or quilt. **Embroidery** uses ornamental stitches to add thread to the surface of a woven piece of fabric as embellishment. Oregon artist Kate Simmons reaches past simple decoration in this embroidered drawing of her mother's kitchen window (figure 11). Utility is seldom the sole purpose of crafts, especially with embroidery. This tablecloth combines a skill set traditionally considered feminine with a modern artistic sensibility.

In a similar departure from pure utility, traditional American quilts are known the world over for their thrifty reuse of old cloth in a new, useful, and richly patterned form. This quilt is stitched together in the pattern called Courthouse Square (see figure 12). The varying fabrics are cut from worn out clothing and scraps, and are unified by the repeated patterns of squares and the quilting patterns used to hold the layers of cloth and batting together.

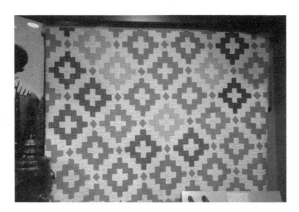

This Anatolian carpet has obvious use as a utilitarian object, but its complex patterns and rich color give it additional aesthetic value (figure 13). Traditional pile carpets like this one are knotted on a loom, using short lengths of weft thread to tie the warp threads together and create a dense layer of vertical threads called the pile. In this carpet, the brick red and ochre colors contrast strongly with the cream, blue, gray, and black, allowing the divisions of the surface and the diagonal fill patterns to stand out against each other. In Turkish tradition, carpet patterns were passed from teacher to student, nearly always women, in the context of household production, changing little by little over the generations with each new artist.

Felting is an ancient central Asian tradition in which wools are boiled and beaten to consolidate their fibers. Though we are most familiar with felted hats, some modern artists use felting techniques in their work. *Global Inversion* by Oregon artist Diane Jacobs uses felted human hair to construct a projection of the world shown not as we usually see it, with North America at the top, but reversed (figure 14). The artist uses an ancient craft to project a new view of the world. Jacob explains her design in this way: "The inequity between nations and individuals based on their position in life is insurmountable unless we make a radical shift. I am talking about flipping the world upside down and leveling the playing field. People of privilege must give up their position."

FIGURE 14.
Diane Jacobs, *Global Inversion*, 2008. Human hair on wool felt, acrylic ball, 61 × 83 × 36 in. Collection of the artist.

D. Glass

Glass making is one of the most demanding and dangerous crafts. It involves working with both molten glass and the sturdy but brittle material that results when glass is properly cooled, or **annealed**. At the same time, working with a transparent or translucent medium presents unique challenges and possibilities. This "cage cup" dated to fourth-century Rome is an excellent example of these challenges (figure 15).

The Roman era saw the invention of glass blowing, the precursor to modern glass vessels. Roman glass was a combination of beach sand, quartz, seashell bits, and natron, a naturally occurring soda mineral found in Egypt. Color is determined by added minerals. This mixture is melted and a gob of the molten, pliable glass gathers onto the tip of a hollow clay tube called a blowpipe, which allows craftsmen to fill the substance with air from their lungs and expand the bubble of glass into the desired size. The glass is then cut or broken off the pipe and annealed by placing it in an oven to cool. The result is a clear, brittle form that can be further worked by grinding. This Roman cage cup was first blown as a thick-walled bubble, then annealed, and finally cut back using grinders to create the fragile, high relief ornament. The fact that it has survived the ages intact is a testament to its ultimate strength and beauty.

FIGURE 15.
[Cage cup], Roman, mid-fourth century. Glass, 4.8 in. State Collection of Antiquities, Munich, Germany.

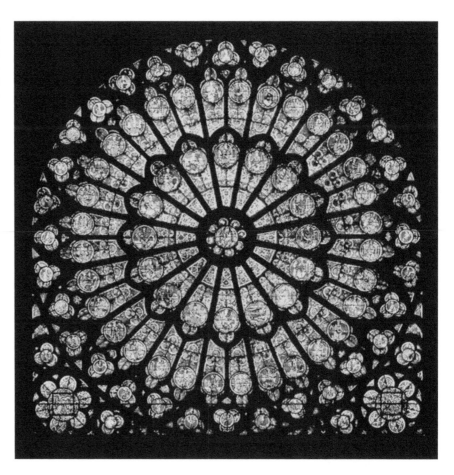

Stained glass is made from flat pieces of colored glass held together by u-shaped strips of soldered metal, called **caming**. Stained glass made from blown glass is a notable feature of Gothic architecture, with its immense pointed and rose windows filled with saints and angels in rich reds and blues. This ornate rose stained glass window shows the degree of detail achievable with this centuries-old technique (figure 16).

Louis Comfort Tiffany, whose early twentieth-century designs were influenced by the Art Nouveau style, popularized stained glass in American houses. *Landscape Window*, made by skilled craftsmen working in Tiffany's studios, combines the complex colors and visual textures of the glass with the flexible shapes of caming to create a formalized vision of magnolias seen against a distant landscape (figure 17).

Stained glass as a decorative ornament to both public and private places continues today. Contemporary stained glass artist Al Held designed

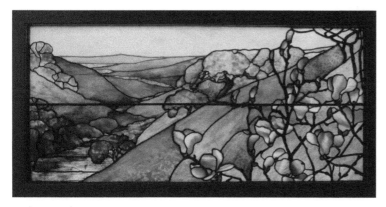

this stained glass window for the U.S. Courthouse in Orlando, Florida in 2006 (figure 18, for a view of another window in this courthouse, see Chapter 2.2, Figure 11). Since the courthouse is a modern architectural building, the striking geometric forms suit the location.

Figure 17 [Left]. Tiffany Studios, *Landscape Window*, 1910–20. Glass, 25 × 55 in. New York Historical Society, New York.

Figure 18 [Right]. Al Held, *Untitled*, 2006. Stained glass, 50 × 20 ft. U.S. Courthouse, Orlando, Florida.

E. Crafts and Art

In all crafts, the maker must carefully balance the restrictions imposed by materials and methods with the demands of function and the desire for embellishment. The best results often come from the maker's sensitivity to the possibilities of the materials and command over the complexities of the process. This is not so different from the skill expected of any artist, and many contemporary artists and students of art consider the distinction between art and crafts a false one. At the same time, objects that are not restricted by the demands of functionality and material are open to a much wider range of possibility in process and design.

3.5 Printmaking

The goal of printmaking as an art form is to make multiple originals. That may seem like a contradiction in terms, but the ability to produce prints is what makes this method exciting to explore. For the purpose of printmaking, it is important to make a distinction between a print and a reproduction. A **reproduction** is made typically by mechanical means without the artist's guidance. While commercial mass printing may result in high-quality images by artists, the result is a reproduction. A fine art **print** has been touched by the artist's hand in some way, and sometimes the original image or template is destroyed to ensure that only a limited number of prints exist.

Starting with an original image or template, a printmaking artist uses a transfer process to transmit the image onto another medium, often paper of some kind. The artist can use the same template to print many copies of an image. These print copies are called an edition, with each print signed and numbered by the artist. The three basic techniques of printmaking covered in this section are relief, intaglio, and planar printing.

A. Relief Printing

A **relief print** begins with a thick block of wood, sometimes covered with a layer of linoleum. Rather than adding material to a surface to create an image — as in painting or drawing — printmakers remove the parts of the block that are to be ink-free. Doing so allows the image surface to rise above the cut away sections of the block. Once the area around the image is removed, the surface of the block is coated with a stiff ink. Paper is laid over the block, and both are run through a press, transferring the ink from the surface of the block to the paper.

The nature of the relief results in graphic images with strong contrasts. Norwegian artist Edvard Munch's print, *The Pretenders: The Last Hour*, shows how a woodcut can look printed in black (figure 1). The areas that are not black are the areas that were cut away from the block.

Block printing developed in China hundreds of years ago and was common throughout East Asia. Relief printmakers

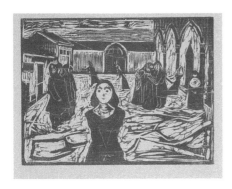

FIGURE 1.
Edvard Munch, *The Pretenders: The Last Hour*, 1917. Woodcut, 16.8 × 22.9 in. Metropolitan Museum of Art, New York.

FIGURE 2.
Katsushika Hokusai, *Rooster, Hen, and Chicken with Spiderwort*, 1830–33. Polychrome woodblock print, ink, and color on paper, 9 × 11.5 in. Metropolitan Museum of Art, New York.

can use a separate block for each color printed or, as in reduction prints, they can use a single block, cutting away areas of color as the print develops. This method can result in a print with many colors. Historically, the most famous woodblock prints are the Japanese Ukiyo-e, or "floating world," prints. Made in the Edo period, these prints became popular in Europe in the nineteenth century, even influencing European artists during the Industrial Revolution. This Japanese woodblock print by Katsushika Hokusai shows the detail and variety of color possible in woodcut printing (figure 2).

B. Intaglio Printing

Intaglio means "to cut." Intaglio prints such as etchings are made by incising narrow channels into a copper or other metal plate with a sharp instrument. The entire plate is inked and then wiped, removing almost all of the ink from the surface of the plate but leaving it in the carved channels. Dampened paper is laid over the plate and put through a press under high pressure, forcing the ink to transfer to the paper. The process leaves an embossed ridge in the paper where it was pressed down over the

plate. This edge is a guarantee that the work is a true intaglio print. Examples of the intaglio process include engraving, drypoint, and etching.

Engraving began as a method of decorating metal objects like swords and armor. Using a graver, the artist cuts fine, sharp lines that are the same thickness. The graver leaves no burrs of rough metal to catch ink. Engraving is used to make the plates from which money is printed, because of its exacting and sharp result. This engraving, *Knight, Death, and the Devil* by German artist Albrecht Dürer, shows how intricate and detailed engraving prints can be (figure 3).

In **drypoint**, the artist also creates an image by scratching the graver directly into a metal plate (usually copper) before inking and printing. Unlike engraving, drypoint uses the little burrs thrown up by the graver to catch a fine film of ink. Characteristically, drypoint prints have strong line quality and exhibit a slightly blurred edge as the result of burrs created in the process of incising the plate, similar to the clumps of soil left on either side of a furrowed trench. The entire image is created with the use of line, even the cross-hatched lines.

The process of **etching** allows artists to create lines much more swiftly and freely, and to work out ways to develop smooth gradations of value. Etching begins by first applying a protective wax-based coating, known as a ground, to both sides of a thin metal plate. The artist then scratches an image through the wax with a needle-like tool, exposing the surface of the metal. The whole plate is then submerged in an acid bath, which eats away at the exposed areas of metal. The plate is removed from the acid, and the protective coating is removed from the plate.

Now the bare plate is inked, wiped, and printed. The image is created from the ink in the etched channels. The amount of time a plate is kept in the acid bath determines the quality of tones in the resulting print: the longer it is etched

(corroded by being submerged in the acid bath), the darker the lines will be. Values can be created on an etching plate using a technique called **aquatint**. In aquatint, the clean plate is dusted with powdered resin and melted, leaving small dots of resin. During etching, the acid eats around the tiny resin dots, creating a reversed dot pattern.

In French artist Édouard Manet's *Exotic Flower*, value is created in the woman's dress with the dense application of line, but the use of aquatint in the background shows how a broad area of value can be formed by this other means (figure 4).

Oregon artist Rosemary Cohen combines intaglio printing techniques with three-dimensional collage in her work, *Canyon View*. The prints are made from multiple copper plates, chosen for their specific texture and color. They are then cut up and reassembled as collages (figure 5).

FIGURE 5.
Rosemary Cohen, *Canyon View* [detail], 2014. Intaglio collage, 8 × 12 in. Collection of the artist.

C. Planar Printing

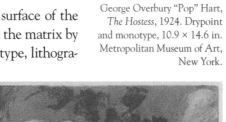

FIGURE 6.
George Overbury "Pop" Hart, *The Hostess*, 1924. Drypoint and monotype, 10.9 × 14.6 in. Metropolitan Museum of Art, New York.

Planar printing is performed without cutting or incising the surface of the printing material, or **matrix**. The image is crafted directly onto the matrix by other means. Three popular types of planar printing are monotype, lithography, and screen printing.

By definition, **monotypes** cannot be reproduced in editions. In this technique, the surface of the matrix — usually a thin metal plate or Plexiglass — is completely covered with ink. Areas of ink are then partially removed by wiping or scratching to form the image. Paper is laid over the matrix before it is run through a press to transfer the image. Monotypes are the simplest and most immediate of printing media, and this image by American artist George Overbury "Pop" Hart displays their unique, painterly quality (figure 6).

FIGURE 7.
[Left], Lithography stone; [Right], Mirror image print of a map of Munich.

FIGURE 8.
Henri de Toulouse-Lautrec, *Portrait Bust of Mademoiselle Marcelle Lender*, 1895. Crayon, brush, and spatter lithograph, 12.9 × 9.6 in. Metropolitan Museum of Art, New York.

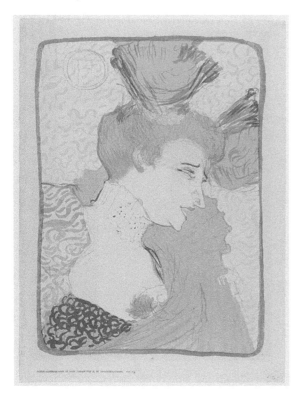

Lithography is another example of planar printmaking that was developed in Germany in the late eighteenth century. *Litho* means "stone" and *graph* means "to draw." The traditional matrix for lithography is the smooth surface of a limestone block. This image of a lithography stone and the print it produces shows how everything is in reverse on the stone before it is transferred onto paper (figure 7).

In traditional lithography, an image is created on the surface of the stone or plate using grease pencils or wax crayons or a grease-based liquid medium called **tusche**. The finished image is covered in a thin layer of gum arabic that includes a weak solution of nitric acid as an etching agent. Because grease and wax repel water, the resulting chemical reaction divides the surface into two areas: the positive areas containing the image that will repel water, and the negative areas surrounding the image that will be water receptive. Finally, while printing a lithograph, the gum arabic film is removed, and the stone surface is kept moist with water. When the stone is rolled up with an oil based ink, the ink adheres to the positive (image) areas but not to the negative (wet) areas.

Because of the media used to create the imagery, lithographic images show characteristics

much like drawings or paintings, as can be seen in this lithograph by French artist Henri de Toulouse-Lautrec (figure 8).

Prior to the digital age, **screen printing** was used in advertising as an efficient means to print posters or announcements. Since computer printers have made that process even easier, screen printing has resurged in the fine art realm. Screen printing is a technique that uses a sheet of woven mesh to support an ink-blocking stencil. Stencils can be made by hand or with photographs or other images. The stencil is affixed to the screen and a squeegee is used to scrape and push ink through the exposed areas of mesh. This screen print by German artist Ingeborg Bernhard shows an image that was made using multiple stencils for each color (figure 9).

D. Printmaking and the Viewer

Another way a reproduction can be distinguished from a print is that a reproduction starts with a final image and creates more of the same. In printmaking on the other hand, the original block or template from which the print is made looks nothing like the final work of art. Many of the printmaking methods require the artist to think and draw backwards. Just as the printmaking process often results in images reversed from the original, the art form itself requires the viewer to think and look in new ways to appreciate an image.

FIGURE 9.
Ingeborg Bernhard, *Banana Knot*, 1972.
Silk-screen print, 11.8 × 15.7 in. Collection of the artist.

3.6 Photography

It's hard to imagine a time when we all didn't have cameras in our back pockets. If you own a smart phone or digital camera, you have the ability to take and access hundreds of photographs at a time, upload them instantaneously to the web, and share them electronically via an increasing array of social media sites. Of all art media, photography is the most pervasive, filling our electronic devices and photo albums with an abundance of images.

As curators of our own lives, we examine these innumerable images to determine what to keep — the sunset at the peak of its brilliance, the wedding party with all eyes open, the child's first step — and what to delete — a less than photogenic view of our backsides, an embarrassing stain on a shirt, that same sunset a few moments later, with muted colors and gray clouds looming. For some, the camera has become a form of external memory, a way to remember what we've seen, where we've been, and who we were. From personal record to historical document to expression of artistic vision, we'll take a look at the ways artists have used this technological innovation to create images that transcend mechanical reproduction and become art.

FIGURE 1.
[Cross-section of a camera obscura from Sketchbook on military art, including geometry, fortifications, artillery, mechanics, and pyrotechnics], seventeenth century. Ink and paper. Library of Congress, Washington, DC.

A. History of Photography

The earliest mention of photography (a means to capture an image directly using focused light) dates back to 400 BCE. Chinese scholars noted that a pinhole in the wall of a **dark room** would act as a lens and cast a ghostly image of the world onto the opposite wall. It wasn't until the sixteenth century that a version with a lens, called a **camera obscura**, came into use by artists. This Latin phrase means "dark chamber" and refers to a box or a room with a small hole and lens on one side (figure 1). Light from outside the camera obscura passes through the lens and is projected onto the opposite wall with

color and perspective preserved. The projection can then be traced by the artist to produce a highly accurate representation.

The camera obscura, as the precursor of modern **photography**, led to even more sophisticated devices for the capture of images. During the 1830s, the French artist Louis-Jacques-Mandé Daguerre perfected a process to reliably fix images to a polished copper plate treated with silver by exposing it to light. **Daguerreotypes**, the self-named product of his ground-breaking process, required an exposure

time of ten minutes or more. You can see the effect of this exposure time in his photograph *Boulevard du Temple* (figure 2). From his studio window, Daguerre photographed his busy Parisian street, but none of the moving traffic or pedestrians stayed still long enough for their images to become fixed to the copper plate. The only person in the image is a man on the lower left, standing at the corner getting his shoes shined. This picture is significant as the first known photographic image of a human being.

At the same time in England, William Henry Fox Talbot could be found in his studio experimenting with other photographic processes. He created photogenic drawings by placing objects over light sensitive paper or plates and then exposing them to the sun. By 1844 he had invented the **calotype**, a photographic print made from a negative image. In contrast, Daguerreotypes were single, positive images that could not be reproduced. Talbot's calotypes allowed for multiple prints from one negative, setting the standard for the new medium.

Color photography was created in 1861 by color theorist and physicist James Clerk Maxwell and photographer Thomas Sutton. They devised and used a three-color layering process in *Tartan Ribbon* (figure 3). Maxwell and Sutton created the image by photographing a ribbon three times through red, blue, and green filters. They then combined the three images, creating a composite that appears to have all three colors. We now know that this three-color system works best in digital displays and projections, and is still used to achieve the simulation of the full range of visible color.

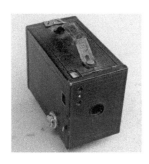

FIGURE 4.
Image of a Kodak Brownie
camera (ca. 1920).

By the end of the nineteenth century, cameras had been refined into devices with built-in shutters that reduced exposure times. Heavy glass or metal plates were replaced with flexible film. The one-off print gave way to multiple prints created from one negative. These advances allowed the camera to be easily portable and more affordable to the upper-middle class consumer. Inventions like the Kodak Brownie camera (figure 4), which cost far less than previous models, reached the middle class by 1900 and heralded an explosion of popular interest in photography.

Modern Photography Processing

Present-day photography processing falls into two distinct camps: film and digital. Within those camps, black and white photography and color photography differ in how they are processed.

Modern black and white film has a plastic base with an emulsion layer containing silver crystals in a bromide solution. Color film adds layers of color dyes to the emulsion layer. When the film is exposed to light, the light records a latent image as dark areas on the film. In the process of developing the film, wet chemicals are combined with the film to wash away the emulsion layer and solutions, leaving the inverted visual image on the base, known as a negative.

A positive image (a **print**) is created by projecting light through the negative onto photo-graphic paper. The paper is submerged in liquid chemicals to create the resulting photograph. With black and white film negatives, this is done in a dark room lit only by "safe lights" that do not add any light to the exposed negatives. With color film, this is done in a closed space with no light, typically inside a "drum" container.

FIGURE 5.
Louis Ducos du Hauron,
*Cathedrale Sant-Caprais
d'Agen*, 1877. Heliochrome
photograph. George Eastman
Museum, Rochester, NY.

As with any color printing process, the colors are added as additive layers in cyan, magenta, and yellow, as shown in the early color photographs of the French pioneer Louis Ducos du Hauron. In *Cathedrale Sant-Caprais d'Agen*, the edges of the photograph reveal the overlapping colors used to simulate the full color spectrum (figure 5).

Digital Photography

Digital images are captured with a sensor in a digital camera and stored as data. Although digital cameras record images in color, some can be set to record in black and white. The images are processed in a photo-editing computer program that can adjust many aspects of the image quickly and simply compared to adjusting film. For example, color images can be converted to black and white if they haven't been recorded in black and white by the camera. Images are printed with layers of ink on photographic paper made for digital printing, most commonly using an ink jet printer.

B. Photography as Documentation

Because cameras could document people, places, and events, they gained credibility as tools that could produce evidence of objective reality. Eadweard Muybridge used photography to study the ways humans and animals moved. Like looking at a series of stills from a film, his photos allowed scientists to see minute changes in muscle and limb movement in ways unavailable to their unassisted eyes (figure 6).

Another way that photography served as documentation was in the photographs taken during the American Civil War, which gave sobering witness to the carnage produced by war. Timothy H. O'Sullivan's photograph of soldiers killed in the field helped American citizens realize the human toll of war and put an end to their ideas of battle as being particularly heroic (figure 7).

Likewise, the news industry was fundamentally changed with the invention of the photograph. Although pictures were taken of newsworthy stories as early as the 1850s, the

FIGURE 6.
Eadweard Muybridge, [Animal locomotion. Plate 62, Vol. I: Males (nude)], 1887. Collotype. Rare Books Department, Boston Public Library, Massachusetts.

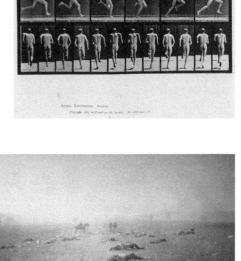

FIGURE 7.
Timothy H. O'Sullivan, *Incidents of the war. A harvest of death, Gettysburg, July 1863*, 1863. Photographic print, 7 × 8.9 in. Library of Congress Prints and Photographs Division, Washington, DC.

FIGURE 8.
[Front Page of *The Globe*, 29 September 1909]. Wilbur and Orville Wright Papers, Manuscript Division, Library of Congress, Washington, DC.

photograph had to be translated into an engraving to go to press. But by the twentieth century, the development of halftone screens meant that photos from around the world showed up on front pages of newspapers, documenting the news as never before (figure 8).

Photography's Social Power

The emotional immediacy of a photograph and its power to reveal, engage, or rile the public is well known today. In the 1930s, the federal government's Farm Security Administration employed photographers to document the plight of migrant workers and families dislocated by the Dust Bowl and the Great Depression in America. Dorothea Lange's photograph of a migrant mother in California is an iconic image of hardship and survival (figure 9). Like O'Sullivan's Civil War photos, Lange's picture presents us with a human face so that we can better understand this struggle. Photographs like this helped win continued support for President Franklin Roosevelt's social aid programs.

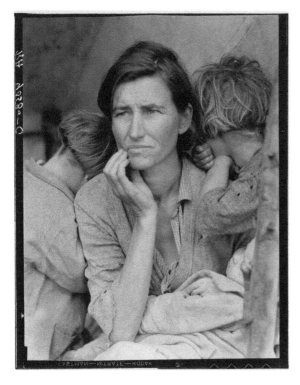

C. Photography as Art

While photography was considered useful for replicating exact details and duplicating famous works of art for publication, it was not considered a means for creating original art at first. Most people saw the camera as a machine that produced images through a chemical reaction. If art is the combination of human skill, imagination, and craft, how could a photograph — the product of an instrument of science — be art? For most of the nineteenth century, this distinction between art and photography held firm.

FIGURE 9.
Dorothea Lange, [Destitute pea pickers in California. Mother of seven children. Age thirty-two. Nipomo, California], 1936. Black and white photography from negative nitrate, 5 × 4 in. Library of Congress, Prints & Photographs Division, FSA/OWI Collection, Washington, DC.

It took twenty-five years after Daguerre's first successful image for photography and art to be displayed side by side in Paris's Universal Exposition of 1859. As momentous as this occasion was, the symbolic distinction between art and photography was emphasized with separate entrances to the two exhibition spaces.

During the late nineteenth century, photographers gathered in groups and formed official societies in order to uphold the value of photography as art. They promoted a style of "art photography," as seen here in Alfred Stieglitz's *Winter — Fifth Avenue*, a low-contrast, warm-toned image that shows off the medium's ability to mimic paintings (figure 10). The textures of the snow tracks and receding buildings are like daubs of paint. The blurry, atmospheric perspective in the photograph conveys the soft transitions of wet media.

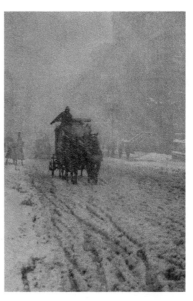

FIGURE 10.
Alfred Stieglitz, *Winter — Fifth Avenue* (1893), Printed 1905. Photogravure, 8.5 × 6 in. Metropolitan Museum of Art, New York.

The turn of the twentieth century brought many changes, including avant-garde ("innovative") artists who saw the appeal of photography as an art medium. They were drawn to the camera as a tool that captured images of the world with scientific objectivity. Influenced by post–World War I era industrialization, affected deeply by war and political unrest, and shaped by modern developments of radio and talking pictures, these artists sought to create a new way of seeing that could match the radically different world in which they found themselves. For the same reasons that the camera had been suspect fifty years earlier, these artists considered the camera an instrument that could modernize art. Not only did the camera offer a new mechanical method of producing images, it could, they believed, revolutionize the standards of visual representation.

Composition

Even as digital images become more common than darkroom photography, the standards for successful works of art remain the same. Both processes must work with design and composition. The artist must imagine, observe, and choose how to frame subject and scene. Later, the artist can choose to adjust or manipulate the subject, the lighting, the frame. Excellent composition can be found in all photography examples in this section, but here we take a close look at the intentional composition of *The Dancers*, a photograph by Oregon artist Barry Shapiro. This image of a single, linear

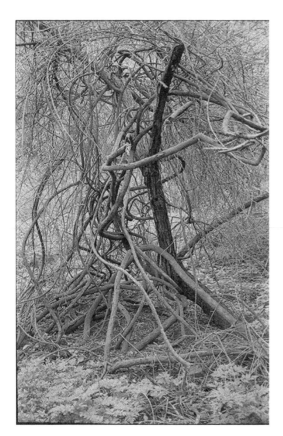

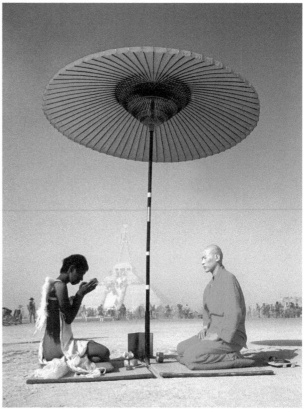

branch as the point of emphasis displays clear composition (figure 11). The dark branch is surrounded by a complex web of curvier, thinner, and grayer branches, thus providing contrast and variety. The tangled branches are in a portrait format, not unlike the verticality of a dancing couple. The scale of the subject is large in the frame, but "the dancers" are still given room to move within it.

Photographers consider composition even when the subject is comparably less under their control. In photographs that document events, such as Gabe Kirchheimer's photograph of a gathering at the Burning Man festival in 2003, artists can use perspective and viewpoint to capture inspired and rich angles of their subject (figure 12).

FIGURE 13 [LEFT].
Head and shoulders of a child emerging from the petals of a calla lily, 1920. Black and white photomontage, 8.6 × 6.7 in. California Historical Society Collection, 1860–1960, USC Libraries Special Collections, Los Angeles, California.

FIGURE 14 [RIGHT].
Lajos Vajda, *Panther and Lilies*, 1930–33. Photocollage on paper, 25.5 × 20 in. Ferenczy Museum, Szentendre, Hungary.

Collage

Collage, the technique of pasting multiple images to a single surface, grew in popularity alongside photography. Due to the availability and quantity of inexpensive reproductions, photographs were a choice material for collage artists. Parts of photographs were removed from their original context and juxtaposed with other photographic remnants such as objects, places, or figures. The **photomontage** became an ideal avenue to reflect the complex internal dialogues of the evolving modern world.

The two examples here interpret contrasting feelings of safety or fear. The first photomontage, referred to as *Calla Kid* by an unknown California photographer, shows the surreal image of a child emerging, protected, within a calla lily (figure 13). The second photomontage, *Panther and Lilies*, by Hungarian artist Lajos Vadja was made in the early 1930s, a time of great social and political anxiety. Vadja was also influenced by surrealism, an art movement that tries to reveal subconscious feelings through irrational imagery. The artist juxtaposes a dark-skinned woman, two human skulls, and some lilies, all traditional symbols of the fragility and beauty of life. The snarling head of a leopard looms over them all like an unknown and threatening future (figure 14).

FIGURE 15.
Alexandra Opie, *Echo no. 43*, 2013. Tintype, 10 × 8 in. Collection of the artist.

Capturing Moments in Time

Even with advancements in technology, today's artists continue to experiment with early photographic methods. The long exposure times and laborious process of taking and developing images using these older methods offers a stark contrast to the immediacy and accessibility of digital photography. Oregon artist Alexandra Opie has explored the tintype photograph, a form of photography on a thin sheet of coated metal popular during the 1860s and 1870s. Her tintypes create multi-layered portraits that merge formal poses and dress of the past with a contemporary artistic vision (figure 15).

Going Digital

Digital cameras appeared on the market in the mid-1980s. They allowed the capture and storage of images through electronic means instead of photographic film. This new medium created big advantages over the film camera: the digital camera produced an image instantly, stored many images on a memory card in the camera, and the images could be downloaded to a computer where they could be further manipulated by editing software and sent anywhere through cyberspace. This eliminated the time and cost involved in film development and created another revolution in the way we access visual information.

Digital cameras and editing software also let artists explore the notion of staged reality: not just recording what they see but creating a new visual reality for the viewer. This photomontage of multiple digital images has been edited to look as if the separate images all belong in the same landscape (figure 16). By skillfully applying the rules of diminution, atmospheric perspective, and linear perspective, this photomontage blurs the line between the real and the imagined in art.

The Uniqueness of Color Photography

Black, white, and shades of gray help us see form, lines, shapes, contrast and balance. Color lets viewers experience a subject in ways that black and white can't offer by adding chromatic value to the areas between the black, white, and gray. The expressive qualities of color can evoke a wide range of feelings such as anger, tranquility, peacefulness, or uneasiness. For more details on the emotional aspects of color, see Chapter 2.3, "Formal Elements: Value and Color."

Color photography excites us, guides our imagination, and compels us to see life in ways we wouldn't otherwise experience. It speaks to our senses, creates feelings, and evokes sensory responses. Colors may trigger primal psychological or physiological responses that inform the human condition. We have all "had the blues," or felt "green with envy," or been "so angry we saw red." Maybe you've been tickled pink by a golden opportunity that came out of the blue? Color plays such an integral role in our lives that it even shapes the way we describe our moods.

Color in photography is often taken for granted rather than seen as a creative tool. Now that photography is as accessible as reaching for your phone, most people don't bother to consider how color appears in their photographs.

FIGURE 16.
Forggensee Panorama, 2010 is a digitally altered photomontage by MMxx.

FIGURE 17.
Martin Giovannini, *Blue and Yellow Macaw*, 2010.
Color photograph. Collection of the artist.

On the other hand, in photographic art, color can be the predominant theme or subject. A photograph's visual impact — the thing that grabs the viewer's attention — is an essential element. With color photographs, this can be the saturation of colors, as in Oregon photographer Martin Giovannini's photograph, *Blue and Yellow Macaw* (see figure 17). The subject of the photograph is obviously a bird, but what catches the viewers' attention is the vibrant blue and yellow areas of the image.

D. Photography and the Viewer

Photography plays an important role in marking time and celebrating momentous occasions. School photos commemorate the start of each academic year. Wedding photographers capture the happy couple and their guests. We hang family photos on the wall or set them in places of honor on mantels and desks. We turn the camera on ourselves, the now ubiquitous "selfie," to try to comprehend the constantly shifting subject of the individual. While photography serves a personal and social role in recording the past, it also serves the artistic purpose of illuminating how we see ourselves and the world around us.

3.7 Installation and Performance Art

Artists create **two-dimensional** images, such as photographs, to help us see the world around us in a new way. As you've read earlier in this chapter, sculptors shape raw material to create **three-dimensional** objects that occupy space and are defined through the dimensions of height, width, and depth. Traditionally, sculpture has focused on the naturalistic portrayal of the human body. As modern extensions of traditional sculpture, installation art and performance art focus on three-dimensional art that engages the viewer's senses and invites the viewer to experience the art by moving through space, hearing sounds, touching props, or even tasting. Often these works are **time-based**, meaning they change over time, happen in real-time, or last for a defined period of time, effectively blurring the boundaries between visual art and performance. These modern artistic explorations encourage the viewer to consider the ways that art can make lasting change even if the work itself does not last.

A. Installation Art

Installation art incorporates multiple objects, often from various media, and takes up entire spaces. Installations may use sound, light, movement, and live performers. They may be generic or site specific. Because of their relative complexity, installations can address aesthetic and narrative ideas on a larger scale. The genesis of installation art can be traced to the Dada movement, during and after World War I. Proponents of this movement cultivated a new aesthetic by their unconventional natures and ridicule of established tastes and styles.

One of the earliest and well-known examples of installation art is the work of German artist Kurt Schwitters. In 1923, he began a creative project to transform his family house into several room-sized sculptural constructions collectively called *Merzbau* (see figure 1).

One of the three existing photographs from 1933 shows a room overtaken by black and white forms that protrude from the walls and ceiling. No photograph can truly capture the totality of installation art, which

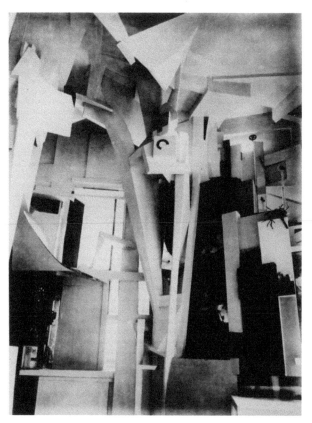

comes alive only when the viewer is surrounded by and can become part of the work of art. The idea of *Merzbau* has inspired artists with its innovative hybrid of sculpture and architectural construction, but, regrettably, nothing remains of the original, which was destroyed in an Allied bombing raid in 1943.

A present-day example of installation art can be seen in Georgia artist Christina West's installation *Shadows and Fog* (figure 2). On display in 2008, this exhibit filled the gallery with portrait-quality, unnaturally painted, nude figures. Imagine walking through the gallery as you encounter these salmon-colored humans. Witnessing their intimate, awkward, and sometimes humorous expressions and poses produces a mix of vulnerability and voyeurism. The figures, slightly reduced from natural scale, draw attention to the way their bodies — and your own — exist in space: they are like us and at the same moment very much *not* like us. Turning a corner, you come face-to-face with an agonized grimace, a human figure, reduced and bared. For another view, see page 78 (Chapter 2.5, figures 19 and 20).

How an installation piece takes up space, and how you move through the constructed environment, make up the aesthetic experience just as much as do the formal elements or compositional principles we studied in Chapter 2.

B. Performance Art

Performance art goes a step further, involving not just the viewer but also the artist as part of the work itself. Similar to installation works, performance art had its first manifestations during the Dada art movement, which began as a reaction to the horror and absurdity of World War I. Live performances were deliberately chaotic and confusing. They included nonsense poetry, visual art, dance, random noise, and music — often simultaneously. Performance art still focuses on social and political issues. The heart of the medium is its ability to use live performance in the same context as static works of art: to expand our understanding of human experience.

The German artist Joseph Beuys was instrumental in introducing performance art as a legitimate medium in the post–World War II artistic milieu. *I Like America and America Likes Me*, from 1974, finds Beuys co-existing with a coyote for a week in the Rene Block Gallery in New York City (figure 3). The artist is protected from the animal by a felt blanket and a shepherd's staff. Performance art, like installation, challenges the viewer to reexamine human history and experience.

FIGURE 3.
Oriol Tuca, Illustration of Joseph Beuys's *I Like America and America Likes Me*, 2012. Ink drawing. Collection of the artist.

In the 1960s, Allan Kaprow's "Happenings" in upstate New York invited viewers to be participants. These events, sometimes rehearsed and other times improvised, began to erase the line between the artist and the audience. One example of participatory performance art is Japanese artist Yoko Ono's *Cut Piece* from 1965. In that work, Ono sits on a stage in a black dress with a pair of scissors beside her. Audience members take turns coming onto the stage and using the scissors to cut her clothing. As time progresses, her garments are slowly cut away a scrap at a time. In this piece and many others, the artist's body and the breaking of taboos surrounding social interactions become the subject of the art.

Argentine artist Marta Minujín referred to her performance works as "livable sculptures." In her 1965 happening, *Reading the News*, she squirmed into the Río de la Plata, an Argentine river, wrapped in newspapers (figure 4).

In another work, *La Menesunda*, Minujín combined aspects of both installation and performance. Participants were asked to go through sixteen chambers, each separated by a human-shaped entry. Led by neon lights, groups of eight visitors would encounter rooms with television sets at full blast, couples making love in bed, a cosmetics counter and its attendant, a dental office that required dialing an oversized rotary phone in order to exit, a walk-in freezer with dangling fabrics suggesting sides of beef, and a mirrored room with black lighting, falling confetti, and the scent of frying food. In this case, the viewers became both the performers and the consumers of the art.

Another example of a participatory performance is *Capital Cleanse* by Massachusetts artist Tereza Swanda. She cast fifty bars of soap that resembled American twenty-five cent coins (figure 5). These were then installed in public restrooms.

The total amount of these "coins," twelve dollars and fifty cents, represents the "bride price" or money exchanged for one girl sold to Nigerian Boko Haram militants in April 2014. The artist intends the soaps to be used, to change, and to disappear, inviting reflection on the fate of these girls and the role of money in human trafficking. The viewer's participation completes this time-based performance work.

FIGURE 5.
Tereza Swanda, *Uncertain White III, Capital Cleanse Series*, 2014. Carved and cast soap, 2 × 2 × 0.5 in.

Today we see a new form of performance art happen unexpectedly around us in the form of **flash mobs**, groups of people who gather in public spaces to collaborate in short, seemingly spontaneous events that entertain and surprise passersby. Many flash mobs are arranged in advance through the use of social media. One such event coordinated through social media is this flash mob pillow fight that took place in Lausanne, Switzerland (figure 6).

FIGURE 6.
Flash Mob at Lausanne, Switzerland, 2011.

Visual and performance artist Rebecca Szeto created her performance piece, *The Drawing Chair: A Performance Piece for the Fidgety Child*, after her daughter accidentally broke a chair while experimenting with its other possible uses (figure 7). Szeto grabbed onto the idea that a chair could be used for other purposes than sitting, and built a child-sized chair with graphite pencil lead into the four legs to encourage children's creativity in using everyday objects. The floor becomes the drawing space, and different children were given opportunities to manipulate the chair in the space to create collaborative, evolving drawings (figure 8).

Kathryn Cellerini Moore's performance piece, *Rubin Schuhe (Ruby Shoes)*, recalls the popular book and film *The Wizard of Oz*, particularly Judy Garland's performance as main character Dorothy Gale in the film

FIGURE 7 AND 8.
Rebecca Szeto, *Drawing Chair: Performance Piece for the Fidgety Child*, 2014. Graphite pencil leads, wood, metal, and masonite, 20 × 11.5 × 11.5 in.

FIGURE 9.
Kathryn Cellerini Moore,
Rubin Schuhe (Ruby Shoes),
2015. Participatory perfor-
mance. Alexanderplatz,
Berlin, Germany.

adaptation (figure 9). Moore's performance in Berlin in 2015 included Moore dressing as Dorothy in blue and white gingham, rolling a suitcase onto the plaza, and carefully unwrapping and displaying the contents: 23 pairs of handmade ruby slippers (based on the film's design using glue, glitter, and spray paint). Once laid out, Moore encouraged onlookers to try on and appreciate the shoes.

Moore's process of intimately interacting with each shoe, each participant, and her memories of childhood, supports the performance as a work of art. Moore's experiences with the film and her past, along with the concept of magical shoes that, when worn correctly, can transport the wearer "home" as they do in the film, make for a touching, evocative performance that contrasts nostalgia and sentimentality with a desire to remake and renew experiences by making contact with strangers.

C. Installation, Performance, and the Viewer

In 1969, performance artist Vito Acconci followed random people he encountered on the streets of New York and documented their movements and reactions over a period of three weeks. You would not be the first to wonder what differentiates this performance piece from stalking. Does it really require that much creativity to sit in a chair and stare silently at strangers for 736 and a half hours as Marina Abramovi did in her 2010 performance piece, *The Artist Is Present*? What distinguishes a publicity stunt from true art? Where do you draw the line?

These questions bring us back to the beginning of this textbook, where we suggested that art is always shifting and being reshaped by cultural changes, artistic preferences, and innovation. Installation art and performance art defy traditional notions of art and encourage viewers to participate in the creation of meaning. Artists invest their time, thought, and energy in developing concepts and performances. They can be serious social commentary, as in Tereza Swanda's work, an investigation into human behavior, as in Yoko Ono's *Cut Piece*, or absurd and fun, like a pillow fight. Sometimes, if the concept that drives the installation or performance falls flat, the work can seem self-serving, purposeless, or simply bizarre. But successful performance and installation pieces challenge viewers and connect to questions surrounding our most basic human instincts. At times uncanny, absurd, or uncomfortable, these pieces encourage us to reflect on our behaviors, our values, our fears, and our ideas about others, art itself, and the world in which we live.

3.8 Public Art

Previous sections in this chapter discuss the different media that artists use to create their work. In this section, we look at **public art**, which is created for a specific place or purpose through an artist's collaboration with public institutions, corporations, or communities.

The process of creating public art typically begins with a panel of public officials and private citizens who decide on a distinct vision for the chosen location of the art. This vision might be built around a particular theme, an inspirational idea, or a visual concept, but it is almost always connected to the intended purpose of the space or how the public will use the space. After the vision is defined, the panel publishes a request for submissions of creative proposals, reviews the submitted ideas, and selects the proposal that best fulfills the panel's vision.

Once selected, the chosen artist then begins a collaborative design and construction process with architects, engineers, public administrators, and others connected with the project. The final result is a new installation of public art. However, not all public art projects are created in this way. Artists are sometimes invited to place existing art in public spaces instead of designing something new for a particular place.

Funding sources for public art projects vary widely, from private donations to public tax dollars to a combination of the two. Many states have "One Percent for Art" laws in their budgets. These require one percent of the cost of any public construction project to be reserved for art to be placed on the site. The purpose of this kind of law is to include beautification as a part of publicly funded building projects and restorations.

Some public art is temporary and movable, but most public art is permanent. In this section, we'll focus on mostly permanent works that are open to the general public and available for all to view and enjoy, whether funded privately or publicly. In particular, we'll look at memorials, monuments, and murals.

A. Memorials

One well-known example of public art is the *Vietnam Veterans Memorial* in Washington, DC, designed by artist Maya Lin (figure 1). The memorial's polished black granite is positioned on a sloping grassy area as if it were carved directly into the earth. The granite seems to rise gradually, forming a wall that gets taller as the viewer descends along the flagstone pathway.

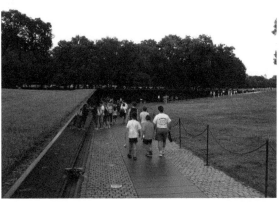

Carved into the wall are the names of the men and women who died in the Vietnam War, grouped by the year of their death. In the war's earliest years, the wall is relatively short, and the names listed are fewer. The number of names and height of the wall increases as the wall continues down the pathway, corresponding to the worsening of the conflict in Vietnam. At the pathway's lowest point, the names on the wall tower over the viewer, stretching from the top of the wall to where the granite meets the pathway. One of the monument's architects hoped that "these names, seemingly infinite in number, [would] convey the sense of overwhelming numbers, while unifying these individuals into a whole."

The *Vietnam Veterans Memorial* process offers a unique story of how public art can be created. Artist and architect Maya Lin entered the national competition to design the memorial when she was just twenty-one years old and a student at the Yale University School of Architecture. The selection committed had the following set of criteria for the memorial:

(1) that it be reflective and contemplative in character,
(2) that it harmonize with its surroundings, especially the neighboring national memorials,
(3) that it contain the names of all who died or remain missing, and
(4) that it make no political statement about the war.

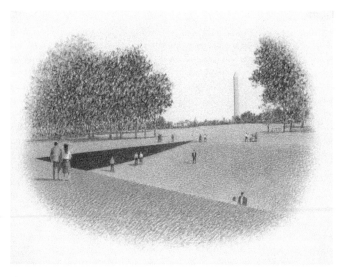

FIGURE 3 [ABOVE].
Paul Stevenson Oles, Perspective drawings, *Vietnam Veterans Memorial*, 1981. Charcoal and pencil drawings on rag board. Prints and Photographs Division, Library of Congress, Washington, DC.

FIGURE 2 [ABOVE].
Maya Lin's original competition submission for the Vietnam, Veterans Memorial in Washington, DC, 1980–1981. Mixed media and paper on board, Library of Congress, Washington, DC.

Lin's original submission — one of 1,421 total submissions — allows us to evaluate how effectively her initial design satisfied the selection committee's criteria (figure 2).

Initially, the committee worried that Lin's design was too vague or abstract in appearance, so they asked Oles, another architect, to create perspective drawings with figures to show scale and depth (figure 3). Changes are common in most commissioning of public art. The artist must be flexible to meet the many variable requirements of a public space. Notice that no walkway appears in the early drawings or in Lin's original submission. The later addition of a walkway, for example, made the project accessible without diminishing its impact.

Public art projects can be subject to controversy. It's never easy for everyone involved to agree on what constitutes "good" or "bad" art — or even what's appropriate for a public space. The issue takes on an even more complex perspective when public money is involved, as you can see in this project's fourth criteria and its concern about politics. The approval of a design is always a complicated process, and Lin's submission was no exception. Even after the project was underway, the committee worried that the general public would reject it.

This was a reasonable fear, too, because so many previous memorials look very different from Lin's memorial. For example, Daniel Chester French's memorial to Boston figure John Boyle O'Reilly is a larger than life granite sculpture of three allegorical figures framed by Celtic patterns (figure 4). The mythical beings Patriotism, Erin (symbolic of Ireland), and Poetry represent the memory of O'Reilly, an Irish poet who was fiercely protective of and embraced by his adoptive city of Boston. A bust of his likeness is on the reverse side of the sculpture.

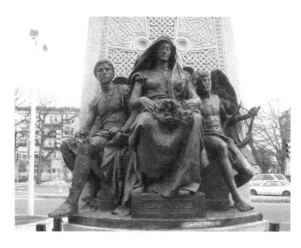

FIGURE 4.
Daniel Chester French, *John Boyle O'Reilly Memorial*, 1896. Bronze and granite. Boston, Massachusetts.

The *Vietnam Veterans Memorial* committee had to judge whether Maya Lin's conceptual leap away from representation like French's would cause public outcry from veterans' groups. Their consideration led to the commissioning of a second, figurative sculpture just before the completion of Lin's memorial. *The Three Servicemen*, by sculptor Frederick Hart, was unveiled two years later and positioned near the memorial (figure 5).

In the end, however, the fears about public outcry over Lin's design were unfounded. The public embraced the memorial. Today, most people do not even notice the nearby companion sculpture. In their final arrangement, however,

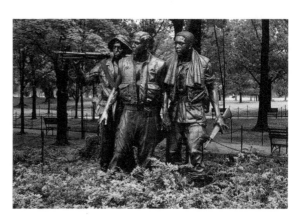

FIGURE 5.
Frederick Hart, *The Three Servicemen*, 1984. Bronze, 96 in. Vietnam Veterans Memorial, Washington, DC.

the statue and the wall interact with each other. The soldiers appear to look on in solemn tribute at the names of their fallen comrades. The distance between the two allows them to interact while minimizing the impact of the addition on Lin's design.

Most memorials are permanent public art installations. However, public art can also consist of temporary exhibits, such as the AIDS Memorial Quilt Project. The quilt is made of squares of fabric created by families and friends of AIDS victims (see figure 6). Begun in 1987, the project memorializes the thousands of lives lost to the disease. The quilt squares are sewn together to form larger sections, uniting the people who share a common grief to help commemorate and celebrate the lives of their loved ones.

The AIDS Memorial Quilt is an ongoing project, continually growing in size and exhibited throughout the world. Today, there are over forty-eight thousand individual squares. The project is evidence of the beauty and potential vastness of a focused community art project. This public art is not only available to be viewed by the public, but is partially created by members of the public.

B. Monuments

The most recognizable public art pieces are monuments. The origin of the word "monument" comes from the Latin *moneo*, which means to remind, advise, or warn. This suggests that a monument allows us to look back at the past, reminding us about what happened so that we can be ready for the future. In English, the word "monumental" is often used in reference to something with extraordinary size and power. Fittingly, monuments are often large, grand structures and are intended to appeal broadly to a large group of people.

Monuments, like memorials, may commemorate the deaths of individuals, but their scale and scope is generally much larger than one person, making them symbolic of larger themes. They can also commemorate an event, celebrate national success, or represent an important part of a cultural heritage. Some become instantly recognizable symbols for an entire nation, as you will see in some of the examples in this section.

FIGURE 7.
Frédéric Auguste Bartholdi, *Statue of Liberty*, 1886. Copper, 151 ft. Ellis Island, New York.

FIGURE 8.
Ustad Ahmad Lahauri, *Taj Mahal*, 1632. White marble and semi-precious stones. Agra, Uttar Pradesh, India.

One of the most beloved monuments in the United States, for example, is the *Statue of Liberty*, which was a gift from the people of France in 1885 (figure 7). The copper statue is of a robed woman who raises a torch and carries a tablet inscribed with the date of the United States Declaration of Independence from Britain. At her feet is a broken chain. The statue symbolized freedom from colonial oppression. It was a celebration of the victories of the Revolutionary War over Britain and the more contemporary Civil War over slavery.

Positioned facing southeast from the New York City seaport, the woman looks toward arriving ships in greeting, a welcome sight to immigrants travelling by boat to the United States. Her torch seems to light the way for voyagers or ship landing on North American shores, and the seven points to her crown recall the sun's rays, the seven seas, and the seven continents. These references to light and the entire globe all build into the common understanding of the *Statue of Liberty* as a global symbol of freedom and welcome.

FIGURE 9.
Jean Chalgrin, *Arc de Triomphe*
(*Triumphal Arch*), 1836. Stone
and limestone, 164 × 148 × 72
ft. Paris, France.

Monuments that commemorate people take many forms, from obelisks like the *Washington Monument* to giant structures like the pyramids at Giza. In India, the *Taj Mahal* was built in 1653, twenty years after Shah Jahan commissioned it as the final resting place of his favorite wife, Mumtaz Mahal (see figure 8). The internationally celebrated structure is recognizable for its marble domes and its tall columns, called minarets, which rise above the surrounding gardens. Over three million people visit this monument each year. It has become one of the world's most celebrated structures and a symbol of India's rich history.

In France, the elegant *Arc de Triomphe* (or *Triumphal Arch*) celebrates the many victories of the French army (figure 9). The arch stands in northeastern Paris at a location where six prominent streets — including the city's famously large boulevard, the Champs-Élysées — all meet. The arch has been a symbol of French patriotism since its construction in 1836, and its central location has been the starting point for French troops parading after successful military campaigns and the annual Bastille Day military parade.

Commissioned by Emperor Napoleon in 1806 to commemorate the French victory at Austerlitz, the building of the arch continued through many interruptions for thirty years. By the time it was finally finished, the relief sculptures on all sides of the arch contained commemorative scenes of war and peace from 1792 through 1815. More recent military conflicts have been commemorated by added features underneath the arch, such as the Tomb of the Unknown Soldier. This monument commemorates the fallen soldiers in both world wars who were never identified, and is accompanied by an eternal flame.

All around the world, national monuments exist in part to give physical representation to the ideas, emotions, and heritage of a nation. These important cultural landmarks and symbolic structures help define a nation's values. We can see what a nation places importance on by the kind of art they produce, and that is most clear when it comes to their public art, particularly monuments.

C. Mural Art

Humans have been painting on walls since prehistoric times. In the same way that we use monuments today, ancient civilizations used **mural art** to commemorate and glorify their accomplishments, rulers, and religious themes. For this reason, mural painting is also associated with public art, but it wasn't until the so-called Mexican Renaissance in the twentieth century that mural painting became an artistic discipline.

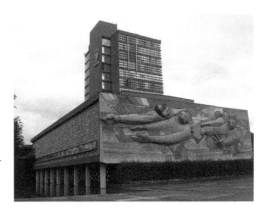

FIGURE 10.
David Alfaro Siqueiros, *El Pueblo a la Universidad y la Universidad al Pueblo (The People to the University and the University to the People)*, 1952-1956. Iron and cement with glass mosaic. Rectoría de la Universidad Nacional Autónoma de México en Ciudad Universitaria, Mexico City, Mexico.

The contemporary mural movement has its roots in the Mexican mural movement that ran from 1920 to 1960. The Mexican Revolution of 1910 ended the Porfiriato dictatorship that had been in place for many years, but that victory resulted in violent political upheaval that shook Mexican society and culture. The Mexican school of painting was born in this context of newness and uncertainty. Led by Mexican painters David A. Siqueiros, Diego Rivera, and José Clemente Orozco, mural activity experienced an innovative renaissance.

At first, these painters followed European traditions of composition, using fresco and oil. Later, they began to incorporate modern materials and methods such as acrylic paint and airbrush tools, opening new approaches in art media and materials in contemporary art worldwide. Siqueiros further pushed the limits of mural art with his construction of *El Pueblo a la Universidad y la Universidad al Pueblo* (figure 10). This large-scale mosaic mural uses underlying iron structures and cement to add physical depth to the

FIGURE 11.
Diego Rivera, *Man-Controller of the Universe* (detail), 1934. Fresco, 189 × 450 in. Palacio de Bellas Artes, Mexico City, Mexico.

subjects' heads and arms, which actually protrude from the wall. This technique evolved into what is known as sculpt-painting.

In addition to new techniques, Mexican mural artists also introduced new subjects. Through collaborations with local institutions and governments, these artists created murals that reflected their activist view of contemporary social and cultural issues. One clear influence in their work is the writing of Karl Marx, whose ideas about workers' rights and labor unions punctuate the artists' large-scale work.

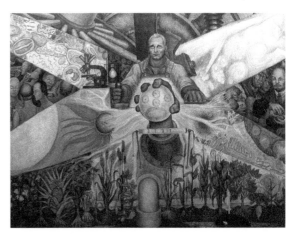

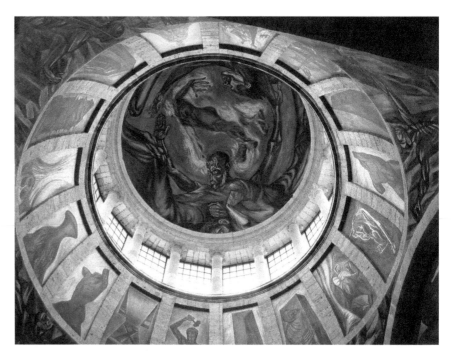

In Rivera's *Man-Controller of the Universe*, for example, the composition of the mural draws comparison to earlier religious works in the way it includes an array of complementary scenery surrounding a central figure (see figure 11). However, where a savior or saint would normally reside in traditional religious art, the central figure in Rivera's mural is a laborer at work. The glorification of the worker is an important Marxist theme.

Generally, these artists enjoyed broad freedom in their design, even though most Mexican mural projects were commissioned by government or private owners who may not have shared the artists' political inclination. This is remarkable because of the stark contrast that some of these same artists experienced when working in the United States. The freedom of design afforded to Mexican mural artists did not extend to their work in the United States. As an example, the detail image of Rivera's mural in this chapter is actually Rivera's recreation of the original mural in a Mexican cultural center. The original, *Man at the Crossroads*, was first created in the United States but was destroyed before completion.

Nelson Rockefeller commissioned Rivera's mural to coincide with the construction of Rockefeller Center in New York City in 1934. Originally intended as the central mural in a series that contrasted capitalism and

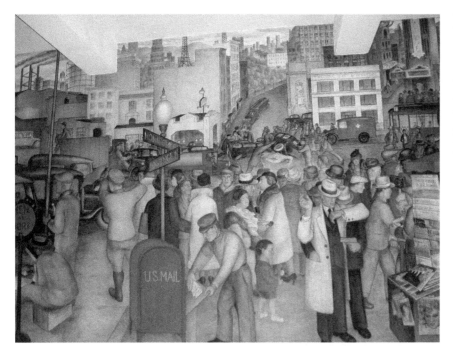

FIGURE 13.
Victor Arnautoff (and uncredited WPA workers including Ralph Stackpole, Bernard Zakheim, Edward Hansen Farwell Taylor, and faculty and students of the California School of Fine Arts), *City Life* (detail), 1934. Fresco, 10 × 36 ft. Coit Tower, San Francisco, California.

socialism, the mural came under public scrutiny when newspaper articles began to call the mural communist propaganda. Possibly in response, Rivera added a portrait of Vladimir Lenin (visible at the right edge of figure 11), one of the leaders of the Russian revolution. This sparked even greater controversy surrounding the mural, upsetting Rockefeller. Rivera refused to remove the image of Lenin, but offered to add a portrait of Abraham Lincoln as a form of compromise. Rockefeller, facing great pressure from the art community and the press, left the fate of the mural in the hands of his architects, who eventually ordered its destruction. Some claim that Rockefeller himself ordered the destruction, but the truth remains controversial.

Mexican mural artists also proposed a new way to combine mural art and the architecture on which it was placed. Supporters of the movement called this "Plastic Integration." This meant that instead of a mural being subordinate to the architectural design or designed to decorate blank walls, murals were an integral part of the architectural design. One example is Orozco's *Hombre de Fuego* (figure 12). Although the building was completed in 1829, Orozco's 1939 mural certainly works as an integral part of the architectural structure. The mural centers on a man either being consumed

by fire or rising from its ashes. But the centerpiece is actually just part of multiple panels that line the walls and other ceiling vaults surrounding the rotunda, which ascends to over sixty feet. The entire series, often referred to as the Sistine Chapel of the Americas, references the contrasting natural elements of fire, water, earth, and air. The elements symbolize Mexico's push and pull between European and indigenous influences.

The influence of the social mural movement in Mexico spread to the United States when the Works Progress Administration (WPA) was implemented in the 1930s. The WPA program was developed after The Great Depression of 1929 to provide much needed work to the overwhelmingly unemployed population. Many construction and infrastructure projects began as a part of the WPA. As an added public benefit, the WPA was charged with producing public beautification projects alongside or as part of these large improvements.

Victor Arnautoff's *City Life* mural, for example, depicts scenes of life during the Great Depression (see figure 13). Like the Mexican mural artists, the artists who completed *City Life* and several other murals in the Coit Tower WPA project in San Francisco were sympathetic to the revolutionary theories of communism and socialism. In *City Life*, these political interests were more subtle than in Rivera's *Man at the Crossroads*. One man in the middle left carries a red flag, a symbol of communism, and socialist magazines are on sale at the newsstand. Contemporary viewers of this mural would have easily recognized these symbols as supportive of a Marxist political agenda.

Mural art has remained political long after its inception. During the United States Civil Rights movement of the 1960s and 1970s, the creation of murals became a way to express social demands while also

FIGURE 14.
Hector H. Hernandez, *Overcoming Global Warming*, 2009. Acrylic on interface fabric on wall, 13 x 86 ft. Beaverton, Oregon.

providing beautification benefits to the communities in which the murals were located. Many poor neighborhoods developed a new image with the creation of large, colorful murals in parts of Los Angeles, San Francisco, Philadelphia, New York, and Chicago.

Judy Baca implemented a Los Angeles mural program in the 1970s that integrated the role of the artist with the community and gathered contributions from private and public funding sources to create large scale murals. Just as the Mexican mural artists influenced the work done by the WPA, Baca's Citywide Mural Program became the model of other collaborative mural programs around the country. Oregon artist Hector H. Hernandez's public mural, *Overcoming Global Warming*, was developed and created through a similar program in the Portland area and focuses on the artist's interest in social issues (figure 14). This and other murals by Hernandez form a link between today's mural artists and the Mexican mural movement through their style, technique, and inclusion of political material.

Mural art is a discipline that people from many different communities have embraced and made their own. Artists have been beautifying neighborhoods, cities, and communities with murals for nearly a century. Community mural art has spread from its roots in Mexico throughout the United States and the world, continuing to be a movement of cultural and artistic expression for the people. They help to define the identities of these communities and make them culturally vibrant and unique.

D. Public Art and the Viewer

Public art supplies us with beautiful and memorable evidence of a shared history, culture, and purpose. The fact that most public art is funded by public institutions like government underscores its collective cultural value. The places where public art exists can become like hallowed ground, and the dedication of public space to the commemoration of an idea, person, or event says a lot about the society that created that space. Public art is a clear example of this book's title — public art is quite literally art that is meant to be viewed and appreciated by everyone.

Chapter 4:
Modernism

4.1 Modern Art

Modern art is the living art of the twentieth and twenty-first centuries. Modern art can be difficult to understand because it often doesn't look anything like the art of the past. Some modern art has no clear subject, and some depicts subjects that make the viewer uncomfortable. It may appear chaotic, messy, or even disturbing. On the other hand, it may resemble someone's geometry homework as in the angular work of Russian artist Wassily Kandinsky (figure 1). Students at times struggle to understand why works that seem unfinished or even child-like are valued over the refined products of a skilled hand, why ugliness and disorder may be sought over beauty and tradition, and why modern artists tend to provoke controversy. In our introduction, we'll highlight a few of the most important trends of this dynamic, modern, and challenging shift in art.

FIGURE 1.
Wassily Kandinsky,
Yellow Border, 1930. Oil
on cardboard, 19.3 × 19.3 in.
Los Angeles County
Museum of Art,
Los Angeles, California.

A. Changes in Art

Since the first prehistoric artist picked up a chunk of burnt wood to draw on a cave wall, people have produced art in response to a changing world. As artistic methods flourished over time, the materials, tools, and training for art became more varied and costly. Those who made art their full-time profession required financial backing. As a result, the support of artists and the possession of art became symbols of leisure, power, and wealth. Patrons with prestige, goods, or money did not generally support — or patronize — artists out of the goodness of their hearts. For these privileged individuals, art was a commodity, one that reinforced the power of their lineage, institutions, or social status.

Patrons were generally conservative and adverse to change. As a result, they were more likely to support art that reflected their worldview. They valued traditional subjects and treatments because these did not disrupt the social hierarchy that had secured them positions of power. But as the saying goes, the only constant in life is change. As new groups acquired wealth and competed for prominence within the social structure, they

questioned everything their predecessors held dear, including their art. Those with new wealth rejected traditional styles or subjects and sought artists who worked in new modes. With every social upheaval, with every new discovery, and with every philosophical shift, the boundaries of art are challenged, resisted, and broadened to reflect these changes.

Today's rapid social and technological advances may seem unparalleled, but let's look at these changes in perspective. Two hundred years ago saw the beginning of the machine age and its philosophical products, mercantilism and capitalism. Mechanized production and mass education drew young people from farms and into early factory cities. They formed a new class of employed factory workers, and this situation lead to repression, political activism, unions, and strikes. The German economist Karl Marx responded with a literally revolutionary analysis of the relationship between workers and capitalists. English naturalist Charles Darwin posed theories that overturned traditional beliefs about human evolution. Austrian neurologist Sigmund Freud upended previous understandings of the human mind through his development of psychoanalysis. By the early twentieth century, new technologies and new ideas had altered where people lived, how they lived, and how long they lived.

Just think of some of the changes of the last two hundred years: the abolition of slavery, the electric light bulb, airplanes, motion pictures, women's suffrage, household appliances, telephones, liquid-fueled rockets, television, fast food, nuclear weapons, feminism, personal computers, space travel, the Internet, psychiatrists, advanced understanding of genetics, poison gas, antibiotics, the electric grid, recorded sound, and radio. This list includes only a few Western innovations of the nineteenth and twentieth centuries.

Modern artists have responded to these changes by producing new kinds of art supported by new kinds of patrons. They work in wildly varying styles and with radically different subjects, but they have one idea in common: they believe art can change how people see, think, and live. Some view technological change as a threat to traditional values, while others see it as humanity's salvation. Many artists are activists who criticize the way that social institutions have failed to meet the challenges of the modern era. They believe that artists who critique a society must also critique the work that praises or pleases that society. This requires the development of new approaches to subjects, styles, form, and composition.

FIGURE 2.
Jean-Léon Gérôme, *Pollice
Verso* (Turned Thumb), 1872.
Oil on canvas, 38 × 58.7 in.
Phoenix Art Museum,
Phoenix, Arizona.

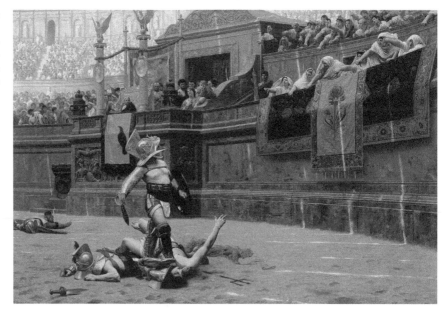

B. The Avant-Garde

The term **avant-garde** ("advance guard") comes from French military practice. It refers to the soldiers on the front lines who were sent into battle first. This term was borrowed by artists who saw themselves on the metaphorical front lines of a cultural battle. These artists attempted to distinguish themselves from the mainstream art world through the creation of groundbreaking work that rejected the status quo. Avant-garde is now applied to any form of artistic creation — music, theater, food, or writing — considered ahead of its time.

The avant-garde art movement can be traced back to mid-nineteenth century France. During this period, the Royal Academy of Painting and Sculpture, France's state-sanctioned school, controlled how art was taught and which works of art received public acceptance. In their annual juried competition, called the Salon, Royal Academy members selected artists and works for display. Not surprisingly, these judges appreciated works of art that emulated styles taught at the Royal Academy. The preferred style included large-scale, smoothly finished, highly representational history paintings depicting stories from the past. Jean-Léon Gérôme's painting of a victorious gladiator is an example of the kind of classical subject matter and finish that the Salon favored (figure 2).

C. Realism and the Painting of Modern Life

The Royal Academy set the standard for what was accepted in art for over a century, but they could not control the forces of **Modernism**. In 1853, Napoleon III commissioned Georges-Eugène Haussmann to renovate and redesign Paris, a strategic move that was part aesthetic improvement and part riot-proofing of a city plagued by political unrest. City parks were developed and narrow medieval streets that could be easily barricaded by angry mobs were transformed into the wide boulevards and green spaces that Paris is known for today. Newly-constructed apartment buildings housed people of different socio-economic levels. Haussmann's urban redevelopment led to social transformation. People of different classes, professions, and walks of life now inhabited the same spaces. Avant-garde artists were keenly aware of and embraced this change. They found real people, current events, and the details of daily life more fascinating as artistic subjects than people, places, and times that were long gone or never existed at all.

This focus on what artists saw and experienced — rather than on historical scenes prescribed by the Royal Academy — led to the development of a style of painting called **Realism**. Realist artists considered themselves "painters of modern life." One major proponent of Realism was French painter Gustave Courbet. Though associated with the Salon, he rejected idealized historical subject matter and believed that art should engage contemporary concerns with as much accuracy as possible. The social consciousness of his work aimed to draw attention to all parts of Parisian society and often portrayed the plight of the poor and working classes.

In his painting *The Stonebreakers*, Courbet captures modern life in France, but a side of that life modern Parisians did not necessarily want to see (figure 3). At first glance, the work reveals an everyday scene of life for laborers, but classical art embraced the

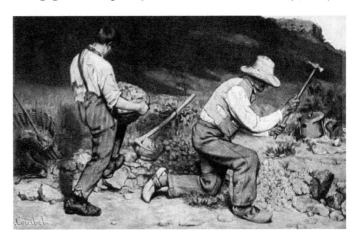

FIGURE 3.
Gustave Courbet, *The Stonebreakers*, 1850. Oil on canvas, 65 × 101 in. Gemäldegalerie, Dresden, Germany (destroyed).

idealized human form. Salon audiences would have found the realistic depiction of working life distasteful. Most controversial of all, Courbet painted ordinary men — not gods, not Biblical heroes — and the disshevelled and dirty appearance of the men were a bit too brazen for polite society.

D. Impressionism

Another group of artists that resisted the Royal Academy's influence later became known as the Impressionists, an initially belittling term that suggested their works were "just impressions." This group, which included Claude Monet, Pierre-Auguste Renoir, Edgar Degas, Berthe Morisot, and Camille Pissarro, among others, established their own exhibition apart from the Salon. Calling themselves the Anonymous Society of Painters, Sculptors, and Printmakers, they pooled their money, rented a studio, and set a date for their first exhibition.

Opening at about the same time as the annual Salon in May 1874, their provocative show was the first of eight exhibitions through 1886. In contrast to the Salon's crammed wall space with three or four paintings hung floor-to-ceiling, the Impressionists' exhibit featured a single painting at eye level with ample space between works. The artists were displayed, not by rank and prestige, but in alphabetic order by last name. For the first time in Western art history, artists instead of institutions or patrons controlled how art was shown and what could be called "art" in the first place.

Acceptance, however, was not immediate. Not only did this first exhibition flop as a financial venture, but it also drew critics who judged the Impressionists' work as abominable. For a long time, French audiences refused to find this new approach worthy of praise. American and non-French collectors, however, *did* see value in this original style. For this reason, the United States and other foreign collections own much of the surviving Impressionist art.

The Royal Academy valued paintings that had a finished appearance with no visible brushstrokes, as seen in the work of French painter Jean-Auguste-Dominique

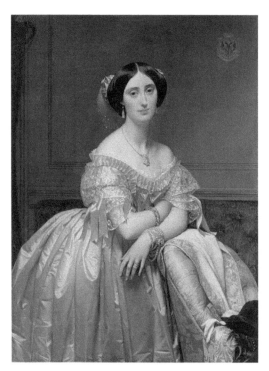

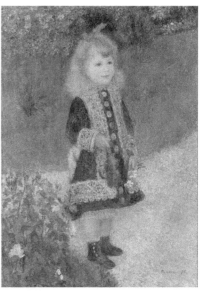

FIGURE 5.
Claude Monet, *Impression Sunrise*, 1872. Oil on canvas, 18.9 × 24.8 in.
Musée Marmottan Monet, Paris.

FIGURE 6.
Pierre-Auguste Renoir, *Girl with a Watering Can*, 1876. Oil on canvas, 39.375 × 28.375 in. Chester Dale Collection, National Gallery of Art, Washington, DC.

Ingres (figure 4). The completed works of the Impressionists, however, looked more like sketches to the critics. Normally, an artist's sketch was not sold but made as the first step in the creation of a completed masterpiece painted in the studio. The critics ridiculed the attempt to sell such preliminary "impressions." The Impressionists, however, rejected the idea of finishing works in the studio. They wanted to work from life, *sur le motif,* and make works that retained the freshness of a sketch.

Realists such as Courbet also challenged the Salon's hierarchy of subject matter. Rejecting history as art's only valid inspiration, Realists and Impressionists believed that landscapes and scenes from everyday life were equally important. Claude Monet's *Impression Sunrise* provides an example of this approach (figure 5). The painting gives the viewer the impression of a harbor that the artist frequented as a child with its hazy industrial shoreline in the background, dark patches of fishing boats in the middle ground, and choppy horizontal brushstrokes for the water in the foreground. This painting was derided by critics for its rough finish and commonplace subject matter, as opposed to the Salon works praised by the Royal Academy.

Impressionist artists tried to paint moments in their fast-paced lives by pinpointing specific atmospheric conditions — light flickering on water, moving clouds, or a burst of rain. They painted small strokes of pure color, one next to another. Standing at a reasonable distance from the painting, the viewer's eyes could mix the individual marks and blend the colors together optically. This method created more vibrant colors than those that could be mixed on a palette. French painter Pierre-Auguste Renoir's *Girl with a Watering Can* exemplifies this innovative approach (see figure 6). Form is built with the application of paint and color rather than the blending of paint associated with Salon paintings. The pure application of color creates a vibrant image.

The appearance of quickly shifting light on a surface played an important role in impressionist paintings. Claude Monet painted over thirty images of the same structure in his *Rouen Cathedral* series. By studying the cathedral at different times of the day in different atmospheric conditions, Monet was able to demonstrate how light and atmosphere change color. The effects of light and atmospheric conditions on the subject can be seen clearly in these two paintings of Rouen Cathedral (figures 7 and 8). Conveying the sense of quickly changing atmospheric conditions in a world that changes even more quickly was a key principle of impressionism. They wanted to create art that felt modern and dealt with modern subjects. They aimed to capture the fast pace of contemporary life and the continual movement of light across a landscape. Painting outdoors in a method called *en plein air*, these artists worked with the appearance of light as it flickered and faded around them.

FIGURE 7 [TOP].
Claude Monet, *Rouen Cathedral*, 1892. Oil on canvas, 39.25 × 25.875 in. National Museum of Serbia, Belgrade.

FIGURE 8 [BOTTOM].
Claude Monet, *Rouen Cathedral: Portal (Sunlight)*, 1894. Oil on canvas, 39.25 × 25.875 in. Metropolitan Museum of Art, New York.

E. Post-Impressionism

Post-impressionism refers to an approach to painting that rejected the naturalism of impressionism in favor of using color and form in more expressive manners. Post-impressionists extended the use of vivid colors, thick application of paint, distinctive brush strokes, and everyday subject matter, but they were more inclined to emphasize geometric forms, distort forms for expressive effect, and use unnatural or arbitrary colors in their compositions. Though Impressionist and Post-Impressionist artists often exhibited together, they were not a single cohesive movement, and they worked in different stylistic categories.

From the 1880s onward, several artists, including Vincent van Gogh, Paul Gauguin, Georges Seurat, and Henri de Toulouse-Lautrec, envisioned different guidelines for the use of color, pattern, form, and line, deriving these new directions from the Impressionists. Painting at the same time as the Impressionists, these artists were slightly younger, and their style became known collectively as post-impressionism. Some of the original Impressionists also ventured into this new territory. Danish-French painter Camille Pissarro briefly experimented with **pointillism**, the systematic use of dots of color to compose an image. Paul Cézanne developed a highly individual vision emphasizing pictorial structure, and although he participated in the first and third Impressionist exhibitions, he is most often called a Post-Impressionist.

The Post-Impressionists were dissatisfied with the triviality of subject matter and the loss of structure in Impressionism, but they could not agree on the way forward. Georges Seurat and his followers, for instance, concerned themselves with pointillism. Seurat's painting, *A Sunday Afternoon on the Island of La Grande Jatte*, is a well-known example of pointillism (figure 9). Seurat called it divisionism, from the fact that the colors were never mixed but instead laid side by side on the canvas. Seurat's approach to pointillism had

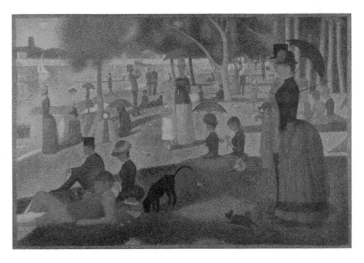

FIGURE 9.
Georges Seurat, *A Sunday Afternoon on the Island of La Grande Jatte*, 1884–1886. Oil on canvas, 81.7 × 121.3 in. Art Institute of Chicago, Illinois.

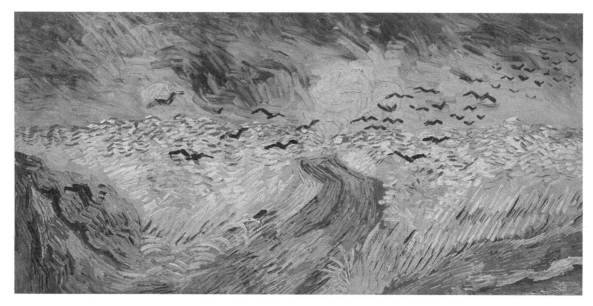

two steps: first, sections of the canvas were divided, and second, colors were laid beside each other. If you were to approach this work in a museum, the forms of the park visitors would begin to disintegrate into dots of pure color placed intentionally side-by-side to produce a bright, harmonious composition. Seurat's compositional rigor was meant to give an eternal quality to a momentary event.

Paul Cézanne set out to restore a sense of order and structure to painting by reducing forms to their basic shapes and interlocking them tightly while at the same time retaining the bright fresh colors of Impressionism (figure 10).

Vincent van Gogh's paintings use vibrant colors and swirling brush strokes to convey his feelings and state of mind. Van Gogh's landscape painting *Wheat Field with Crows* is a clear example of the recognizable forms of Impressionism being taken in a new direction (figure 11).

FIGURE 11.
Vincent van Gogh, *Wheat Field with Crows*, 1890. Oil on canvas, 19.9 × 40.6 in. Van Gogh Museum, Amsterdam, Netherlands.

4.2 Cubism

Depictions of space and shape in Western art underwent a revolution at the beginning of the twentieth century. For the past five hundred years, artists had relied on **linear perspective** to create the illusion of distance and depth in their works. This technique allowed artists of the past to faithfully represent the world around them by using a single viewpoint. But some modern artists found this approach inadequate for addressing their rapidly changing world.

As people whizzed past on new-fangled bicycles, sped across land-scapes on trains or in automobiles, or soared above in airplanes, they gained new perspectives. Modernity didn't possess a single stable view-point, as demanded by this traditional artistic technique. Instead, the modern world seemed more like the recently-invented motion picture camera, blurring thousands of images at sixteen frames a second into a seamless flow of movement. How could art, especially painting, catch up with this new world?

Two young artists, the French painter Georges Braque and the Spanish painter Pablo Picasso, answered this question and changed art forever. Drawn to the reputation of Paris as the capital of Western art and the avant-garde, both moved there separately, met, and together developed a new approach to pictorial space. **Cubism**, as it would come to be called, attempted to depict objects from multiple viewpoints, as if the viewer were seeing the subject from many sides or during many moments at the same time.

For first-time viewers, then and now, cubist works can seem confusing. At the time, public reaction to Cubism was negative, but the artistic exper-iments with spatial relationships reverberated with other artists and became — along with new ways of using color — a driving force in the development of a movement based on the rejection of the picture plane. Imagine that tra-ditional paintings are windows through which you look. In Cubism, the artist uses the canvas as a foundation from which to build formal arrangements of shapes, colors, and compositions. For another take on this idea, refer back to abstract approaches in Chapter 2, "The Language of Art."

A. Simultaneous Perspectives

Cubist paintings, and eventually sculptures, combined different points of view, light sources, and planar shapes. It was as if they were presenting their subject matter in many ways at once, all the while shifting foreground, middle ground, and background so the viewer could not be sure where one started and the other ended. In an interview, Picasso explained Cubism in this way: "The problem is now to pass, to go around the object, and give a plastic expression to the result. All of this is my struggle to break with the two-dimensional aspect." His use of the word "plastic," which he thought of as a label for sculpture, and his desire "to go around the object" make it clear that he envisioned creating movement and depth from these multiple viewpoints.

You can see the radical changes made to perspective by the cubist approach in Robert Delaunay's figurative landscape *La Ville de Paris* (figure 1). The figures and surrounding buildings are shown simultaneously from the front and from the side, marked off by sharp edges. At the same time, the forms are allowed to blend into one another through little gaps in their stiff edges, where value and color merge. As they link, they construct complex forms within a larger abstracted expanse of figures, sky, and city.

FIGURE 2 [LEFT].
Juan Gris, *La Bouteille d'Anis (The Bottle of Anís del Mono)*, 1914. Oil, collage, and graphite on canvas, 16.5 × 9.4 in. Queen Sofia Museum, Madrid, Spain.

FIGURE 3 [RIGHT].
An actual bottle of Anís del Mono.

As the cubist style developed, its forms became even flatter. Juan Gris's *La Bouteille d'Anis (The Bottle of Anís del Mono)* flattens the subject across the canvas (figure 2). This cubist take on the traditional still life — a painterly depiction of ordinary objects — shows that there was nothing still about modern life. In Gris's depiction, the bottle is seen from the front *and* diagonally. The tabletop turns sideways and flips up to show a view looking down. The shapes cast shadows upon each other at the same time that they turn into a set of angular forms. Collage elements like the newspaper and the actual bottle label, both glued to the canvas and overpainted, reinforce the physicality of this painting. Compare Gris's image to an actual bottle of the same brand with its textured glass (figure 3).

B. Dynamic Movement

While two-dimensional space was radically re-envisioned by cubist artists, three-dimensional space did not experience the same degree of transformation, at least not at first. Sculptors continued to rely on the visual tug between positive and negative spaces. Influenced by Cubism, however,

FIGURE 4.
Umberto Boccioni, *Synthesis of Human Dynamism*, 1913. Plaster, dimensions unknown, original destroyed.

FIGURE 5.
Raymond Duchamp-Villon, Two views of *The Large Horse*, 1914. Bronze, 39.375 × 24 × 36 in. Museum of Fine Arts, Houston, Texas.

they did develop new forms to fill this space and to suggest movement, including abstract and non-objective works that challenged viewers to see the works of art on their own terms.

One painter and sculptor particularly intrigued with the synthesis of form, motion, time, and place was Italian artist Umberto Boccioni. He explored dynamic motion with sculptures such as *Synthesis of Human Dynamism* (figure 4) and paintings such as *Dynamism of a Soccer Player* (see figure 10).

French sculptor Raymond Duchamp-Villon was also an expert horse-man, serving as a doctor in a cavalry regiment during World War I, so we can be assured he knew what horses looked like. However, in his sculpture *The Large Horse*, Duchamp-Villon was more interested in capturing the essence of the horse's power and movement than its form (figure 5).

C. Technological and Scientific Advances

It's not so difficult to understand how artistic concepts of perspective, movement, and space influenced cubist artists, especially when considered in the context of comparable advances at the beginning of the twentieth century. The Wright brothers took to the air with powered flight in 1903. That same year, Marie Curie won the first of two Nobel prizes for her pioneering work involving radiation. Sigmund Freud's new ideas on the inner spaces of the mind and its effect on behavior were published in 1902, and Albert Einstein's calculations on relativity, the

idea that space and time are intertwined, first appeared in 1905. Each of these discoveries added to human understanding and realigned the way we saw ourselves and our place in the world. Indeed, Picasso, speaking of his struggle to define Cubism, said, "Even Einstein did not know it either! The condition of discovery is outside ourselves; but the terrifying thing is that despite all this, we can only find what we know."

Technological and scientific advances led Russian intellectuals and artists such as Kazimir Malevich to the hope that human reason and modern technology would engineer a perfect society. Malevich was fascinated with technology, particularly with the airplane as an instrument of the human yearning to break free from the earth. He studied aerial photography and wanted his painting *White on White* to create a sense of floating and transcendence (figure 6). The white square appears to float on a backdrop of white, while the color shift, from a warm white to a cool white, purifies the floating image. For Malevich, white was the color of infinity and signified a realm of higher feeling.

Carried to its logical extreme, Cubism can be used to show the ideal nature of the universe when stripped of its humanity, which is to say its impermanence and fragility, its complexity and disorder, and above all, its human emotion. For further discussion of this trend, refer back to non-objective approaches in Chapter 2, "The Language of Art."

FIGURE 7.
Cover illustration for *The Steam Man of the Prairies* by Edward S. Ellis, Beadle's American Novel No. 45, August 1868. Only known copy with cover housed by the Rosenbach Museum and Library, Philadelphia, Pennsylvania.

D. Futurism

Beginning in the nineteenth century, as factories gained control over not just the way employees moved and worked but also their time, artists began to question the relationship between people and machinery. A similar exploration is taking place right now in the age of computers. Today's artists are asking some of the same questions posed by artists of the machine age: Should people be more rational and tireless like machines? Can people avoid becoming like machines, losing their creativity and ability to love? Will people become more like machines whether they like it or not? What about machines? Will they become more like people?

Futurism was an artistic and social movement that began in Italy in the early twentieth century. It emphasized the concepts of speed, technology, youth, and violence, and objects such as the car, airplane, and industrial cities. Futurists practiced in every medium of art including painting, sculpture, ceramics, graphic design, industrial design, interior design, urban design, theatre, film, fashion, textiles, literature, music, architecture, and even culinary arts.

Futurism's fascination with industry and machines is rooted in Mechanomorphism, the blending of humans and machines. The Industrial Revolution brought with it visions of an ideal world perfected by machines and inhabited by rational rather than emotional humans. However, people then were the same as people now — passionate, unpredictable, and stubborn. Because it seemed unlikely that flawed humans could create a perfect world, futurists focused on machines as the tireless, controllable, and perfectly rational tools of progress. This passion for technology can be seen in this cover illustration for *The Steam Man of the Prairies*, the first science fiction dime novel sold in the United States (figure 7). This novel featured the fictional account of the Steam Man, a humanoid machine powered by the same steam technology that powered locomotives. The Steam Man appeared in Beadle's American Novels No. 45 in 1868, at the end of the Civil War. The timing of this imaginative development is no coincidence. Steam Man was essentially a legal, inexhaustible slave.

Futurism is also rooted in Cubism, as the artists of the Russian avant-garde adapted Cubism to make human labor appear more machine-like and therefore more modern. This emphasis on labor coincided with the rise of the Russian communist and socialist movements before World War I. Kazimir Malevich morphs both humans and nature into mechanical forms in his painting *Taking in the Rye* (figure 8). The figures are a powerful and seemingly tireless force, cutting an endlessly perfect harvest.

In the United States, works depicting labor weren't necessarily part of a Futurist ideal, but similarly blended themes of mechanomorphism and labor. Douglass Crockwell depicted laborers in his painting, *Paper Workers*, as part of the government's Public Works of Art Project to showcase the main industry in his town (figure 9). Crockwell's workers appear to be made of wood, just like the roll of newsprint they are working with. When Crockwell painted this during the Great Depression, workers identified their work as an essential part of their lives when even having a job was fortunate. Artists like Crockwell use the machine as a metaphor and ask viewers to confront their deepest desires and fears for the future.

For futurists like Umberto Boccioni, the main style of painting was Cubo-Futurism, which combines the forms of Cubism with the representation of movement. Boccioni was fascinated by dynamism, movement, speed, and the restlessness of modern urban life. In *Dynamism of a Soccer Player*, Boccioni presents multiple simultaneous views of a soccer player, exploring the range and speed of movements in a colorful, Cubist tangle of geometric limbs (see figure 10).

American artists exploring futurism in a similar way include Joseph Stella, whose painting, *Brooklyn Bridge*, views the bustling New York City landmark from multiple simultaneous angles (figure 11). This unique perspective is interesting because the bridge itself does not move, but the movement of its automotive and pedestrian travelers is as dynamic as Boccioni's soccer player. The bridge takes on the speed and urgency of the people using it, giving the huge structure a living quality, its angular criss-cross steel patterns running impossibly into each other.

Futurism as a coherent and organized artistic movement is considered extinct by most art historians, having died out in 1944 with the death of its leaders. Nonetheless, the ideals of Futurism remain significant components of modern Western culture. The continued emphasis on youth, speed, power, and technology can be found in much of modern commercial cinema and culture. However, the fascination with machine and industry has generally taken a more sinister tone in recent depictions.

Consider The Borg of the iconic science fiction television series Star Trek. "Borg," a shortening of "cyborg," is the collective noun for the race of alien machines. In this futuristic narrative of space exploration, The Borg serves as antagonist, a collective of cybernetic drones that threaten human invention and individuality. In another contemporary example, Transformers are machines with something to hide. But they are not only "more than meets the eye," as the children's television series tells us. They are also ways for children to deal with issues of power and justice in an increasingly mechanized world. In the film *2001: A Space Odyssey*, the computer HAL 9000 goes mad, which seems very human indeed. Futurism has also produced several modern reactions, including the literary genre of cyberpunk — in which technology was also treated with a mostly critical approach. In every case, the fascination with the future and machines, as well as humans' place in a world full of technology, has been a significant driving force behind art since the Industrial Revolution. As technology continues to influence our lives, art will continue to reflect that influence, whether as fear or hope for the future.

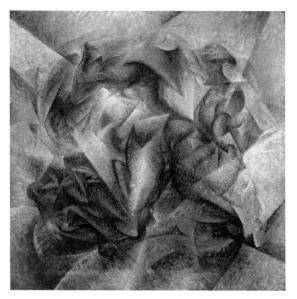

FIGURE 10.
Umberto Boccioni, *Dynamism of a Soccer Player*, 1913. Oil on canvas, 76 × 79 in. Museum of Modern Art, New York.

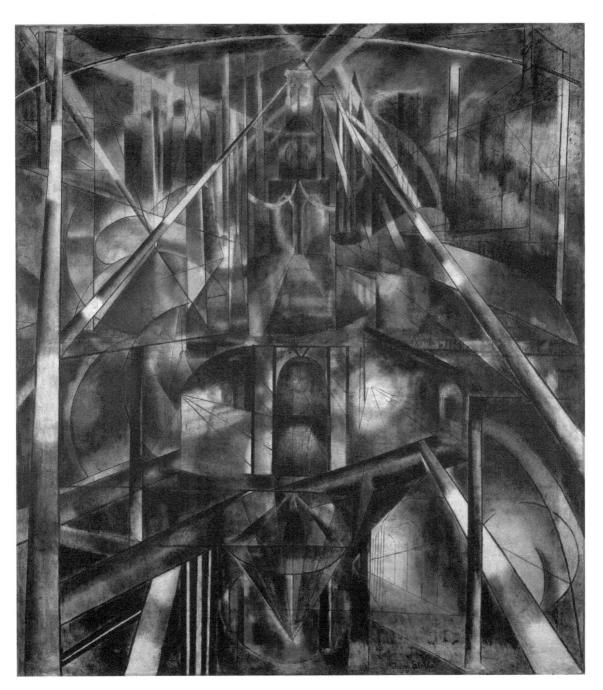

FIGURE 11.
Joseph Stella, *Brooklyn Bridge*, 1919–1920. Oil on canvas, 84.8 × 76.6 in.
Yale University Art Gallery, New Haven, Connecticut.

Cubism **177**

4.3 Conceptual Art

As you saw earlier in the "Impressionism" and "Post-Impressionism" sections, nineteenth-century artists were often interested in social criticism. This is in contrast with much earlier art, which was made for patrons who were interested in maintaining the political, social, and religious status quo of the day. This critical eye continued to drive artists of the twentieth century.

A. Dada

During World War I, young artists — whether fighting or avoiding fighting in the war — began to discuss and make art that expressed their view of both the war and life as absurdly irrational. The first movement that embraced irrationality as a way of understanding the world called its artistic perspective **Dada**, or nonsense art. The name for the movement itself was selected at random from the dictionary. Though the word has meanings in many languages, including "hobby horse" in French, the word itself is intended to be an expression of nonsense.

Dada may appear simple, but it often hides complex ideas. In one way, nonsense art is like a Zen Buddhist riddle — it wants to change you and the world. A Zen saying like "What is the sound of one hand clapping?" is a way of getting you to look at the world from a different perspective. At first, it seems like nonsense, a sort of joke. You think about it and think about it until — in a flash — you get it. One hand clapping is a slap. You've turned the meaning of the words upside down and will never think of them as you did before. In the same way, nonsense art tries to make you re-examine your basic assumptions about the world so that you will see them differently.

Dada was a political movement that was opposed to artistic and social conformity as well as the capitalist forces that led to World War I. In addition to opposing the war, Dada was also anti-bourgeois, which was the social class associated with the conventional attitudes, complacency, and materialism of the middle class. After the war, Dada spread throughout Europe and North America. By the early 1920s, the center of Dada activity was Paris, and the movement possessed strong political affinities with the radical left.

Dadaists explicitly rejected prevailing artistic standards by producing "anti-art." French Dada artist Marcel Duchamp pioneered the important

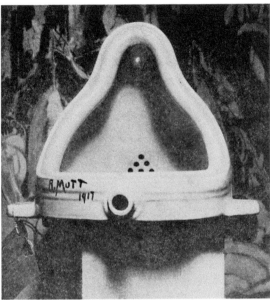

notion of **readymades**, everyday objects appropriated for artistic purposes. Duchamp's readymades are ordinary manufactured objects that the artist selects as an antidote to what he called "retinal art," art made simply to please the eye. By choosing the objects, arranging them, titling and signing them, the objects become art.

Many Dadaists worked in **collage**, creating compositions by pasting together transportation tickets, maps, plastic wrappers, and other artifacts of daily life. The work by French artist Theo van Doesburg provides an example of letters cut from other publications or hand-lettered and pasted together to create this poster for a Dadaist event (figure 1).

Dada artists also worked in **photomontage**, a variation on collage that used actual or reproductions of photographs. German artist Max Ernst used photographs taken from the front during World War I to comment on the war. An example of Ernst's collage work can be seen on page 183 (see figure 5). Another variation on collage used by Dadaists was **assemblage**, the assembly of everyday objects, including military paraphernalia and trash, to produce meaningful — or meaningless — pieces.

During this time, Duchamp began exhibiting his readymades and was active in the Society of Independent Artists. In 1917, he submitted the now famous *Fountain* to the Society's exhibition (figure 2). Duchamp's choice of a urinal as a piece of art challenged the prevailing definition of sculpture in several important ways. The first is that it is not, by any traditional measure,

FIGURE 1 [LEFT].
Theo van Doesburg, *Poster Kleine Dada Soirée Haagsche K.K. [proof]*, 1922. Lithograph. Centraal Museum, Utrecht, Netherlands.

FIGURE 2 [RIGHT].
Marcel Duchamp, *Fountain*, 1917. Readymade, whereabouts unknown. Photograph by Alfred Stieglitz, 1917. Gelatin silver print, 9.25 × 7 in.

a work made by an artist. It is a factory-made porcelain urinal just like thousands of others. It is art because the artist says it is. The second challenge comes from the subject matter. In 1917, urinals were not discussed in polite society, much less exhibited in an art show. The third challenge comes from the title. Labeling a urinal as a fountain invites the viewer to drink from it, which is inherently disgusting rather than being pleasing or edifying, which was then regarded as the role of sculpture and art in general. As Duchamp saw it, the object was only one part of the entire work of art.

You will notice that the urinal in the photograph has a crude signature and a date: R. Mutt, 1917. Duchamp entered the piece in the 1917 Society of Independent Artists show under the pseudonym of R. Mutt, not as himself. When the work was rejected by the jury, he wrote to the Society in his own name, defending the nonexistent R. Mutt's artistic inventiveness and insulting the knowledge of the jury. In doing so, Duchamp continued the tradition of Dada as a performance-based art.

Although wide-ranging, the Dada movement was unstable. By 1924, artists had gone on to other ideas, but Dada — and more particularly, Duchamp — had great influence on the development of postmodern art. Initially an object of scorn within the arts community, *Fountain* has since become near-universally praised as one of the most recognizable modernist works. The committee presiding over Britain's prestigious Turner Prize in 2004, for example, called it "the most influential work of modern art."

B. The Art of Ideas

Conceptual art emerged as a movement during the 1960s, but it was directly influenced by Duchamp's work. In part, it was a reaction against the formalism articulated by influential New York art critic Clement Greenberg. According to Greenberg, the goal of modern art should be to define the essential, formal nature of each medium. If the nature of painting is to be a flat surface onto which colored pigment is applied, for example, then Greenberg asserted that such things as figuration, three-dimensional perspective illusion, and references to external subject matter were extraneous to the essence of painting and should be removed.

Many conceptual artists see conceptual art as a radical break with Greenberg's kind of formalist modernism. In place of formalism that focuses on a medium, conceptual artists work directly with ideas, actions,

and words. Traditional media are abandoned for more directly meaningful materials and tools — installation art, performance art, and digital art are only some of the areas in which ideas are more important than medium and formal concerns.

Some conceptual artists are faithful to ideas of formalism but in their own way, by using non-traditional materials or by completely taking over the space of a gallery. An example of this is the work of German-born American artist Eva Hesse whose *Expanded Expansion* overwhelms the gallery space but may be altered to reduce the space it inhabits. Hesse uses the non-traditional media of fiberglass, polyester resin, latex, and cheesecloth. These are tactile materials that create a work that is not static or permanent. Unlike artists who practiced formalist modernism, Hesse is keenly aware of the fact that she is creating an art experience that, like us, will change over time and eventually reach its demise. The work represents a statement about existence more than an artifact of the artist. You can see an image of this installation piece online at The Guggenheim's museum website (*www.guggenheim.org*) with a search for artist or title.

C. Surrealism

Surrealism was a cultural movement that began in the early 1920s, and is best known for its visual art that mixes imagery from dreams and reality. The grammatical prefix "sur" means "above" or "over," so "surreal" literally means "above what's real." Surrealist painters created scenes and characters, sometimes with photorealistic precision, that defy viewers' expectations for what scenes and characters look like in reality. Surrealism is familiar enough to be recognizable but still unexplainably or unexpectedly strange. Everyday objects, people, animals, and familiar settings become unsettling through their surreal representation.

Surrealist works power comes from their surprising juxtapositions —the placement of two things next to one another that encourages viewers to form connections between them. However, many Surrealists claimed their work was an expression of a revolutionary way of thinking. They were trying to develop painting techniques that allowed their unconscious to express itself.

Artists like Salvador Dalí and René Magritte created the most widely recognized paintings of the movement. Some consistent themes in their works are exposing psychological truth, stripping ordinary objects of their

normal significance, creating compelling images that were beyond ordinary formal organization, and evoking empathy from the viewer. The characteristics of this style — a combination of depictive, abstract, and psychological themes — represented the alienation which many people felt in the modern period, combined with the sense of reaching more deeply into the psyche.

Surrealist art often simultaneously explores the sublime, the terrifying, and the whimsical parts of our experiences. For example, Remedios Varo's painting *Papilla Estelar* shows a human figure spoon-feeding a crescent moon meant to be a star, held in a birdcage (figure 3). The pair are in some kind of tower-like structure with stairs leading to it. Built into the ceiling is a tool that siphons moon and starlight into the room and processes it through a meat grinder into food for the moon. The juxtaposition — a lonely tower containing at least one trapped occupant with the notion that a star (*estelar*) is fed on a slurry (*papilla*) made from the light of other stars — is both unnerving and oddly comforting.

Surrealist art frequently uses a similarly uncanny mixture of the eerie and the familiar. Famous Mexican Surrealist painter Frida Kahlo explores the relationship between familiar and eerie in her painting *Las Dos Fridas*, in which she connects two self-portraits with a set of veins between them and their impossibly exposed hearts (figure 4). They

FIGURE 3 [TOP].
Remedios Varo, *Papilla Estelar*, 1958. Oil on masonite, 36.02 × 23.89 in. Los Angeles County Museum of Art, Los Angeles. © 2016 Artists Rights Society (ARS), New York / VEGAP, Madrid.

FIGURE 4 [BOTTOM].
Frida Kahlo, *Las Dos Fridas*, 1939. Oil on canvas, 68.11 × 68.30 in. Museum of Modern Art, Mexico City, Mexico. © 2016 Banco de México Diego Rivera Frida Kahlo Museums Trust, Mexico, D.F./ Artists Rights Society (ARS), New York.

Figure 5.
Max Ernst, *Murdering Airplane*,
1920. Photographic collage,
2.5 × 5.5 in. Private collection.
Used with permission. © 2016
Artists Rights Society (ARS),
New York / ADAGP, Paris.

both stare blankly at the viewer and hold hands while blood leaks from the severed end of one vein. The juxtaposition of calm and violence is jarring, but so is Kahlo's presentation of her dual selves despite not having a twin.

Surrealist visual artists were not just painters. Well-known Surrealist artist Max Ernst created photo collages like *Murdering Airplane* that juxtaposes and combines human limbs with the frame of an early biplane (figure 5). Other artists created sculptures and other work that seems straight out of dreams, forcing the viewer to confront their own subconscious and surreal thoughts.

D. Abject Art

The term "abjection" means "the state of being cast off" and bears connotations of degradation, filth, and meanness of spirit. In art, the abject has been explored as those things that inherently disturb conventional identity and cultural concepts. According to Bulgarian-French philosopher Julia Kristeva, forced confrontation with the abject is an inherently traumatic experience. Think, for example, of the revulsion we experience with the smell of raw sewage on a hot summer day.

Biologically speaking, disgust is a physical reaction, a bodily warning signal that something might be harmful. There is also a psychological component to disgust that doesn't always serve in self-protection. Consider the child who turns her nose up at Brussel sprouts or the adult who finds the taste of synthetic banana flavoring revolting. What humans find disgusting is irrational, idiosyncratic, and often culturally defined. Abject art is designed not simply to get a reaction out of the viewer — although that is often part

of it. The experience of abject art often brings into question the deeply held notions of what we consider good and bad.

The Whitney Museum in New York coined the term **abject art** in 1993, but the movement of abject art existed well before then. The deep roots of abject art reach back a long way beginning with Dada's fascination with taboo and forbidden subjects. Their artistic trailblazing made it possible for abject art to exist as a recognized movement of its own. Another precedent for this movement included the films and performances of Austrian performer Hermann Nitsch. His interest in the German artist Kurt Schwitters's constructivist approach of using many or all art forms at once led to his setting up the radical theater group, *Orgien Mysterien Theater* (Theater of Orgies and Mysteries), which used animal carcasses and bloodshed in ritualistic ways. Nitsch served time in jail for blasphemy before being invited to New York in 1968 where he organized a series of performances that greatly influenced the radical New York art scene.

This style continues to offer contemporary artists ways of pushing the boundaries of art. Oregon artist Gabriel Parque's sculpture, *The Infant II*, combines imagery that — separately — is not offensive (figure 6). Together, however, this imagery asks viewers to reconsider a subject that has a long history of being viewed as divine. Parque's sculpture includes historical gestures and cues that identify the subject as Christ. The infant's right hand is raised in blessing, and the mass behind the head indicates a halo. Upon closer inspection, the viewer realizes that the artist has alluded to a halo with a distended cranium. The Christ figure is shown in a traditional pose, but the additional elements of the umbilical cord and the placenta are physical elements associated with birth that society in general is reluctant to look at or discuss. The resulting image is a sacred figure that has been rendered heretical by its earthly and physical components.

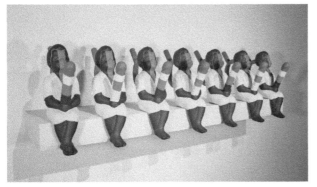 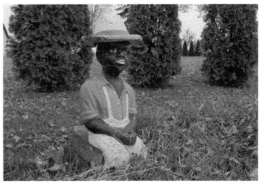

In *You're the Bomb, Pop*, Maryland artist Benjamin Schulman pairs an iconic American lawn ornament with an enlarged penis (figure 7). By juxtaposing the two objects, he questions the origins and innocence of these boy figures as lawn ornaments (figure 8). Schulman writes, "This series of sculptures, derived from contemporary lawn ornamentation, investigates topics such as racism, latent racism, and associated eroticism. The work is not meant to reinforce societal stereotypes but to reveal some of the ways in which these stereotypes are unthinkingly propagated." The repetition of these boys with their hands clasped around their penises is intended to provoke disgust. By using this abject approach, the artist intends us to never see the ornaments in the same way again.

FIGURE 7 [LEFT]. Benjamin Schulman, *You're the Bomb, Pop*, 2007. Slip cast terra cotta, 17 × 59 × 16 in. Collection of the artist.

FIGURE 8 [RIGHT]. Example of a vintage backyard Black Face Boy, Lake Winnebago, Wisconsin, 2013.

E. Appropriation

Appropriation is an important part of modern and postmodern art practice. **Appropriation** in art is the borrowing of imagery, styles, or entire works of art to create new content, subvert the original content, or question assumptions. As we will see in a later section, for example, **Pop art** borrows from consumer and pop culture to create a new context and question assumptions about those images. Dada collage and readymades take materials from outside traditional art media to question the norms in art as well as society. As we saw earlier in this section, Schulman borrows the lawn ornament to question the innocence of its origins and continued use.

Duchamp is also known for his appropriations involving works of art made by other artists that he made his own, often by scribbling on the

Figure 9.
Marcel Duchamp, *Mona Lisa parody, L.H.O.O.Q.*, 1919. Postcard reproduction with added moustache, goatee, and title in pencil, 8 × 5 in.

image. The most famous of these is a print of the *Mona Lisa*, on which he wrote the initials "L.H.O.O.Q." (figure 9).

At one point in his career Duchamp stated that the initials "L.H.O.O.Q" were meant to be read phonetically. Translated from Duchamp's native language of French, the initials may be perceived as the French phrase *Elle a chaud au cul*, which means, "She is hot in the ass." Either way the initials are translated or perceived they make a statement, as if to say, "Look what I did to one of the most important paintings in the history of art."

Appropriation can lead to serious, thoughtful consideration of the past and art's role in depicting it, as we see here with New York artist Tessa Sutton's painting *George's False Support* (figure 10). Sutton reimagines Henry Shrady's sculpture *George Washington at Valley Forge* without its pedestal (figure 11). It is instead held up by a human figure struggling under the statue's weight. The result questions the bronze rendering of Washington as a sole heroic individual. With the second figure added, Washington's role becomes a more complex historical conundrum. As you've seen from the examples in this section, art can raise eyebrows as well as questions, and it can teach us about our own biases and expectations in what we consider art.

Figure 10 [Left].
Tessa Sutton, *George's False Support*, 2011. Oil on canvas, 13 × 13 in. Collection of the artist.

Figure 11 [Right].
Henry Merwin Shrady, *George Washington at Valley Forge*, 1901–06. Bronze, Continental Army Plaza, Brooklyn, New York.

4.4 Nonrepresentational Approaches

FIGURE 1 [LEFT].
Piet Mondrian, *Haystack*, 1897–1898. Watercolor and gouache on paper, 25.2 × 18.5 in. Gemeente Museum, The Hague, Netherlands.

FIGURE 2 [RIGHT].
Piet Mondrian, *The Red Tree*, 1909. Oil on canvas, 27.5 × 39 in. Gemeente Museum, The Hague, Netherlands.

Nonrepresentational or non-objective art does not resemble anything in the real world. Instead, formal elements and design principles like color, space, balance, and repetition take the place of subject matter. Just as the evolution of art did not simply leap from representational to nonrepresentational forms, some artists also pass through many stages of development. We can see this progression of art — from naturalistic through abstraction into complete nonrepresentational imagery —in the work of Dutch artist Piet Mondrian.

These five Mondrian paintings form an evolving series of landscapes with increasingly pared down subject matter. First, *Haystack* provides a naturalistic scene of nature (figure 1). Next, *The Red Tree* presents a single tree (figure 2), and that leads to a more cubist interpretation of a tree shape in *Gray Tree* (see figure 3). In *Composition No. IV*, Mondrian moves away from recognizable form altogether while maintaining the essence of the artist's hand in the brushstrokes (see figure 4). In the final painting, *Composition*, which is emblematic of the style Mondrian would use until his death, the paint application is vacant and the grid becomes dominant (see figure 5).

Chapter 2 briefly discussed nonrepresentational art, but here we will explore two specific and separate trends within this approach to art: pure geometry, as seen in the work of Piet Mondrian, and pure expression.

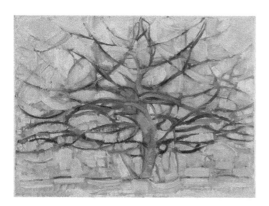

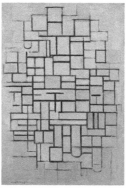

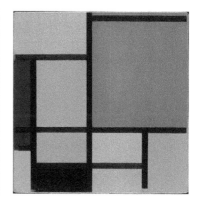

FIGURE 3.
Piet Mondrian, *Gray Tree*, 1911. Oil on canvas, 31.4 × 42.9 in. Gemeente Museum, The Hague, Netherlands.

FIGURE 4.
Piet Mondrian, *Composition No. IV*, 1914. Oil on canvas, 34.6 × 24 in. Gemeente Museum, The Hague, Netherlands.

FIGURE 5.
Piet Mondrian, *Composition*, 1921. Oil on canvas, 19.5 × 19.5 in. Metropolitan Museum of Art, New York.

A. Pure Geometry

On one hand, **pure geometry** is exactly what it sounds like — simply shapes. On the other hand, the purity of geometry was a philosophical and spiritual ideal for some artists. Geometric abstraction is a form of nonrepresentational art based on the use of geometric forms. The nonrepresentational style of pure geometry was itself the goal for some, but other artists used pure geometry to express something deeper. This was especially true for Mondrian, who was influenced by the theosophical movement that sought to attain knowledge that was more profound than what could be known through measurable, scientific means. In *Composition*, the color, shape, and lines are pure geometry and, for Mondrian, pure spirituality (figure 5).

One of the original non-objective artists who upheld spirituality's role in her artistic development was Swedish artist Hilma af Klint. She chose to paint in a nonrepresentational style because as a spiritualist, she believed a higher consciousness was speaking through her. Her art has been described as striving to give insights into the different dimensions of existence. The circular forms in her large-scale painting, *The Ten Biggest, No. 3, Youth, Group IV*, embody this goal (figure 6).

Another inspiration behind pure geometry was music. Russian artist Wassily Kandinsky, another forerunner of non-objective painting, cited a connection with music in his work. He understood that just as music could

capture feelings and ideas without reliance upon or reference to recognizable forms, the same could be done in art. In his playful drawing, *Free Curve to the Point — Accompanying Sound of Geometric Curves*, the eye is directed toward a circle by a tapering stroke of black (figure 7). Overlapping the stroke are thinner lines, which appear to be interrupted circle segments. The variety of delicate and forceful line reflects the liveliness of a classical music composition.

Use of pure geometry was not exclusive to these avante-garde twentieth-century artists. It can be found in the art of many cultures throughout history, both as decorative motifs and as art pieces themselves. For many Muslim artists, Arabic calligraphy takes the place filled by depiction in the Western world. This is because Islamic custom avoids depiction of religious figures. In this page from a manuscript of Persian poet Firdawsi's *Book of Kings*, the unknown artist arranges the poem to create a repeating zigzag pattern surrounded by strong verticals and horizontals (see figure 8). Geometric patterns visually connect spirituality with science and art, all of which are key to Islamic thought from the seventh century to now. This measured and precise consistency is sometimes interpreted as connected to a holy or spiritual ideal.

FIGURE 6.
Hilma af Klint, *The Ten Biggest, No. 3, Youth, Group IV*, 1907. Oil and tempera on paper, 126.4 × 94.5 in. Moderna Museet, Stockholm.

De Stijl

De Stijl is a Dutch artistic movement founded in 1917 that uses pure geometry in its design. The term De Stijl means "The Style" in Dutch. In general, De Stijl proposed ultimate simplicity and abstraction — both in architecture and painting — by using only straight horizontal and vertical lines and rectangular forms. Furthermore, the color vocabulary was limited to the primary colors (red, yellow, and blue) and the three primary values (black, white, and gray). The works avoided symmetry and attained aesthetic balance by the use of opposition.

This modern art movement sought to express a new utopian ideal of spiritual harmony and order. Theo van Doesburg was a founding member, as was Piet Mondrian. Notice the exclusive use of vertical and horizontal lines and the pared down color palette of gray, white, black, and blue throughout Doesburg's *Composition IX* (see figure 9). The repetition of **rectilinear** shapes creates rhythm as shapes connect across the visual field.

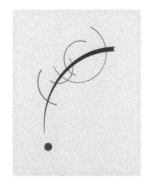

FIGURE 7.
Wassily Kandinsky, *Free Curve to the Point — Accompanying Sound of Geometric Curves*, 1925. Ink on paper, 15.7 × 11.8 in. Metropolitan Museum of Art, New York.

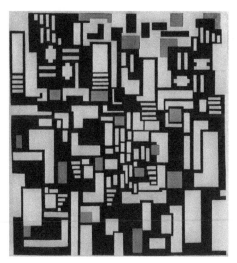

FIGURE 8.
The Story of Zahhak and His Father [Page from a Manuscript of the *Shahnama* (*Book of Kings*)], seventeenth century. Ink and gold on paper, 9.7 × 15.2 in. Brooklyn Museum of Art, New York.

FIGURE 9.
Theo van Doesburg, *Composition IX*, 1917–1918. Oil on canvas, 45.7 × 41.7 in. Gemeente Museum, The Hague, Netherlands.

FIGURE 10.
Gerrit Rietveld, *Red and Blue Chair*, 1917. Painted wood, 34.1 × 26 × 33 in. With permission of the chair's owner.

In many three-dimensional De Stijl works, vertical and horizontal lines are positioned in layers or planes that do not intersect, thereby allowing each element to exist independently and unobstructed by other elements. This feature can be found in *Red and Blue Chair* by Dutch furniture designer and architect Gerrit Rietveld (figure 10).

Bauhaus

The **Bauhaus** was a school in Germany that combined crafts and fine arts. Famous for its functionalist approach to design, Bauhaus style was marked by the absence of ornamentation and the harmony between function and overall design. The most famous example of Bauhaus style is the architecture of the school itself (figure 11). The design innovations commonly associated the Bauhaus — radically simplified forms, rationality, functionality, and the idea that mass-production was reconcilable with the individual artistic spirit — were already partly developed in Germany before the Bauhaus was founded. Within this movement, working architects rejected fanciful experimentation, focusing on rational, functional, and standardized buildings. The acceptance of modern design into everyday life was the subject of publicity campaigns, well-attended public exhibitions, films, and public debate.

Hungarian-born furniture designer Marcel Breuer was head of the woodworking shop at the Bauhaus when he designed the *Wassily Chair* (figure 12). Its original tubular steel and canvas construction creates a functional form based on line and plane. This chair was intended to be mass-produced and is still available today.

After Hitler's rise to power and the beginning of World War II, the teachers from the Bauhaus were scattered across the world. Many landed in America and began teaching in Boston, Washington, DC, Chicago, New York, and Ohio. Their influence upon later generations of students and architects cannot be overstated. Study and imitation of Bauhaus is an important part of visual design concepts, and is regularly taught as part of college courses in design.

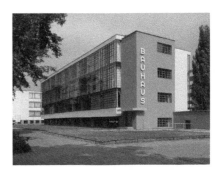

FIGURE 11.
Walter Gropius, *The Bauhaus Building*, 1925-26. Dessau, Germany.

B. Minimalism

In the visual arts, **Minimalism** is a style that uses as few elements as possible in its general composition. Minimalism in the arts began in post–World War II Western art, most strongly with American visual arts in the 1960s and early 1970s. It has origins in modernism's desire to reduce art to its core components and is often acknowledged as a reaction against Abstract Expressionism.

The term "minimalist" often refers to anything that is stripped to its essentials — it includes the bare minimum. The European roots of minimalism come out of the geomet-

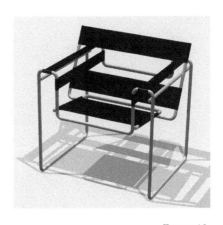

FIGURE 12.
Marcel Breuer, *Wassily Chair*, designed 1925. Tubular steel with leather straps, 31.1 × 27.1 × 28.7 in. Computer generated photo model.

ric abstractions of painters associated with the Bauhaus, in the works of Kazimir Malevich, Piet Mondrian, and other artists associated with the De Stijl movement. The word minimalism was first used to describe *Black Square*, a 1913 painting by Russian painter Kazimir Malevich (see figure 13).

Minimalism emerged in the United States in New York in the early 1960s as old and new artists moved toward the abstractions in pure geometry. They were heavily criticized by modernist formalist art critics and historians. Some critics thought minimal art represented a misunderstanding of the modern artistic dialogue, particularly in sculptors' separation of material and design. Many sculptures were purely

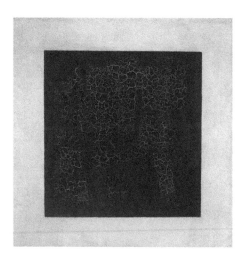

Figure 13.
Kazimir Malevich, *Black Square*, 1915. Oil on canvas, 31.29 × 31.29 in. Tretyakov Gallery, Moscow, Russia.

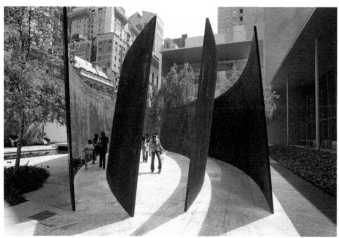

Figure 14.
Richard Serra, *Intersection II*, 1992–1993. Four identical conical sections of weatherproof steel, 157.48 × 618.11 × 2.12 in. Sculpture Garden, Museum of Modern Art, New York. © 2016 Richard Serra / Artists Rights Society (ARS), New York.

manipulations of materials that were otherwise untouched, as in Richard Serra's *Intersection II* (figure 14). Serra is the designer who chose the size, shape, and material of the sculpture, but the resulting art feels so far removed from the hand of an artist. The gloriousness of the art is in the utter perfection of the materials.

Dan Flavin's repeated use of fluorescent lightbulbs in his sculptures follows this logic. In his series of untitled sculptures, *Untitled* (For Don Judd), Flavin crafts five T-shaped structures, identical in every way except the color of light emitting from the fluorescent bulbs (figure 15). The balance of light and dark in the room is Flavin's focus, as well as the purity of the bulbs and fixtures that stand alone in each of the five pieces. The dedication to "Don Judd" references Minimalist artist Donald Judd, who named his son after Flavin.

Some Minimalists broke from the previous decade's Expressionism very explicitly, stating that their art was not about self-expression at all. Unlike more subjective philosophies about art, making theirs was objective. In general, Minimalist art features mostly geometric forms purged of any metaphor or grander meaning. Their art was about equality of parts, repetition, neutral surfaces, and industrial materials.

C. Pure Expression

Pure expression relies not on the purity of geometric shapes but on the power of the artist's mark. The movement and intention of the artist is captured in colors, layers, visual texture, lines, organic shapes, drips, or all of them combined. This is certainly visible in Oregon artist Robert Tomlinson's *Stream #20* (figure 16). The strokes and drips of paint follow a single vertical direction, with an occasional rippling curve to the left or right. Rather than a single subject centered in the painting, pure expression paintings typically share this "all-over" approach, in which the whole canvas is treated with equal importance.

FIGURE 15.
Dan Flavin, *Untitled* (For Don Judd) 483–488, 1987. Flourescent lights, 48 × 48 in. Photograph of Structure and Clarity exhibition at Tate Museum, London, UK. © 2016 Stephen Flavin / Artists Rights Society (ARS), New York.

The origins of pure expression can be seen in the work of earlier artists. As we have seen throughout this book, Vincent van Gogh's paintings show the movement of the artist's hand dashing over the surface. These brushstrokes reveal more than the objects they represent. They conjure emotions or evoke movement on the two-dimensional surface. Likewise, Austrian painter Egon Schiele uses daubs of paint and colors symbolically in *Self-Portrait with Chinese Lantern Plant* to embed emotional content into his own likeness, accenting the misery in his facial expression (see figure 17).

If this color and technique-based approach to painting can underscore the mood of a scene or portrait, it ought to be able to convey mood and feeling without any subject matter. Nonrepresentational painting that aims for pure expression takes this as its premise. In the rest of this section we will look at two specific types of pure expression painting: abstract expressionism and color field painting.

FIGURE 16.
Robert Tomlinson, *Stream #20*, 2014. Oil stick, pastel, chalk, pencil, and acrylic on paper, 44 × 30 in. Collection of the artist.

Abstract Expressionism

Abstract Expressionism is an American post–World War II art movement. The movement took its name by combining the style of German Expressionists, who shared their emotional intensity and self-denial, with the anti-figurative aesthetic of the European abstract schools such as the Bauhaus and Synthetic Cubism. The movement was the first specifically

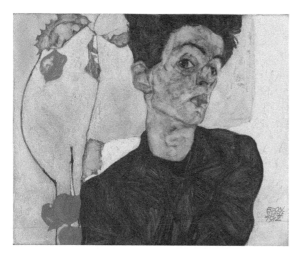

Figure 17.
Egon Schiele, *Self-Portrait with Chinese Lantern Plant*, 1912. Oil on panel, 12.7 × 15.7 in. Leopold Museum, Vienna, Austria.

American movement to achieve international influence and put New York City at the center of the Western art world, a role formerly reserved for Paris.

American painter Jackson Pollock epitomizes Abstract Expressionism. During the late 1940s, Pollock began a radical approach that made the process of painting equally important to the art itself. His technique was unique. Most of Pollock's paintings were created using the same technique, and *Cathedral* is just one example (figure 18). Instead of using an easel, he placed raw canvas on the floor — frequently over a dozen feet wide — where it could be attacked from all four sides. He used both art and industrial materials in his paintings. He threw and dripped paint onto canvases, drew, stained, and brushed. Pollock was both encouraged and supported by Clement Greenberg, an influential critic who maintained that subject was unnecessary to art and should be abandoned. Other Abstract Expressionists followed Pollock's lead with breakthroughs of their own, opening the floodgates to diversity, inventiveness, and far-reaching scope. One trait they continued to use after Pollock was exceedingly large canvases.

Color Field Painting

In contrast to the emotional energy and gestural surface of Abstract Expressionists, the color field

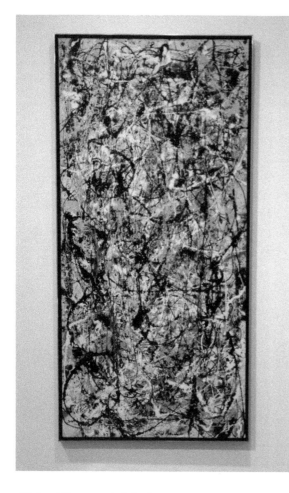

Figure 18.
Jackson Pollock, *Cathedral*, 1947. Enamel and aluminum paint on canvas, 71.5 × 35.075 in. Dallas Museum of Art, Dallas, Texas. © 2016 The Pollock-Krasner Foundation / Artists Rights Society (ARS), New York.

painters initially appeared to be cool and austere. They rejected the individual mark of Expressionism in favor of large, flat areas of color. Color field artists considered their work to be the essential nature of visual abstraction. American artists such as Mark Rothko and Helen Frankenthaler painted with a highly articulated and psychological use of color. Many images of their work can be found online by searching for the artist's name. By pursuing this direction, artists often present each painting as a cohesive, monolithic image. While color field painting is considered both sensual and deeply expressive, it maintains a clear visual distinction from the more gestural Abstract Expressionism.

FIGURE 19.
Dayna J. Collins, *The Essence of a Thing*, 2015. Plaster, oil, and cold wax, 30 × 30 in. Collection of the artist.

Dayna J. Collins is an Oregon artist who follows in the footsteps of color field painters. We see this in the structure of *The Essence of a Thing*, primarily in the horizontal magenta and lime green color bands (figure 19). Looking more closely, a bridge is created between the two by a pure red and pale blue. The color is applied to give it substance. This can be seen in the hot pink circle and the layering of vertical strokes in the magenta color band beneath it.

Looking at nonrepresentational art in this way shows us that art does not necessarily require a precise answer to the question: "What is this supposed to *be?*" Nonrepresentational movements freed artists from the need for a clear and specific subject. While this was not immediately accepted — as evidenced by frequent critiques that Pollock paintings look like a child had painted them — a 2013 auction at Christie's auction house saw a Pollock painting sell for over $58 million, showing that at least where the market was concerned, Pollock's work had gained acceptance by serious collectors. There is something elemental and deeply satisfying about the way that simple shapes or patterns, drips of paint or fields of color, can evoke rich, subjective responses from viewers of art.

4.5 Pop Art and Postmodernism

As we've seen in this chapter, art is always changing in response to a changing world. The twentieth century has seen the definition of art crack wide open in response to a world wracked by major wars, economic turmoil, technological advancements, and cultural shifts. Our exploration of art's expanding definition concludes with overviews of Pop art and Postmodernism.

A. Pop Art

Pop art is characterized by themes and techniques taken from mass culture such as advertising and comic books. It uses images of popular — as opposed to elitist — culture in art and emphasizes the banal or "kitschy" elements of any given culture. Pop art is easy to recognize because of its similarity to advertising and mass media. Pop art emerged in the late 1950s and has been embraced by museums and artists. However, to understand how radical this borrowing from popular culture was at the time, we need to consider the prior rift between popular culture and high art.

High art is art that deals with lofty and dignified subjects and is characterized by an elevated style. This definition comes from the nineteenth century. At that time, people who had been wealthy and powerful for many generations felt threatened by the new and wealthier industrialists. The old wealth felt socially undermined by the new, so they responded by making an issue of their own relationship to art. They asserted that only people with high social status or connoisseurs — people who made a special study of art but may have been of lower social status — were allowed

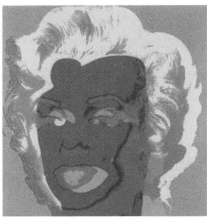

to have opinions about it. Anyone who hadn't grown up with art couldn't properly understand or appreciate it. This attitude about appreciation for high art made people who aspired to high social status feel uncomfortable and out of place around art.

Popular culture was also born in the nineteenth century. With the Industrial Revolution, it became possible for original works of art to be duplicated in large numbers by machines. These machine-made works were affordable for people who previously hadn't been able to purchase art at all. Appealing to this new, broad audience was crucial for success, so these works of art had unspoken guidelines. They avoided controversy, produced an instantaneous emotional reaction, and presented popular or common ideals of beauty and social behavior in a simple, straightforward way. This kind of art was often used to sell products or services as part of early advertising campaigns such as this ad for soap from 1886 (figure 1).

As this kind of art became available to just about anyone, consumers of traditional art tried to create distinctions between the high art that they valued and the art that popular audiences enjoyed. This "art-that-wasn't-art" gradually came to be known as **kitsch**, a German word meaning trivial, shallow, sentimental, and cheap. Kitsch appeals to the uneducated and is machine-reproduced. By definition, anyone who liked kitsch could not be part of the world of "real" art.

Pop art, however, embraced the concept of kitsch — if not the word — and turned it on its head. The avant-garde artist most associated with this movement is Andy Warhol (figures 2 and 3). He was an artist who started out as an illustrator for advertising and magazines and then moved into showing paintings and drawings at art galleries. He also made silkscreen prints,

Figure 4 [Left].
sandra "sloy" nichols, *what women make*, 2014. Oil, pen, and pencil on canvas, 48 × 48 in. Collection of the artist.

Figure 5 [Right].
Peter Morgan, *The Icecream-burrrg Slurptastic Titanic Disaster of 2008*, 2005–2008. Earthenware and mixed media, 45 × 22 × 20 in. Collection of the artist.

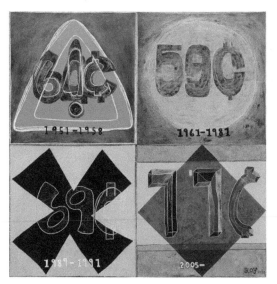

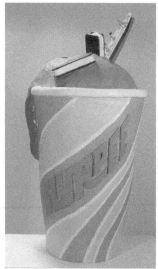

a process of reproduction used for mass media like posters and T-shirts. His prints of enlarged Campbell's soup cans and his series of colorful Marilyn Monroe portraits have become iconic images in modern art. These and other of his images are easily found online by searching for the artist's name.

With the emergence of Pop art, a sense of the epic quality of art is replaced with a sense of the everyday, and mass-produced commodities are awarded the same significance as one-of-a-kind objects. Pop art intentionally erodes the gulf between high art and popular art. The irony, however, is that although pop art sometimes targets a broad audience, much of Pop art is considered highly academic and beyond the grasp of most viewers.

Borrowing from popular culture phenomena such as advertising does not mean the art will have the limited scope of an advertisement. A typical advertisement will attempt to sell a service or product as long as that product is available. Oregon artist sandra "sloy" nichols borrows from a style of storefront signage for her painting, *what women make* (figure 4). These graphics display the gap between men's and women's pay rates, and the use of advertising underscores the parallel gap between knowing that this difference exists and taking action to change it.

Americans may not use the word "kitsch" very often, but most know the term "popular culture." These two terms describe the same things, but they place different values on those things. People use the term "kitsch" to distinguish mass-produced work from "real" art. People who use "popular

culture" accept that commercial art — including TV shows and video games — is a necessary part of culture.

Artists will often both embrace and subvert their subject within pop art. Wisconsin artist Peter Morgan juxtaposes a historic iceberg with a "cool and refreshing" fast food drink in *The Icecream-burrrg Slurptastic Titanic Disaster of 2008* (figure 5). By combining symbols of marketing with symbols of death and destruction, Morgan seems to be saying that manufacturers and their advertisers will stop at nothing to market their products.

Robert Rauschenberg's work falls into many of the categories in this chapter, from Surrealism and Expressionism to Pop art, and he falls neatly into the Postmodern art of the final section, too. Recognizing the transitional movements throughout modernism, Rauschenberg seems to capture them all with his "Combines," mixed-media installations that baffle viewers with their complexity and downright weirdness. *Monogram*, one of Rauschenberg's Combines, incorporates a stuffed goat, a flat tire, and a collage painting all on a platform that rolls on casters (figure 6). Such a combination is bewildering like Expressionism, a little dreamy like Surrealism, a little scary like Abject Art, and a little elusive and visually striking like Minimalism. Rauschenberg's ability to elicit all these emotions at once sets him apart as a voice in modern and postmodern art, which opened the floodgates even further for what could be considered art in the twentieth and twenty-first centuries.

The Pop art movement provided the necessary shift from old ways of thinking to the present belief that art can, in fact, be for everyone. The techniques and subjects of Pop art are taken from everyday processes and images, adding to the feeling that art can be accessible to and understood by everyday people.

FIGURE 6.
Robert Rauschenberg, *Monogram*, 1955–1959. Combine: oil, paper, fabric, printed paper, printed reproductions, metal, wood, rubber shoe heel, and tennis ball on canvas with oil and rubber tire on Angora goat on wood platform mounted on four casters, 42 × 63.25 × 64.5 in. Moderna Museet, Stockholm, Sweden. Purchase 1965 with contribution from Moderna Museets Vänner/The Friends of Moderna Museet. © Robert Rauschenberg Foundation.

B. Postmodernism

Postmodernism describes a range of artistic movements that both arise from and reject the trends of modernism. The supposed mutual exclusiveness of abstraction and reality — one or the other, but never both — is one important modernist idea that Postmodernism rejects. Postmodern art also resists all ideological positions. For example, one

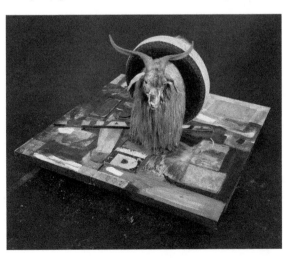

idea of the modern era is to lament that war has caused humanity to become fragmented and fractured. Postmodernism might celebrate that fragmentation. This mistrust of ideology is so deeply embedded in postmodern work that Postmodernism is frequently not just self-aware but self-referential.

An example of Postmodernism's self-reflexive tendency can be seen in "Duck Amuck," the 1953 Warner Bros. cartoon in which Daffy Duck wrestles with the illustrator's pencil that threatens to erase the character completely. The capricious illustrator continually draws and erases backgrounds, shifting scenery to place the main character in laughable situations. The cartoon shows awareness of one of its most iconic and comedic tropes by exchanging Daffy's parachute for an anvil. At the end of the cartoon, we find that Bugs Bunny is the one controlling the storyboard. This is Postmodernism by means of popular culture.

Postmodernism's most successful tool for exercising this self-awareness is irony, which Postmodernists define as a state of affairs or event that seems deliberately contrary to what one expects. Although many examples of Postmodernism seem dark or depressing, there is often underlying humor that focuses on the absurdity and irony of that darkness. Postmodern art tends to take two disparate ideas and play with the differences. Nichols' *what women make*, for example, draws on the irony of wage inequality legislation (see figure 4). The top left panel shows 64 cents, the average comparable earnings per dollar of women from 1951 to 1958. When President Kennedy signed the Equal Pay Act in 1963, women's average wages had actually been lowered to 59 cents in anticipation of the change. The irony is that the attempt to require employers to make earnings more equal resulted in the situation getting worse.

Another characteristic of Postmodernism is its combination of elite and popular culture, similar to Pop art's combining of high art and low art. An object that would be considered elite culture is a sculpture by Michelangelo. The lowest of low culture is pornography. Postmodern art blurs the distinctions between what is perceived as elite or high art and what is generally seen as low or kitsch art. By introducing elements of commercialism, fashion, kitsch, and a general camp aesthetic — a style of exaggerated theatrics — into older styles seen in Renaissance, Baroque, or Gothic art, postmodern art plays with the difference by blending the two. Imagine Michelangelo's *David* wearing a foam finger. The blending is part of the joke.

Postmodernism claims that there is no absolute truth and that the way people perceive the world is entirely subjective. It emphasizes the role of language, power relations, and motivations in the formation of ideas and beliefs, in particular. It attacks the use of exclusive binary classifications such as male/female, straight/gay, white/black, and imperial/colonial. Instead, it asserts that realities are plural and relative to the individuals involved. Postmodern approaches explore how social dynamics, such as power and hierarchy, affect our understanding of the world. For obvious reasons, this has important effects on the way knowledge is constructed and used. The well-known saying, "History is written by the victors," is an example of postmodern thinking about power affecting knowledge.

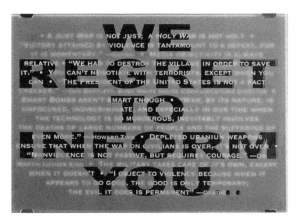

FIGURE 7.
Carol Hausser and Robert Bibler, *We Regret to Inform You...*, 2007. Etched glass and text, 12 × 18 in. Collection of the artists.

An example of a postmodern work about language and plural realities is *We Regret to Inform You* by Oregon artists Carol Hausser and Rob Bibler (figure 7). During times of war, letters with this opening phrase have been sent to disclose a loved one's death. Here, that phrase heavily obscures statements beneath by leaders and thinkers on war and nonviolence. The artists intend this obscuring to call to mind the "fog of war." We can imagine those background quotes paling into hushed voices as all thought stops when military officers appear at the door with the feared announcement. The artists write, "The phrase 'we regret to inform you' has a tragic, devastating clarity, and it casts in relief the harsh truths about the shallow promises and devastating costs of war." This collaborative approach to making art likewise challenges the traditional notion of individuality and the uniqueness of the singular vision.

Chapter 5:
Themes in Art

5.1 Identity

The idea of art as an isolated artifact, something made purely for its own sake, is relatively modern. As you saw in Chapter 1, the applied art objects now collected in museums were originally made to accomplish everyday tasks. Stone-age artists who carved bone and horn tools into animal shapes needed them, first and foremost, to function. Fine art objects today also have work to do, but this work is less physical and more metaphysical. Freed from utilitarian requirements, art invites us instead to ask the great questions of human existence: Why are we here? What are the causes of suffering and how can we control them? Where do we go when we die?

Some scholars suggest that we have an "art instinct," a natural inclination to perceive our surroundings with an aesthetic sense, and that this results in creative expression. Because the history of art is filled with images that represent people, it appears that we are and have always been intensely interested in what it means to be human, with a particular focus on the central experiences of birth, death, wonder, and celebration. In art, we call these recurring ideas themes. In order to consider the themes in works of art, we need to look beyond the subject, style, or technique of a particular work and consider its underlying **concept**. This chapter cannot cover the wide range of themes in art, but it can show you how they operate by looking at five important themes — identity, social order, the invisible, place, and narrative — that are repeated in art from prehistoric times to today.

A. Ancient Art

Paleolithic works were created in the prehistoric era. The term "prehistory" literally means the time before writing, so prehistoric art does not have documentation to tell us about its original meaning or function. Scholars have to compare works of art, their media, and their place of origin to make objective, informed conclusions about the works' original meanings and functions.

One of the earliest examples of human expression is *Woman of Willendorf*, which has been dated to about 30,000 years ago (figure 1). The small figure is abstract, with a simplified form. The female figure's arms are

draped over enormous breasts, and the enlarged genitalia, short legs, and protruding abdomen reinforce the importance of childbearing in primitive society. Some scholars think the tightly patterned headpiece indicates either braided hair or a knit cap. This figure is one of many from the Paleolithic period that emphasizes the fertility of women.

The sculpture is remarkable both for what the ancient sculptor included and what was left out. What is missing is any hint of facial features, which erases the figure's individual identity in favor of a more universal representation of the primary Paleolithic need for survival. Most of us would expect that early humans would be most concerned with the continuation of their species, and the *Woman of Willendorf* confirms that expectation. It also shows us that those same humans were interested in creating artistic self-representations.

In addition to small abstracted sculptures, Paleolithic artists also contributed to galleries of paintings. These "galleries" were not in museums like we have today. They appear in large and small caves across the world. One of the best known collections of paintings is in the Lascaux caves in southwestern France. Although scholars cannot determine a definitive meaning or reason for the images at Lascaux, it is clear — 17,000 years after their creation — these cave paintings call attention to the presence of individuals with unique perspectives on life.

The Lascaux caves consist of many chambers containing nearly one thousand depictions of animals on its walls. The most famous part of the cave is often referred to as the *Grand Gallery* or the *Hall of Bulls* (figure 2). This room is decorated with thirty-six different animals including bulls, horses, and deer. Paleolithic artists produced this work with a mineral pigment medium, drawn with or blown through hollow reeds or bones. Additional media include drawing with charcoal from scorched sticks and cutting the wall of the cave.

While the thirty-six animals in the Hall of Bulls appear at first glance to be a planned mural of a stampede with an unusual variety of animals, this may be a result of our modern inclination to perceive such a vast collection as a singular work. It is more likely that the thirty-six images were produced by different individuals at different times because the materials and media change between animals, the paintings exhibit different artistic styles, and some paintings are in silhouette while others are in outline (figure 2). These stylistic

FIGURE 1.
Woman of Willendorf, ca. Paleolithic period. Limestone, 4.4 in. Natural History Museum, Vienna, Austria.

FIGURE 2.
Hall of Bulls [detail], ca.15,000 BCE. Lascaux Caves, near Montignac, France.

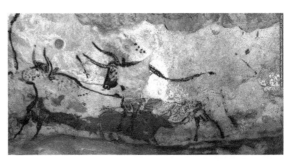

differences can be seen in the two bulls shown, both in profile and both executed with contour line.

The use of profile enables the artist to convey the most information possible about this animal. The viewer understands the detail, girth, and power of the animal. The artists were so concerned with detail that the horns are portrayed from the front rather than in profile. This is a common technique in Paleolithic painting. Other artists have placed silhouettes of horses and deer between and around the bulls. Some theories suggest the paintings were used in training for hunting, while others suggest the images served mystical purposes and were used as an attempt to control the environment. What's certain is that these humans are locked in a constant battle against harsh natural forces. Just as *Woman of Willendorf* illustrates the continuation of generations through reproduction, the cave paintings capture the extremes of this struggle to survive.

Ancient Egyptian sculpture provides us another example of the importance of the individual and a desire for continued existence. As you may already know, high-ranking individuals in Egyptian society were mummified and buried in tombs. These burial structures included the mummified remains of the deceased, and they served as a memorial to the person's life. In a practical sense, the structure of the tomb and the practice of mummification ensured the remembrance of the individual after death.

However, these tombs also had a purpose beyond memorializing these leaders. Egyptians believed that humans have a spirit, called the *Ka*, which exits the body upon death. Mummification and burial preserved the individual's body until it could be reunited with the *Ka*. This reunion was so important that the Egyptians included a sculpture of the deceased in its own special chamber, called a *serdab*, as a kind of spiritual insurance. If the tomb was pillaged or the mummification process unsuccessful, the *Ka* sculpture represented a place for the *Ka* to return.

This sculpture of a scribe is an example of a *Ka* statue and includes elements that tell us about the life of a scribe (figure 3). The figure is seated with an open scroll placed on his lap, indicating his lifelong profession of reading and writing. Scribes were some of the most respected members of the Egyptian court. Most people in ancient Egypt were illiterate, and training to be a scribe took years. The scribe's *Ka* statue reveals a lot about Egyptian cultural emphasis on an individual's occupation rather than their appearance. Although we can identify the profession of this person, the sculptor's goal was not to replicate the exact features of the deceased.

The viewer recognizes the form as human, but closer inspection reveals that the work is delicately abstracted. The head consists of a series of flat and rounded planes which communicate a general facial structure rather than a specific person's appearance. The simplified body structure indicates musculature with line, and there is no separation between the arms and torso. This figure is depicted in a closed form space, meaning that space is filled in to complete an almost block-like form.

These stylistic elements — which might seem impersonal to us — were crucial for the scribe's continued existence in the afterlife. Remember, if the mummification process is disturbed, the sculpture is there to house the *Ka*. The closed form is a stable structure that serves to protect the sculpture from destruction and decay. The existence of this sculpture after millennia helps ensure the permanent remembrance of this individual.

Many art historians and artists view the production of art as a way for individuals to express their identities across time. So far, we have been looking at images that focus on mostly unidentifiable individuals, but art is also used to identify specific people and their position in society, as we will see in the next section.

FIGURE 3.
[Scribe Sitting with a Papyrus], Egyptian 5th dynasty (2500 – 2350 BCE). Painted limestone, 21.14 in. Louvre, Paris.

B. Portraits

A portrait captures a likeness while also telling a story about the subject. In the same way the Egyptian sculptor included the profession of the scribe, the portrait artist includes details to reveal information about other facets of the subject's life, from family history and social status to political leanings and hobbies. In seventeenth-century Holland, for example, it was common for individuals to declare their position in society by commissioning a portrait. Typically, this was assigned to an artist who could paint the portrait of the important person. However, Judith Leyster's *Self-Portrait* was created to reveal

the artist's own status and technical skill (figure 4). After years of rigorous training, this painting served as Leyster's presentation piece to the Haarlem St. Luke's guild, the city's association of painters. As evidence of her capabilities, *Self-Portrait* literally became her masterpiece. The work was accepted, signifying Leyster's transition from student to master.

In a notably self-aware decision, Leyster asserts her presence and profession by painting herself in front of an easel. The easel contains a canvas that she is working on, which cleverly allows her to show — twice — that she is able to masterfully reproduce the human form. As an accomplished painter, she comments further on her identity by depicting herself painting a live subject, an uncommon practice for women in the seventeenth century when most women were limited to still-life painting. Her clothing also indicates her social status. Her dress is made from a variety of expensive fabrics lined with lace cuffs, and she wears an elaborate lace collar. These are not the

clothes that Leyster would have worn while painting. They tell the viewer that in addition to being an accomplished painter, Leyster's profession and wealth afford her an elegant lifestyle. Leyster's *Self-Portrait* tells us about her accomplishments almost four hundred years after her death. Like the scribe sculpture, her image ensures that she will be remembered.

In Leyster's time, individuals used portraiture to depict themselves as upstanding middle-class citizens. This tradition continues with the modern technology of photography, as individuals and families regularly record their images with the help of portrait studios and personal cameras. Oregon artist Ann Ploeger carries on this tradition with her contemporary portraits of middle-class Oregonians. She presents her subjects holding objects that define their accomplishment and refinement. In *Zak and Erin* (figure 5), the couple is dressed nicely and appears to interact with the viewer as a host would with a guest. Both offer the viewer a drink, and the table is set and ready for a feast of Pacific Northwest fare. This pair appear to be approachable, polite people who work hard and enjoy having company over for a home-cooked meal.

You might notice, however, that the scene in Ploeger's photograph is not perfect. Burning food is left on the grill, debris is strewn about the deck, and the couple stands barefoot. Ploeger is not afraid to focus on her subjects'

FIGURE 4.
Judith Leyster, *Self-Portrait*, 1630. Oil on canvas, 29.38 × 25.63 in. National Gallery of Art, Washington, DC.

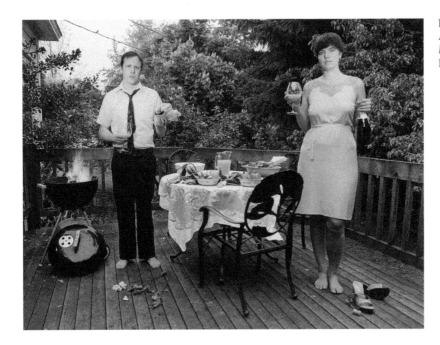

FIGURE 5.
Ann Ploeger, *Zak and Erin,
Portland, OR*, 2014. Photograph.
Private collection.

flaws. In real life, things are not always ideal, and photography's ability to capture precise detail allows Ploeger to show us a more realistic — and imperfect — image of everyday life and identity.

C. Graffiti

Leyster and Ploeger's portraits and the sculpture of the scribe stress the presence of specific individuals. *Woman of Willendorf* and the Hall of Bulls indicate how art can assert the existence of individuals without specifically identifying who they are. This is often the case with **graffiti** or **street art**, too.

Graffiti artists produce work in a variety of media, commonly including spray paint, stencils, stickers, or prepared images on paper that are pasted onto surfaces. These surfaces are typically outdoors and highly visible, and in many cases, the owner of the surface has not approved the addition of art — in fact, graffiti is usually considered vandalism, an illegal activity in most areas. This makes graffiti controversial, of course, but it also makes it temporary. The owners of the surfaces often remove or paint over the art, sometimes after just a short time.

Like mural art, street art can be an important element of a community's artistic style and expression. However, through the end of the twentieth century, the clearest public attention to graffiti artists came from the police, who punished the art as an act of vandalism and a sign of gang activity. It is still widely understood as a destructive act rather than one that beautifies the community. In the midst of this contentious debate about the validity of their work, graffiti artists have developed individual styles and sophisticated visual messages, and this has gradually begun to change public perception.

Some graffiti artists have gained recognition in major art circles and seen their style become fashionable — even accepted as fine art — after years of hiding in the shadows or running from police. Under new city regulations, street art is now more likely to have its own place in urban landscapes, reflecting the identity and culture of the cities that willingly harbor it. Street art and mural art share many of these common characteristics, and like mural artists, street artists' creativity has exploded into a wide variety of styles, subjects, techniques, and colors.

An example of these formal characteristics can be seen in the large-scale graffiti art compilations in a series of abandoned railroad tunnels just above Donner Pass in northern California (figure 6). The individual contributions at Donner Pass range from carefully planned stencils and paintings to words scrawled on the walls with a quick application of spray paint. This variety recalls the bulls and deer at Lascaux. Just like the prehistoric cave paintings, what may have started out as a singular expression of one person's idea becomes part of a larger collective. These tunnels stretch for hundreds of yards and have been "tagged" and painted on by multiple individuals over the course of many years, resulting in a monumental expression. For these reasons, it is easy to see the example of graffiti at Donner Pass as a modern-day cave painting (figure 7).

One part of the Donner Pass Graffiti, known as *Only You*, reflects an individual artist's concern for issues facing the state of California (figure 8). The image combines the iconic face of Smokey the Bear, a well-known character and symbol of fire safety in forested areas, with part of Smokey's famous catchphrase, "Only you can prevent forest fires." The West Coast is increasingly plagued with forest fires, and preventing them

FIGURE 6.
Various unknown artists, [Donner Pass Graffiti detail]. Donner Pass, California.

FIGURE 7.
Various unknown artists, [Donner Pass Graffiti detail]. Donner
Pass, California.

FIGURE 8.
Unknown artist, *Only You*, date unknown. Donner Pass,
California.

is of grave importance for most inhabitants of the western United States.
The artist has added commentary below Smokey's head: "Burn walls, not
forests." With this statement, the image merges individual and communal
concerns. The viewer is instructed to direct any burning away from forests
and toward social barriers. The suggestion that the viewer "burn walls" pos-
sibly indicates the frustration of one individual who has their voice silenced
elsewhere in society. This dramatic association links a destructive, anarchist
statement with a well-known conservationist catchphrase.

By choosing graffiti as the method to deliver this message, the artist
gains the opportunity to voice anti-social, counter-cultural, or destructive
ideas from outside of the established art world. In this way, a statement or
idea that would be silenced by a more mainstream art audience is allowed
to exist, perhaps permanently in a location such as Donner Pass. Just as
important, it allows these artists to assert their own identity.

5.2 Social Order

When most people imagine an artist, they think of a single person working alone in a studio late into the night to create a personal vision. This may be an accurate perception of some artists, but it's not the whole story. Art has many other functions, and there are many types of artists.

Earlier, we looked at how art communicates individual identity, but for most of history, art has functioned as a way for powerful groups or individuals to proclaim their power and influence over others. At times art has celebrated the powerful, while at other times it has questioned or even ridiculed them. This section will look at the way art reflects, maintains, or challenges societal conventions. We'll look first at how a particular piece of art addresses past politics, conflict, and war. We'll follow that by examining how two contemporary artists respond to social order in the United States.

A. Politics and Conflict

You may have heard the well-known phrase, "history is written by the victors." This refers to how the winners of a war can influence the official version of a conflict by wiping out the memory of their opponents. Art is one way for victors to show who has the power, whose voices will be heard, and whose version of events will become fixed in time.

Leaders in the ancient society of Sumer — present-day Iraq — used art to record the roles and actions of individuals with power. An example of this is *The Standard of Ur*, which English archaeologist Leonard Woolley

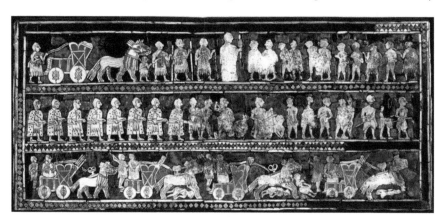

FIGURE 1.
The Standard of Ur, "War" panel, Sumerian box, 2600–2400 BCE. Lapis lazuli, shell, and red limestone, 8.5 × 19.5 in. British Museum, London, England.

found in a large burial pit outside the ancient city of Ur. The Standard is a wooden box decorated on four sides with lapis lazuli, shell, and red limestone (figure 1). It is just one of the many items from the burial site that tells a story of wealth and power. The artwork is arranged in three horizontal levels, called registers, which are meant to be read from bottom to top. Although the work is quite small, its intricacy and beauty say a lot about the benefits of being in power in Sumer.

One side of *The Standard of Ur* is referred to as the "War Side" (figure 1). From bottom to top, soldiers in chariots trample their enemies, the victorious soldiers capture their enemies, and the prisoners of war are presented to a central figure identified as the leader of the victors. You can tell who the soldiers are by their helmets and cloaks. The prisoners of war, humiliated by the victorious army, have been stripped of their clothing. The top and final register is a final statement of power, as the defeated soldiers are paraded in front of the larger, central figure. The registers employ an ancient tool of representation called **hierarchy of scale**, where the most important or powerful figures are portrayed as larger than their surroundings.

The opposite "Peace Side" of *The Standard of Ur* contains registers that use **composite view** — with faces, torsos, and feet shown in profile — and hierarchy of scale (figure 2). Depicting a time of peace, the lower two registers show figures gathering agricultural wealth in the form of livestock, fish, and grain. In the top register, the king sits on the left, identified again through hierarchy of scale. To his right are other people of power enjoying the abundance brought before them by the people who are, literally and figuratively, beneath them.

The Standard of Ur clearly identifies people in power and demonstrates how people born into a lower social status were committed to serving those above them. It stands as a permanent record of the Sumerian class and power structure. Whether it was used by the king himself or some other ancient person, this piece celebrates the social hierarchy of Sumerian royals and their subjects.

FIGURE 2.
The Standard of Ur, "Peace" panel, Sumerian box, 2600-2400 BCE. Lapis lazuli, shell, and red limestone, 8.5 × 19.5 in. British Museum, London, England.

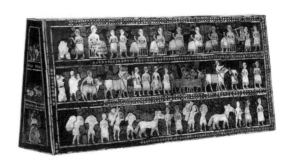

Miller & Shellabarger, *Untitled (Graves)*, 2010. Performance at Time-Based Art performance festival in Portland, Oregon.

FIGURE 4.
Miller & Shellabarger, *Untitled (Graves)*, 2010. Performance at Time-Based Art performance festival in Portland, Oregon.

B. Contemporary Power Relationships

Most of us will never be royals. But we can be unique. Individuality has been an important social theme since the eighteenth and nineteenth centuries. It is common for artists to focus on their own relatively low position in society. Rather than glorify the agenda of kings or powerful leaders in business, government, or religion, artists can tell the stories of the powerless. Contemporary artists are generally more interested in images of common life rather than those that favor the powerful, such as *The Standard of Ur.*

Societies maintain order by enforcing rules through cultural expectations and customs. When inequity is observed in everyday decisions, including significant choices surrounding life and death, it is known as pervasive power. Institutional power describes power that is built into the very systems that guide and control a society's operation — such as financial institutions, government, or religion. Two contemporary artists who question pervasive and institutional power are the Chicago-based duo Dutes Miller and Stan Shellabarger — known together as Miller & Shellabarger — who create collaborative art in different media to fight for power and recognition. Until recently, Miller & Shellabarger's relationship as married partners of the same sex was regarded as socially taboo. Much of their work, which ranges from found art and recordings of day-to-day interactions to more elaborate performance pieces, is grounded in the claim that same-sex couples deserve access to the same privileges that straight couples have had for centuries.

In 2010, Miller & Shellabarger performed *Untitled (Graves)* at the Time-Based Art performance festival in Portland, Oregon (figure 3). The artists worked together digging two graves, and then lay side-by-side in the holes. The bleakness of watching the couple dig their own graves was quite

apparent during the performance, but the result was far from gloomy. The performance was not complete until Miller & Shellabarger constructed a small tunnel connecting the holes. In the graves they dug themselves, the two artists held hands through the tunnel, symbolizing the warmth and connection between the two men persisting beyond the grave (figure 4). The focus on mortality in *Untitled (Graves)* does more than simply remind viewers of death's inevitability. The work also demands equality through a change in social order. Under United States law, only married couples have the right to make end-of-life decisions for each other. Until the July 2015 US Supreme Court decision to legally recognize same-sex marriage, same-sex partners were forced to sever their relationship in times of sickness and death. In this context, Miller & Shellabarger's 2010 gesture of holding hands literally from the grave poignantly calls for equality in this important rite.

Symbols can often be used to great effect in art that attempts to undermine prevailing power structures. Through the use of found objects, New York artist Charles McGill points out the pervasiveness of institutional racism. McGill, who plays golf, began using the sport as a symbol for power and economic access in the 1990s. Golf, its facilities, and its organizations remain a symbol of social power across socioeconomic, class, and race lines because of golf's recognizable distinction as an exclusive and expensive leisure activity. McGill's art employs the tools, clothing, and visual design of golf, but it juxtaposes those symbols of power with symbols of powerlessness.

McGill's sculpture, *Arthur Negro II*, features a golf bag and clubs, pieces of police riot gear, a firearm, and a hyper-realistic, life-sized sculpture of the artist placed on a square pedestal (figure 5). The golf bag is covered with a variety of images that represent black American culture. Some images are of cultural leaders, including civil rights movement leaders, actors, and others who are known in part for their public demands for equal treatment for black

FIGURE 5.
Charles McGill, *Arthur Negro II*, 2010. Found objects, collage, and sculpture, 90 × 66 × 66 in. Virginia Museum of Fine Arts Permanent Collection, Richmond, Virginia.

people. Several individuals, from Frederick Douglass to Condoleezza Rice, represent the strength of black Americans. These figures are interspersed with television characters, images of propaganda, and some people that represent or promote derogatory stereotypes of black people. These include a prominently-placed image of a figure in blackface and disgraced athlete O.J. Simpson. These combined images in juxtaposition make a statement about the continued stereotyping of African Americans.

Next to the bag, the realistic sculpture stands wearing clothes that first appear to be typical golf attire. The recognizable sweater vest, knee pants, and argyle patterns seem to have little significance other than emphasizing the golf theme of the sculpture. On closer inspection, however, the argyle on the sculpture's chest area is not a sweater vest at all — it's body armor. Scattered around the pedestal and on the floor are pieces of riot gear. In the golf bag is a selection of clubs, one of which is adorned with dreadlocks.

McGill's sculpture repurposes symbols of racial inequality to craft an artistic exploration of the continuing struggle for power, respect, and equality by black people in the United States. The significance of a black man and riot gear — as a symbol of police use of force — is a part of American cultural awareness from the civil rights movement onward, and the relevance continues today in light of continued tensions between police and black communities throughout the country. However, McGill's work has reversed the traditional position of power. In *Arthur Negro II*, a black man wears the riot gear and has all the clubs.

Active looking is an essential part of responding to art that challenges the social order. By its nature, this kind of art can be extremely controversial. It is natural to want to look away from something that makes us uncomfortable. Active looking requires that we resist the impulse to disregard or dismiss a work of art simply because it does not reflect our view of the world. Some viewers may believe that partners in same-sex marriages should not have the same rights as heterosexual couples. Other viewers may think that black Americans have gained the equality they have sought since slavery, making pieces such as McGill's obsolete. Recognizing potential controversy, examining your response, and engaging in a broader conversation about how others might respond are all a part of active looking, too.

Another crucial task of active looking is to understand that art is always asking questions and challenging you to think about your own answers. Ask yourself this: *What does this piece of art ask members of different audiences?* The response may be very different for a viewer who is black and a viewer who is white; for same-sex couples and for straight couples; or for police officers, gun rights advocates, and golfers. This is one of the triumphs of art that examines and questions social order. It requires viewers to ask themselves questions about the wider implications of art in their lives and their own places in the prevailing social order.

It requires you to ask: *How does looking at this art affect me?*

5.3 Seeing the Invisible

Active looking means more than just observing a piece of art. It's a matter of knowing what to look for and taking the time to really see and understand it. By closely examining the techniques and concepts an artist uses, we can uncover layers of meaning. In this section, we will see that interpreting the meaning of art requires us to go beyond first impressions. When we take the time to look at and contemplate subjects, we can participate in the act of meaning-making. Sometimes this meaning is explicit, right on the surface, but other times it's implicit, hidden from the viewer's immediate understanding. It's *invisible*. The skill of seeing the invisible requires a combination of basic knowledge of art vocabulary, active looking, and patience.

A. Moral Lessons

Throughout the history of art, morality has played a large role in creating meaning. In other words, the moral codes and expectations of a particular culture will inform the meaning of that culture's art. Morals are the essential beliefs about right and wrong or what is true.

An example of this can be seen in seventeenth-century Dutch art, which contains a particularly strong emphasis on morality. During that time, the Netherlands experienced a great expansion of wealth and commerce because of increased colonization, and many families enjoyed a high standard of living. However, because of their devout Protestant culture, the Dutch were keenly aware that they needed to remain humble in their success. One expression of Dutch humility can be seen in painter Pieter Claesz's *Vanitas Still Life with the Spinario*, where symbols are employed to reinforce the concept of humility and its importance to the religious lives of the Dutch (figure 1).

A *vanitas*, which literally means "vanity," is a common type of still life associated with Dutch painting. The content of a Dutch *vanitas* frequently focuses on the irony of vanity in the context of religious belief. In other words, their Protestant Christian belief in an afterlife caused them to regard any personal gain on

FIGURE 1.
Pieter Claesz, *Vanitas Still Life with the Spinario*, 1628. Oil on panel, 27.8 × 31.7 in. Rijksmuseum, Amsterdam, Netherlands.

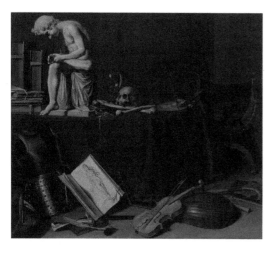

earth as pointless. A work with *vanitas* in the title implies that any non-religious objects in the work are vain pursuits, and it reinforces that point by juxtaposing those objects with more explicit symbols for death.

Vanitas Still Life with the Spinario looks like a disheveled room at first glance, with books, instruments, and other materials scattered around the floor. By actively looking, however, we can see that these objects are symbols that are intended to remind the viewer of the certainty of death. Most of the objects in the room represent knowledge in some way. In the foreground, a violin and lute have been cast aside, with the lute landing upside down. In seventeenth-century Dutch culture, musical instruments were a reference to romantic love. On the floor and table are tools associated with being an accomplished artist. To the left of the instruments is a sketchbook, an ink well, and a quill. On the right edges of the table are a palette, brushes, and a mahlstick — a long stick or pole to steady a painter's hand while working. Like the musical instruments, these have all been cast aside. Next to the painter's tools is a classical sculpture known as *Spinario*, or *The Thorn Picker*, which depicts a young man pulling a thorn out of his foot. Like the instruments and the materials to make art, this sculpture represents the classical influence of Greek and Roman antiquity. On the floor rests an empty suit of armor, representing increased worldliness and the importance of social class. In the center of everything is a timeless symbol of death — a skull and crossbones — and an upside-down timepiece.

The combination of physical objects and their associated symbols reminds viewers that, no matter their accomplishments, life is fleeting. Each of these items appears to have been dropped or cast aside, suggesting that whoever owns these objects no longer cares for them. The things they once cared about will be forgotten, the lover they once serenaded with romantic music will die, and time will most certainly run out.

By adding symbolic objects to a work of art, artists can communicate complicated ideas about their culture's moral code. Active looking is what compels us to learn about the culture the art comes from, including its religious and historical context. Active looking often means we must look elsewhere — to scholarly texts, historical documents, and other works of art — in order to access the full picture. Our efforts pay off when we recognize the influence of the artist's Dutch Protestantism and the cultural response to increased wealth from colonization. As a result, Claesz's painting can be more deeply understood as a historical moment captured in timeless images that reveal a complex exploration of morality and mortality.

B. The Human Experience

When artists depict the human experience, they are exploring how their own experiences fit into a larger idea of what it means to be alive. Artists working with the theme of the human experience often use **symbolism** and **allegory** — a representation of events that has parallels with events in history, literature, or other art — to simplify the big ideas of humanity in a creative, accessible way.

Francisco Goya's *Saturn Devouring One of His Children* is a work that uses allegory to connect Goya's experiences to history and literature (figure 2). Art historians have suggested that the instantly repulsive image represents the Roman god Saturn. According to myth, Saturn once heard a prophecy that said he would have a child who would overthrow his position as chief. Saturn wanted to keep his power, so he vowed to destroy the child. But because the prophecy didn't say *which* child would do this, Saturn chose to eat all of his children shortly after their birth to prevent this from happening. Eventually, Saturn's wife grew tired of her children being eaten and tricked Saturn by giving him a rock to consume instead of his son, Jupiter. The child grew safely and eventually did cause Saturn's demise, becoming the new chief god in Roman mythology. The image of Saturn shows him eating an unknown child, and the bloody spectacle is made additionally disturbing by Saturn's wild eyes and strangely disjointed, angular body.

The work is painterly in technique, but Goya paints the figures in two different styles. Saturn's body is abstract and consists of ambiguous parts that are connected by sinews of expressively applied paint. The dismembered figure that he holds in his hands is also painterly, but more

FIGURE 2.
Francisco Goya, *Saturn Devouring One of His Children*, 1819–1823. Plaster mounted on canvas, 57.5 × 32.7. Museo del Prado, Madrid, Spain.

detailed to evoke the abhorrence that one feels in the face of such violence. Goya's painting fully portrays the horror of a parent harming their own child.

Saturn Devouring One of His Children presents more than the story of Saturn, however. It expresses Goya's interest in the human experience, particularly cruelty and violence toward others. This gruesome painting was not a commissioned work. It was created for Goya's private retirement residence in the Spanish countryside. Goya decorated the walls of his dining room with this and twelve other works, all of which became known as the "Black Paintings" because of their dark subject matter. Earlier in his career, Goya had been the painter for the Spanish royal court. He was employed in the city of Madrid during the Peninsular War, the struggle between France and Spain to control the Iberian Peninsula. From 1808 to 1814, the French occupied the city of Madrid, using violence to suppress the residents during the occupation. From rape and dismemberment to mass executions, thousands of innocent people were tortured, maimed, and left for dead. Goya's witness to these horrors may be what inspired his "Black Paintings."

The layers to this allegory are split between ancient literary tradition and Goya's own reaction to the atrocities of war. For Goya, the horrors of Saturn's appetite are not unlike the horrors of war. Reflected in Saturn's terrifying gaze are our own reactions to the experience of deadly conflict. In this way, Goya relates the mythological tales of the past with the tragedies of his present in an attempt to reflect on all of humanity and our tendencies toward destruction.

C. Cultural Identity

As our earlier discussion of morality and human experience demonstrated, art asks us to see the invisible in the ways that artists reflect on their cultural identity. But both Claesz and Goya were members of their dominant cultures, which made their work and its meaning accessible to audiences with similar cultural backgrounds. However, an artist's identity or subject matter do not always align with that of the dominant culture. As a result, works of art can sometimes expose the conflict between cultures. Oregon artist Gary Westford provides an example of threatened cultural identity with his painting *Shadows* (figure 3). Though he is not a Native American artist, Westford uses the surreal images of invisibility to ask the viewer to consider the line between observable reality and symbolic, invisible subjects from Native American culture.

Westford's painting makes a statement about the eradication of Native American culture in North America. The scene of a canoe on a lake would ordinarily be considered peaceful and pleasing, but everything is not as it seems. The Algonquin-style canoe is empty. The oars — meant to propel the canoe — stand upright, but no one is holding them. Closer inspection of the water shows the reflection or shadow of two unseen figures. The invisibility of the figures is suggestive of the displacement caused by British and French colonization and the influx of European settlers in North America that resulted in the steep decline in populations of Native American tribes from the seventeenth century through the nineteenth century. The painting deliberately plays with our sense of logic, but only if we are willing to look at the work longer than just a passing glance. What might just be an empty boat becomes much more with a little patience. The painting invites us to ponder the boat's occupants and question where they have gone.

Westford intentionally seeks to provide viewers with what he calls "the shock of recognition." The image of the lake and canoe come from television advertisements for Hamm's beer in the 1950s. Westford fondly remembers

FIGURE 3.
Gary Westford, *Shadows*, 2010. Oil on canvas, 36 × 48 in. Collection of the Artist.

watching the commercials and being captivated by the idealized "land of sky-blue waters" featured in the ads. He also visited reservations in the American southwest, where he saw Navajo families living in degraded and impoverished circumstances. In his painting, Westford combines the notion of "sky-blue waters" with the image of an Algonquin canoe. The idyllic scene is juxtaposed in direct opposition to the lifestyle of many Native Americans after westward expansionism, including those who were forced to leave their ancestral homes for the reservation system. Like the title of Westford's painting suggests, he is concerned about Native American culture being reduced to a shadow on the American landscape while only reflections of the people remain.

Today, many Native artists assert and affirm the presence of Native American culture and history in the United States. Seneca Nation artist Marie Watt combines traditional Native American textile art — a celebrated craft in Native American communities — with found objects to convey her ideas about cultural identity. Her piece, *Transportation Object (Lamp)*, repurposes a discarded blanket to illustrate that even simple objects like blankets serve purposes beyond warmth and comfort; they also contain stories (figure 4). The stories can be of life in the mended spots, worn binding, and stained bits; or the stories can be about culturally significant events and traditions. Truly, as Watt has said, "Blankets record our dreams."

FIGURE 4.
Marie Watt, *Transportation Object (Lamp)*, 2015. Reclaimed wool blanket, satin, floss, and thread, 12.3 × 13.8 in. Courtesy of PDX Contemporary Art and the Artist.

Transportation Object (Lamp) consists of a reclaimed blanket with wool and embroidery floss added to it. Although these materials are not usually associated with fine art, this piece is comparable to some of the pure expression paintings discussed in Chapter 4. Just like those paintings, the layers, textures, shapes, and colors of this work convey meaning. The concentric circles, for example, are an ancient symbol of unity and the cycles of nature, appropriately referencing a variety of ideas such as the sun and moon, an eye, a breast, a globe, and more. The bright yet muted colors evoke clouds, light, peace, and harmony. The added layers of fabric imply a figurative piecing together, like a culture that must adapt to change or cover old wounds. The radiating pattern of the embroidered circles creates a symbolic image of movement, perhaps through realms beyond the physical. Finally, the colors of the blanket allude to its humble origins and the unknown human story of its owner woven into its very fibers. When viewers learn that this piece is made from a discarded blanket, they are invited to consider comforting objects from their own past and perhaps wonder what remains of them.

Our above interpretations rely on nothing more than the expressive qualities of the art itself, but an understanding of the artist's context for the work reveals that this work is part of a complex negotiation of the relationship between Native cultural history and the importance of reclamation as an essential part of Native identity. What is invisible in this kind of art is the historical context of how making the art references significant artifacts and events from the artist's and their culture's history.

Watt is reclaiming and exploring specific cultural events in this work. This 1913 photo is of a First Nations Quamichan Potlatch, off Vancouver Island (figure 5). A potlatch is a ceremonial tradition shared by Coast Salish Indigenous people from the Pacific Northwest coast of Canada and the United States, and the word potlatch (or *patchitle*) means "to give" in Chinook language. The photo shows a blanket literally flying through the air, as the host family casts gifts from a rooftop porch to the crowd below. Some potlatches were rumored to have so many gifts, particularly folded and stacked blankets, that they actually would touch the ceilings of the longhouse. Despite being banned by the Canadian and US governments from 1885 to the 1950s, potlatches were and continue to be part of the Coast Salish economy and a means for displaying wealth and social relationships in the community.

Compare the central shape in *Transportation Object (Lamp)* to the falling blanket in the photograph. Watt reclaimed more than the blanket she used in her piece, she reclaimed the shape of the blanket from this photograph as it falls from the longhouse. The cloud-like white patch below the falling blanket shape is like the gathered crowd of potlatch witnesses in the photo.

Watt's title is also reclaimed, in a way. It comes from the Smithsonian Museum of Native American Art's description of cradle boards, a traditional Native American baby carrier, as "transportation objects." This seemingly clumsy description provided Watt with a complex interpretive framework for talking about the transformative properties of blankets in Native culture. This easily applies to any example of applied art. What does it really do?

Watt's title is a further exploration of the idea that blankets, a critical part of a cradle board that literally transports a baby, perform their own kind of symbolic transportation, too. Blankets transport us between consciousness and unconsciousness when we go to sleep, or between life and death when used to cover our body when we die.

Without the additional context the photo provides for this piece, the typical viewer will miss most of the significant references *Transportation Object (Lamp)* makes to Native American culture. Context isn't always available for art whether it's ancient or contemporary. But this example illustrates the value of context as an invisible element in art that helps viewers appreciate the work's broader meaning.

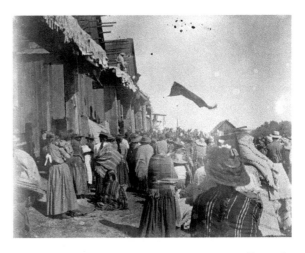

FIGURE 5.
James Skitt Matthews, [Potlatch at Quamichan. Blankets being throw from the stage], 1913. Photograph, 3.54 × 4.33 in. City of Vancouver Archives, Vancouver, British Columbia.

5.4 Place

The importance of place in art can be seen throughout the centuries, both in portrayals of natural settings as well as architectural structures. From landscapes and monuments to interiors and memorials, art can change the way we look at a place and offer us a new point of view. Some art focuses on personal connections, such as an image of a house or room that is meaningful to the artist. Some art focuses on communal spaces, such as buildings that serve ceremonial or cultural purposes. The most common place-based art focuses on the geographic and natural properties of a place, known as a **landscape**.

Since art is a reflection of human experience, and so much of what we experience involves the land we live on, artists and architects seek to record the spaces they inhabit in a variety of styles and media. This section will look at three different types of places artists study: interiors, architecture, and landscapes.

A. Interiors

FIGURE 1.
Pieter De Hooch, *A Mother's Duty*, 1658-1660. Oil on canvas, 20.7 in × 24 in. Rijksmuseum, Amsterdam, Netherlands.

Some of the first people to realize the validity of place in art were the Dutch in the seventeenth century. Many Dutch artists specialized in a kind of painting called an **interior**. These paintings focused on and even elevated the common, domestic experiences of their time by depicting routine tasks. Pieter de Hooch's painting, *A Mother's Duty*, features a mother and her child in a domestic interior. The painting depicts an ordinary task for any parent — checking a child's head for lice (figure 1). De Hooch has turned a chore into an tender experience between a mother and her child. But the subject of the painting is more than the mother and child. The room they are in is as much the featured subject of the painting as they are. The sense of place in *A Mother's Duty* creates a feeling of intimacy for the viewer, reminding us that places resonate with our experiences inside them.

The painting shows a quiet, comfortable home. The mother and child occupy a relatively small part of the right side of the canvas. Around the mother and child are several utilitarian tools of a typical seventeenth-century Dutch home. A bed, behind the curtains, has been built into the structure of the house. To the left of the bed hangs a bed warmer. On the floor, in the lower right-hand side of the canvas, is a chair used for toilet training a young child.

The window in the upper right-hand corner lets in bright diffused light, illuminating the mother and child. This light also draws attention to the warm tones of the wood beams that support the structure of the house. The viewer's eye is drawn to the open door to the left that leads to an alcove. Through it, we see another door that has its top half open to let in air, and this hint of a world outside enhances the room's familiarity. The light from the open doors leads us back into the intimate space, which is further enhanced by the family pet and gleaming tile floor. De Hooch places these objects and activities associated with parenting into a painting about place, drawing intimacy into the familiar surroundings. The viewer is reminded that homes are important because they are the location of our activities that — while mundane — are most meaningful.

B. Architecture

Many formal elements of art are used in architecture to give specific places a significance that is otherwise impossible. Architecture that is large or impressively detailed can add a sublime sense of spirituality and grandeur. For example, the Gothic structure Sainte-Chapelle combines the formal elements of light, color, and space, creating a place of ostentatious beauty and spiritual reverence for power (figure 2). French King Louis IX built Sainte-Chapelle in the thirteenth century to protect relics believed to have been used in the crucifixion of Christ. These objects are considered some of the most important relics in Catholicism, and the most respectful and safe way to store them was in a stone Gothic structure.

Sainte-Chapelle is an undeniably imposing structure. Its thin, stone tracery support fifteen lancets with stained glass windows (see figure 3). Each window is just under fifty feet high (see figure 4). Illuminated by 1,113 stained glass scenes from the

Old and New Testament, the interior of Sainte-Chapelle offers a somber place of contemplation and sublime beauty that encourages reflection and prayer. This combination of materials results in a mystical experience for the visitor who enters the upper chapel.

The main entrance is through a lower, basement-like chapel. Visitors then climb a spiral staircase to the upper chapel where they are suddenly surrounded by light and color. The transition from walking and climbing stairs in darkness to suddenly being bathed in multicolored light is astounding. Each window contains many stained glass images that tell the story of Christ's life and death, and the history of Christianity in France. The viewer can look closely at each image or simply take in the space and its overwhelming light, which represents both the presence of God and the power of the French royalty.

C. Landscapes

Light and color are powerful tools used by architects to convey a sense of place and its meaning, but painters do the same in landscape paintings. Early in the history of art, landscapes were not seen as valid subject matter for painting. Landscapes were background for "important" subject matter,

typically religious or historical scenes. But as time progressed, people began to realize the importance of landscapes to human experience, both as a symbol of national pride and as a representation of the natural resources and industry that nations possessed.

Landscape painting was very popular in the United States in the nineteenth century. A group of painters in upstate New York specifically focused on American landscapes and became known as The Hudson River School for their interest in their local environment. The goal of Hudson River School painters was not just to record what the landscape looked like, but to give viewers the same sense of place that only being immersed in nature could provide.

Frederic Edwin Church's first landscapes were produced in the United States, but as his career progressed, he felt compelled to travel where he could experience more extreme landscapes. In South America, Church painted *The Andes of Ecuador*, a large-scale landscape painting which is meant to convey the awe one feels when viewing vast mountains (figure 5).

The viewpoint of the painting is above a valley with a small lake. Mist rises from a waterfall. A mountain peak rises in the distance and foothills spread before a glorious sun viewed through the haze of the mountain atmosphere. The painting's central element, the sun, bathes the scene in a yellow light that causes reflections off the water and illuminates the mountains. The shadows on several trees and hills add perspective, but they

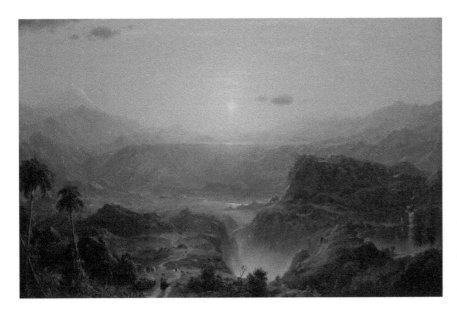

Figure 5.
Frederic Edwin Church, *The Andes of Ecuador*, 1855. Oil on canvas, 66.1 × 119.3 in. Metropolitan Museum of Art, New York.

also allow the viewer to see much smaller details. Just left of the painting's center, a small figure is traveling the paths through the Andes.

The beauty of nature creates such an epic sense of place in landscapes that it often makes us feel small. Church makes the viewer part of the scene by painting from a mountaintop viewpoint, adding to the awe-inspiring feeling. The wildness of places like the Andes makes them seem wondrous and limitless, contributing to a feeling of imposing or overwhelming fear and wonder often labelled as **sublime**.

It's no wonder that Church felt compelled to travel to South America to capture its grandeur. The Andes mountains are one of the most enchanting landscapes in the world, compelling artists since prehistory to focus on the area. Machu Picchu is one such site where ancient Incan architects were clearly inspired by the sublime landscape. Machu Picchu is an archeological site in the Andes that is 9,000 feet above sea level (figure 6). Machu Picchu is **site specific**, a structure that can only be built in one location. It is built on a saddle ridge top between two mountains, focusing on the natural power of the sun.

Everything about Machu Picchu shows that its builders carefully considered their location. The sides of the mountain are terraced to grow crops and control torrential rains common to the region. Homes and religious structures are built right into the saddle of the mountain. Some windows in structures like the observatory perfectly frame the rising sun on the day of the summer solstice. The buildings all use the standard architecture of the Inca empire, **ashlar masonry**, that is based on combining precisely cut stones without the use of mortar. The builders of Machu Picchu were so

FIGURE 6.
Bill Damon, *Sunrise at Machu Picchu*, 2010. Photograph.

precise that the structures incorporate parts of the actual mountain, along with immoveable boulders, all seamlessly.

The builders also took advantage of the location as a prime spot to observe astrological phenomena. The site includes a large altar carved out of the surface of the mountain, known as the Intihuatana Stone. It combines two natural elements that perfectly represent the location — stone and the sun. The Incas believed that stone was sacred. Their gods created people from stones, and the Earth was created by casting stones in four directions. Additionally, they believed that the sun was born from a central island of Lake Titicaca. Because the sun was born from stone, its interaction with the Intihuatana Stone at Machu Picchu unites it with its origins. The Intihuatana Stone is known as "the sun's hitching post." This means that the Incas could track the movements of the sun including its location during winter and summer solstice by the shadow it cast on the Intihuatana stone.

5.5 Narrative

Many of us approach art with the goal of learning what a piece of art means. Throughout this chapter, we have described the wide variety of possible meanings art can have. Some works of art are persuasive, others are meant to convey a feeling, and some are simply about enhancing the space and shape that the art creates. Knowing how art achieves its meaning can take intensive study of history, culture, and architecture. Other times, art's meaning is not so difficult to grasp. Art can also be about the most basic of all human experiences — **narrative**, or telling a story. These stories may be personal or universal.

A. Universal Art

Storytelling itself is one of the earliest forms of art. The few intact records of early civilization almost always include some sort of narrative. When most people think of ancient stories, the myths and legends of ancient Greece come to mind. Greek mythology started as an oral tradition that was eventually recorded in manuscript form and also in visual art.

FIGURE 1.
Attributed to the Painter of the Woolly Satyrs, [Terracotta volute-krater], c. 450 BCE. Red-figure terracotta, 25 in. Metropolitan Museum of Art, New York.

Some of the earliest Greek narratives were recorded on pieces of pottery. An example of this is a terracotta vase called a Volute-krater that shows battles between the Greeks and Amazons and between centaurs and the Lapiths, dated 450 BCE (figure 1). This vase is an example of **red-figure** pottery. The large black sections are added to the red clay by applying a very thin layer of black clay called slip, which serves as paint. The negative space of exposed, red terracotta clay creates the forms. Details in line and shape are painted on the clay form with finely applied slip. Kraters are wide-mouthed vessels that were used for mixing water and wine. The word "Volute" is added to the type of vase because of the spiral ends of the handles, a volute style. Many pots like this still exist because they retained their value over the centuries as both functional and decorative pieces.

The design on this piece actually retells two important Greek narratives, one around the main form of the vase, and another, smaller narrative around the neck of the vase above.

The stories are told in visual form, and they represent narratives that were particularly important in fifth century BCE. The lower part of the vase represents the story of the Greeks battling the Amazons. According to Greek myth, the Amazons were a race of female warriors who lived in Scythia, a region to the northeast of Greece. The Greek heroes, Hercules and Theseus, visited the Amazons, and each visit ended up offending the Amazons. Hercules' visit was part of his twelve labors to pay penance for killing his family. A king sent Hercules to retrieve a belt worn by the queen of the Amazons, Hippolyta. In the confusion of his arrival, a battle began. Rather than fight all of the Amazons, Heracles killed queen Hippolyta and fled. In a separate story, Theseus tried to abduct Hippolyta and make her Queen of Athens. Not to be outwitted, the Amazons chased Theseus and rescued their Queen. On the vase, the Amazons are identified by their clothing. They were known as excellent horse riders and fierce warriors, and are recognizable by their patterned pants that protected their legs on horseback and in battle.

The top scene decorating the vase tells another story about the hero Theseus. He was invited to a wedding party by a group of people known as the Lapiths. The Lapiths also invited a group of centaurs, mythical creatures whose bodies are half-man, half-horse. At the wedding, the centaurs got drunk and attempted to assault the bride and her party, resulting in a bloody fight. The vase shows specific events from the battle including the use of banquet items as weapons. This battle is significant because it didn't end with brute force. Instead, Theseus used the power of reason to calm the centaurs and stop the fighting.

For the ancient Greeks, both narratives represent their superiority in the ancient world. Their interactions with the Amazons show that they have the power to take on the fiercest warriors. The quelling of a battle through reason shows they are intelligent and wise. The combination of the narratives communicates an idea that the ancient Greeks saw as universal, their domination of the known world in matters of mind and might.

The narrative here is universal. The story of skill in battle and intellect is relatable to any nation as proud of their accomplishments as the ancient Greeks. In 479 BCE, the Greeks defeated the Persians. After this victory, the Greeks saw themselves as the most sophisticated and powerful people in the ancient world. Even today's viewers can look at the Volute-krater and understand the scenes of a glorious battle without knowing the stories. The images create a universal narrative.

B. Personal Art

Narratives can also be personal. In the photographic series, *If I Had Known My Mother Back Then*, by Portland artist Danielle Delph, the artist imagines what it would have been like to be friends with her mother when she was young. Using Photoshop and old family photographs, Delph seamlessly inserts herself into pictures of her mother when she was growing up. The result is a transformation of old family photographs from something like a relic of the past into a new narrative of shared experiences between two best friends.

In the first image, Delph's mother sits on the floor as a toddler in a frilly dress and black shoes. She is no more than three years old. Next to her is Danielle Delph, at the same age, coloring (figure 2). The film grain and color are matched with photo editing software to make them appear together. The next image shows two girls around the age of fourteen, as though the toddlers have grown together and remained friends (figure 3). They still spend time together, this time shown in a park on a summer day. The artist is on the left, and her mother is on the right. In the final image, mother and daughter are shown together as young adults in an American rite of passage, preparing for a formal dance (figure 4). Again, the artist is on the left, her mother on the right.

Delph created the series to explore a longtime curiosity. She had always wondered what it would be like to know her mother as a friend rather than as a parent. The combined images create an intensely personal narrative. Instead of purely imaginative work, these images are of real people in real places, just thrust together by a technological trick. But we

FIGURE 2, 3, AND 4.
Danielle Delph, *If I Had Known My Mother Back Then*, 2016. Digital photo collage. Collection of the artist.

can imagine these scenes being real. The photographic series — depicting friends playing on the floor, hanging out in the park, and goofing off in formal wear — represents the lived experiences of the two subjects, just separated by time. Both mother and daughter once sat on the precipice of adulthood, and Delph has created a narrative that allows them to share that experience. Anyone who has ever wondered about the life of their parents as children can relate to these images.

Finding or creating meaning in art is a normal desire. Most of us feel that if we know what a piece of art means, then we will be able to understand something more. This textbook provides you with the tools to do that. By considering the formal elements of art, its design, and medium, and through a clear understanding of themes like narrative, art is more readily accessible to the viewer. Consider the photograph, *Fresh Kills Landfill*, by Gabe Kirchheimer (figure 5). How does this photograph employ the tools of art? What does the photographer's use of formal elements and design tell you about the image? How can you combine these objective observations with your subjective ideas to create a narrative for the image? If you ask "What's happening in this image?," you are participating in a narrative exercise. Other questions you might ask are "Who are the people?," "Why are they holding umbrellas?," or "What brings them to a landfill?"

You can use your own powers of observation to develop ideas about art. Using critical vocabulary from *Art for Everyone* indicates that you can take the time to observe the art, giving you the authority to speak about the narrative in art and its meaning.

FIGURE 5.
Gabe Kirchheimer, *Fresh Kills Landfill*, 1996.
Photograph. Collection of the artist.

Conclusion

The themes in this chapter list several ways artists encounter their culture, whether by expressing and celebrating its successes and strengths or by determining and questioning its weaknesses. As the examples illustrate, examining individuality, assessing the social order, seeing the invisible, recognizing place, and connecting narratives in art require us to use active looking. We must consider not just what meets the eye, but also what those visual objects suggest about things beyond what we can see.

What we see and how much we see depends on our different experiences and our prior knowledge of culture, literature, history, and artistic techniques. However, we have to always remember that this is not a matter of finding one "true" meaning of a work of art. Instead, it is a matter of exploring many possible meanings. The variety of possible interpretations about art's exploration of human themes is one thing that makes viewing and interpreting art such a rich, exciting, and enlightening experience.

Chapter 6:
Where Is Art?

We began this book by asking a big question — what is art? By now, you've seen just how many different answers there are to that question. Art can be so many things, and this book has shown you numerous forms of art. We spent the rest of Chapter 1 learning how to identify art. We talked about the language of art in Chapter 2 and then described the techniques and materials used to make it in Chapter 3. We analyzed the styles and contexts of art in Chapter 4, and we explored some themes in art during Chapter 5. Time and again, we emphasize the importance of active looking, which requires that you spend time with art.

This brings us to our final question — where is art? The answer this time is a simple one. Art is everywhere! That may not sound simple, but we can find art all around us, from museums to craft fairs, from coffee shops to skate parks, and from advertisements to inside your own home.

The idea that art is everywhere might suggest to you that everything is art, but as you know by now, that's not quite the case. In Chapter 1, you saw that the meaning of the word "art" is shaped by cultural shifts, artistic preferences, and innovation. We invited you then to come up with your own definition using the information contained in the rest of this book. Now that you are here at the end, you're better able to determine for yourself what qualifies as art. Your ability to find art everywhere will depend on your new understanding of what art is and on your evolving definition of "art."

In this final chapter, we'll wrap up our examination of art by looking at some of the places where you can be sure to find it.

A. Art on Display

The obvious place to start looking for art is by looking for places where the primary purpose is to display art. These places include museums and art galleries across the country — some large and some very small. These places may sometimes seem expensive, inaccessible, or even exclusive. This is not the case. Remember, artists want people to see their work, and the same is true for the places and institutions that display art. Although some require membership or entrance fees to see the art on display, this is not meant to keep people out, only to keep their doors open. Most are accessible, even for free, at least some of the time.

FIGURE 1.
"Our America: The Latino Presence in American Art,"
October 2013–March 2014. Installation view at the
Smithsonian American Art Museum, Washington, D.C.

FIGURE 2.
Confederated Tribes of Grand Ronde Gallery at the Hallie Ford
Museum of Art. Courtesy of Hallie Ford Museum of Art, Willamette
University, Salem, Oregon.

Museums

Museums are widely known as a place to find art. Most major cities in the United States have at least one museum featuring travelling exhibitions of famous art and rotating permanent collections of art. Often supported at least in part by taxpayer funding, museums are a committed part of artistic culture.

In Oregon, for example, the Portland Art Museum is the state's biggest art museum, with dozens of separate galleries housing 42,000 objects. Salem is home to Willamette University's Hallie Ford Museum of Art, Oregon's third largest museum (figure 2). Some Oregon universities also feature an art museum on campus, and many natural history or folk museums in the Pacific Northwest prominently feature art in their collections.

One common misconception about art museums is that they are uninviting to visitors. They have an unfair reputation for being grand, echoing hallways where people in formal clothes pay enormous sums of money to contemplate deeply and talk intelligently about art. However, art is meant to be seen and appreciated, and museums are the places where that art is on display to the public. Visitors are always welcome, since museums quite literally depend on visitors remaining interested in the exhibitions they provide. If no one came to the museum, they would likely close down, so museums are always working to add new features or exhibitions to draw visitors in.

Another misconception about museums is that a person's socioeconomic status prevents them from accessing this part of art culture. In reality, while most museums do charge a modest admission fare, nearly all of those museums schedule a weekly or monthly "free day," where admission to the museum is completely free-of-charge. Besides displaying art, many museums host regular events that support arts education and access for a much wider group of people than just museum donors or patrons. Museums are for everyone, and they display a wide variety of art in a consistent space reserved for that purpose.

Formal Galleries

Formal art galleries can be quite varied in location and size, but most exist in commercial storefronts alongside businesses as part of cities' shopping or arts districts. The primary purpose of most formal galleries is to provide a way for artists to sell their art to interested patrons. A secondary important purpose of galleries, much like museums, is to display art to a wide variety of people.

There are dozens of formal art galleries in Oregon, and many commonly feature crafts from around the state. Coastal cities and antique shopping areas have a relatively high number of formal galleries as tourist attractions. These galleries are typically open during regular business hours and are free to the public. Visitors to a region may want to purchase an example of traditional regional craftsmanship as a souvenir of their visit, and art galleries provide a marketplace of unique objects for them. Formal galleries also display artists' work that is not available anywhere else, and art collectors can visit an art gallery to see examples of new work from the surrounding area that is available for purchase.

Formal galleries are not just points of sale, however. The second purpose of a gallery is to enhance the community that contains the gallery. Most people who enter an art gallery are not there to buy art. They are there to appreciate the art and validate the community's artistic culture with an investment of their time. Like museums, art galleries want visitors to come and view the art. Moreover, as you might expect, gallery staff are typically people who enjoy and care about art. Having visitors gives these fellow art lovers a welcome opportunity to talk about art.

Chemeketa Community College's Gretchen Schuette Art Gallery is located on the Salem campus, and hosts multiple exhibits each year

FIGURE 3.
"Drawing Deeper," October–December 2015. Installation view at the Gretchen Schuette Art Gallery, Chemeketa Community College, Salem, OR.

FIGURE 4.
"Vivian Maier: Exposed," June 2014–August 2014. Opening Reception at Cleve Carney Art Gallery at the College of DuPage, College of DuPage, Glen Ellyn, Illinois.

featuring local and traveling art (figure 3). At select times, student and faculty art is on display as well. This free and open to the public space is a great way for students at our college to experience a lot of different kinds of art throughout the year. In the summer, the gallery becomes a working studio with a rotating Artist in Residence program, followed by an exhibition in the gallery later in the year. In exchange for the studio space, the artist "gives back" by offering two public educational programs such as slide lectures, open visitor hours, or workshops. Galleries like Chemeketa's offer not just a place to find art, but a venue to see art in the process of being created.

Informal Exhibitions

Another place to see art on display is in an informal exhibition. These are exhibitions or events, usually with a set time limit, in spaces where a general audience will come for some alternate purpose and happen upon the art by accident. Your favorite local coffee shop or restaurant probably has some kind of monthly or quarterly art exhibit as a decorative display on their walls. Informal exhibitions are not the same as galleries because the coffee shop or restaurant is still the main purpose of the space. However, they still provide a service like galleries to their community and the chosen artist. At Chemeketa's Salem campus library, for example, Carol Hausser's painting, *Transillumination*, is on display for students to view when visiting

FIGURE 5.
Kaitlin Pearson,
[Chemeketa Students View
Art on Campus], 2015.
Chemeketa Community
College, Salem, Oregon.

the library (figure 5). The library's purpose is the same, but art is there to beautify the space.

The next time you buy your coffee, look around the coffee shop for local art on display. First, enjoy the experience, but then look closely at the description tags that accompany the pieces. Some will have the title of the piece and its medium, like in a formal gallery or museum, but it may also have a purchase price. Businesses that display art typically share a portion of any sales that result from an informal exhibition, but the additional exposure an artist gains from these kinds of exhibitions can be invaluable, potentially earning them fans and patrons as a result. Many artists place a stack of business cards on a nearby shelf with contact information, adding inexpensive advertising for commissioned work or future projects.

B. Visual Culture

Many art historians believe that the kind of art a culture produces and holds in high esteem says a lot about the values of that culture. The art endorsed by governments, businesses, and cultural leaders can act as a visual shorthand for the culture's thinking. Three important ways we see these cultural images are in advertisements, propaganda, and iconic cultural capital. These examples surround us, even when we don't notice them.

Advertisements

Advertisements, at their core, attempt to persuade an audience to purchase a product or service. Visual advertisements are carefully constructed by marketing agencies and designers to convince the greatest number of targeted people to choose a particular product or service over its competition. This is no easy task, but the payoff for effective advertising can be astronomical for some products. It might be difficult for us to appreciate all advertising as art, but think of how carefully designed most advertisements are. For that reason, some ads are art.

In order for a piece of advertising to work, it must appeal to some kind of need that the advertisement's audience has. When advertisers design commercial campaigns, they carefully craft the imagery, language, color, and even finer details to make that appeal to their audience's needs. The needs vary widely from simple — the need for food or shelter — to more complex human needs — the need for leisure, intimacy, or security. Sometimes the appeal is subtle, but the advertisements we remember are the ones that appeal in direct and obvious ways. The message is carefully crafted to be most effective for its audience. Clearly, that's a pretty creative process.

A group project by advertising and photography students at the Savannah College of Art and Design uses the elements and principles of art to create awareness of the product with both written copy and the company logo (figure 6). The color scheme is warm and analogous with pinks, yellows, and oranges. Perhaps especially appealing is the ad's sense of a warm summer day. The work is also balanced. The largeness of the simple space on the right might have been out of balance with the heavy form on the left, but instead, the line of text on the right suggests a horizon line, counterbalancing the image with depth. This depth also suggests open space and the freedom that the viewer could share if they purchase the product. The way this image generates meaning is not unlike other examples of art we have analyzed in this book by actively looking.

FIGURE 6.
Logan Zawacki, Amelia Jamerson, and Shirmira Hill, [Vespa Double Page Advertisement], date unknown. Advertising and Photography student group project, Savannah College of Art and Design, Savannah, Georgia.

Advertisements may not immediately strike us as beautifully crafted, but if the composition of an advertisement is visually appealing, perhaps because it uses some of the principles of art described in this book, the viewer may be more receptive to the persuasive message. The creation of images for a commercial purpose does not mean the method or techniques required to create images must change. The tools are the same.

Propaganda

In some cases, art that is explicitly persuasive is similar to advertising. In Chapter 4, we looked a Pop art as a stylistic movement that embraces the qualities of advertising as a valuable contribution to culture. Propaganda takes that embrace to the extreme by attempting to create social change through persuasive art. The term "propaganda" is used in a mostly negative way because of the manipulative ways it has been used in history, but the original meaning of propaganda was neutral. It referred to genuinely positive persuasive communication such as recommending public health solutions, motivating citizens to participate in political processes, or encouraging neighborhoods to report crimes to local law enforcement.

For propaganda to be effective, it must be simple to understand in order to reach and persuade a broad audience. This can make the message communicated in the propaganda seem oversimplified, even though the goals of propaganda might be complicated and even corrupt. A visual element is often included to create a memorable connection for viewers between an image and an idea. Wartime recruitment posters for the United States military bear a familiar image of Uncle Sam, a fictional character whose image represents patriotism, bravery, and — in his clothing — the United States flag (figure 7).

Propaganda shares techniques with advertising, which can be thought of as propaganda that promotes a commercial product or shapes the perception of an organization, person, or brand. Post–World War II propaganda typically

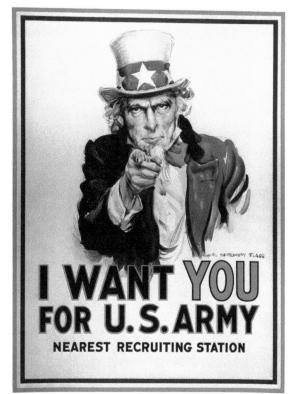

FIGURE 7.
James Montgomery Flagg, [United States Army recruitment poster featuring Uncle Sam], 1917. Library of Congress, Washington, DC.

refs to the visual promotion of a set of ideas. The most common examples of propaganda now are political or nationalist ideas. Propaganda's images quickly get inside our heads, sometimes making use of stereotypical imagery of people or activities to craft memorable or recognizable messages of relatively simple construction. Simplicity is what makes propaganda so effective, and it's also what can make negative propaganda so damaging. But not all propaganda deserves this label.

For example, street artist and political activist Shepard Fairey has seen his work transition from avant-garde to fashionable. Fairey is the artist behind the OBEY poster and sticker art campaign that has seen worldwide success. The chief example is the Obey Icon Face poster that has been affixed to walls and objects around the world since 1989 (figure 8).

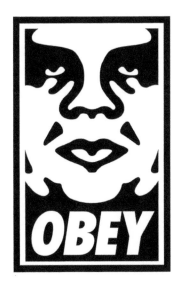

FIGURE 8.
Shepard Fairey, *Obey Icon Face*, 1989. Digital file used for poster, sticker, and stencil production. Courtesy of the artist.

Fairey's activist campaign reached a peak in 2008 with his unsolicited creation of a propaganda poster in support of President Barack Obama's election campaign (figure 9). This poster was eventually adopted as the official 2008 campaign poster, and caused Fairey's popularity to skyrocket, including appearances on television talk shows and interviews in national magazines. Fairey's new popularity spread into the existing OBEY campaign, and the success of the OBEY clothing line, print collection, books, and other collectibles has rested at least in part on the success of the Obama HOPE poster. Fairey's art is some of the most recognizable street art in the world, but it began as a relatively humble series of posters and stickers.

Cultural Capital

For all this discussion about art existing all around us, isn't it still important to look at something and know without a doubt that it is art? When we see a painting, for example, most people can somehow tell automatically that it is art. In a way, our culture "trains" us to recognize certain kinds

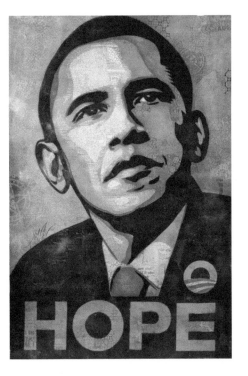

FIGURE 9.
Shepard Fairey, *OBAMA Hope*, 2008. Digital file used for poster, sticker, and stencil production. Courtesy of the artist.

of images as art. This recognition is symbolic of our cultural values. Art is unique and difficult to make, so we want to show it respect. Art is special, so don't venture beyond the velvet rope, and certainly don't ever touch it or change it. Our culture places great value on recognized works of art, such as famous paintings that hang in world-renowned museums. Obviously not all art is valued as highly as a masterpiece, but we think that even the less iconic art — found in coffee shops, local galleries and museums, and well-made objects — can tell us about our culture, too.

Iconic examples of art give us something called cultural capital. In other words, the ability to instantly recognize art is a form of currency that we store up as part of our individual cultural understanding. Other artists, advertisers, or propagandists can then spend that currency by using these images' collective value and meaning as a shorthand for more complex ideas. If you know a lot about art, other people might think that you are smart, charming, or refined. That knowledge is valuable. Cultural capital lets us broaden the definition of art and lets us find art in places we might not expect it.

Think about Internet memes. A **meme** is an idea or image that spreads rapidly among members of a specific audience. Usually a meme contains within it some kind of cultural symbol or practice, but it only communicates effectively to those who understand and recognize that meaning. Thousands of memes are created daily, but most of them follow a fairly consistent pattern. An Internet meme has large text superimposed onto a still image, and the image has meaning either in its subject, the subject's facial expression, or the subject's relative significance in its original context. Like an inside joke, these creative expressions are extremely effective when their audience gets it. To outsiders, a meme can be bafflingly strange in appearance.

For example, to understand the "Philosoraptor" meme, the viewer only has to recognize that the curving talon of the famous dinosaur looks like a stereotypical gesture of deep thinking or contemplation: scratching one's chin (figure 10). Active looking at memes requires that we know the context of the image, combine that knowledge with the superimposed text, and create a meaning based on that combined interpretation. Whether the image is a perplexed-looking baby, an outline illustration of a

FIGURE 10.
Lonelydinosaur.com,
[Philosoraptor meme example],
2015. Digital image.

grinning "troll," or actor Gene Wilder as Willy Wonka looking particularly condescending, the success of a meme rests on viewers effectively interpreting the combination of the image's meaning with its text. With memes, art is on your computer and on your Smartphone. Lots of mobile apps are available for users to create their own memes, where text is imposed either onto images from their own collection or from a set of popular meme images. If you've ever made a meme, you've made art, simple though it may be.

C. Art in Us

Another great place to find art is in the work that we produce ourselves. From early life through education and into adult experiences, art is a significant part of many of our lives. Whether we relax or focus our minds by doodling, solidify our ideas by creating a sketch, or exercise our minds with an art class, most of us find art around us whenever we can. In Chapter 5, we describe the theory of a human "art instinct," and though we may not always feel like an artist, we truly believe that each of us that commits to the creation of expressive visual images is an artist, and their work is art.

Nowhere is this clearer to us than in children's art. We encourage artistic expression in children from a very young age, and continue to foster creativity in our education system. Art is a significant part of education in early childhood. Preschoolers study elements of art and design principles such as shape, color, line, and texture. Children in primary and secondary education typically explore these concepts with more sophistication.

Most children enjoy drawing, coloring, and painting. Wax crayons and colored pencil are favorites for adding colorful life to images in coloring books. The sheer recklessness with which children use artistic expression to entertain themselves is often enjoyable for adults, too. Kids make art almost by nature, and their visual interpretation of people, places, and events in their lives is unhampered by expectations of style and skill. That kind of pure expression is not unlike the techniques of the same name or Abstract Expressionism, both described in Chapter 4. Children ignore all pre-conceived artistic expectations or "rules," making their creativity stand out as unique. What better way to describe an artist?

FIGURE 11.
Jim Penucci, *Untitled* (Ryder), 2011. Photograph. Hope, Arkansas.

Look at this drawing by the four-year-old child of this book's editor (figure 12). Their concept of a staircase that appears in this drawing is anything but logical and is unbound by physics or the laws of gravity. And yet, the rapid, cramped lines are unmistakably stairs, though they are strange, unique, and purely creative.

That creativity doesn't need to stop in childhood. With a little freedom of spirit, anyone can make art that taps into their art instinct at whatever level of involvement they feel comfortable. Simply sketching in private is certainly a way to access our creativity, but sometimes the public process of creating art in a group of fellow artists opens up whole worlds of possibility. Art classes are available at nearly every local community center, many art stores hold workshops, and college classes are available for adults who want to develop artistic skill or just explore an artistic experience (figure 13).

FIGURE 12.
Reid Mosher, *Old House*, 2015. Crayon and ink on paper, 11 × 8.5 in. Collection of the artist (Refrigerator Gallery).

Art can bring about a peacefulness in us when we return to the child-like boundlessness of expression. As with most skills, learning the basics can sometimes prepare us for a less structured, more freeing experience with that skill. When we break the rules a little and just let loose, we can find joy, serenity, and satisfaction in the process of being creative.

The works created by you and the people around you may go unnoticed as art. When art is privately produced, it probably won't end up in a museum, and might not even be hung on the refrigerator door. But it's still art whenever it gives shape to our feelings and ideas and experiences. It's still art whenever it captures patterns and images that please us in some way.

FIGURE 13.
Terri Jacobson, *Calvin Stinger Teaching a Ceramics Sculpture Class*, 2014. Photograph. Chemeketa Community College, Salem, Oregon.

The nineteenth-century definition of art no longer fits our present-day understanding. Art is for everyone — and we can find art *in* everyone, too.

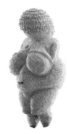

<< Paleolithic period.
Woman of Willendorf.

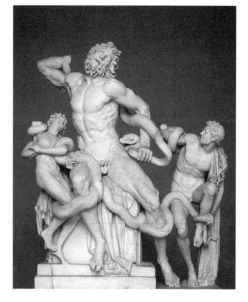

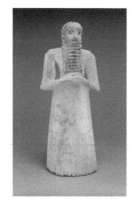

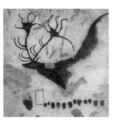

◄ 15,000 BCE.
[Megalocerus, geometric form, and dots] Lascaux Caves.

2900 BCE.
Standing Male Worshipper.

753 BCE.
Foundation of Rome.

27 BCE–68 CE.
Laocoön and his Sons.

3000 BCE ▼ ▼ ▼

∧
3000 BCE.
Building of the Great Pyramid.

∧
2600–2400 BCE.
The Standard of Ur,
"Peace" panel.

2ʳ
Work on the Great Wall
China begi

∧
3001–3100 BCE.
[The Narmer Palette].

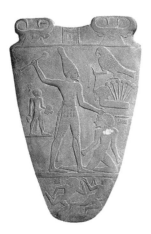

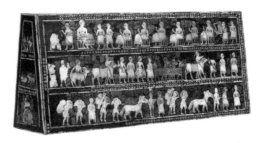

636–649.
"Saluzi" One of the
Tang Horses, Yan Liben
∨

1283–1284.
The Crevole Madonna, Duccio.
∨

1348.
English face Black
Death Plague.
∨

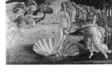

1483–1485.
The Birth of Venus,
Alessandro Botticelli.
∨

1611–1612.
*Judith Beheading
Holofernes,*
Artemisa Gentileschi.
∨

1760–1765.
The Happy Lovers,
Jean-Honoré Fragonard.
∨

of the Roman Empire.

∧
725 CE.
[Lintel 24 of Structure
23 from the Mayan site
of Yaxchilan.]

∧
13th century.
[Rayonnant Gothic
rose window of
north transept],
Jean De Chelles.

∧
1453.
Renaissance in Europe.

∧
1656.
Las Meninas, Diego
Velázquez .

∧
1503–1505.
Mona Lisa,
Leonardo da Vinci.

1808.
The Atelier of Madame Vincent,
Marie-Gabrielle Capet.
∨

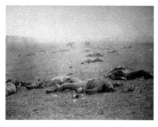

1863.
*Incidents of the War, A harvest
of death, Gettysburg, July 1863,*
Timothy H. O'Sullivan.
∨

1825.
Rocket steam locomotive built.
∨

1861.
Beginning of the American Civil War.
∨

1872.
Impression Sunrise, Claude Monet.
∨

1800

∧
1838.
Boulevard du Temple, Louis Daguerre.

∧
1868.
In the Sierras, Albert Bierstadt.

≪ 1776.
American Declaration
of Independence.

< 1789.
French Revolution.

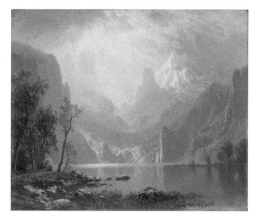

1884–1886.
A Sunday Afternoon on the Island of La Grande Jatte, Georges Seurat.
∨

1885–1890.
Lidded Basket, Isabella and Charles Edenshaw.
∨

1889.
The Starry Night, Vincent van Gogh.
∨

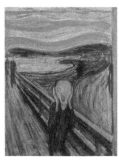

1893.
The Scream, Edvard Munch.
∨

1900

∧
1885.
Benz develops first petrol driven car.

∧
1888–1889. *La Petite Niçoise*, Berthe Morisot.

∧
1889.
The Agnew Clinic, Thomas Eakins.

∧
1885.
Gardanne, Paul Cézanne.

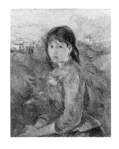

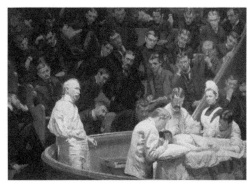

1914.
La Bouteille d'Anis,
Juan Gris.

1921.
Composition, Piet Mondrian

1934.
Paper Workers, Douglass
Crockwell.

1910

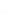

1914–1918.
World War I.

1917.
Fountain, Marcel Duchamp

1939–1945.
Second World War.

1934.
Man-Controller of the Universe,
Diego Rivera.

1914.
Two views of *The Large Horse*,
Raymond Duchamp-Villon.

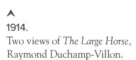

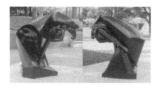

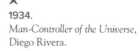

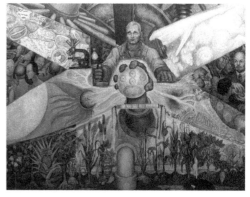

1955–1959.
Monogram, Robert Rauschenberg.
∨

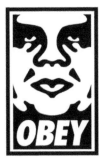

1989.
Obey Icon Face,
Shepard Fairey.
∨

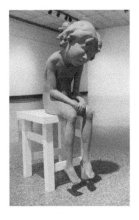

2007.
*Jane from The Big Head
Boys series*, Anne Drew
Potter.
∨

1969.
Stonewall riots.
∨

2005.
Hurricane Katrina.
∨

2016

∧
1968.
Martin Luther King
assassinated.

∧
1991.
First Gulf War.

∧
2015.
Gay marriage
legalized in US.

∧
1959.
Invention of the silicon chip.

∧
1982.
*Vietnam Veterans
Memorial*, Maya Lin.

2000.
World AIDS Days observed.

∧
2010.
Untitled (Graves),
Miller & Shellabarger.

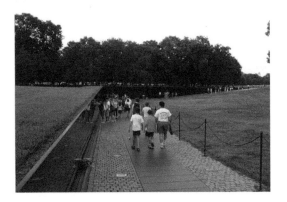

Glossary

1:√2: A proportional relationship based on geometrical construction of a rectangle from a square. The rectangle is made by taking the diagonal of the original square and using it as the long side of the new rectangle. A square has a proportional relationship of 1:1 between its sides. The new rectangle has a proportional relationship of 1:√2.

Abject: Art that inherently disturbs conventional identity and cultural concepts.

Abstraction: 1. Reduction of complex detail to simple form. 2. Rejection of representational images altogether.

Active looking: A disciplined way of looking at art that involves looking beyond mere appearances, becoming more visually aware by paying attention to things we might normally ignore.

Additive: Sculptural technique of adding and combining separate parts to create the piece. Additions can be joined by nails, joints, welds, and so on.

Additive color: Light-based color system. Primary hues are red, green and blue. When the three primaries are combined, they create white light. Used in TVs, computer monitors, cell phones, digital cameras, and theater lights.

Adobe: Simple clay created by forming and drying bricks. The basic building block of the ancient world.

Aesthetic: 1. A theory of beauty. 2. Something that is associated with the study or appreciation of beauty.

Allegory: A representation of events that has parallels with events in history, literature, or other art.

Ambiguous, Ambiguity: Open to a variety of interpretations. Much art takes its power to amaze — and to change as the viewer changes — from inherent ambiguity.

Amorphous: Fuzzy, foggy or defused shapes with no distinct or hard edges.

Analogous color scheme, hues: Colors adjacent to one another on the color wheel. Because they share hues, they can make up a harmonious color scheme.

Annealing: A heating and slow cooling process used to help strengthen the materials such as metals, glass, and clay, and to prevent breakage.

Anthropomorphism: The representation of non-human beings, ideas, deities, or concepts in human form.

Applied art: Work made for useful purposes but made by the hand of an individual artist rather than being made by machines.

Appropriation: The borrowing of imagery, styles, or entire works of art to create new content, subvert the original content, or question assumptions

Approximate balance: When a composition is divided along the vertical axis, the visual units are similar but not exact on both sides.

Aquatint: A technique used in etching that involves dusting the clean plate with powdered resin and melting the resin to leave a pattern of reversed small dots. The process allows the artist to make a wide range of values.

Arabesque: Geometric or plant-based designs woven together to form a repeating and infinitely extendible pattern.

Art: 1. Skill, and in technical knowledge and trained ability. 2. Ingenuity, as in the ability to generate inventive, creative solutions. 3. An activity that requires both skill and ingenuity.

Ashlar masonry: A type of building with stone that is based on combining precisely cut stones without the use of mortar to bind them together.

Assemblage: The assembly of everyday objects to produce meaningful — or meaningless — pieces.

Asymmetry: When the composition in divided along the vertical axis, the left and right side contain dissimilar visual weight.

Avant-garde: From French, "advanced guard," ground-breaking or new art that rejects the status quo in the art world.

Balance: The process or result of equalizing the varying visual and or physical weights of formal and compositional elements in a work of art. When this is done symmetrically, the balance is nearly equal across a single axis of symmetry.

Bas-relief: Sculpture that protrudes from a flat surface.

Bauhaus: A school of art in Germany that combined crafts and fine arts, 1919-1933. It is famous for its functionalist approach to design.

Beauty: A sensory experience that results in a positive emotional response. In the visual arts, this response may be triggered by some or all of the following attributes: proportionally based structure, pattern repetition, compositional stability, balanced use of hue and value, and culturally appropriate idealizations. It is more easily recognized than understood.

Bilateral Symmetry: Symmetry across a vertical axis. Also called mirror symmetry and heraldic symmetry.

Binder: Agent or substance used to hold dry materials together. Binders vary depending upon the specifics of the medium.

Bisque: Refers to the clay after the object is shaped to the desired form and fired in the kiln for the first time, known as "bisque fired" or "biscuit fired." This firing creates chemical changes in the clay.

Calotype: A photographic print made from a negative image with the lights and darks reversed. Calotypes were the first photographs that could be used to make multiple reproductions.

Camera obscura: From the Latin for "dark chamber," this early photography apparatus used light focused with a lens onto an opposite wall of a room or box. This projection could then be traced by the artist to produce a highly accurate representation.

Caming: U-shaped strips of soldered metal between panes of stained glass.

Cardinal directions: North, south, east and west. Orientation to the cardinal directions may signal that the object or structure so oriented is intended to be in harmony with the movement of the cosmos, and thus with the intentions of the divine.

Cartoon: From the Italian "cartone" and Dutch "karton," a full-size drawing made on sturdy paper as a study or modello for a painting, stained glass or tapestry. Cartoons were typically used in the production of frescoes to accurately link the component parts of the composition when painted on damp plaster over a series of days. Cartoons often have pinpricks along the outlines of the design. A bag of soot is then patted or "pounced" over the cartoon, leaving black dots on the plaster.

Carving: The oldest known method for creating three-dimensional work, this process involves removing material from an existing form to achieve the final three-dimensional result.

Casting: First used in manufacturing over five thousand years ago, this process begins with a mold that contains a hollow cavity of the desired shape. Molten metal is poured into the mold and allowed to solidify. Other materials that begin as liquid and can become solid are also used in casting processes today.

Ceramics: Clay that has been fired to produce the hardened material that will no longer melt when exposed to water.

Chalk: Made from nearly pure calcium carbonate consisting of the compressed shells of microscopic sea creatures, chalk is used to add highlights to charcoal drawing or alone on sidewalks and in classrooms.

Charcoal: A dry art medium made of finely grounded organic materials that are held together by a gum or wax binder. The most common forms are vine, compressed, and charcoal pencil.

Chiaroscuro: From Italian, "light and shade." An approach developed in the Italian Renaissance as part of naturalistic depictions. Chiaroscuro uses attention to the differences between light and shade falling over a lit form to construct an illusion of three dimensions on a flat surface. Another term used for this is modeling.

Chroma: The purity of a hue or color. Also referred to as intensity or saturation.

Circle: A plane geometric form in which all points are equidistant from a central point.

Clay: Naturally occurring substance that can be shaped into decorative or functional forms. See *Ceramics*.

Coherence: See *Unity*.

Coil method: Pottery technique using long "snakes" of clay, coiled up on one another, to raise the walls of a vessel. The coils are typically joined, using a process called luting.

Collage: Creating compositions by cutting and pasting media together.

Color: Hue, value, and saturation considered together. Common names are pink, mauve, olive, or teal.

Color scheme: A group of colors, chosen for their relationships and interactions with one another, used in a work of art. Another term for this is a palette of colors. Modern color schemes tend to be based on the color wheel, while pre-modern color schemes may be based on available pigments or on their costliness. See complementary, triadic, analogous, tetradic, achromatic and monochromatic.

Color wheel: A color diagram that arranges colors in a set relationship with one another, based on the triadic and complementary relationships between colors. Complementaries are set facing each other on a chord of the circle.

Complementary hues or colors: Colors that are opposite to each other on the color wheel. When mixed together, they neutralize each other's hue. The result is a grayish hue that is different for each mixture. The basic complementaries are red/green, blue/orange and yellow/violet, but any color has its complementary. Because basic complementaries are always composed of a primary and a secondary, and the secondary is always composed of the other two primaries, this rule follows for other complementaries. The complementary of blue-green will be red-orange, and of blue violet will be yellow-orange.

Composite view: A type of perspective that shows elements of a subject in profile. See *Schemata*.

Composition: The arrangement of all of the formal elements of a work of art, placed within the artist's chosen format, taken as a whole. Two-dimensional composition arranges the elements on a flat surface. Three-dimensional composition arranges the elements in a three-dimensional space.

Concept, Conceptual art: Art that privileges ideas over observation or beauty.

Conceptualized representations: Subjects or forms constructed according to mental images rather than by following what appears in nature. Conceptualized representations tend to be schematic rather than naturalistic.

Content: The meaning or message of a work of art, carried through subject, style composition, and technique. The subject content of a work of visual art often will include some or all of the following: story, metaphor, symbolism, and personification.

Continuation: Creating a visual pathway that moves the eye through and around the composition.

Contour lines: Artistic technique in which the artist sketches the contour of a subject by drawing lines that result in a drawing that is essentially an outline. Contour drawings emphasize the mass and volume of the subject rather than the detail, focusing on the outlined shape of the subject and not the minor details.

Contrast: Difference, when a focal point is created by a difference in color, value, shape, texture, and so on.

Convergence: When parallel appear to meet as they recede into the distance. See *Vanishing points*.

Cosmological: Related to or referring to the cosmos. Cosmological metaphor is sometimes built into architecture or earth-based art by orienting the work to specific heavenly bodies, such as the sun, the moon, a planet, a star or a constellation, or to some spiritually significant element of the surrounding landscape.

Cosmos: The universe when regarded as a systematically arranged whole. This emphasizes the cosmos as a social or religious concept rather than as the complex physical structure that it is.

Counterweight balance: A mode of asymmetrically balancing a work of art by balancing the visual elements of one area of a work against the visual elements of another area of the work.

Craft: An applied art form, where works of art have a functional purpose beyond their aesthetic or ornamental value.

Cross contour lines: When lines explore the interior of a shape, its inner topography. Cross contour lines give flat shapes a sense of form — the illusion of three dimensions — and can be used to create shading.

Cubism: Style developed in the early twentieth century. Cubism attempts to depict objects from multiple viewpoints, as if the viewer were seeing the subject from many sides or during many moments at the same time.

Curvilinear: Characterized by smooth curving lines, edges or shapes.

Dada: Art that embraces irrationality as a way of understanding the world.

Daguerreotypes: The first publicly announced photographic process, and for nearly twenty years, the one most commonly used. It was invented by Louis-Jaques-Mandé Daguerre and introduced worldwide in 1839.

Dark room: An enclosed space for development photographic film negatives and prints, lit only by special lights to avoid damaging film negatives.

Decorative: Purely ornamental.

Decorative pattern: Repetitive ornamental forms, lines, values and colors. As a work includes more and more pattern, it generally becomes flatter and flatter because pattern calls attention to the surface of a work.

Design: 1. The process of deciding how to arrange the formal elements principles in art. 2. The finished arrangement. In this sense, a design is like a composition.

De Stijl: From Dutch, "The Style." A Dutch artistic movement founded in 1917. De Stijl proposed ultimate simplicity and abstraction.

Detail: The presence of precise and individual features. When a subject is shown in detail, it can evoke a closeness with that subject, as detail replicates physical closeness — the closer one's eye to an object, the clearer that object appears.

Distortion: Altering the natural proportions, color, surface texture, or other characteristics of a subject. Ideal distortion chooses some or all of the locally determined qualities of beauty and exaggerates them to the point that no real subject could be that "perfect." Expressive distortion exaggerates any of the formal elements or compositional approaches to create a negative emotional response in the viewer such as sorrow, fear, anger, or distress. See *Expressive distortion*.

Draftsman: A person skilled in drawing plans or designs.

Drawing: An image made by rubbing or marking dry or wet pigments onto a surface.

Drypoint: An etching technique that creates additional burrs of metal on the plate surface by scratching directly onto it. These burrs catch a fine film of ink, strengthening and blurring the lines at the same time.

Echoing shape: See *Repetition* and *Rhythm*.

Egg tempera: A painting medium that combines pigment with egg yolk and water.

Elevation: A measured drawing of the side of a building

Embroidery: This refers to both the process and the product where ornamental stitching adds thread to the surface of a woven fabric.

Emotional content: Elements of a work of art that attract and influence viewers by engaging their emotions. This can be done in a wide variety of ways.

Emphasis: An area that draws attention. See *Focal point*.

Encaustic: A painting medium that combines dry pigment with heated beeswax.

Engraving: An intaglio printmaking technique that uses a graver, or cutting tool, on a metal plate to create a reverse image. That plate is then spread with ink and pressed against damp paper to transfer the image as a print. Also used as decoration on metal objects.

Enlightenment: a philosophical, scientific, and cultural movement based on exploration and understanding of the natural world through personal, rational investigation rather than through religious faith. Enlightenment thinkers opposed what they regarded as superstition and tyranny, both in the Christian churches and in traditional government by kings. As part of the enlightenment, natural philosophers — the scientists of their day — developed the foundations of today's science and technology that sparked the industrial revolution.

Erasers: A drawing tool that subtracts — entirely or partly — existing marks on paper without destroying the paper.

Etching: This refers to both the process and the product of an intaglio printmaking technique where a metal plate is covered by a thin layer of wax before cutting, after which it is placed into an acid bath. The places where the plate was cut allow acid to eat at the metal, but the wax-covered surfaces stay clear. The acid-marked areas create dark lines when the plate is inked and pressed onto paper.

Exhibition: A display of art, whether in a formal gallery, museum, or informal gallery.

Expressive art: Art that focuses more on emotion than ideals by revealing the artist's feelings and attempting to make the viewer feel the same way.

Expressive distortion: Distortion of any aspect of a work of art for the purpose of evoking strong, often negative emotion.

Eye level: The same relative height as the viewer's eyes. Used to determine the vanishing point in linear perspective.

Felting: A fabric-making process where wool is boiled and beaten to consolidate its fibers. The process can be applied to other textile materials, as well.

Fibonacci sequence, Fibonacci numbers: Important source of proportional relationships in art. The Fibonacci sequence is constructed by adding taking the last number of the pair as the first half of a proportional relationship and adding the two numbers together for the second half of the relationship. Thus, 1:1, 1:2, 2:3, 3:5 5:8, 8:13, 13:21, and so on. As the proportions develop, they approximate the golden ratio of 1:1.61819. See *Golden rectangle, Golden mean*.

Field: The area of a two-dimensional work of art.

Figural: Based on forms that appear in the visual world.

Fine arts: Art objects that are defined by their aesthetic value rather than function or utility.

Fired: A step in the ceramics process where clay is baked in a kiln. See *Ceramics* and *Kiln*.

Flash mobs: A group of people who rapidly assemble unannounced in a public place and perform an unusual or seemingly pointless act for a brief time before quickly dispersing. They are often used for the purposes of entertainment, satire, or artistic expression and are typically organized via social media. (Wikipedia)

Focal points: The area in the composition intended to attract the viewer's eye. The primary point of importance in the composition.

Foreground: In two-dimensional images, the part of the scene that appears closest to the viewer. It is usually the lowest part of the field.

Foreshortening: The accurate depiction of a three-dimensional form as seen from an angle. If a form appears to be the way the eye would see it in the visible world, especially if it is depicted using light and shade to mimic shadow, it is almost certainly foreshortened.

Form: 1. Shape, mass, volume, and space are all aspects of form. A shape is usually two-dimensional. A mass is a solid three-dimensional form, while a volume is a surface circumscribing a contained space. 2. The basic building blocks in art, the use of the elements and principles.

Formal analysis: A study of the formal qualities of a work.

Formal elements: Sometimes called visual elements, the basic building blocks of visual art: value, line, form, shape, color, texture, and mass.

Formalism, Formalist: Artwork or artists that focus on the formal elements as the study and subject of art.

Formal qualities: An artist's application of the principles of composition to the formal elements. Discussions of formal qualities generally disregard any subject.

Format: The underlying shape of the work. Basic formats are vertical/portrait rectangle, horizontal/landscape rectangle, square, circular, or round. Statues and other three dimensional works of art also have underlying shapes, which one discovers by building an imaginary box around the work.

Framing: The artist's decision as to how much of the subject will be included in the work. This is constructed by imagining how closely the viewer is standing to the work and then recreating the visual sensations and relationships that the viewer would feel from that distance. See *Viewpoint*.

Freestanding: Art, typically sculpture, that is self-supporting and can be viewed from multiple angles.

Fresco (buon, secco): Painting on fresh plaster. Fresco, translated from Italian, means fresh. Buon means good or true and refers to painting on wet plaster. Secco means dry and refers to painting on dry plaster.

Futurism, Futurist: A social and artistic movement characterized by interest in machinery and machine-like qualities, including speed, violence, and automation.

Gallery: A location where art is displayed, either formally or informally. Galleries often display art for sale, although this is not always the case.

Geometry/geometric lines: Plane or three-dimensional forms constructed by lines arranged in specified relationships to create surfaces.

Gesso: A mixture of ground chalk and glue that is painted onto a surface before beginning a painting.

Glazes: In painting, a thin, transparent layer of paint usually added to increase luminosity. In ceramics: ground up matter which is added to a slip and painted or dropped on the ceramic vessel and then fired.

Golden rectangle, Golden mean: A proportional relationship constructed by dividing a square into two halves, and using the diagonal of one rectangle to extend the length of the square to a larger rectangle. 1: 1.61819. 1:1.4142 reflects the use of 1:√2, a rectangle constructed by extending one side of a square to the length of the diagonal of the square. Also called the Golden Mean. See *Fibonacci sequence*.

Gothic: Style of art and architecture popular in Europe from the twelfth through fifteenth centuries. Gothic architecture is identified by the use of the pointed arch, ribbed vault, and flying buttress. Gothic artwork is identified in part by the presence of religious symbols and its frequent placement in churches and cathedrals as frescos, stained glass, illuminated manuscripts, and panel paintings. (Wikipedia)

Graffiti: See *Street art.*

Graphite: A dark gray drawing medium which comes in various degrees of hardness. Frequently referred to as the 'lead' in a pencil.

Gray scale: A tool for measuring relative value. A gray scale divides the value range from lightest to darkest into an even series of steps.

Grid: A composition device to create unity which relies on the intersection of strong, parallel vertical and horizontal lines.

Grotesque: 1. Distorted so as to appear ugly or unnatural. 2. A figure made up of a mixture of different animals, or that mixes human and animal or human and vegetal characteristics. 3. Decorative forms that include grotesques.

Ground: A mixture of binder and chalk that, when dry, creates a non-porous layer between the support and the painted surface, protecting the support from chemical attack by the paint. Gesso is a common ground, but acrylic grounds are also available. See *Gesso*.

Ground plan: A measured drawing of the footprint of a building, showing all weight-bearing walls and other supports.

Harmony: Similar to a harmony in a song, everything goes together. See *Unity*.

Hatched or cross-hatched: Hatching is an artistic technique used to create tonal or shading effects by drawing closely-spaced parallel lines. When lines are placed at an angle to one another, it is called cross-hatching.

Hellenistic: Art and culture associated with ancient Greece, from the death of Alexander the Great until the incorporation of Egypt into the Roman Empire. Hellenistic works are emotional and dramatic and contain a variety of subject matter.

Heraldic symmetry: Symmetry across a horizontal axis. Often found in landscape compositions using bodies of water to reflect across the axis. When balance is developed asymmetrically, the result is called counterweight balance.

Hierarchical scale: Manipulating the sizes of natural objects or persons to show their relative importance, the most important person or thing is the tallest and the least important the shortest, regardless of how these objects or people may appear in nature. Sometimes called hieratic scale.

Hierarchy: An arrangement in order of importance, from most important to least important. This may be done vertically, with the most important subject at the top and the least at the bottom, or through heraldic symmetry, with the most important subject at the center and the least important at the edge.

Hieratic scale: See *Hierarchical scale.*

High art: Art which deals with lofty and dignified subjects and is characterized by an elevated style.

High relief: More than 50% of the sculpture is protruding off of the back. See *Relief.*

High-key: See *Key.*

Horizon line: The edge where the earth and the sky meet. The horizon line is often used in compositions to suggest that parts of the work that are above the horizon line are heavenly or superior, while parts below the horizon line are earthly, earthy, or inferior. Works that don't show the earth or the sky can still have an implied horizon line built into the composition in order to suggest these same distinctions.

Hue: The underlying wavelength of a color, as in the rainbow, independent of its value or saturation. Common names are red, blue, or orange.

Idealism: 1. Construction of images based on ideas about a perfect world, rather than on what the viewer sees. 2. Distortion of forms to create a perfect or ideal beauty impossible in real life. Ideal beauty varies by culture.

Illusion of depth: The creation of three-dimensional illusion on a two-dimensional picture plane.

Impasto: Thick application of paint.

Implied lines: Lines created by visually connecting two or more areas together.

Impressionism: An artistic movement characterized by artists' depiction of scenery as they might see it, replicating their vision as work from life, often appearing sketch-like or unfinished compared to earlier work in realism.

Ink: A wet drawing medium that can be diluted or used at full strength for tonal variation. Inks can come from a variety of sources, both natural and man-made.

Installation art: Art which takes over predictable space. The viewer experiences rather than views installation art.

Intaglio: From the Italian "to cut," a type of printmaking where an artist cuts a reverse image into a metal plate, inks the plate, and presses that plate with wet paper to transfer the ink onto the paper.

Intensity: Relative purity or neutrality of a hue. See *Chroma.*

Interior: Art that focuses on the insides of places, particularly dwellings or domestic environments.

Intermediate hues: Hues created when a primary and a secondary hue are mixed. Common names are Red orange, Yellow green, or blue purple. See *Hue*.

Intuitive perspective: See *Perspective, intuitive*.

Isolation: A focal point that is moved away or separated from a group.

Jagged lines: Lines that are rough, serrated, and irregular.

Juxtaposition: Placing two objects together in close proximity, inviting interpretive connections and comparison between two potentially unrelated things.

Key (high-, middle-, low-, and split-): This refers to value in a work of art. High-key emphasizes pale values, middle-key emphasizes middle values, and low-key emphasizes dark values. Split-key drops out some of the values in the middle.

Keystoning: A distortion caused by holding a lens at any angle other than ninety degrees to an image about to be photographed or projected. The shape of the work is shifted from rectilinear to a truncated pyramid shape, and all of the content is equivalently distorted.

Kiln: A thermally insulated oven that produces temperatures sufficient to complete a ceramic process such as hardening, drying, or chemical reactions. See *Ceramics*.

Kinetic sculpture: Sculpture that moves.

Kitsch: Art that is pretentious, shallow, and popularly appealing.

Landscape: Art that focuses on nature, particularly the grandness and sweeping beauty of viewpoints that capture large areas of the outdoors at once.

Light and shadow: 1. As light hits a three-dimensional object, some surfaces reflect the light, creating the effect of bright spots on the surface, while some surfaces do not receive any light to reflect, creating the effect of dark spots on the surface. We experience these effects as light and shadow. 2. Mimicking the effects of light and shadow in a two-dimensional work.

Line: A mark noticeably longer than it is wide. Lines come in infinite varieties, may be implied or strongly marked, can enclose a form, mark internal divisions, or be independent of form. Line can be harsh, liquid, elegant, or brutal, and thus draws an emotional response from the viewer. Three basic types are rectilinear, curvilinear, and jagged.

Linear perspective: See *Perspective, linear*.

Linear, linearity: 1. Emphasizing line rather than form. 2. Using line in a decorative and often flattening way.

Lithography: A printmaking technique where an image is first drawn on stone using wax crayons or grease-based tusche. Using gum arabic, nitric acid, water, and ink, a positive image is then printed onto paper from the stone. Lithography literally means " stone drawing".

Low-key: See *Key*.

Luting: In coil method pottery, the process of joining the coils together using clay slip. See *Coil method*.

Manner: Another word for *Style*.

Mannerism: Borrowing of an already established artist's style.

Mass: Solid three-dimensional form.

Materials: See *Medium, media.*

Matrix: The physical surface of the printing material used in a printmaking process, such as metal for etching and engraving, stone for lithography, and stencil for screen-printing.

Meaning: Works of art have messages that go beyond the recognizable subject or use. They show the viewer ways to understand the world and teach the viewer how to behave and think. In order to do this, they use symbolic objects and subjects, meaningful placement within the work, symbolic color, and so on.

Medium, media (plural): 1. The material with which a work of art is made. 2. The adhesive mixed with pigment to adhere it to a surface, such as oil, glue, resin, wax, and so on.

Meme: An internet phenomenon where images and text are combined to create meaning for viewers who understand the specific context of either text, image, or both.

Metaphor: The visual arts equivalent of metaphor in language. A word whose meaning is transferred from the word it ordinarily designates to a word it may only designate by implicit comparison or analogy, as in the phrase "twilight of life."

Middle-key: See *Key.*

Minimalism, Minimalist: An artistic movement characterized by minimal involvement of the artist. Themes in minimalism might be materials including medium or color, where the art is the placement of the unmodified material itself.

Modeling: 1. Using chiaroscuro to create the illusion of three-dimensionality on a two- dimensional surface by shading and blending. 2. In sculpting, the process of using a malleable material, such as clay, to create a three-dimensional object.

Monochrome: A very narrow range of hue, even though the hue may be broken into many different values.

Monotype: A form of printmaking that has images or lines that can only be made once, unlike most printmaking, which can make multiple prints. Standard printmaking techniques that can be used to make monotypes include lithography, woodcut, and etching.

Modernism: An international movement of art and culture representing the dramatic shift in artistic and cultural conscience after World War I. In the constantly changing world of the early twentieth century, many modern artists sought to respond to these changes — of perception and worldview caused by the horrors of war — with mourning for the strengths and values of the past. Others marveled at the technological and social advances that seemed to be happening daily, attempting to capture the change, whether by accenting the new world's absurdity or by honoring and respecting its mechanization. In all cases, modern artists often risked their reputations to create new methods, new expectations, and ultimately new art.

Movement: See *Continuation.*

Mural art: Art that is painted or sculpted onto a wall, generally in a public space.

Museum: A formal place to view art that is generally funded by public funds, admission fees, and philanthropic donations.

Narrative: Story. Narrative art is art that involves a story or history to be understood.

Natural, naturalism: Depicting events or beings that could exist in real life without surprising anyone and depicting them in such a way as to give the illusion that they are real.

Negative shape or space: The shapes of the spaces between the positive forms of a work of art, often as important as the shapes of the forms themselves.

Neolithic: From the New Stone Age. The Neolithic period began around 10,000 BCE and marks the end of the great ice ages and the human shift from hunter-gatherer to agricultural-pastoral society. The Neolithic is characterized by domestication of livestock, true agriculture, settled villages and, eventually, towns, ceramic, and weaving. Along with these great changes came shifts in art and spiritual beliefs.

Neutral, neutralization: The process of mixing complementary colors to make a new hue. As the complementary is mixed in, the hue will darken and lose luminosity and intensity.

Non-figural: Art based on forms that exist only in the mind of the artist and do not draw on visual experience. See *Nonrepresentational.*

Nonrepresentational: 1. Not having any recognizable subject. 2. Rejecting visual experience as an appropriate part of art. Also called non-objective.

Objective: Based on factual observation.

Optical illusion: A visual illusion characterized by visually perceived images that differ from objective reality. The information gathered by the eye is processed in the brain to give a perception that does not match up with physical measurements of the same information. (Wikipedia)

Orientation: Placement or location in a specific relationship to the cardinal directions, or deliberate and meaningful situation in respect to other objects.

Organic: Shapes based on nature or natural references. Edges tend to be softened or smoothed like a river rock or an amoeba.

Ornament: Decorative additions that do not alter the function of an object but make it more attractive or meaningful to the viewer.

Overlapping: A method of illustrating depth by placing one object in front of another. The object that is placed behind appears to be further away because only part of the object is visible.

Painterly: Relying on color and value to create an illusion of form, usually having a less hard-edged appearance, and sometimes showing clear marks of the hand of the painter, called brushwork.

Painting: Both the process and the product of creating a work of art, usually two-dimensional, made by layering a blended medium mixed with pigment onto a surface with brushes or other tools.

Paleolithic: From the Old Stone Age. Art history concerns itself mostly with the very late Old Stone Age, when painting and sculpture appeared. The Paleolithic period, also called the ice age, is a time of hunter-gatherer societies. The only known Paleolithic domesticated animal is the dog.

Parietal: Pertaining to the walls of an enclosed form.

Pastels: A dry, powdered drawing medium that is held together by a gum binder agent. Although similar in consistency to charcoal, pastels are available in a wide range of colors.

Pattern: A repeating arrangement of lines, forms, hues, or value.

Performance art: Art that uses performers as its medium, often involving the audience in ways traditional dramatic plays do not. Live performance art, deliberately chaotic and confusing, may include nonsense poetry, visual art, dance, random noise, and music, often simultaneously.

Period label: Arbitrary but traditional name applied by art historians to times when many practicing artists shared approaches to subject, composition, style, or technique. Period labels are useful for placing an artist in chronological history but not so useful for describing the nature of the shared approaches. They also tend to mask the extent to which some artists, while contemporaries, may be at odds with those shared approaches.

Personification: Representation of an idea or concept in human form with appropriate dress and attributes. The Statue of Liberty is a personification.

Perspective: The illusion of depth depicted on a two-dimensional surface. This illusion may be created in a number of ways, all of which depend in some way on mimicking what the eye sees rather than depicting what the mind knows about the world.

Perspective, aerial: See *Perspective, atmospheric.*

Perspective, atmospheric: 1. The scattering and diffusion of light due to water and dust in the atmosphere, which is strongest at the horizon where we look through thick air and weakest at the zenith. This accounts for the saturated blue of the sky at the zenith and the pale blues seen at the horizon. This phenomenon also affects the appearance of distant objects, so that distant mountains appear blue rather than dark green. 2. The depiction by artists of this effect in an attempt to mimic the appearance of distance.

Perspective, composite: Showing a form from several different viewpoints at once, each viewpoint being the most legible for the desired detail. Composite perspective is used in situations where it is important for all parts of the figure to be seen to exist, such as images for use in the afterlife. Also called twisted perspective. See *Cubism.*

Perspective, intuitive: Unsystematic or inconsistent use of linear perspective in order to construct an illusion of depth on a two-dimensional surface. Sometimes called herringbone perspective from its tendency to mark a series of vanishing points on a vertical line.

Perspective, linear: A means of representing three-dimensional space on a two-dimensional surface. Parallel lines lead to a vanishing point on a horizon line. Human binocular vision creates the optical illusion that parallel lines come closer together as they recede, until finally they meet. The brain interprets this convergence as evidence of distance from the viewer, and with practice can judge that distance quite well. Linear perspective reproduces that optical illusion in two dimensions.

Perspective, one-point: An elaborate, measured system for reproducing the effects of linear perspective, developed by Filippo Brunelleschi in 1415 for producing measured drawings of architecture.

Perspective, rising: A system for depicting the illusion of depth on a two-dimensional surface that does not depend on linear perspective but relies on the relationship between placement in the visual field and closeness. Under most conditions, objects closest to the viewer are lowest in the visual field. The further away objects become, the higher they move in the visual field. Structures are constructed so that the floors or roofs are seen from an angle as if they were tilted out toward the viewer, while the verticals remain vertical. A special version of this is axonometric projection, which standardizes both the tilt and the measurements of structures. In either case the effect is the same. Either the structure has been tilted up toward you or you are flying above it. Also called isometric perspective.

Perspective, scientific: See *Perspective, one-point.*

Photography: A means to capture an image directly using focused light.

Photomontage: A variation on collage that uses actual or reproductions of photographs.

Picture plane: An imaginary window through which we see a work of art that is two-dimensional that attempts to show a three-dimensional view. The picture plane corresponds to the surface of the work, and separates the imaginary world of the work from the world of the viewer.

Pigment: Raw coloring material, unmixed with the adhesive that will adhere it to a surface. Can be from mineral, plant, or synthetic sources.

Placement: Directing the eye through visual movement to a specific area in the composition creates the focal point.

Planar printing: Printmaking techniques that do not cut into the printing surfaces but augment the surface to carry paint or ink in other ways, such as monotype, lithography, or screen-printing.

Plane: In geometry, a two-dimensional area determined by width and length. A plane has no thickness.

Plasticity, plasticity: 1. Malleable sculptural materials, such as clay, are plastic. From this, the area of sculptural form in general is known as the plastic arts. 2. In two-dimensional art, an emphasis on the sculptural qualities of a work, using modeling in value to create or mimic three-dimensional shapes while carefully depicting the edges of objects. Plastic works value form over line or color and rely on what the mind knows about the form as much as they do on what the eye sees.

Plinth: A raised base supporting an object.

Pointillism: Nineteenth century art movement that used tiny dots of color that the eye optically blender together. Sometimes referred to as divisionism or neoimpressionism.

Polychromatic color scheme: A color scheme that is based on multiple colors and does not fall into one of the traditional color schemes.

Pop art: Twentieth century art movement characterized by themes and techniques drawn from popular culture such as advertising and comic books.

Porcelain: A ceramic that is white, fine bodied, and fired to an extremely high temperature to produce an almost glassy material.

Positive shape or space: The suggested or actual shapes that an artist creates by adding material in their medium. Positive space is "filled" by the artist's markings. See *Negative shape or space.*

Postmodernism: An international movement of art and culture that continues today. Postmodern art is generally defined by its focus on irony, parody, collage (pastiche), and sense of play. Where modernism rose as a response to World War I, postmodernism is a response to modernism, finding lofty goals and grand narratives to be less a reflection of real life than silly or otherwise meaningless. Essentially obsessed with irony, postmodern art is self-reflexive and self-aware in the extreme, making it frequently both funny and depressing at the same time. This two-sided nature is apparent in many postmodern artists' work as a playfulness, where artists are willing to laugh at both themselves, and the often very serious topics they address.

Potlatch: A Native American traditional celebration of wealth and prosperity.

Potter's wheel: In pottery, a machine used in shaping round ceramic ware. The wheel may also be used during the process of trimming the excess clay from dried ware, and for applying incised decoration or rings of color. (Wikipedia)

Pottery: Containers made of fired clay are known as pottery. The artist's studio or commercial factory where these objects are made is also called a pottery.

Primary hues: Red, yellow, and blue. They are primary because they cannot be mixed from other pigments but must be made. Secondary colors can be mixed from them. Also known as primary colors.

Print: An image created through one of the printmaking processes such as intaglio. Also used to describe photographic prints.

Proportions: The relationship between two measures. Proportions are found by reducing measurements to common units. For example, a work that is 36 inches tall and 24 inches wide has proportions that are 3:2 (36/12 = 3, 24/12 = 2). A work that is 50 inches tall and 125 inches wide has proportions that are 2:5 (50/25 = 2, 125/25 = 5). Proportions are not themselves dependent on measurement. An area 100 miles x 200 miles has the same proportions as an area 1 inch by 2 inches — 1:2. Proportional relationships are important components in composition and in constructing symbolic meaning in a work of art.

Proximity: Visual or physical grouping of similar or disparate shapes that are viewed as a group before being seen as separate objects.

Public Art: Art that is created in collaboration with public institutions, corporations, or communities, and is therefore publicly displayed and publicly owned.

Pure expression: Art where the movement and intention of the artist is captured in colors, layers, visual texture, lines, organic shapes, drips, or all of them. Rather than focusing on specific subjects, the expressiveness of the painting process is valued.

Pure geometry: Non-representational art based on the use of geometric forms.

Putto, putti (plural): Nude male infants, with or without wings, who often appear in Christian art as infant angels. In mythological images, they are messengers of Eros, the god of erotic love or sex. They first appear in Roman art.

Radial balance: See *Symmetry*.

Ratio: A mode of expressing a proportional relationship in real numbers.

Readymades: Ordinary manufactured objects that the artist selects and modifies. By choosing the objects, arranging them, titling, and signing them, the objects become art.

Realism: See *Natural, naturalism*.

Rectangle: A four-sided plane geometric shape with two parallel sides of equal measurement, two sides of another equal measurement, and all four sides arranged at ninety degrees to each other.

Rectilinear: Contained by or consisting of straight lines and angles.

Red-figure: A type of pottery where red clay bodies are decorated with a thin layer of black slip.

Relief sculpture: A three-dimensional sculpture that is meant to be viewed from one direction. In this technique, parts of a surface are either raised above or lowered below the general plane of the surface.

Relief print: Relief printing is a printmaking process where protruding surface faces of the printing plate or block are inked; recessed areas are ink free. Printing the image is therefore a relatively simple matter of inking the face of the *Matrix* and bringing it in firm contact with the paper. A printing-press may not be needed as the back of the paper can be rubbed or pressed by hand with a simple tool such as a brayer or roller. (Wikipedia)

Repetition: Repeated patterns of shapes, often found at different scales, in different orientations and in different materials, which help to give a work underlying visual harmony or unity. See *Rhythm* and *echoing shapes*.

Representational: Realistic rendering of subject matter.

Reproduction: A copy of the original.

Rhythm: A term borrowed from music, referring to a repeated pattern of sound that underlies and orders a musical composition. In visual art, the pattern is visual rather than aural, and is constructed by repeating patterns of formal elements, or the more complex shapes made by them. See *Echoing shape*.

Rising (or isometric) perspective: See *Perspective, rising*.

Saturation: See *Chroma*.

Scale: Size measured against another object. In art, that object is usually the viewer. Works of art have both external scale, and internal scale.

Scale, relative: The relationship between the size of one object and the size of another when they are perceived as at the same distance from the viewer. This can be repeated at different layers in depth to create a more natural illusion of three-dimensionality.

Schema: 1. Reduction of real-world detail to a pattern. 2. A pattern that represents a larger and more complex body of knowledge or structure.

Schematic: Reduced to a pattern. A schematic human figure would not look like a real person, but would be recognizable as representing the idea of a person. The male and female icons that mark restroom doors are schematic figures.

Schematism: Reduction of knowledge or structure to a schema.

Screen printing: Printing technique in which a mesh is used to transfer ink onto a substrate — such as cloth, vinyl, or wood — except in areas made impermeable to the ink by a blocking stencil. A blade or squeegee is moved across the screen to fill the open mesh apertures with ink, causing the ink to wet the substrate and be pulled through of the mesh.

Sculpture: An art form characterized by its three-dimensionality.

Shade: Any hue mixed with black.

Shape: A line whose ends meet in two-dimensional art. Also called form in three-dimensional art.

Secondary hues: Orange, green and violet (purple). They are secondary because they can be mixed from the primary colors. Red and yellow make orange, red and blue make violet, and blue and yellow make green. Also known as secondary colors.

Signifier: A sign or symbol associated with a meaning but not identical with that meaning.

Simultaneous contrast: Perception of value and hue in relationship to opposite values and hues around it. If the background is broken into many values and hues, the phenomenon is strengthened. No one is sure if this happens in the eye or the brain or both, but it indicates the human preference for seeing difference over seeing similarity.

Site specific: A structure that can only be built in one location.

Size: 1. Actual measurements of a work of art. Always given as height x width (x depth). 2. An adhesive made of gelatin, varnish or starch, used variously to seal a surface for painting, to mix with pigments as a medium, or as an adhesive.

Slip: A suspension in water of clay and/or other materials used in the production of ceramic ware.

Solvent: A substance that is capable of being dissolved into another liquid. Mineral spirits, for example, is a solvent used to thin paint.

Somatic: Of or pertaining to the body.

Space: See *Two-dimensional, Three-dimensional.*

Square: Plane geometric form having four equal sides joined at right angles to one another. Developed into three dimensions, a square becomes a cube.

Stoneware: Vitreous or semi-vitreous ceramic made primarily from stoneware clay or non-refractory fire clay and fired at high temperatures

Story: In visual art, a narrative suggested or dictated by the work.

Street Art: Often considered vandalism, street art is typically unclaimed (artist is unknown) and created in secret or very quickly to avoid discovery. While some street artists are widely known for their work and respected as artists, most street artists are anonymous. Styles of street art range from calligraphic to stencils and stickers, and some artists employ complete paintings. The most common tools of street artists are spray paint and stencils for fast application and mobility.

Style: 1. An approach to depicting a subject or making an object in any of a wide variety of ways. Each approach is a separate style. Style, whether of an individual artist or of a period, begins with the choice of one or a mixture of the following approaches: naturalism, idealism, conceptualized representations and schematism, expressive distortion, abstraction, or nonrepresentation. However, style is affected by all of the formal choices made by the artist, especially choices of technique. 2. A label for an approach to depiction used as a matter of course by an individual artist, or by a group of artists, such as the Rococo style, cubism or impressionism. In this case, the style label is a sort of shorthand for the art historian. To understand how an artist is working, the work must be investigated in terms of the approaches to style given above.

Subject, subject matter: The story, topic, or theme of a work of art.

Subjective: Based on personal response without regard to fact.

Sublime: From the theory by philosopher Edmund Burke, an experience inspired by awe and terror in the face of nature, which creates a kind of delight at having lived through the experience. Expressive art often attempts to capture this feeling and inspire it in the viewer.

Substitutive: Sculptural technique in which one material is replaced by or filled with another, as in casting.

Subtractive method: Sculptural technique of taking away from the mass, such as carving, chiseling, and cutting.

Subtractive color: Color system based upon the reflection of color off of a surface. Primary hues are magenta (red), yellow, and cyan (blue). When the three primaries are combined, they create black.

Supernaturalism: Depicting events or beings, usually in a naturalistic or idealistic style, that could not happen or exist in real life because they would break the laws of physics. Often but not always associated with religious imagery.

Surrealism, Surrealist: An art movement of the early twentieth century that either used a naturalistic style drawn from the imagination or dreams of the artist or was automatism. These images reveal the inner life of the subconscious.

Symbol, symbolism, symbolic: Something that represents or stands for something else. Usually the symbol possesses attributes that reveal the true nature of the thing being symbolically represented. For example, a balance scale is often used to symbolize the act of judgment, because the judge compares evidence, weighing one testimony against another, just as the balance compares the weights of two different things.

Symmetry: A pattern in which components mirror each other across an axis, which can be vertical or horizontal, or, in the case of radial symmetry, across two or more axes at the same time. See *Balance*.

Technique: 1. Method of using tools and media. Dividing technique into linear, painterly and plastic approaches is one way of systematizing discussion of technique. 2. Skill in using tools and media.

Tempered clay: Clay that has additional substances such as sand or rock added to help prevent shrinkage and cracking during drying and firing.

Tempering: A heat treatment technique for metals and alloys. Glass can also be tempered.

Terracotta: A type of earthenware clay, brownish orange in color. Frequently used for utilitarian purposes such a pots.

Tertiary hues: Blue-green, Red-violet, or Yellow-orange. Tertiary hues result from mixing a primary hue with a secondary hue. Also known as tertiary colors.

Texture: The feel of an object. Textures may be hard or soft, smooth or rough.

Texture, abstracted: Texture that is simplified from visual texture, a flattening of texture. See *Texture, visual.*

Texture, invented: Texture that is made up and does not represent the realistic texture of the object.

Texture, physical, tactile: The direct feel of a surface under the hand or against the body.

Texture, visual: Mimicry of physical textures where there are none, using light and shade to create an illusion of texture.

Three-dimensional: Having volume, determined by height, width and depth. Sculpture and architecture are three-dimensional. Some traditionally two-dimensional works, such as paintings, may also be three dimensional if they layer up canvases or objects attached to the canvas.

Time, time-based: Time-based media is any media that takes time to view. In other words, it has a dimension of duration — for example, five minutes or 10 seconds. Time-based media also contain a technology component because hardware is required to view the work. Time-based media art may be made with a physical media, such as film stock, with digital means, or with a combination of the two.

Tint: Any hue mixed with white.

Triadic color scheme: A color scheme using colors picked out from the color wheel by an equilateral triangle. The primary and secondary triads are the best known, but any color is part of a unique triad.

Trompe l'oeil: From the French, "deceive the eye," a technique that uses realistic imagery to create the optical illusion that the depicted objects exist in three dimensions.

Tusche: In printmaking and lithography, a greasy substance applied to a plate or stone.

Two-dimensional: Having only two dimensions, length and width. Paintings, prints, photographs, and digital media are two-dimensional. Many of these works create an illusion of depth or volume but are still defined as two-dimensional.

Tone: Any hue mixed with gray, brown, or its opposite.

Underpainting: A first thin layer of paint, usually monochromatic, that is used to establish the range of values for an image.

Unity: A quality achieved by a work of art when all of its parts come together into a unified whole. Other terms for this are harmony and cohesiveness.

Value: The range of light to dark. With color: chromatic value; without color: achromatic value. Values are discussed as high-key (very light), middle-key (neither light nor dark), or low-key (very dark). May be used to create an illusion of depth, to mimic texture, or to create pattern.

Vanishing point: In linear perspective, the point where parallel lines appear to converge.

Variety: Change, the counterpoint to unity and harmony. Helps to keep the viewer visually engaged.

Vertical: Upright. In art, a format that is taller than wide.

Viewpoint: The relative position in which the artist has imagined the viewer as standing when looking at a work of art. The three standard viewpoints are above the work, even with the work, or below the work. Viewpoint and framing are very closely related. Viewpoint may be used metaphorically.

Virtues: Personifications of desired traits. The cardinal or basic virtues are prudence, justice, temperance, and fortitude. These are part of the Roman virtues. The theological virtues are faith, hope, and charity.

Visual art: See *Art*.

Visual elements: See *Formal elements*.

Visual flow: See *Continuation*.

Visual hierarchy: See *Hierarchy*.

Visual movement: See *Continuation*.

Visual texture: See *Texture*.

Volume: An enclosed three-dimensional area.

Warp: In weaving, the lengthwise or longitudinal thread in a roll.

Weaving: A method of textile production in which two distinct sets of yarns or threads are interlaced at right angles to form cloth.

Weft: In weaving, the thread or yarn which is drawn through the warp yarn to create cloth.

Woodworking: The use and technical skills of working in wood, such as carpentry, furniture making, and sculpture.

Acknowledgments

Text Acknowledgments

The starting point for this project was Saylor Academy's online course, "Art Appreciation And Techniques." Thank you, Saylor Academy, for all your fine work. Our finished text uses material that is available from the following sources:

Chapter 1 What Is Art?

"Perception and Visual Awareness," *ARTH101: Art Appreciation and Technique.* Saylor.org. © Saylor Academy 2015. Original material licensed under a Creative Commons CC-BY 3.0 Unported License.

Boundless. "What Makes Art Beautiful?" *Boundless Art History.* Boundless.com, 3 July 2014. Retrieved 8 Apr. 2015. Original material licensed under a Creative Commons CC-BY-SA 3.0 Unported License.

Chapter 2 The Language of Art

2.1 Style and Technique

"Artistic Styles," *ARTH101: Art Appreciation and Technique.* Saylor.org. © Saylor Academy 2015. Original material licensed under a Creative Commons CC-BY 3.0 Unported License.

2.2 Formal Elements: Line, Shape, Mass, and Texture

"Definitions and Qualities of the Line," *ARTH101: Art Appreciation and Technique.* Saylor.org. © Saylor Academy 2015. Original material licensed under a Creative Commons CC-BY 3.0 Unported License.

2.4. Formal Elements: Space and Depth

"The Element of Space," *ARTH101: Art Appreciation and Technique.* Saylor.org. © Saylor Academy 2015. Original material licensed under a Creative Commons CC-BY 3.0 Unported License.

2.5 Compositional Principles

"Unity and Variety," *ARTH101: Art Appreciation and Technique.* Saylor.org. © Saylor Academy 2015. Original material licensed under a Creative Commons CC-BY 3.0 Unported License.

"Emphasis," *ARTH101: Art Appreciation and Technique.* Saylor.org. © Saylor Academy 2015. Original material licensed under a Creative Commons CC-BY 3.0 Unported License.

"Balance," *ARTH101: Art Appreciation and Technique.* Saylor.org. © Saylor Academy 2015. Original material licensed under a Creative Commons CC-BY 3.0 Unported License.

"Scale and Proportion," *ARTH101: Art Appreciation and Technique.* Saylor.org. © Saylor Academy 2015. Original material licensed under a Creative Commons CC-BY 3.0 Unported License.

Chapter 3 Media and Methods

3.1 Drawing

"Drawing," *ARTH101: Art Appreciation and Technique.* Saylor.org. © Saylor Academy 2015. Original material licensed under a Creative Commons CC-BY 3.0 Unported License.

"Ask the Art Professor: How do you develop an idea from a sketch to a finished work?" *Art Prof: Clara Lieu.* claralieu.wordpress.com. Original material licensed under a Creative Commons CC-BY 3.0 Unported License.

"Artist's Statement," by Samantha Wall. Original material licensed under a Creative Commons CC-BY-SA 4.0 License.

3.2 Painting
"Painting," *ARTH101: Art Appreciation and Technique*. Saylor. org. © Saylor Academy 2015. Original material licensed under a Creative Commons CC-BY 3.0 Unported License.

3.3 Sculpture
"Definitions, Processes, and Sculptures," *ARTH101: Art Appreciation and Technique*. Saylor.org. © Saylor Academy 2015. Original material licensed under a Creative Commons CC-BY 3.0 Unported License.

3.4 Crafts
"Decorative Arts," *ARTH101: Art Appreciation and Technique*. Saylor.org. © Saylor Academy 2015. Original material licensed under a Creative Commons CC-BY 3.0 Unported License.

"Artist's Statement," *(ex)change*. DianeJacobs.net. © Diane Jacobs 2015. Permission of the artist.

"Shigarake Ware," *Wikipedia*. Wikipedia.org. Last modified on 22 June 2015. Original material licensed under a Creative Commons CC-BY-SA 3.0 Unported License.

3.5 Printmaking
"Collage," *ARTH101: Art Appreciation and Technique*. Saylor. org. © Saylor Academy 2015. Original material licensed under a Creative Commons CC-BY 3.0 Unported License.

3.6 Photography
"Early Development," *ARTH101: Art Appreciation and Technique*. Saylor.org. © Saylor Academy 2015. Original material licensed under a Creative Commons CC-BY 3.0 Unported License.

"Photojournalism," *ARTH101: Art Appreciation and Technique*. Saylor.org. © Saylor Academy 2015. Original material licensed under a Creative Commons CC-BY 3.0 Unported License.

"Modern Developments," *ARTH101: Art Appreciation and Technique*. Saylor.org. © Saylor Academy 2015. Original material licensed under a Creative Commons CC-BY 3.0 Unported License.

3.7 Installation and Performance Art
"Modern Variations of Three-Dimensional Media," *ARTH101: Art Appreciation and Technique*. Saylor.org. © Saylor Academy 2015. Original material licensed under a Creative Commons CC-BY 3.0 Unported License.

"Marta Minujín," *Wikipedia*. Wikipedia.org. Last modified on 23 June 2015. Original material licensed under a Creative Commons CC-BY-SA 3.0 Unported License.

Chapter 4 Modernism
4.1 Modern Art
"Impressionism," *SmartHistory*. Saylor.org. © Saylor Academy 2015. Original material licensed under a Creative Commons CC-BY-NC-SA 3.0 Unported License.

Salvador Dalí quote on madness from "Dali is a Dilly" in *The American Magazine* 162.1 (July 1956) by Henry La Cossitt.

4.2 Cubism
"The Element of Value," *ARTH101: Art Appreciation and Technique*. Saylor.org. © Saylor Academy 2015. Original material licensed under a Creative Commons CC-BY 3.0 Unported License.

Pablo Picasso quote on Cubism from *Picasso on Art: A Selection of Views*, edited by Dore Ashton. Boston, De Capo Press, 1972. Print.

"Futurism," *Wikipedia*. Wikipedia.org. Last modified on 17 June 2016. Original material licensed under a Creative Commons CC-BY-SA 3.0 Unported License.

4.3 Conceptual Art
Boundless Learning. "Dada," *Boundless Art History*. Boundless.com, 22 July 2015. Retrieved 23 July 2015. Original material licensed under a Creative Commons CC-BY-SA 3.0 Unported License.

"Artist's Statement," by Benjamin Schulman. Artaxis.org. © Benjamin Schulman 2015. Used by permission of the artist.

"Geometric Abstraction," *World Heritage Encyclopedia*. www.worldheritage.org. © World Heritage Encyclopedia 2014. Original material licensed under a Creative Commons CC-BY-SA 3.0 License.

"Surrealism." *Wikipedia*. Wikipedia.org. Last modified on 14 June 2016. Original material licensed under a Creative Commons CC-BY-SA 3.0 Unported License.

4.4. Nonrepresentational Approaches
"De Stijl," *ARTH101: Art Appreciation and Technique*. Saylor. org. © Saylor Academy 2015. Original material licensed under a Creative Commons CC-BY 3.0 Unported License.

Boundless Learning. "German Bauhaus Art," *Boundless Art History*. Boundless.com, 21 July 2015. Retrieved 22 July 2015. Original material licensed under a Creative Commons CC-BY-SA 3.0 Unported License.

"Minimalism." *Wikipedia*. Wikipedia.org. Last modified on 14 June 2016. Original material licensed under a Creative Commons CC-BY-SA 3.0 Unported License.

"Abstract Expressionism," *World Heritage Encyclopedia*. www.worldheritage.org. © World Heritage Encyclopedia 2014. Original material licensed under a Creative Commons CC-BY-SA 3.0 License.

4.5 Pop Art and Postmodernism
"Pop Art," *New World Encyclopedia*. www.newworldencyclopedia.org. Original material licensed under a Creative Commons CC-BY-SA 3.0 License.

"Postmodern Art," *Wikipedia*. Wikipedia.org. Last modified on 12 May 2015. Original material licensed under a Creative Commons CC-BY-SA 3.0 Unported License.

Image Acknowledgments
Images in *Art for Everyone* are used with the following permissions.

Chapter 1: What Is Art?
Figure 1. *Cabinet-vitrine*, by Gustave Serrurier-Bovy, photo by The Metropolitan Museum of Art. All rights granted under OASC.

Figure 2. *The Starry Night*, by Vincent van Gogh, photo by Wikimedia Foundation. All rights granted under Public Domain via Wikimedia Commons.

Figure 3. [Megalocerus, geometric form, and dots], by Unknown, photo by Wikimedia Foundation. All rights granted under Public Domain via Wikimedia Commons.

Figure 4. *The Birth of Venus*, by Alessandro Botticelli, photo by Wikimedia Foundation. All rights granted under Public Domain via Wikimedia Commons.

Figure 5. ["Saluzi," One of the Tang Horses], by Yan Liben, photo by University of Pennsylvania Museum of Archaeology and Anthropology. All rights granted under Public Domain via Wikimedia Commons.

Figure 6. [Lintel 24 of Structure 23 from the Mayan site of Yaxchilan (Mexico)], by Unknown, photo by Michel Wal. All rights granted under a Creative Commons CC-BY-SA 3.0 License via Wikimedia Commons.

Figure 7. [Funerary relief (Stele) of a young man, a hunter, holding a throwing weapon for hare hunting, his dog next to him], by Unknown, photo by Wikimedia Foundation. All rights granted under Public Domain via Wikimedia Commons.

Figure 8. Judith Beheading Holofernes, by Artemisia Gentileschi, photo by Wikimedia Foundation. All rights granted under Public Domain via Wikimedia Commons.

Figure 9. In the Sierras, by Albert Bierstadt, photo by Harvard Art Museums. All rights granted under Public Domain via Wikimedia Commons.

Chapter 2 The Language of Art
2.1 Style and Technique

Figure 1. [Standing Male Worshiper], by Unknown, photo by The Metropolitan Museum of Art. All rights granted under OASC.

Figure 2. [Standing Female Worshiper], by Unknown, photo by The Metropolitan Museum of Art. All rights granted under OASC.

Figure 3. My Pharmacy: Homage to Malevich, by Catherine Haley Epstein, is copyrighted work and used by permission in this work only. It may not be used outside of this work or in any derivative work without further permission.

Figure 4. Paying the Harvesters, by Léon Lhermitte, photo by Musée d'Orsay. All rights granted under Public Domain via Wikimedia Commons.

Figure 5. Portrait of Alexander Sakharoff, by Alexej von Jawlensky, photo by Lenbachhaus. All rights granted under Public Domain via Wikimedia Commons.

Figure 6. Night Walk, by Ruth Armitage, is copyrighted work and used by permission in this work only. It may not be used outside of this work or in any derivative work without further permission. For more information, please see rutharmitage.com.

Figure 7. Bush House, by Eric Wuest, is copyrighted work and used by permission in this work only. It may not be used outside of this work or in any derivative work without further permission.

Figure 8. Woman with a Parasol—Madame Monet and Her Son (Camille and Jean Monet), by Claude Monet, photo by Wikimedia Foundation. All rights granted under Public Domain via Wikimedia Commons.

Figure 9. will and nellie's ride, by dave "nic" nichols is copyrighted work and used by permission in this work only. It may not be used outside of this work or in any derivative work without further permission.

Figure 10. Music Hall in the Ali Qapu Palace, by Unknown, photo by Mohsen Ghasemee. All rights granted under a Creative Commons CC-BY-SA 3.0 Unported License.

Figure 11. How Sir Tristram Drank of the Love Drink, by Aubrey Beardsley, photo by Robin Davis. All rights granted under Public Domain via Wikimedia Commons.

2.2 Formal Elements: Line, Shape, Mass, and Texture

Figure 16. *Nonagon Antiprism*, by Alison Reintjes, photo by Access Ceramics. All rights granted under a Creative Commons CC-BY-NC-ND 2.0 Generic License.

Figure 17. *Without Organs (detail)*, by Brian Caponi, photo by Access Ceramics. All rights granted under a Creative Commons CC-BY-NC-ND 2.0 Generic License.

Figure 18. *Madame X*, by John Singer Sargent, photo by The Metropolitan Museum of Art. Licensed under OASC. All rights granted under Public Domain via Wikimedia Commons.

Figure 19. Example of a Ruben's Vase. All rights granted under Public Domain via Wikimedia Commons.

Figure 20. *Head of Ptolemy II or III*, by Unknown, photo by Metropolitan Museum of Art. Licensed under OASC.

Figure 21. *Standing Woman*, by Gaston Lachaise, photo by Metropolitan Museum of Art. Licensed under OASC.

Figure 22. *Vase with Red Gladioli*, by Vincent van Gogh, All rights granted under Public Domain via Wikimedia Commons.

Figure 23. *Platter*, by Ginny Marsh, photo by Access Ceramics. All rights granted under a Creative Commons CC-BY-NC-ND 2.0 Generic License.

Figure 24. *The Fortune Teller*, by Georges de la Tour, photo by Metropolitan Museum of Art. Licensed under OASC.

Figure 25. *Tan Hands (detail)*, by Misty Gambles, photo by Access Ceramics. All rights granted under a Creative Commons CC-BY-ND 2.0 Generic License.

Figure 26. *The Dream*, by Henri Rousseau, photo by Wikimedia Foundation. All rights granted under Public Domain via Wikimedia Commons.

Figure 27. *Aristotle's Foil*, by Lindsay Pichaske, photo by Access Ceramics. All rights granted under a Creative Commons CC-BY-NC-ND 2.0 Generic License.

2.3 Formal Elements: Value and Color

Figure 1. Illustration of gray scale, courtesy of Chemeketa Community College Visual Communications Department.

Figure 2. Illustration of simultaneous contrast in value, courtesy of Chemeketa Community College Visual Communications Department.

Figure 3. *Portrait of a Lady*, by Jean Auguste Dominique Ingres, photo by Metropolitan Museum of Art. Licensed under OASC.

Figure 4. *Saint Jerome Praying in His Study*, by School of Rembrandt, photo by Metropolitan Museum of Art. Licensed under OASC.

Figure 5. *Machinery Abstract No. 2*, by Paul Kelpe, photo by Smithsonian American Art Museum. All rights grated under a Creative Commons CC-BY-NC-ND 2.0 Generic License.

Figure 6. *Evidence from the Cave #1 (The Myth of the Cave Series)*, by Robert Bibler, is copyrighted work and used by permission in this work only. It may not be used outside of this work or in any derivative work without further permission.

Figure 7. Example of primary colors in the additive mode. All rights granted under Public Domain via Wikimedia Commons.

Figure 8. Example of primary colors in the subtractive mode. All rights granted under Public Domain via Wikimedia Commons.

Figure 9. Example of the twelve-hue color wheel. All rights granted under Public Domain via Wikimedia Commons.

Figure 10. *Freedom in the Silence*, by Dayna J. Collins, is copyrighted work and used by permission in this work only. It may not be used outside of this work or in any derivative work without further permission. For more information, please see www.alleyartstudio.com.

Figure 11. *Wheat Field with Cypresses*, by Vincent van Gogh, photo by Metropolitan Museum of Art. Licensed under OASC.

Figure 12. *Dark Water – Diptych*, by Ruth Armitage, is copyrighted work and used by permission in this work only. It may not be used outside of this work or in any derivative work without further permission. For more information, please see rutharmitage.com.

Figure 13. *Depressionware*, by LowkeyVision, photo by Wikimedia Foundation. All rights granted under a Creative Commons CC-BY-SA 3.0 Unported license via Wikimedia Commons.

Figure 14. *The Happy Lovers*, by Jean-Honore Fragonard, photo by Wikimedia Foundation. All rights granted under Public Domain via Wikimedia Commons.

Figure 15. *Beach Weekend*, by Nancy Eng, is copyrighted work and used by permission in this work only. It may not be used outside of this work or in any derivative work without further permission.

2.4. Formal Elements: Space and Depth

Figure 1. *Red Turbine*, by Peter Christian Johnson, photo by Access Ceramics. All rights granted under a Creative Commons CC-BY-NC 2.0 Generic License.

Figure 2. *Self-destructing Porcelain Net*, by Backa Carin Ivarsdotter, photo by Access Ceramics. All rights granted under a Creative Commons CC-BY-ND 2.0 Generic License.

Figure 3. *Paris Street; Rainy Day*, by Gustave Caillebotte photo by Wikimedia Foundation. All rights granted under Public Domain via Wikimedia Commons.

Figure 4. *Still Life with Berries, Chair and Cloth*, by John Van Dreal, is copyrighted work and used by permission in this work only. It may not be used outside of this work or in any derivative work without further permission. For more information, please see www.johnvandreal.com.

Figure 5. Example of foreshortening using John Van Dreal's *Still Life with Berries, Chair and Cloth*, courtesy of Chemeketa Community College Visual Communications Department.

Figure 6. [The Narmer Palette], by Unknown, photo by Wikimedia Foundation. All rights granted under Public Domain via Wikimedia Commons.

Figure 7. *Marion, Arkansas*, by Thomas R Machnitzki (own work). All rights granted under a Creative Commons CC-BY-SA 3.0 Unported License.

Figure 8. *The Piazza di Spagna*, by Giovanni Battista Piranesi, photo by Metropolitan Museum of Art. Licensed under OASC.

Figure 9. *Literary Gathering*, by Huizong of Song, photo by Wikimedia Foundation. All rights granted under Public Domain via Wikimedia Commons.

Figure 10. *Legend of St. Francis: 1. Homage of a Simple Man*, by Unknown, photo by Wikimedia Foundation. All rights granted under Public Domain via Wikimedia Commons.

Figure 11. *The Dream*, by Franz Marc, photo by Wikimedia Foundation. All rights granted under Public Domain via Wikimedia Commons.

Figure 12. *Original Manuscript and Rare Book Library, Walters Art Gallery*, by Frederic Schuler Briggs. Unrestricted use granted under Creative Commons CC0 No Rights Reserved License via The Walters Art Museum.

Figure 13. *The Horse Fair*, by Rosa Bonheur, photo by Metropolitan Museum of Art. Licensed under OASC.

Figure 14. *Love's Passing*, by Evelyn De Morgan, photo by The De Morgan Foundation. All rights granted under Public Domain via Wikimedia Commons.

Figure 15. *La Petite Niçoise*, by Berthe Morisot, photo by Wikimedia Foundation. All rights granted under Public Domain via Wikimedia Commons.

Figure 16. *Mona Lisa*, by Leonardo da Vinci, photo by Josh Hallett. All rights granted under Public Domain via Wikimedia Commons.

Figure 17. *Spring Way*, by Romare Bearden, is copyrighted work and used by permission in this work only. It may not be used outside of this work or in any derivative work without further permission. Art © Romare Bearden Foundation/Licensed by VAGA, New York, NY.

2.5 Compositional Principles

Figure 1. *Palm Prints*, by Jamie Bardsley, photo by Bowling Green State University. All rights granted under a Creative Commons CC-BY 2.0 Generic License.

Figure 2. *Palm Prints (detail)*, by Jamie Bardsley, photo by Bowling Green State University. All rights granted under a Creative Commons CC-BY 2.0 Generic License.

Figure 3. *Metonymic 2*, by Thomas Stollar, photo by Access Ceramics. All rights granted under a Creative Commons CC-BY 2.0 Generic License.

Figure 4. *The Wreck of the Hope*, by Gary Westford, is copyrighted work and used by permission in this work only. It may not be used outside of this work or in any derivative work without further permission.

Figure 5. *Spheres of Influence*, by Eileen Cotter Howell, is copyrighted work and used by permission in this work only. It may not be used outside of this work or in any derivative work without further permission. For more information, please see www.eileencotterhowell.com.

Figure 6. *Peninsula*, by Sarah Fagan, is copyrighted work and used by permission in this work only. It may not be used outside of this work or in any derivative work without further permission. For more information, please see www.sarahfagan.com.

Figure 7. *Organize*, by Sarah Fagan, is copyrighted work and used by permission in this work only. It may not be used outside of this work or in any derivative work without further permission. For more information, please see www.sarahfagan.com.

Figure 8. *The Ladder*, by Barry Shapiro, is copyrighted work and used by permission in this work only. It may not be used outside of this work or in any derivative work without further permission. For more information, please see www.bshapirophotography.com.

Figure 9. *The Agnew Clinic*, by Thomas Eakins, photo by Miguel Hermoso Cuesta. All rights granted under Public Domain via Wikimedia Commons.

Figure 10. *Adrift 1*, by Eric Wuest, is copyrighted work and used by permission in this work only. It may not be used outside of this work or in any derivative work without further permission.

Figure 11. *Transillumination*, by Carol Hausser, is copyrighted work and used by permission in this work only. It may not be used outside of this work or in any derivative work without further permission.

Figure 12. *Balance #1*, by Elaine Green, is copyrighted work and used by permission in this work only. It may not be used outside of this work or in any derivative work without further permission. For more information, please see www.blackthumbart.com.

Chapter 3 Media and Methods
3.1 Drawing

3.2 Painting

3.3 Sculpture

3.5 Printmaking

3.6 Photography

Figure 1. [Cross-section of a camera obscura from Sketchbook on military art, including geometry, fortifications, artillery, mechanics, and pyrotechnics], by Unknown, Library of Congress. All rights granted under Public Domain via Library of Congress.

Figure 2. *Boulevard du Temple*, by Louis Daguerre, photographic copy by Beaumont Newhall. All rights granted under Public Domain.

Figure 3. *Tartan Ribbon*, by James Clerk Maxwell and Thomas Sutton. All rights granted under Public Domain via Wikimedia Commons.

Figure 4. *Image of a Kodak Brownie Camera*, photo by Håkan Svensson. All rights granted under a Creative Commons CC-BY-SA 3.0 Unported License.

Figure 5. *Cathedrale Sant-Caprais d'Agen*, by Louis Ducos du Hauron, photo by Wikimedia Foundation. All rights granted under Public Domain via Wikimedia Commons.

Figure 6. [Animal locomotion. Plate 62, Vol. I: Males (nude)], by Eadweard Muybridge, photo by Boston Public Library. All rights granted under Public Domain.

Figure 7. *Incidents of the war. A harvest of death, Gettysburg, July 1863*, by Timothy H. O'Sullivan, Library of Congress Prints and Photographs Division. All rights granted under Public Domain via Library of Congress.

Figure 8. *Front Page of The Globe, 29 September 1909*, Wilbur and Orville Wright Papers, Manuscript Division, Library of Congress. All rights granted under Public Domain via Library of Congress.

Figure 9. [Destitute pea pickers in California. Mother of seven children. Age thirty-two. Nipomo, California], by Dorothea Lange, FSA/OWI Collection, Library of Congress Prints & Photographs Division. All rights granted under Public Domain via Library of Congress.

Figure 10. *Winter—Fifth Avenue*, Alfred Stieglitz, photo by The Metropolitan Museum of Art. All rights granted under Public Domain and OASC.

Figure 11. *The Dancers*, by Barry Shapiro, is copyrighted work and used by permission in this work only. It may not be used outside of this work or in any derivative work without further permission. For more information, please see www.bshapirophotography.com.

Figure 12. *Tea with Ken*, by Gabe Kirchheimer, is copyrighted work and used by permission in this work only. It may not be used outside of this work or in any derivative work without further permission. For more information, please see www.gabekphoto.com.

Figure 13. *Head and shoulders of a child emerging from the petals of a calla lily*, by Unknown, photo by University of Southern California Library. All rights granted under Public Domain.

Figure 14. *Panther and Lilies*, by Lajos Vajda, photo by Ferenczy Museum. All rights granted under Public Domain.

Figure 15. *Echo no. 43*, by Alexandra Opie, is copyrighted work and used by permission in this work only. It may not be used outside of this work or in any derivative work without further permission.

Figure 16. *Forggensee Panorama*, by MMxx, photo-montage. All rights granted under a Creative Commons CC-BY-SA 3.0 Unported License.

Figure 17. *Blue and Yellow Macaw*, by Martin Giovannini, is copyrighted work and used by permission in this work only. It may not be used outside of this work or in any derivative work without further permission.

3.7 Installation and Performance Art

Figure 1. *Merzbau*, by Kurt Schwitters, photo by Applied Nomadology / Flickr. All rights granted under a Creative Commons CC-BY 2.0 License.

Figure 2. *Shadows and Fog*, by Christina West, photo by Access Ceramics. All rights granted under a Creative Commons CC-BY 2.0 Generic License.

Figure 3. Illustration of Joseph Buey's *I Like America and America Likes Me*, by Oriol Tuca (own derivative). All rights granted under a Creative Commons CC-BY-SA 3.0 Unported License.

Figure 4. Photographs of Marta Minujín's *Reading the News*, photos by Arte de acción. All rights granted under Public Domain via Wikimedia Commons.

Figure 5. *Uncertain White III, Capital Cleanse Series*, by Tereza Swanda, is copyrighted work and used by permission in this work only. It may not be used outside of this work or in any derivative work without further permission. For more information, please see www.mamatereza.net.

Figure 6. *Flash Mob at Lausanne, Switzerland*, photo by Rama. All rights granted under a Creative Commons CC-BY-SA 2.0 France License via Wikimedia Commons.

Figure 7. *Drawing Chair: Performance for the Fidgety Child*, by Rebecca Szeto, is copyrighted work and used by permission in this work only. It may not be used outside of this work or in any derivative work without further permission.

Figure 8. *Drawing Chair: Performance for the Fidgety Child*, by Rebecca Szeto, is copyrighted work and used by permission in this work only. It may not be used outside of this work or in any derivative work without further permission.

Figure 9. *Rubin Schuhe (Ruby Shoes), by Kathryn Cellerini Moore*, is copyrighted work and used by permission in this work only. It may not be used outside of this work or in any derivative work without further permission.

Chapter 3.8 Public Art

Figure 1. *Vietnam Veterans Memorial*, by Maya Lin, photo by Ken Lund. All rights granted under Public Domain.

Figure 2. Maya Lin's original competition submission for the Vietnam Veterans Memorial, Library of Congress, All rights granted under Public Domain.

Figure 3. Perspective Drawings, *Vietnam Veterans Memorial*, by Paul Stevenson Oles, Library of Congress. All rights granted under Public Domain via Library of Congress.

Figure 4. *John Boyle O'Reilly Memorial*, by Daniel Chester French. All rights granted under Public Domain via Wikimedia Commons via Library of Congress.

Figure 5. *The Three Servicemen*, by Frederick Hart, photo by Leo Reynolds. All rights granted under Public Domain via Wikimedia Commons.

Figure 6. The AIDS Quilt on display at the National Building Museum, photo by Ted Eytan. All rights granted under a Creative Commons CC-BY-SA 2.0 Generic license.

Figure 7. *Statue of Liberty*, by Frédéric Auguste Bartholdi, photograph by Rojypala. All rights granted under a Creative Commons CC-BY 2.0 Generic license via Wikimedia Commons.

Figure 8. *Taj Mahal*, by Ustad Ahmad Lahauri, photo by Dhirad. All rights granted under a Creative Commons CC-BY-SA 2.0 Generic license via Wikimedia Commons.

Figure 9. *Arc de Triomphe*, by Jean Chalgrin, photo by Norio Nakayama. All rights granted under a Creative Commons CC-BY-SA 2.0 Generic license via Wikimedia Commons.

Figure 10. *El Pueblo a la Universidad y a la Universidad al Pueblo*, by David Alfaro Siqueiros, photo by Régis Lachaume. All rights granted under Public Domain via Wikimedia Commons.

Figure 11. *Man-Controller of the Universe*, by Diego Rivera, photo by Wolfgang Sauber. All rights granted under a Creative Commons CC-BY-SA 3.0 Unported, 2.5 Generic, 2.0 Generic, and 1.0 Generic license via Wikimedia Commons.

Figure 12. *Hombre de Fuego*, by José Clemente Orozco, photo by Angel Ortega. All rights granted under a Creative Commons CC-BY-NC-ND 2.0 Generic license via Wikimedia Commons.

Figure 13. *City Life*, by Victor Arnautoff (and uncredited WPA workers including Ralph Stackpole, Bernard Zakheim, Edward Hansen Farwell Taylor, and faculty and students of the California School of Fine Arts), photo by Epachamo. All right granted under Public Domain via Works Progress Administration.

Figure 14. *Overcoming Global Warming*, by Hector H Hernandez, is copyrighted work and used by permission in this work only. It may not be used outside of this work or in any derivative work without further permission. For more information, please see www.hectorhh.com

Chapter 4 Modernism

4.1 Modern Art

Figure 1. *Yellow Border*, by Wassily Kandinsky, photo by Wikimedia Foundation. All rights granted under Public Domain via Wikimedia Commons.

Figure 2. *Pollice Verso*, by Jean-Léon Gérôme, photo by phxart. All rights granted under Public Domain via Wikimedia Commons.

Figure 3. *The Stonebreakers*, by Gustave Courbet, photo by Wikimedia Foundation. All rights granted under Public Domain via Wikimedia Commons.

Figure 4. *Princess de Broglie*, by Jean Auguste Dominique Ingres, photo by Art Renewal Center. All rights granted under Public Domain via Wikimedia Commons.

Figure 5. *Impression Sunrise*, by Claude Monet, photo by wartburg.edu. All rights granted under Public Domain via Wikimedia Commons.

Figure 6. *A Girl with a Watering Can*, by Auguste Renoir, photo by Google Cultural Institute. All rights granted under Public Domain via Wikimedia Commons.

Figure 7. *Rouen Cathedral*, by Claude Monet, photo by Wikimedia Foundation. All rights granted under Public Domain via Wikimedia Commons.

Figure 8. *Rouen Cathedral: the Portal (Sunlight)*, by Claude Monet, photo by The Metropolitan Museum of Art. Licensed under OASC.

Figure 9. *A Sunday Afternoon on the Island of La Grand Jatte*, by George Seurat, photo by Art Institute of Chicago. All rights granted under Public Domain via Wikimedia Commons.

Figure 10. *Gardanne*, by Paul Cézanne, photo by Wikimedia Foundation. All rights granted under Public Domain via Wikimedia Commons.

Figure 5. *Murdering Airplane*, by Max Ernst, is copyrighted work and may not be used outside of this work or in any derivative work without further permission. One-time, non-exclusive English language, North American distribution rights granted by Artist Rights Society. For more information, please see www.arsny.com. © 2016 Artists Rights Society (ARS), New York / ADAGP, Paris.

Figure 6. *The Infant III*, by Gabriel Praque, photo by Access Ceramics. All rights granted under a Creative Commons CC-BY 2.0 Generic License.

Figure 7. *You're the Bomb, Pop*, by Benjamin Schulman (own work). All rights granted under a Creative Commons CC-BY 2.0 Generic License via Access Ceramics.

Figure 8. Back Yard Vintage Black Face Boy, photo by Lynn Friedman. All rights granted under a Creative Commons CC-BY-NC-ND 2.0 Generic license.

Figure 9. *L.H.O.O.Q.*, by Marcel Duchamp, photo by Karl Stas. All rights granted under Public Domain via Wikimedia Commons.

Figure 10. *George's False Support*, by Tessa Sutton is copyrighted work and used by permission in this work only. It may not be used outside of this work or in any derivative work without further permission. For more information, please see www.tessasutton.com.

Figure 11. *George Washington at Valley Forge*, by Henry Merwin Shrady, photo by Jim Henderson. All rights granted under a Creative Commons Universal Public Domain Dedication License.

4.4 Nonrepresentational Approaches

Figure 1. *Haystack*, by Piet Mondrian, photo by Gemeente Museum. All rights granted under Public Domain via Wikimedia Commons.

Figure 2. *The Red Tree*, by Piet Mondrian, photo by Gemeente Museum. All rights granted under Public Domain via Wikimedia Commons.

Figure 3. *Gray Tree*, by Piet Mondrian, photo by Gemeente Museum. All rights granted under Public Domain via Wikimedia Commons.

Figure 4. *Composition No. IV*, by Piet Mondrian, photo by Gemeente Museum. All rights granted under Public Domain via Wikimedia Commons.

Figure 5. *Composition*, by Piet Mondrian, photo by The Metropolitan Museum of Art. Licensed under OASC.

Figure 6. *The Ten Biggest, No. 3, Youth, Group IV*, by Hilma af Klint, photo by Gavin Malavolta. All rights granted under Public Domain via Wikimedia Commons.

Figure 7. *From Curve to the Point -- Accompanying Sound of Geometric Cruves*, by Vasily Kandinsky, photo by The Metropolitan Museum of Art. Licensed under OASC.

Figure 8. *The Story of Zahhak and His Father (Page from a Manuscript of the Shahnama (Book of Kings))*, by Firdawsi, photo by Brooklyn Museum. All rights granted under Public Domain via Brooklyn Museum. Licensed under OASC.

Figure 9. *Composition IX*, by Theo van Doesburg, photo by Wikimedia Foundation. All right granted under Public Domain via Wikimedia Commons.

Figure 10. *Red and Blue Chair*, by Gerrit Rietveld, photo by Ellywa. All rights granted under a Creative Commons CC-BY-SA 3.0 Unported License via Wikimedia Commons.

Figure 11. *The Bauhaus Building*, by Walter Gropius, photo by Mewes. All rights granted under Public Domain via Wikimedia Commons.

Figure 4. *what women make*, by sandra "sloy" nichols, is copyrighted work and used by permission in this work only. It may not be used outside of this work or in any derivative work without further permission.

Figure 5. *The Icecream-burrrg Slurptastic Titanic Disaster of 2008*, by Peter Morgan, photo by Access Ceramics. All rights granted under a Creative Commons CC-BY 2.0 Generic license.

Figure 6. *Monogram*, by Robert Rauschenberg, is copyrighted work and may not be used outside of this work or in any derivative work without further permission. One-time, non-exclusive English language, North American distribution rights granted by Robert Rauschenberg Foundation. For more information, please see http://www.rauschenbergfoundation.org. © 2016 Robert Rauschenberg Foundation.

Figure 7. *We Regret to Inform You…*, by Carol Hausser and Robert Bibler, is copyrighted work and used by permission in this work only. It may not be used outside of this work or in any derivative work without further permission. For more information, please see www.robertbibler.com.

Chapter 5: Themes in Art

Chapter 5.1

Figure 1. *Woman of Willendorf*, by Unknown, photo by Wikimedia Foundation. All rights granted under Public Domain via Wikimedia Commons.

Figure 2. Hall of Bulls at Lascaux Caves, by Unknown, photo by Wikimedia Foundation. All rights granted under Public Domain via Wikimedia Commons.

Figure 3. [Scribe Sitting with a Papyrus], by Unknown, photo by Wikimedia Foundation. All rights granted under Public Domain via Wikimedia Commons.

Figure 4. *Self-Portrait*, by Judith Leyster, photo by Google Cultural Institute. All rights granted under Public Domain via Wikimedia Commons.

Figure 5. *Zak and Erin, Portland, OR*, by Ann Ploeger, is copyrighted work and used by permission in this work only. It may not be used outside of this work or in any derivative work without further permission. For more information, please see www.annploeger.com.

Figure 6. [Donner Pass Graffiti], by Unknown artists, photo by Deanne Beausoleil. Used with permission from the photographer.

Figure 7. [Donner Pass Graffiti], by Unknown artists, photo by Deanne Beausoleil. Used with permission from the photographer.

Figure 8. *Only You*, by Unknown, photo by Deanne Beausoleil. Used with permission from the photographer.

Chapter 5.2

Figure 1. *The Standard of Ur, "War" panel*, by Unknown, photo by Wikimedia Foundation. All rights granted under Public Domain via Wikimedia Commons.

Figure 2. *The Standard of Ur, "Peace" panel*, by Unknown, photo by Wikimedia Foundation. All rights granted under Public Domain via Wikimedia Commons.

Figure 3. *Untitled (Graves)*, by Miller & Shellabarger, is copyrighted work and used by permission in this work only. It may not be used outside of this work or in any derivative work without further permission. For more information, please see westernexhibitions.com/miller-shellabarger/index.html.

Chapter 5.3

Chapter 5.4

Chapter 5.5

Chapter 6: Where Is Art?
Chapter 6.1

CPSIA information can be obtained
at www.ICGtesting.com
Printed in the USA
LVHW01s0602140818
586435LV00002B/2/P

9 781943 536153